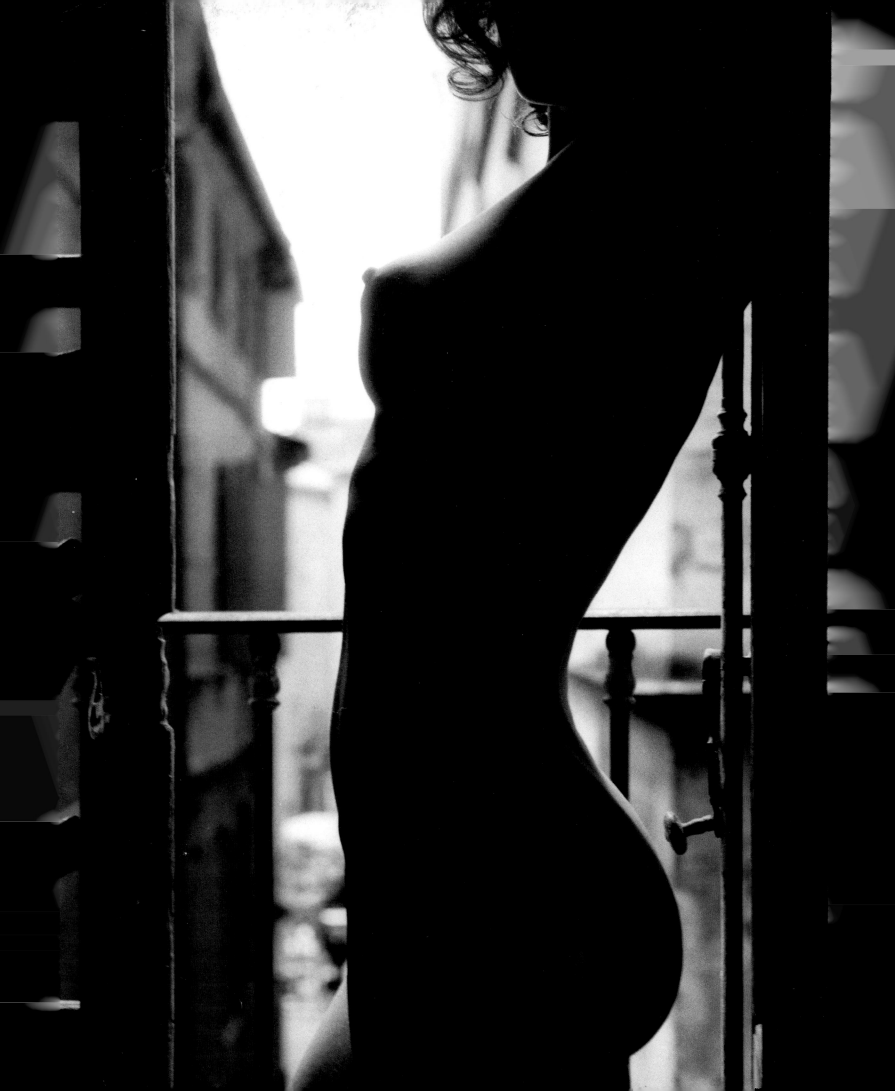

NUDE
PHOTOGRAPHY
THE ART AND THE CRAFT

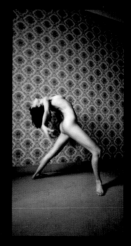

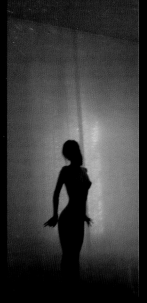

PASCAL
BAETENS

NUDE
PHOTOGRAPHY
THE ART AND THE CRAFT

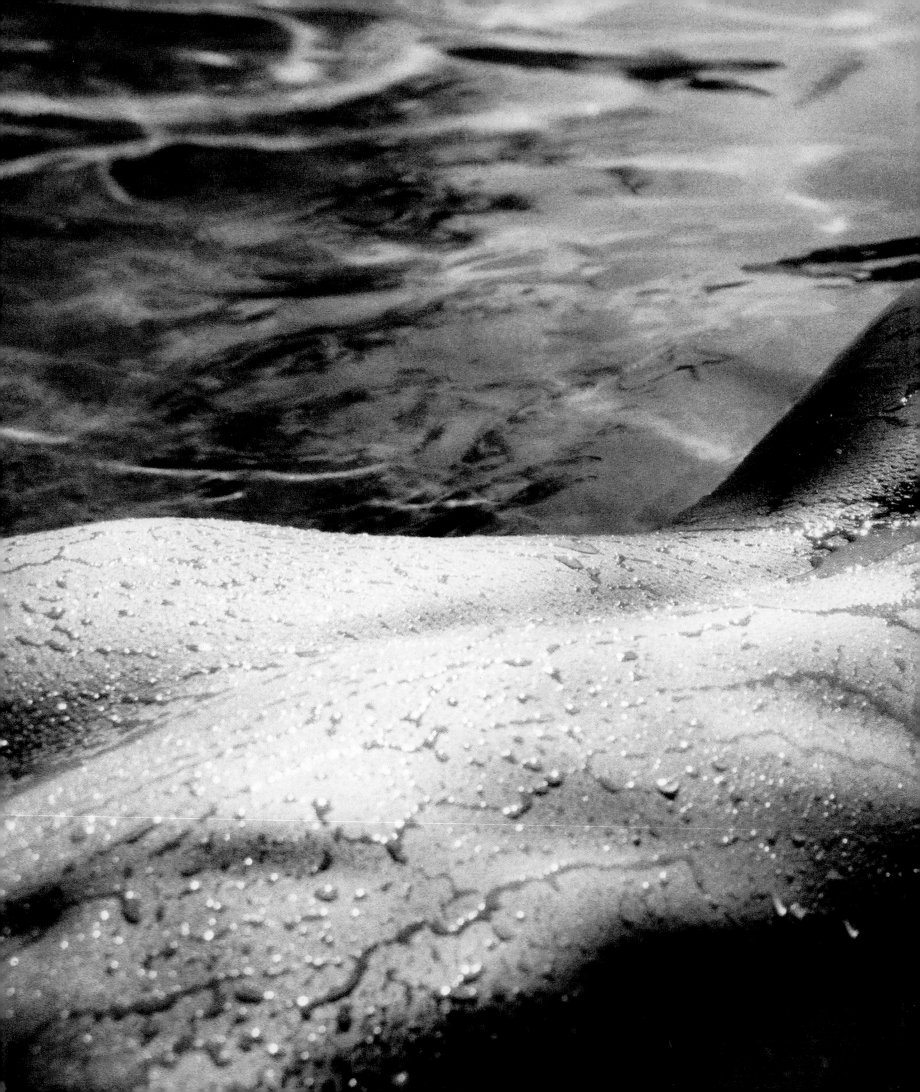

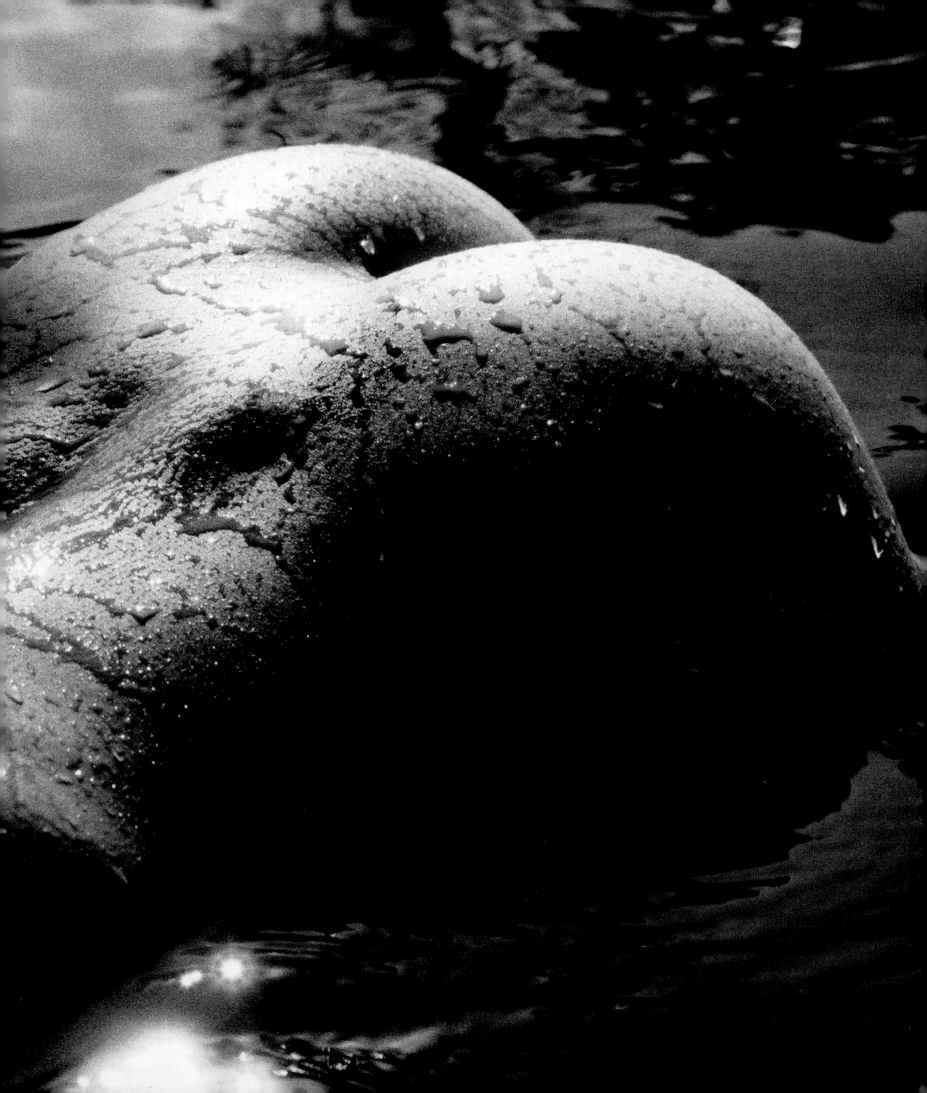

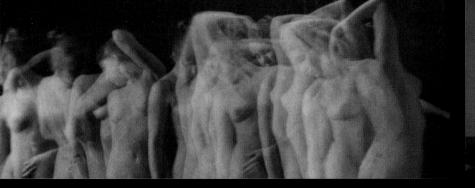
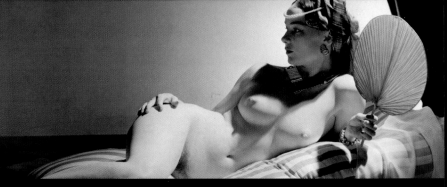

DK LONDON, NEW YORK, MUNICH, MELBOURNE, DELHI

Project Editor Nicky Munro
Editor Diana Vowles
Designer Sarah-Anne Arnold
Senior Editor Simon Tuite
Senior Art Editor Susan St. Louis

Managing Editor Stephanie Farrow
Managing Art Editor Lee Griffiths

Production Editor Clare McLean
Production Controller Tony Phipps

Produced on behalf of Dorling Kindersley by

Sands Publishing Solutions
4 Jenner Way,
Eccles,
Aylesford,
Kent, ME20 7SQ

and

XAB
39A Highbury New Park
London, N5 2EN

First published in Great Britain in 2007
by Dorling Kindersley Limited
80 Strand, London WC2R 0RL

A Penguin Company
2 4 6 8 10 9 7 5 3 1

Copyright © 2007
Dorling Kindersley Limited
Text copyright © 2007 Pascal Baetens
Except Chapter 5 © Dorling Kindersley

ISBN-13: 978-1-4053-2218-8

Printed in Singapore by Star Standard
Colour reproduced by GRB Editrice s.r.l., Italy

See our complete catalogue at
www.dk.com

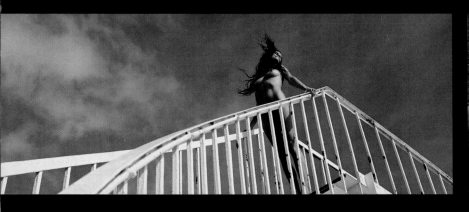
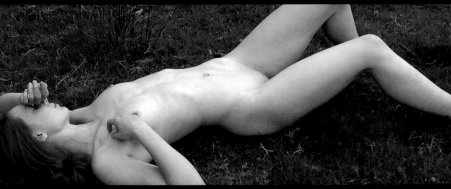

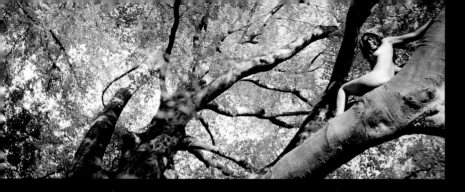

3 exploring techniques

4 postproduction

5 photographers' gallery

introduction

For me, a successful image is one that has an immediate impact on the viewer, that grabs their attention, and makes them dream, smile, think, or simply enjoy it. I tend to think that technique, though important, plays a more humble role: it is the servant of the image.

Photographic technique is like a language. The more refined your language, the more subtly you can express yourself, but if you have no story to tell, no feeling to get across, your words will remain hollow. So my focus in this book is to make you aware of the artistic implications of your technical choices, rather than to discuss the photographic technicalities as such. There are plenty of tips to improve your pictures, but it's mainly a guide for training your eyes to look at nudes with a photographic understanding.

Positioning your model with side light to sculpt his or her body with light and shadows, for example, has nothing to do with your equipment, but everything to do with understanding the possibilities and uses of light; where you place your model in the frame reflects your understanding of composition; guiding your model into expressing the atmosphere you want to create is all about your vision and communication skills; and so on. And you can work on all these elements with even the most basic of cameras.

Once you've read about the history of nude photography, the many ways you can sharpen your vision, and how to bring a particular look and feel to your image, and when you've considered the postproduction techniques you might choose to apply and looked at the gallery of how other photographers have approached this branch of photography, there is a final chapter yet to be written – by you. I can only offer you a book full of photographic ingredients, and tips to help you discover more. Learn to choose them carefully, and to find the perfect mix for your images. Enjoy!

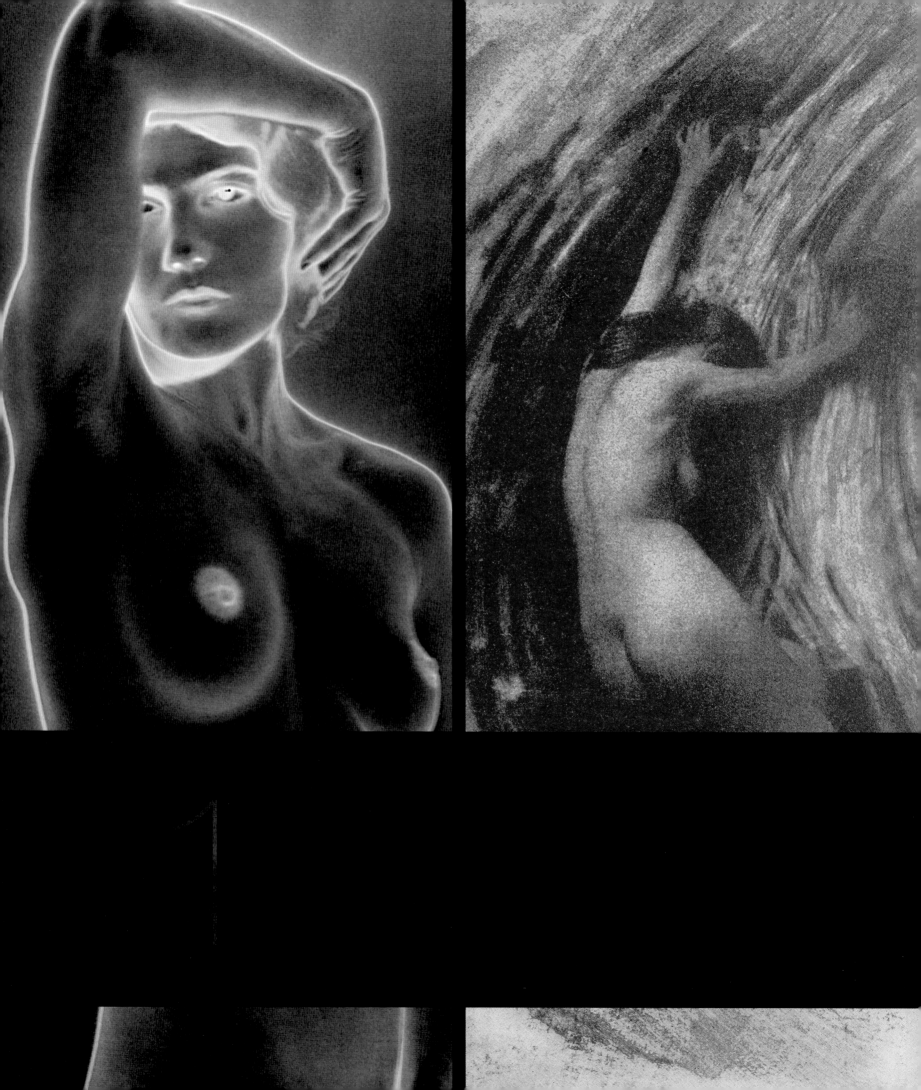

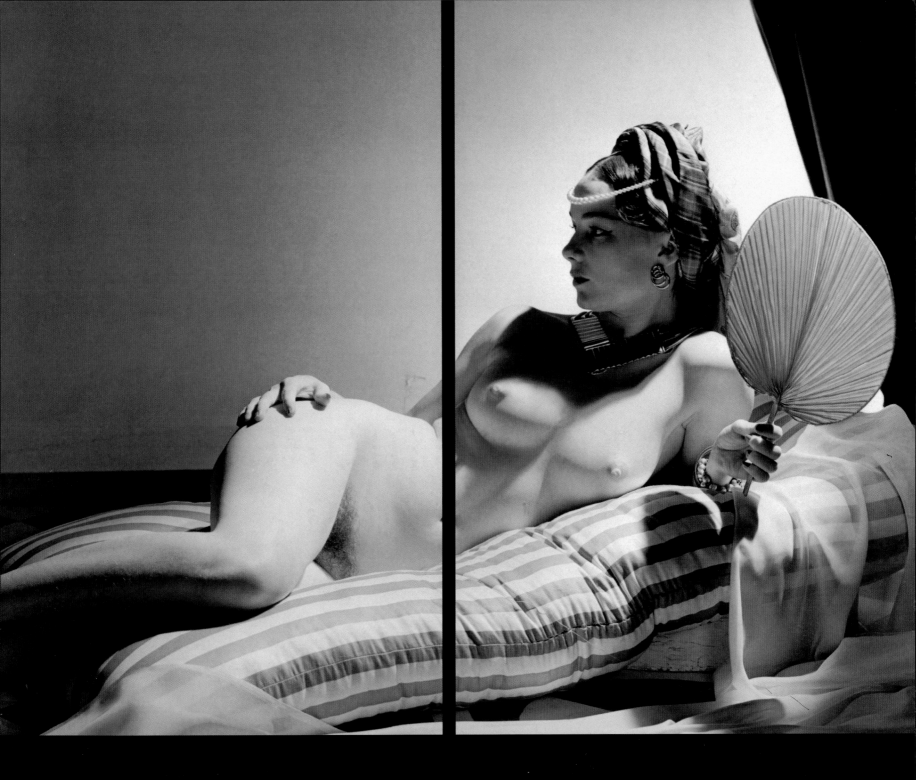

the history of
nude photography

the history of nude photography

Prehistoric cave drawings, statues from ancient Greece and Rome, erotic sculptures from India and Africa, naked female figures and other ancient artefacts the world over are testimony to the powerful fascination of the naked body.

The invention of photography in the 19th century created a new means of portraying the body, and while its early practitioners drew upon European traditions of painting for their subjects, composition, and lighting, the differences in approach between the two art forms soon started to evolve. In particular, rapport between the artist and model became crucial.

Photography also brought a choice never before available in visual art: whether to capture a scene instantly, as it existed – which became known as reportage – or to create an artistic composition by deliberately putting every element in place before the shutter was opened.

NUDITY WITH A MESSAGE

While early photographs were technically difficult to produce, they paved the way for a visual experience that anyone could enjoy. As photography grew in popularity, so did images of the naked body, both male and female, introducing sexuality into the new medium, albeit often in the guise of aestheticism. These nudes, photographed in daylight, seemed excitingly real compared to those in paintings, where the viewer knew that the artist had painstakingly described the light on the model's body in the way that he or she chose.

One of the first nude images, however, by Hippolyte Bayard (1801–1887), had nothing to do with eroticism or any classical appreciation of the human form. In *Self-Portrait As a Drowned Man*, Bayard portrayed himself naked except for a piece of cloth representing a shroud, seated in a slumped position, apparently dead. Bayard had invented his own photographic technique of positive printing at about the same time as Louis Daguerre (1787–1851), but it was Daguerre and his "daguerreotype" that received official recognition from the French government. As a reaction against the injustice he felt had been committed, Bayard created this photograph. Not only was this the first political use of a nude photograph, it was also the first one to show the human body in a theatrical setting. It may in fact have been the first photograph of a nude human figure ever, as Daguerre's technique needed an extremely long exposure time and his photograph of a female body in 1839 had been achieved by photographing a sculpture.

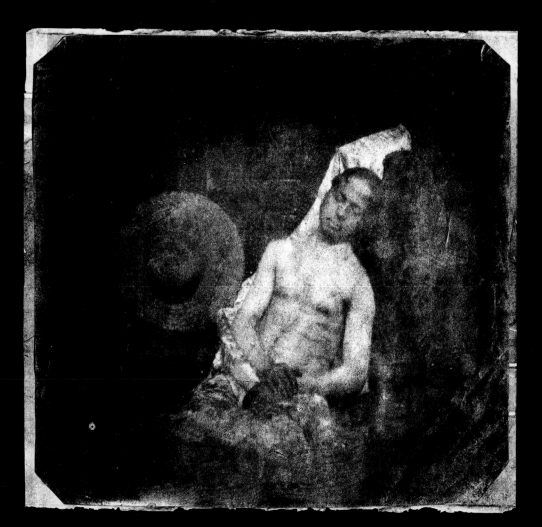

EROTIC NUDES

In the early 1840s, improved lenses and chemicals made exposure times of less than a minute possible, paving the way for popular portraiture. Another development was the stereoscopic camera, which gave the illusion of a three-dimensional image. It did this by presenting slightly different two-dimensional images next to each other. The process was not only used for everyday portraits, but also to show secret, erotic, "real" images.

◁ **Hippolyte Bayard**
Self-Portrait As a Drowned Man (1840) expressed Bayard's despair at the lack of recognition for his work.

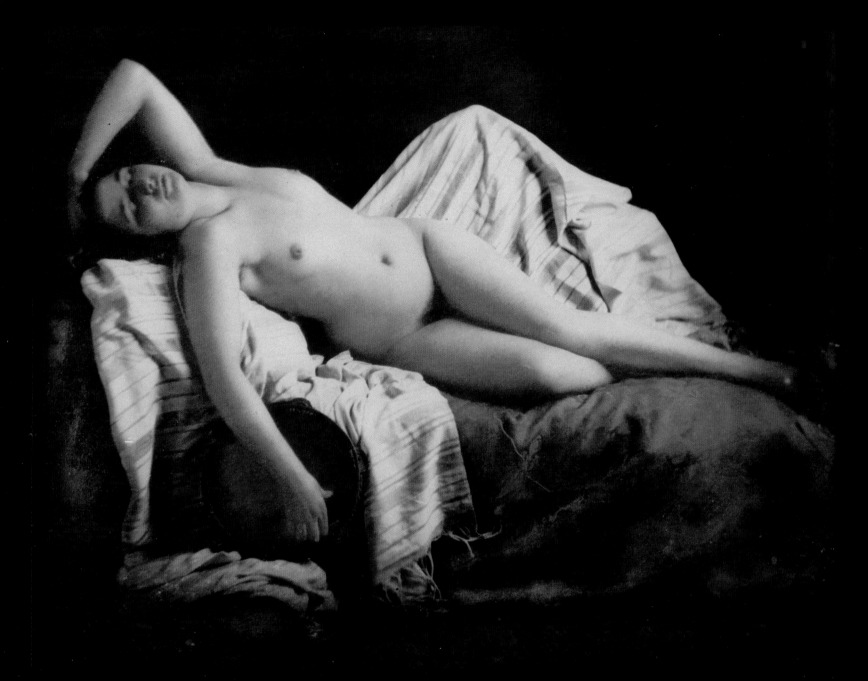

Two of the most prolific proponents of this new technique
were F. J. Moulin (approximately 1800–1868) and Auguste Belloc
(active 1850–1868). These two French photographers seem to
have attempted every different genre in the domain of nudity:
academic nudes, pictorial nudes mimicking famous works of
art, and erotic, even pornographic, images. Their academic
nude photographs were used as reference by painters such as
Courbet and Delacroix, and both men were among the pioneers
of fine art photography.

After the invention of photography the question arose as to how
the human body should be depicted. In paintings, the tradition had
normally been to show nudity in the form of mythological, religious,
and allegorical scenes, which lent a cloak of respectability to the act
of looking at something that frequently had a sexual content. Taken
out of these contexts and made real, photographic nudes inevitably
took on a more sexual connotation. Many of the photographers who

△ Auguste Belloc

This hand-coloured daguerreotype is part of a stereoscopic set
of two, entitled *Femme nue allongée sur un canapé*, created in
about 1850. Nude images such as this were often used and
even commissioned by painters, and were presented in albums.

explored the sexuality of the human body did so anonymously, and
some of their images remain shocking even today. They showed not
only the beauty of their models but also their sexual needs, desires,
and often explicit activities – a theme that was to reappear in the
mid-20th century art scene.

The production of erotic and pornographic nude photographs
quickly developed the world over into a thriving business to feed
the appetites of certain sections of the public, whether officially
sanctioned or existing illegally underground, depending on what was
permissible under local legislation.

THE SCIENTIFIC NUDE

While the genre of erotic photography was developing and artists were discussing the use of the human form in this new medium, other photographers sought to explore the scientific and technical possibilities of photography. In the USA and France respectively, Eadweard Muybridge (1830–1904) and Etienne-Jules Marey (1830–1904) carried out experiments with chronography – a set of photographs of a moving object at regular intervals – in which the naked body became the perfect subject for artistic as well as scientific reasons. Chronography captured movement which was too fast for the eye to see, with a black background allowing the comparison of different positions that the body assumed in motion.

Another popular 19th-century scientific area of research was anthropology, and scientists were keen to build up photographic records of the people who were the objects of their study. As travel became easier, curiosity about foreign lands increased. "Exotic" photographs, often from the colonies in Africa or Asia, seduced Western viewers with images of partially naked people.

This type of imagery and the fascination with people and cultures far away existed in paintings and sculptures long before the invention of photography. However, the new medium gave these images a guarantee of authenticity which resulted in a boom in ethnographic photography. Photographs of people living close to nature, with different cultural values and ideas of sexual morality, became very popular with Westerners for scientific, ideological and, of course, artistic and erotic reasons from the 1860s until well into the 20th century. Although some photographers took a genuinely scientific approach, many of the images could be called "imaginative ethnography". This exotic view of the foreign, the romantic idealization, and the erotic fantasy verged on racism and ethnocentricity, often saying more about the culture of the photographers and their fantasies than about foreign cultures and their indigenous peoples.

Such an approach can be found in the work of Rudolf Lehnert (1878–1948) and Ernest Landrock (1878–1966). Born in Bohemia (then part of the Austro-Hungarian empire), Lehnert met Landrock,

▽ Eadweard Muybridge

Motion Study of an Athlete on the March was created in California in about 1900 as one of Muybridge's movement studies. Influenced by Etienne-Jules Marey's work, it was achieved with the use of carefully timed multiple cameras.

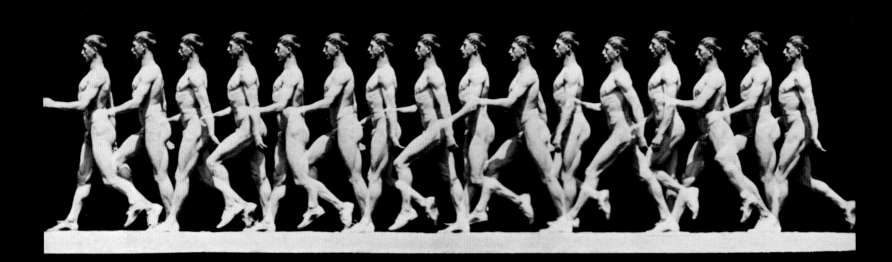

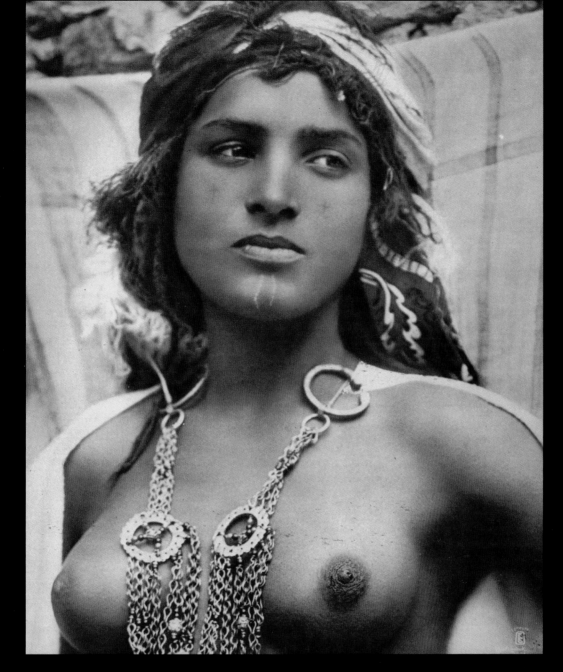

a German, in Tunisia in 1904. The pair established a photography studio in Tunis, with Lehnert taking the photographs and Landrock acting as manager of the studio. They later set up business in Cairo, selling postcards and prints of romanticized desert scenes, Bedouin tribespeople and partially clad or naked girls.

In the early years of the 20th century, while the naked body could be shown under the category of art or science, portraying it in terms of pure sexuality was still taboo. Ernest James Bellocq (1873–1949) photographed prostitutes in New Orleans extensively in the early 1900s, but seems never to have made prints from his 10 x 8–inch glass negatives. Although the models posed proudly for the camera, their faces were often scratched out on the negatives, perhaps to preserve their anonymity. It was only in the 1960s that some of the negatives were discovered and published by the photographer Lee Friedlander.

PHOTOGRAPHY MEETS ART

Since its origin, photography had been a useful aid for painters and sculptors, for whom many books with nudes in different poses and settings were available. By the middle of the 1880s this led to a movement for the recognition of photography as an equivalent art form, known as pictorialism. The aim of the pictorialists was to establish the photographic print as an authentic artistic object, so they created products which were close to paintings, in content as well as in form. Such photographs had to stand the test of criticism as in every other art medium: satisfactory in composition, colour quality, tone, and lighting; having aesthetic charm; and involving some expression of the personal feeling of the photographer.

The pictorialists' images of nude models were not portraits; instead they explored narrative and symbolism and expressed the photographers' emotions and dreams. Rather than trying to produce

▷ Robert Demachy

Struggle (1904) was printed with
the gum bichromate process, that
allowed the use of subtle colour.
Pictorialists such as Demachy
favoured soft focus images and
printing techniques that made their
work resemble paintings.

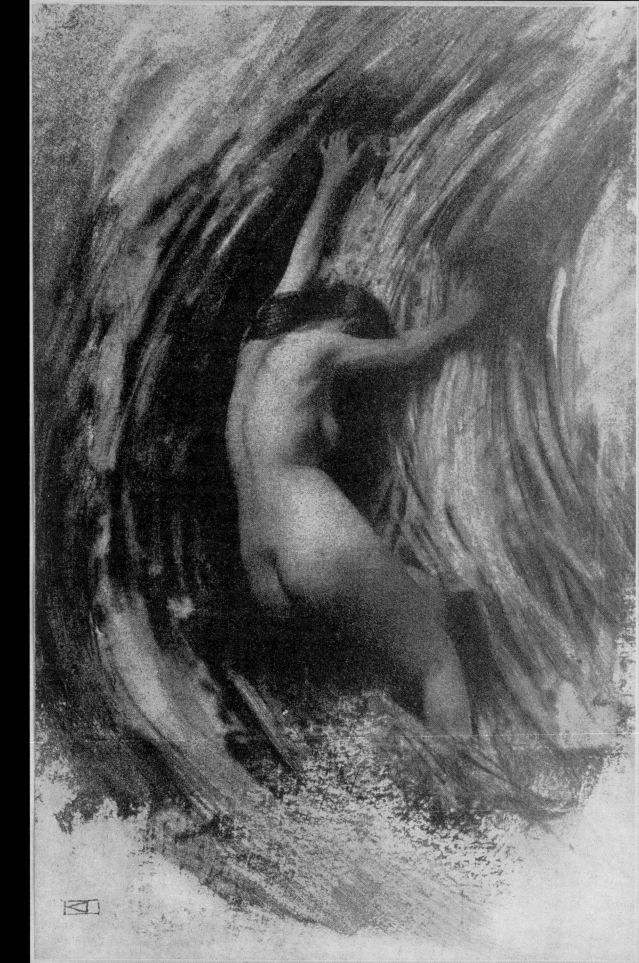

prints by using soft focus lenses and elaborate printing processes.

Robert Demachy (1859–1936) was the most famous representative of pictorialism in France, while Edward Steichen (1879–1973), Frank Eugene (1865–1936), and Heinrich Kuhn (1866–1936) were its most notable proponents in the USA, Germany, and Austria respectively. There is a similarity in their approaches to the female body, not only in the printing techniques but also in their tendency to portray the model in a dream-like atmosphere. Their intention was to represent nudity in its sublimated form to make the viewer reflect upon the meaning of the image rather than to stimulate desire.

PHOTOGRAPHY FINDS ITS DIRECTION

By around 1910, the pictorialist aim of copying the look and feel of paintings gave rise to a new chapter in the history of photography. Reacting against this non-photographic approach, some photographers turned towards what became known as pure, or straight, photography: reality itself became their subject rather than an idealization or sublimation of it. Having found recognition as art, photography had no need to imitate painting any more.

The modernists photographed their subject for its own merits and with techniques specific to the photographic medium. The nude body was presented now as an object in its own right, used in a graphic way with a strong interplay of lines and angles. For artists such as the Austrian Rudolf Köppitz (1884–1936) and the Czech František Drtikol (1883–1961) the nude became a figure with which to create geometric and abstract compositions that drew their influence from Cubism, although they still used the soft printing techniques of the pictorialists. Other photographers sought graphic qualities not only in their compositions but also in the printing techniques.

In the 1920s the Surrealist movement in visual art and literature was born as a reaction against the rationalism in European culture and politics that, the members of the movement believed, had ultimately led to World War I. Influenced by Freud, the aim of the Surrealists was to blur the lines between the conscious and the unconscious and to express the imagination as it was revealed in dreams. The Frenchman André Breton (1896–1966) and his fellow Surrealists soon discovered the artistic possibilities inherent in photography, especially in collages. In their work, the representation of the body took on a mystery and a sense of eroticism. By using the more radical effects that the medium offered – whether bird's-

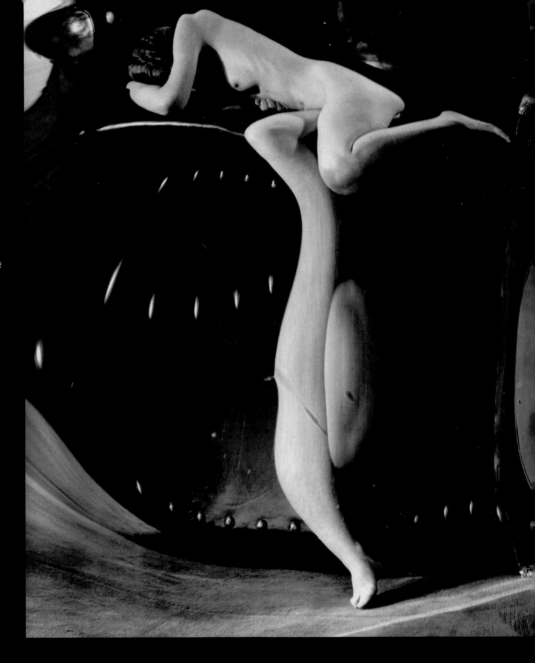

△ André Kertész

The modernists sought to expand the limits of the photographic medium. *Distortion No. 60* (1933) was one of a series in which Kertész played with mirror distortions, transforming his models into abstract creatures.

eye view and a short depth of field, or the use of mirrors and darkroom techniques such as solarization – the body could be presented in unfamiliar guises.

The Hungarian photographer André Kertész (1894–1985) used fairground mirrors in his series *Distortion* to deform the female body. In the US, Edward Weston (1886–1958) created images with fragments of the body, often using an upward perspective, while contemporaries such as Alfred Stieglitz (1864–1946) and Imogen Cunningham (1883–1976) combined geometry and abstraction with a sense of eroticism in their photographs.

Man Ray (Emmanuel Radnitsky, 1890–1976) pioneered techniques of producing surrealist images by means of darkroom manipulation. Born in Philadelphia, he began his artistic career as a painter before he took up photography in 1916. In 1921 he moved to Paris, where he spent most of the rest of his life. He is best known for developing, with his lover and assistant Lee Miller, the process of solarization. In this, the negative or print is briefly exposed to light and as a consequence the tones are partially reversed, often giving the effect of outlining the body in his nude studies. Man Ray's career also encompassed fashion and advertising photography.

Graphic experiments and other explorations with the photographic medium remained popular in the 1940s and 1950s, often introducing new elements, for example the natural landscapes in the work of the British photographer Bill Brandt (1904–1983). In a series of nudes photographed on the beaches of East Sussex, he used a wide-angle lens in close-up, giving extreme distortions of the body, and printed the images in high-contrast black and white. These startlingly white bodies photographed in the English countryside seem to be a part of the landscape – the nude returned to nature, free of the artifices of civilization.

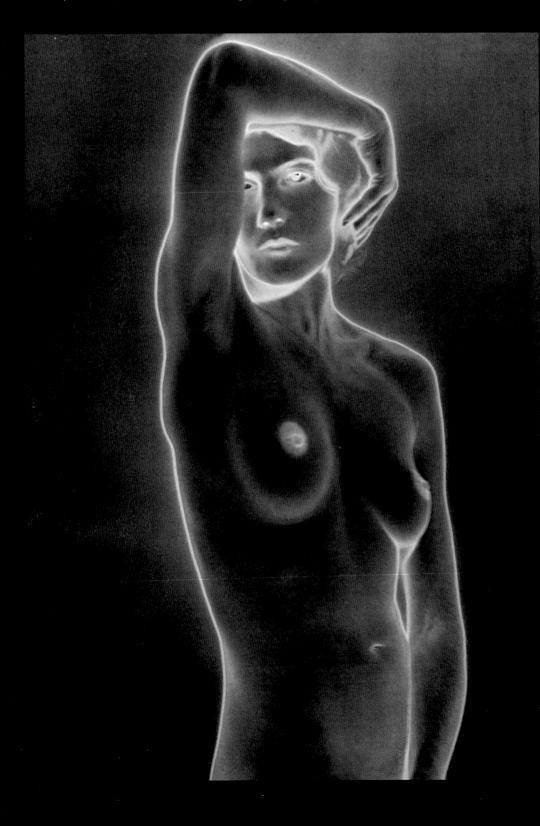

◁ **Man Ray**
Man Ray is best known for his solarized images, made by briefly exposing the negative to light before it is chemically fixed. *Natacha*, taken in about 1930, exists in a positive version as well as in the negative version shown here.

▷ **Bill Brandt**
Nude, East Sussex Coast (1957) is one of a series of images in which Brandt placed his models on rocky beaches and created sculpture-like forms with the use of a wide-angle lens and a low viewpoint.

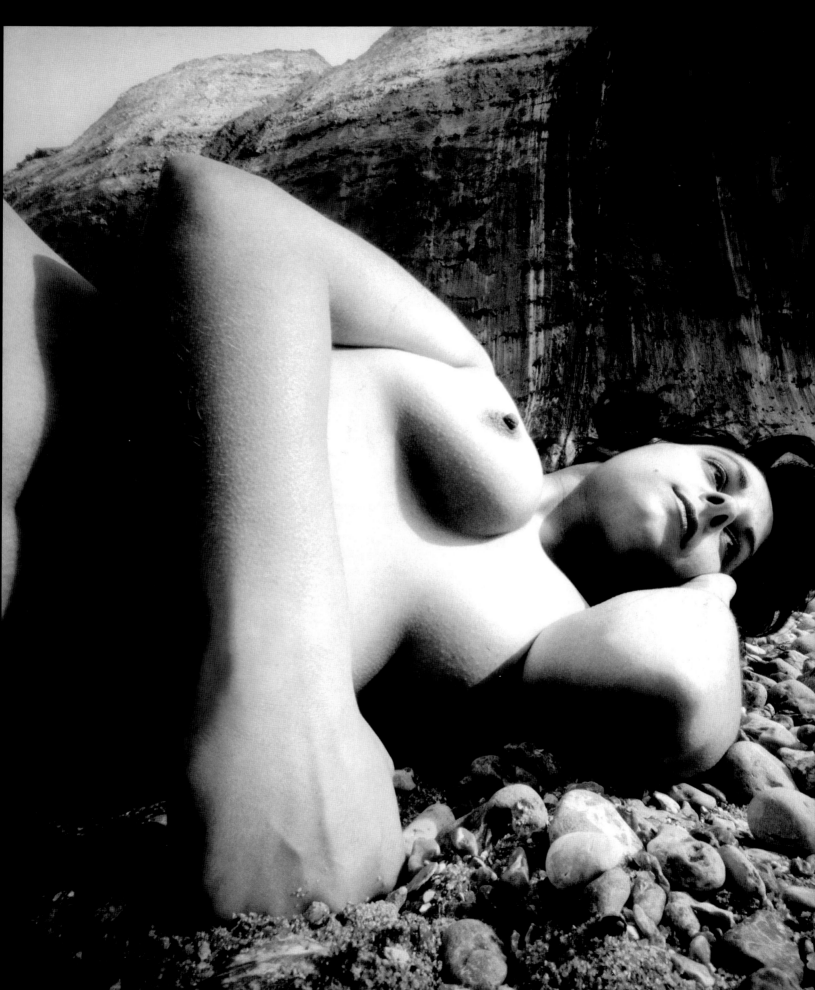

NUDES AND CLASSICISM

The beauty of the statues of ancient Greece and Rome has inspired painters and photographers throughout history, and in the 20th century the classical influence was used for artistic, political, and even erotic purposes. Early in the century the nudist movement celebrated the beauty of the human form with images of healthy young gymnasts in sunny and pure landscapes, while in 1927 Elli Souyoultzoglou-Seraidari (1899–1998), known as Nelly's, photographed the Russian dancers Nikolska and Mona Paiva dancing naked between the pillars of the Parthenon as if they were an incarnation of an ancient myth. Her images of nude female dancers caused a scandal and also secured her fame.

Where the naked human body was the subject, sexuality could still be found in privately produced photographs. The German photographer Herbert List (1903–1975) photographed nude men in the setting of Greek antiquity in a posed style drawn from contemporary literary influences, especially Jean Cocteau. These homoerotic, high-contrast, wide-angle images with naked young men juxtaposed with antique statues show a timeless and mythical viewpoint that gives equal importance to a temple and a body. His images would not be published until after his death.

△ **Leni Riefenstahl**
Lebendige Antike (1936). A gelatin silver print of the German decathlete Erwin Huber posing for Riefenstahl as a living antique statue, embodying the ideals of ancient Greece.

In the 1930s, political regimes used images of naked athletes to show the apparent supremacy of their people. The human body was to be perfect and healthy, the mind free to serve a higher goal – the subjects' country. The artistic experiments of the Dadaists and Surrealists were considered degenerate in countries such as Hitler's Germany and Stalin's Soviet Union, and many avant-gardists left Europe for the USA.

The naked body photographed in a style harking back to the glories of antiquity in the interests of propaganda was most notably represented by Leni Riefenstahl (1902–2003). She photographed the Berlin Olympics in 1936 and her film *Olympia* famously celebrated the athletes of Hitler's Germany in heroic pose; her book of photographs, *Schönheit im Olympischen Kampf*, is less well-known. Her images of beautiful naked men, photographed under a blinding sun, brought her the approval from Hitler which was to overshadow

the rest of her career. Removed from their political context, however, Riefenstahl's images are admired today for their technique and for the beauty of the human body – though she only photographed those that were perfect. Less contentious were her photographs of the Nuba, an ancient tribe in Sudan, whose beauty, traditions, and rituals she recorded for seven years during the 1960s, again with her interest concentrated upon the possessors of magnificent bodies.

THE DOCUMENTARY STYLE

After the horrors of World War II, sensuality and tenderness were emphasized much more in nude pictures. The artists now gave names to their models, some of whom were their wives. The most characteristic example is the American photographer Harry Callahan (1912–1999). He made numerous studies of his wife Eleanor, particularly from 1947 to the late 1950s, using a variety

of techniques, and placing her both indoors and in the natural landscape. Today this series is regarded by some as the most important area of his work, with photographs that speak of the intimacy, trust, and love between them.

The American artist Diane Arbus (1923–1971) also photographed the nude in the environment in a documentary and realistic style throughout the 1950s and 1960s. Arbus is known for her sensitivity toward individuals who lived at the border of society and for her fascination with the grotesque and the marginalized; circus people,

▽ **Harry Callahan**
Eleanor (1948), gelatin silver print. Callahan's warm and tender portrayal of his wife Eleanor over many years created one of the first sensual visual diaries, showing her at home, on city streets, and in the landscape.

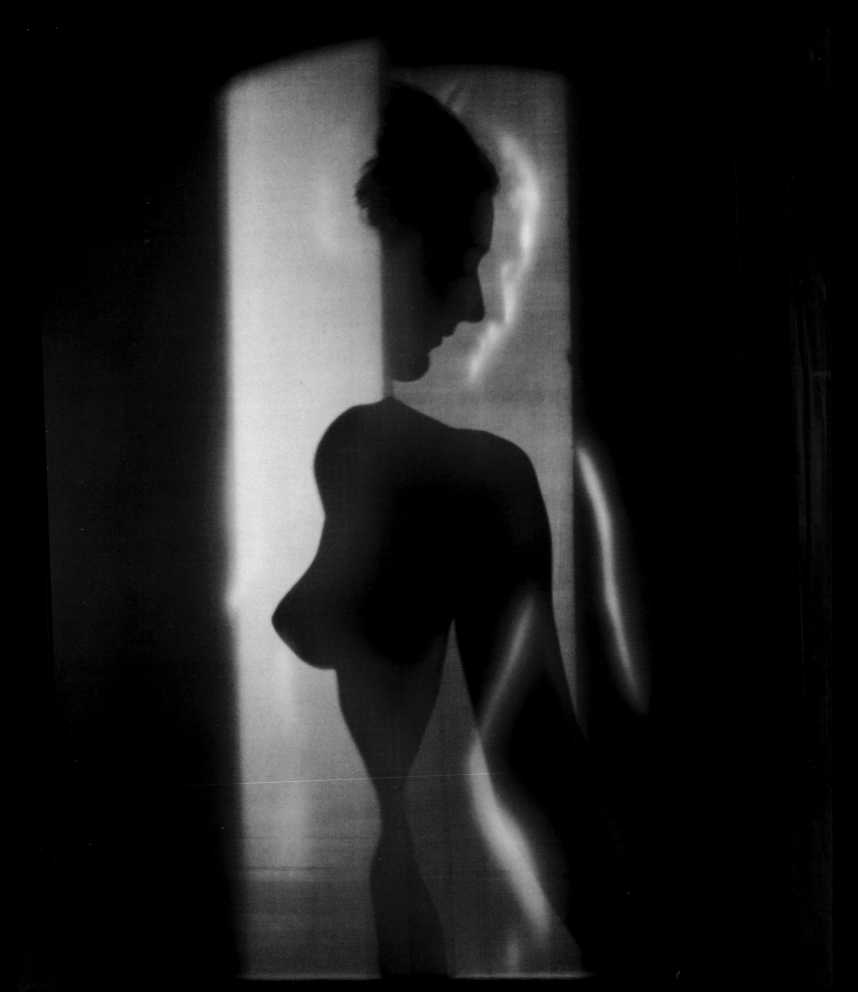

giants, dwarfs, transexuals, and mentally disturbed people were part of her gallery of portraits of an America of exclusion. In contrast, her photographs taken in nudist colonies show the everyday life of American families, with the exception that the people she portrayed were without clothes. As a result of this approach, the viewer pays hardly any attention to the nudity of the models but is more interested in their pose and surroundings. Far from the perfect athlete's physique that Riefenstahl sought, Arbus photographed flawed human bodies with an interest in their circumstances rather than with any sexual connotation. Despite the coldness of her documentary style, her empathy is real and the simplicity of her approach to subjects outside the mainstream of society is both exemplary and moving.

FASHION PHOTOGRAPHY

At the end of the 1930s, fashion photographers began to see models not merely as clothes horses on which to hang the designers' clothes, but as subjects in their own right. Working for *Vogue* and *Harper's Bazaar*, Erwin Blumenfeld (1897–1969) succeeded in uniting the avant-garde approach to composition and the use of solarization with fashion photography. His work depicted fashion in a graphic style, with the clothing abstract and the model's body as the main focus. His emphasis on the models themselves eventually resulted in Blumenfeld photographing some of the first nude images ever to be seen in *Vogue*. In using backgrounds appropriate for the clothing and creating an atmosphere that permeated the whole image, he invented a very personal universe that still influences fashion photographers today.

Horst P. (Paul) Horst (1906–1999) first gained fame on the publication of his photograph *The Mainbocher Corset*, which appeared in *Vogue* in 1939. Though not a nude image, the model's

hourglass shape is emphasized by chiaroscuro lighting and the untied ribbon lacing her corset hints at nudity. With her head bowed and slightly in profile, the model has accepted our gaze, voyeuristic and complicit at the same time. Horst photographed many nudes in this style, using several studio lights to create a stylish play of light and shadow.

In this new fashion concept, the body became the most important feature and the clothes took second place. The images of Horst and Blumenfeld demonstrated the desire for a rediscovery of the body and its artistic dimensions while serving the needs of fashion photography. Magazines on both sides of the Atlantic, from *Vogue* and *Harper's Bazaar* to *Le Jardin des Modes*, encouraged this kind of aesthetic, with images of underwear, bathing suits, and nudes.

But not every fashion photographer made his nudes the servants of the needs of fashion photography. In 1949–1950 Irving Penn (1917–) photographed nudes that were highly unorthodox by fashion standards: their fleshy torsos are twisted

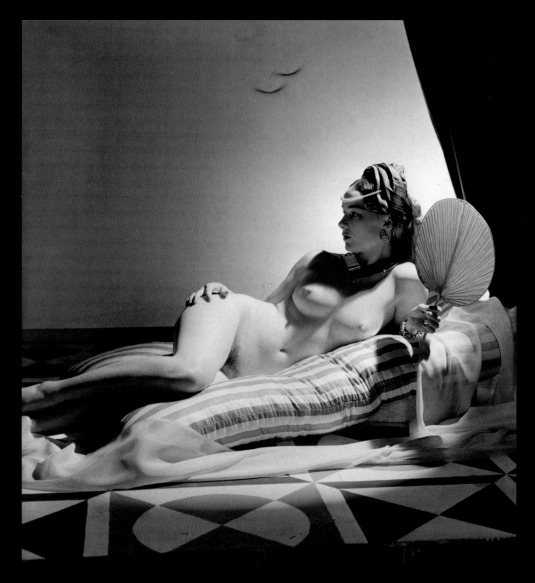

◁ **Erwin Blumenfeld**

Cubistic Purple Nude (1949) was created by superimposing different images, bringing surrealistic experiments into fashion photography.

▷ **Horst**

Odalisque 1, platinum print on canvas (1943). With just a few well-chosen props and dramatic lighting Horst has

▷ **Arno Rafael Minkkinen**
Abbaye de Montmajour, Arles, 1983
was created in the landscape that
Van Gogh painted. Minkkinen has
commented "It is with a deep sense
of humility that I can say what a
great pleasure it was entering the
skies of a Van Gogh landscape for a
split second."

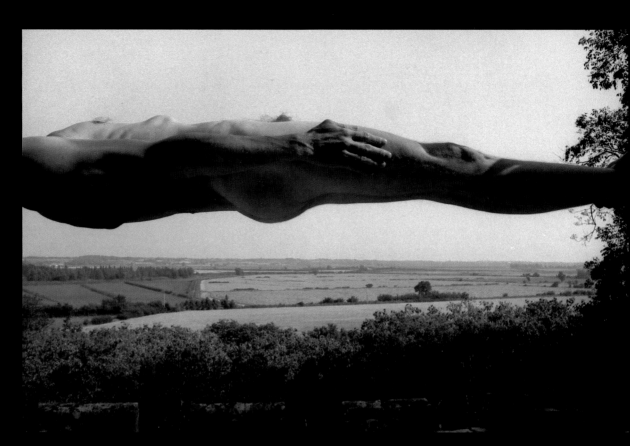

and stretched, with prominent bellies and mounded hips. The
voluptuous forms owe more to the ancient fertility idols found
the world over, the full-bodied women painted by Rubens, and
the distortion experiments of the pre-war modernists, than to the
fashion imagery of the mid 20th century.

THE MALE NUDE

Until the end of the 1960s, images of the body were mainly female
and largely produced by men. The photographed nude mostly
followed academic conventions inherited from classical art,
especially in Europe. However, the social destabilization of the
1960s was to form the basis of a new approach to the body.

In the genre of self-portraiture, three photographers of the same
generation broke taboos, albeit in very different styles. Dieter Appelt
(Germany, 1935–), Jan Saudek (Czech Republic, 1935–), and Arno
Rafael Minkkinen (Finland, 1945–) have dedicated most of their work
not only to the self-portrait but also to the self-nude.

The work of Dieter Appelt displays the human body in a sort of
geological concretion, a mix of theatre, painting, and sculpture,
emotionally disturbing by its brutal dehumanization of the body
through the rough textures of the material used and the unusual
perspectives and compositions.

Jan Saudek, living in communist Prague, translated his sexual
obsessions through his photographs, most of which he created in
an old, relatively small, basement. Paint peeling from the walls,
one small window, and the absolute need for discretion were the
limitations he faced. Saudek photographed erotic scenes of women
and couples, in which he very often played the male role. He
coloured the images by hand, which gave them their characteristic

look and atmosphere. His images, a forerunner to the porn art of
the 1990s, received recognition worldwide after the fall of the Iron
Curtain in 1989.

Until the 1960s, the nude male body was represented only as a
warrior, a sportsman, or a model. However, the body becomes
almost an object, an abstract statue, in Minkkinen's work. Skeletal,
almost 2m (6½ft) tall, he distorts his frame, sometimes showing it in
silhouette. In his series of self-portraits, his body parts, placed in
nature and photographed in close-up, seem to have lost their
traditional function. Paradoxically, he completely unveils his body,
exposing it with its imperfections, but rarely shows his face; and he
is often placed in the pristinely perfect Nordic landscapes of his
native Finland.

The Anglo-American John Coplans (1920–2003) followed in
Minkkinen's footsteps in the 1980s when he photographed his own
imperfect, ageing naked body, demonstrating the desire for showing
and photographing oneself as if looking in a mirror, undressed,
confronting the viewer mercilessly with the cruelty of the human
ageing process.

In contrast to the work of such photographers, there was also an
aesthetic of male seduction whose best representative is the
American Robert Mapplethorpe (1946–1998). With a supreme
mastery of studio lighting and large- or medium-format cameras,
Mapplethorpe created an exaggerated smoothness and perfection
in the idealized body, influenced by the photography of Horst and
the fashion photographer George Hoyningen-Huene. The sculptural
beauty – and erotic power – that he brought to his black and white
naked male bodies was unparalleled. Also in the USA,
photographers such as Greg Gorman (1949–), Bruce Weber

With the birth of magazines such as *Playboy* in 1953 and *Penthouse* in 1965, erotic female nudity entered everyday life and became a fashionable theme within certain sectors of the population in Western Europe and the USA. This type of nude imagery was entirely male-orientated in that it was both produced by, and targeted at, men.

The feminist movement that was born in the 1960s and grew in power and influence in the 1970s rejected this tradition of male exploitation, and since then numerous female artists have used photography and video to reclaim their sexual identity independently of the male gaze. Between 1975 and 1981, the American artist Francesca Woodman (1958–1981) made a series

work is more than provocative; it serves as the image of her soul, an autobiographical emotional diary which ended when she committed suicide at the age of 23. The feminist determination to assert ownership of images of the female body is the rationale for such introspective self-portraits, and Toto Frima (1953–) in the Netherlands has also produced fine examples of this kind of work.

REDISCOVERING EROTICISM

Meanwhile, photographers such as Ralph Gibson (1939–) and David Hamilton (1933–) in the UK and Lucien Clergue (1934–) in France searched for a poetic eroticism in the female body. Clergue usually photographed his models next to natural elements such as

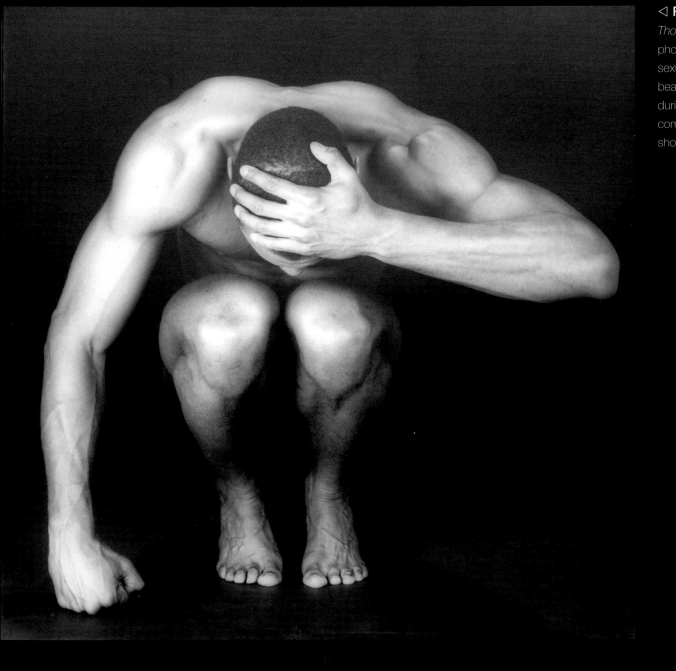

◁ **Robert Mapplethorpe**
Thomas (1986). Mapplethorpe's photographs ranged from sexually explicit to sublimely beautiful. He gained recognition during the 1970s with elegantly composed, sometimes shocking, male nudes.

waves or rocks, and made full use of the strong light of southern Europe. For Gibson, the erotic power of the nude originated from the way the body was dressed or from the detail of its movements. His fragmented perspective proved his love of both abstraction and mystery. One could say that the difference between the true erotic image and pornography is mystery; the covered legs of a woman can be more sensual than those of a naked woman.

David Hamilton, extremely popular in the 1970s and early 1980s, influenced a generation of amateur photographers with his dream-like images of young and innocent girls at the point of discovering their sexuality. The absence of make-up, and the use of soft tones and colours, gentle light, and timeless accessories, conjure up a feeling almost everyone has had at some point in their life: the longing for the perfect, for the promise. More successfully than anyone before him, Hamilton understood the appeal of this promise, an aspiration that advertising photography also loves to invoke.

The American photographer Joël-Peter Witkin (1939–) seems to be in search of mystery as much in the photographic technique as in the human body. He has stated: "I rebuild the negative, I tickle it, I add signs, and I erase parts of it . . . I redesign the image, I make it more powerful, more mysterious." Born in Brooklyn to a Jewish mother and a Catholic father, at the age of six Witkin saw a gruesome car accident that shaped his photographic universe. After studying art history and photography, he embarked on creating images with elaborate, complex settings, borrowed from sources as diverse as mythology, Man Ray, de Chirico, still lifes from the 16th and 17th centuries, 19th-century realism and numerous pictorial artists – his meeting with Diane Arbus shortly before her suicide particularly influenced him. His images of deformities and cadaver parts have often caused outrage. Witkin explores his own universe of sexuality and dares to show us the "beauty" of the body we are afraid to look at, creating his images in large format in the studio, always after months of preparation. The reality of Witkin's naked bodies has been very influential in art photography.

While Witkin uses cameras of a type that date back more than a hundred years, technology has had a big impact on the way that many photographers make images. Modern cameras with automatic functions have considerably reduced the time it takes to create a photograph, and some are produced with an electronic date inscription showing exactly the moment at which the shutter was opened. This has encouraged the production of intimate visual diaries, which has resulted in some artists experiencing situations only to make images of them. In the West, the work of the Japanese photographer Nobuyoshi Araki (1940–) is often thought of only in relation to its sadomasochism but, by the constant use of a compact mini-camera with a date indicator, he creates a fascinating journal of desire.

◁ **Ralph Gibson**
Eye, Ass (1975). For Gibson, creating dynamism in his photographs means eliminating every element until nothing is left in the frame except what he wants.

THE COMMERCIAL NUDE

In the 1970s and 1980s, fashion photographers began to present a new, confrontational image of the female body. The pioneer in this respect was the German Helmut Newton (1920–2004). Newton's photographs of nudes were overtly sexual, with an undertone of menace, and although the impression was usually carefully given that his models were part of the social elite, they were often placed, apparently caught out in reportage style, in sordid environments while engaged in acts of fantasy and fetishism. His work made him highly influential in fashion photography, though some of it was thought too highly sexually charged for American magazines and appeared only in those published in Europe.

In the 1980s, Newton undressed the dynamic and independent female in a series called *Big Nudes*. In this series the women are indeed naked and very tall, wearing nothing but make-up and high heels. The *Big Nudes* were exhibited in the form of life-size prints that were intended to provoke the viewer by showing self-confident women who knew what they wanted and were very aware of their beauty and sexuality.

△ Lucien Clergue

La Chute des Anges, an Ilfochrome print from 2002 and highly untypical for him, shows how much a photographer's work can evolve. Clergue was a friend of Picasso, and this later work clearly shows his interest in art outside the realm of photography.

Other photographers followed Newton's example with the same desire to push nude photography to the limit. With the wide choice of visual stimuli from magazines, satellite and cable TV, video, and cinema, striking images were used to grab the attention of the public. The United Colours of Benetton campaigns of the 1980s, the heroin chic look of the 1990s, and "art porn" photography shortly afterwards, succeeded in shocking viewers by the daring use of political content in fashionable mainstream imagery, as seen in some of the publicity campaigns of the American photographer Terry Richardson (1965–).

Aesthetic considerations and the approval of fellow photographers often had to take second place to the commercial impact the photography was designed to have, and this has applied

to the beautiful nudes created by top commercial photographers such as the German Peter Lindbergh (1944–), the Frenchman Patrick Demarchelier (1943–), and others.

BEYOND NUDITY

In today's digital era, images are invisibly stored in a computer system. While traditional photography was once the most important way of providing pictures for the media, it is now more often the computer which produces and modifies images, using digital codes; a representation of the human body can be constructed entirely from a mathematical scheme or be modified from an existing image.

This revolution obviously also influences the approach photographers take to the naked body; perfection is no longer required at the moment the shutter is released, and the photograph now serves as the basis for a painter's work on the digital canvas. Skin can be airbrushed, eyes, breasts, and lips enlarged, waists and chins reduced, necks and legs made longer; nude perfection can now be entirely artificial, in a completely credible way. Photography no longer needs to capture the "decisive moment", to use Henri Cartier-Bresson's term, and can instead enter the world of the virtual painter. As today's technology opens up endless possibilities, working with the naked body through photography now has no limits other than those of the human imagination.

However, the need to express aesthetics, sensuality, and eroticism is fundamentally human, and this emotional authenticity may often be overlooked when using advanced technical tricks or while trying to grab the attention of the viewer. Pushing the boundaries for the sake of it often results in a mere focus on spectacular effects. But while some artists may have decided to go down that route, there are clear signs of a reaction to the prevailing trend. In spite of the digital age, the beginning of the 21st century shows signs of bringing about a return of the natural, the sensual, and the sensitive, and of revealing more than ever the inner inspiration of the artist.

◁ **Steven Meisel**

Meisel's image for Yves Saint Laurent's perfume 'Opium', featuring the model Sophie Dahl, appeared as a magazine advertisement in 2000. It was banned, however, after it went up on billboards.

2

defining styles
& approaches

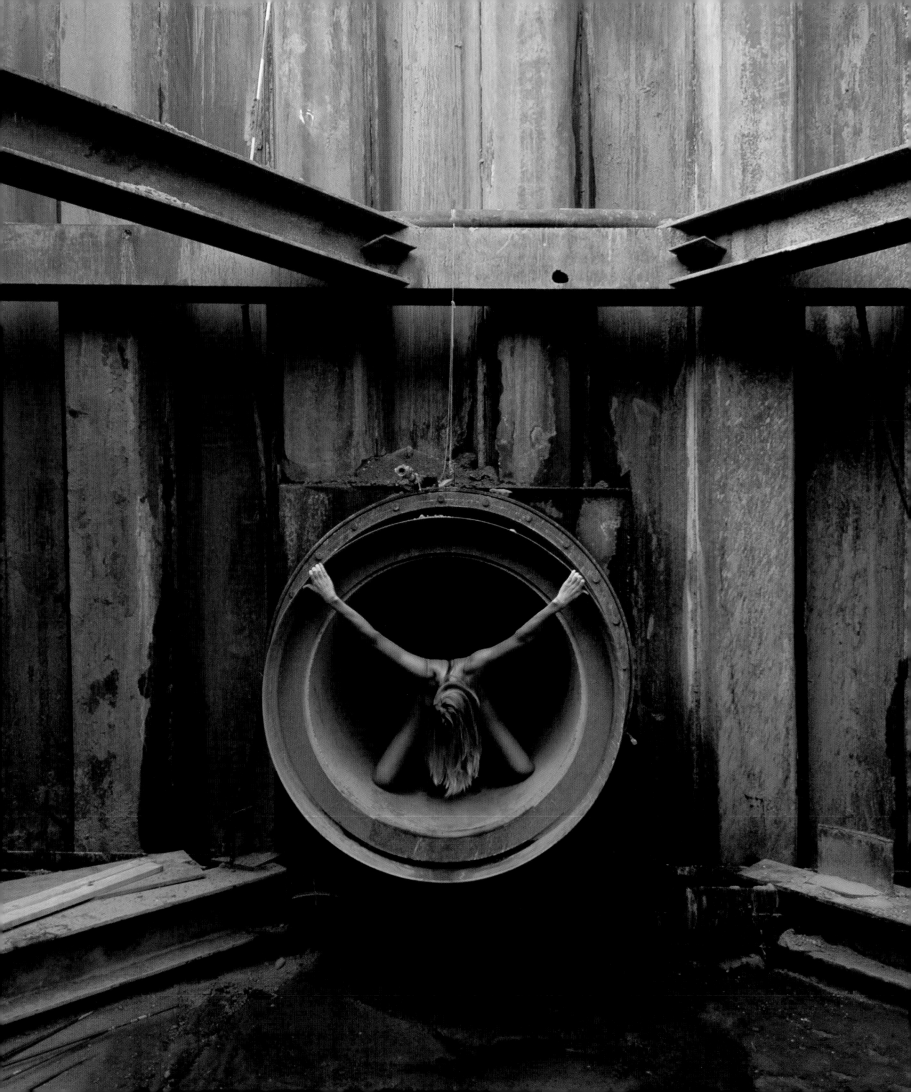

introduction

This chapter shows you the best ways of getting started as a fine art nude photographer and of developing your personal style.

The first questions are about themes. Do you want to photograph intimate nudes, glamorous nudes, erotic nudes? Do you like to tell stories with your pictures, or portray the models in a way that reflects how you feel about them? Or are you more interested in looking for shapes and forms? You may choose to work mainly in black and white or in colour. Both approaches have their pros and cons. Many nude photographers prefer to work in black and white, since it places more emphasis on tone and form, and avoids some of the distractions of colour. Then again, if you work in colour you can play with warm and cold hues, primary and pastel shades, harmony and contrasts.

How will you react to unexpected photographic opportunities that come your way? Will you ignore them and stick to your original plan, or incorporate them into your work? Are you going to overcome limitations of budget, equipment, space, time, and experience, and turn those challenges into opportunities? Are you confident in your use of hairstyling, make-up, and props, and able to use them selectively so that they contribute positively to the overall effect?

Then there are your models. Where will you find them? How do you approach them? What body type works best for your imagery? You will find suggestions on these pages, but approaches, tastes, and preferences are all highly personal, so what I have done is to run through the key questions to be considered before arriving at your own decisions. Having found your models, how will you make them feel at ease? How are you going to direct them into expressing the mood you choose for your image, and convey to them clearly what you have in mind? For how much of your time do you need to play the movie director directing your actors rather than working on perfecting a still pose?

Nude photography is a fascinating craft, but remember that working with people, just as in standard model photography, is all about human interaction, in which open, respectful, and crystal-clear communication is an absolute necessity.

opportunities & choices

Making successful images requires both inspiration and a grasp of the practicalities that are needed to translate your concept into a photograph. You must also be able to communicate your intention to the viewer. Allowing your memories and your experience of the moment to colour your judgement of the image is a common mistake. You need to take a dispassionate look at your photographs, trying to imagine you are seeing them for the first time. If you remember a golden, late summer's afternoon, you might feel the warmth and sunshine coming through, because you were there to experience it. But is this really reflected in your image, or is your memory embellishing things?

A good understanding of technique will help you to master your vision and convey it in your work, and this can be gained from workshops, courses, and books. However, without

> " without motivation, a technician will never be an artist "

motivation, a technician will never be an artist. Knowing what you want to achieve is the first step. Study the style of photographers whose work you admire. Copying them can be useful, as long as you regard it just as a starting point – many of the greats have done just that, before going on to evolve their own style. This chapter offers an analytical approach to themes, moods, and the choice between black and white and colour. You'll also discover ways in which you can exploit any unexpected opportunities that arise and overcome the limitations that beset every photographer, no matter how grand they may be. Clever use of settings will help you to bring a narrative element to your images, as will props. Even something as simple as a chair can be used to enhance a story in different ways – chosen perhaps for its distressed, rustic appeal, or for its sleek modernity.

different themes

There are so many different themes and styles in nude photography it would be impossible to cover them all here. As well as the more obvious areas, such as glamour, fashion, and erotic, you can portray nudes in an allegorical, scientific, pornographic, political, educational, or purely graphic way. Categorizing images into specific styles can be a dangerous exercise, since your interpretation of a picture may be completely different to mine, but at the same time it serves to refine our way of thinking about nude photography and helps us to find a style of our own. Choosing a style has a lot to do with your personality, so whatever direction your nude photography takes, you need to feel comfortable with it.

Glamour

This type of image is all about seduction, with models usually seeking eye contact with the viewer. The pictures are not about deep inner emotions, but rather the play of the protagonist with his or her environment. Models look confident and extrovert – they are attractive and want to show it.

Portraiture

Here, the model's personality, or at least a facet of it, is important. The photographer has to connect with the model, who must pose naturally, rather than play a role. In nude portrait photography, models literally lay themselves bare for public scrutiny, showing their vulnerability but also their strength and courage.

Fashion and beauty

In the pages of fashion magazines the nudes and semi-nudes are all about presentation – of accessories, products, or the body beautiful. The atmosphere evoked is a key factor in the image's commercial success: romantic, glamorous, erotic, polished, grungy, graphically aesthetic, and so on.

Erotic images

When the intention is to stimulate the viewer, the model becomes a sexual subject, often showing availability. There are as many erotic styles as there are fantasies – images of other themes shown here may work in an erotic way for some viewers.

Cinematic styles

When images create a storyline they work like a film still – a small part of a bigger picture. Something is happening and we as viewers want to know what it is, but we are not given enough information to fully understand.

Unusual contrasts

Some nude images are designed to surprise, to make us think about things in a different way and consider previously overlooked possibilities. This type of attention-grabbing image is often used in advertising and publicity.

Romantic images

One of the most popular genres of nude photography is one that conjures up thoughts of tenderness and romance. These images are emotional, rather than sexual, often using soft light and introspective poses and expressions.

pursuing a concept

A series of photographs based on a single concept and realized in a particular style can create a very strong visual impact. The collection must be more than the sum of the individual pictures, and will require detailed preparation and discipline. However, simple but adequate technical means give more energy and focus to the subject, and although

these three of sets of images were commissioned for advertising and promotional purposes, I used extremely simple methods, using only one light source (a spotlight, a softbox, or natural light) without reflectors. When working on commercial assignments, you have to be able to perform as part of a team, and you may need to accept compromises.

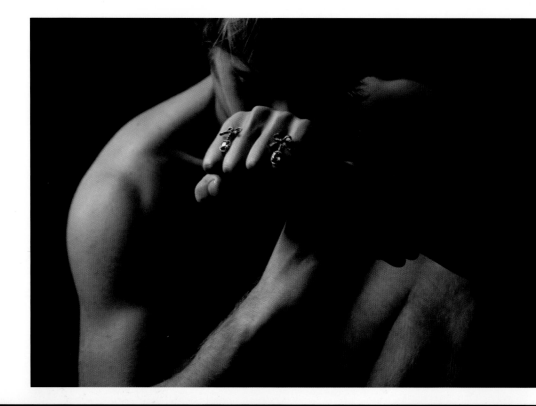

Jewellery

One of my clients asked me to show their female jewellery collection in the context of male bodies. The look needed to be classy and stylish, but at the same time natural. The jewellery had to be shown clearly, while the image had to be strong in its own right, so I used a limited depth of field and a single light source to concentrate the attention on the jewellery.

Chess pieces

These chessboard images were made as part of the interior decoration for a coffee bar. I was invited to create the set in the natural style for which I am best known, so I chose settings with naturally dark and light backgrounds. I positioned the knights and bishops (called "runners" in Belgium, hence the pose) facing the king and queen, setting them alternately higher and lower, to produce an undulating wave pattern. The only pieces showing their faces are the king and the queen; the pawns in the second row are looking down, reflecting their subordinate role. As the images were to be shot with natural light, I waited for an overcast day, to avoid harsh shadows.

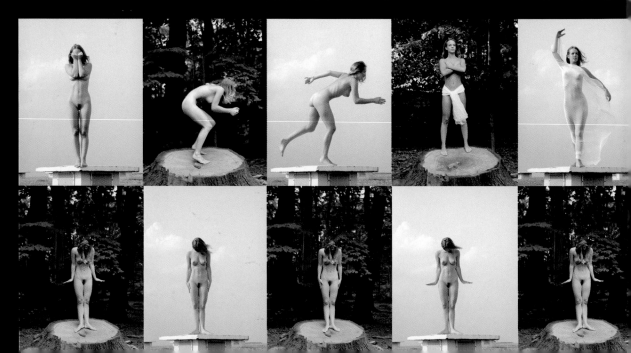

Body paint

This set of images was produced for a book by Jos Brands, one of Belgium's finest make-up artists, to demonstrate the possibilities offered by the use of make-up and an airbrush. To create harmony and enhance the effects of the make-up, we matched the colours of the background and props to the colours of the make-up. The green shots were taken by natural light, the blue ones with a hand-held halogen spotlight. The poses are intimate, avoiding eye contact, making it easier to study the models' bodies and the subtleties of the body-paint.

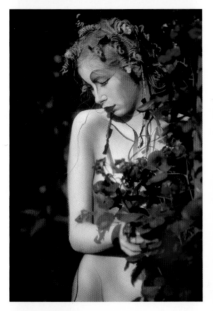

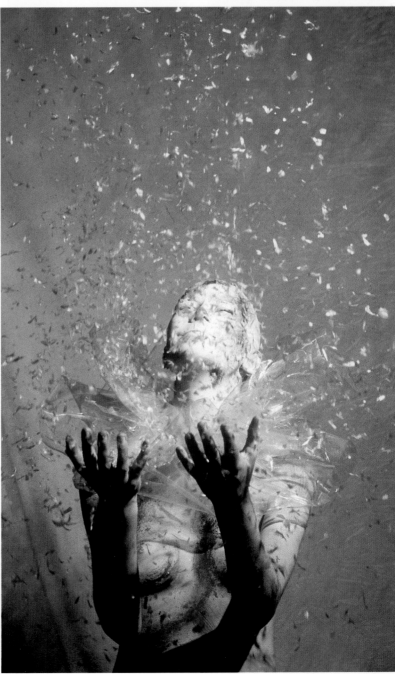

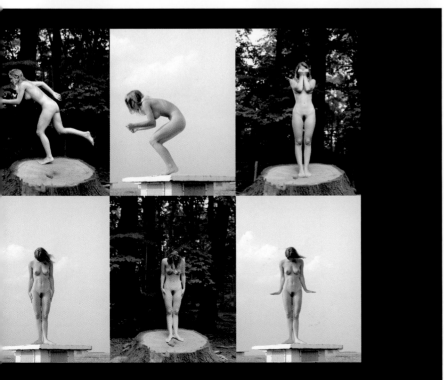

working in black and white

Black and white is an abstraction of reality, reducing the world's countless colours and their various shades into a scale of grey. A monochrome image loses the effects of colour harmony or contrast, instead relying on differences in density and light and dark to create impact. Many photographers find it easier to work in black and white, precisely because most of the tricky issues associated with colour photography are avoided. It could be argued that some nudes are more "acceptable" in black and white, and indeed the majority of the most famous nude photographs are black and white. The absence of colour forces you to focus more attention on tone, contrast, and texture.

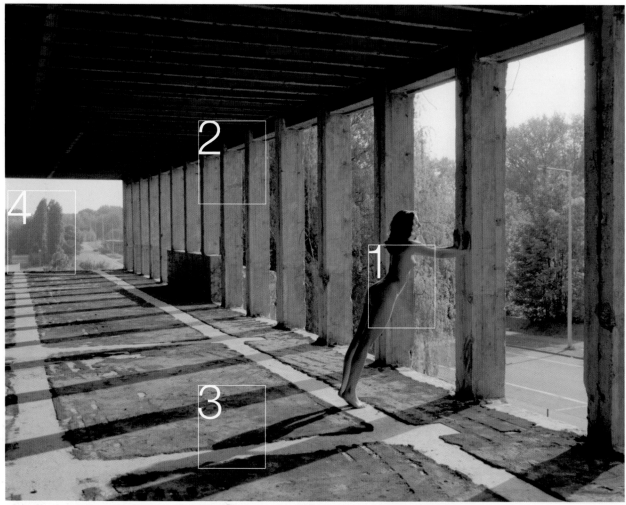

Texture and structure

Freed from all colour distractions – green trees, blue lamp posts and red graffiti – that were present in the scene, the play of light and shadow, interesting textures, and contrast between the structure and the model can be fully appreciated.

1 The soft curves of the model and the subtly drawn lines of sunlight on her body contrast with the geometry of the concrete pillars.
2 The repeating, receding lines of pillars and girders give rhythm and structure to the image.
3 Textures and shadows provide depth and additional visual interest.
4 Strong lines running through the image converge on the hazy rural scene in the distance that is somehow at odds with the industrial nature of the location.

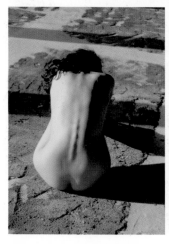
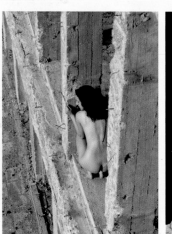
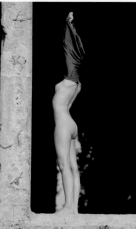
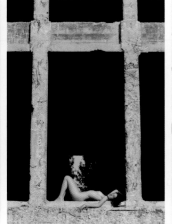
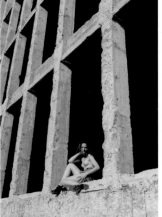

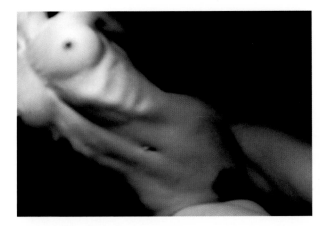

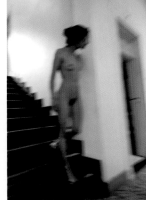

Ambiguity

Deliberate unsharpness can create intrigue in an image, especially when the subjects are in motion. In black and white the effect is enhanced as the images resemble stills from a surveillance camera, adding to the mystery.

Simplicity

The clean, unfussy feel of this image is created by the central position of the model, the artlessness of the pose, and the absence of distracting background elements.

The angular hairstyle is important to the symmetry of the composition: this would be a completely different picture if the model was sporting wild, unruly hair.

If this image was in colour you would see yellow sand, green foliage, and very pink sunburnt upper arms. Reducing it to black, white, and grey gives it a serenity that would otherwise be lost.

High contrast

This image makes use of contrast in two ways. There is a strong contrast between the light and dark areas, and also between the model and her environment.

The image has a very cinematic feel. The model's pose is introspective and thoughtful but she is looking into the environment and in the direction of the light. The position of her legs suggests confidence, yet her arms are protective. If this was a film still, what would the image say to you?

The concrete wall creates a frame around the model. The softness of her skin contrasts with the rough textures of her surroundings.

Grainy effect

Much of the character of this image lies in the grainy texture – the result of using a fast, sensitive film. Working with high ISO values on a digital camera will introduce "noise", which produces a similar effect.

Many image manipulation programs include "grain" filters, which allow you to artificially apply these kinds of effects to clean images.

The light is coming from the side, sculpting the torso. Details and close-ups work in a graphic way, and the anonymity invites the viewer to study the shapes and forms in detail.

working in colour

The way that you use colour in an image has a strong impact on its mood and atmosphere. We tend to think of colours as warm or cold, bright or subtle, dark or light, and so on – but the perception of colour is not absolute; it changes according to the surrounding colours. Generally, strong colours work best with other strong colours – think of a tanned model against a blue sky and turquoise sea – while a soft pastel palette works well if you want to create a fragile, romantic atmosphere. When composing a colour shot, remember that anything that contrasts strongly with other colours in the scene will immediately draw the eye – so unless it is an important element, try to avoid it.

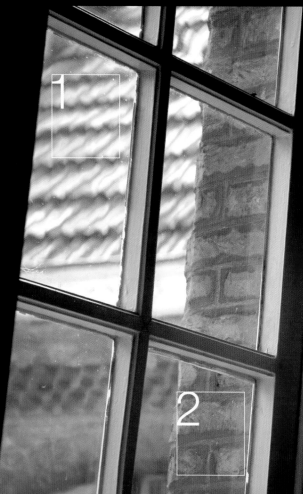

Colour harmony

Soft blue-greys and shades of orange and pink are repeated and reflected throughout this image. The pastel tones are in harmony with the stillness of the pose, the natural look of the model, and the dreamy expression in her eyes.

1 The slates of the roof pick up a reflection of the brickwork, creating a subtle combination of peach and grey tones, which is also just visible on the model's upper arm.
2 The mortar between the bricks corresponds to the colours of the roof and the window frame.
3 The deeper rose-pink of the nipple, and also the model's lips, match the darker tones in the bricks.
4 Softer shades of blue-grey are reflected on the body, while darker shadows are repeated in the unlit parts of the window frame.

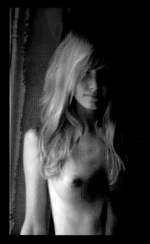
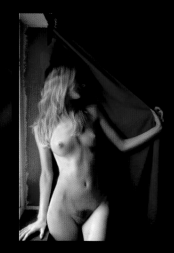

Reflected colour

The charm of this image lies in the green reflections on Annelies's body. This not only creates an interesting colour contrast but also a connection between the model and the setting, which would be lost in black and white. Notice too that the skin tones and the green colour cast are in the same range of saturation, and that the model is brighter than the background, which automatically focuses attention on her.

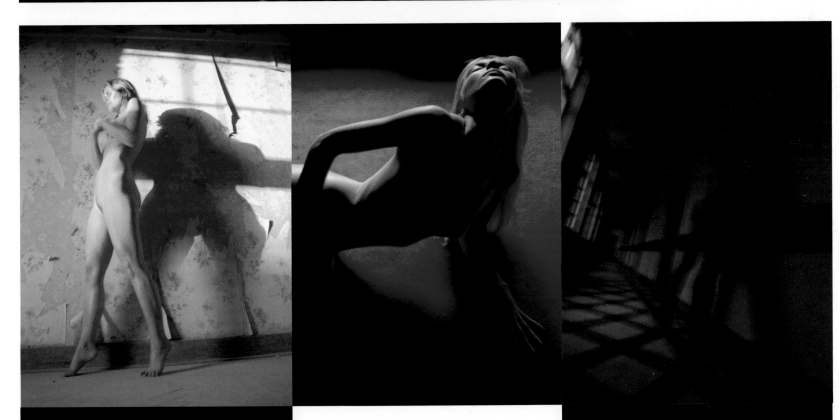

Colour balance

This image finds a balance between a neutral, almost cold light and the patch of warm, late evening light from the window. The model is lit by both and the mysterious quality of the image is enhanced by the shadow on the wall behind her.

Blocks of colour

Here, the strong colour works as a frame, strengthening the image and imparting energy to the pose. The hint of cool blue light on the model's face contrasts nicely with the vivid red and the dark shadows.

Colour cast

The underexposed blue evening light gives this image an eerie feel, which works well with the pose and the camera angle. Notice the orange glow in the background, caused by a tungsten light at the end of the corridor.

exploiting opportunities

Sometimes when you're working – particularly if you're in an unfamiliar location – an unexpected opportunity will arise; you might find a useful prop, an interesting space, or even a pleasing play of light. When this happens you should seize the chance to make an unplanned image. Keep your mind open to possibilities. I've realized some of my favourite images by reacting instantly to unforeseen circumstances, and have lost many more images by not recognizing the opportunity or by hesitating and missing the moment. It's important to remember, even when you're improvising, that a connection between the model and other elements in the image is vital.

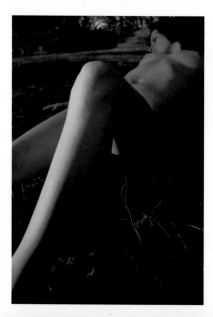

Evening sunbathe
These pictures were taken at the end of a long day's shoot. We had just finished when I noticed the light on this tree, so I asked the model to lie down and sunbathe in the last rays of daylight. I positioned myself low down and used a telephoto lens.

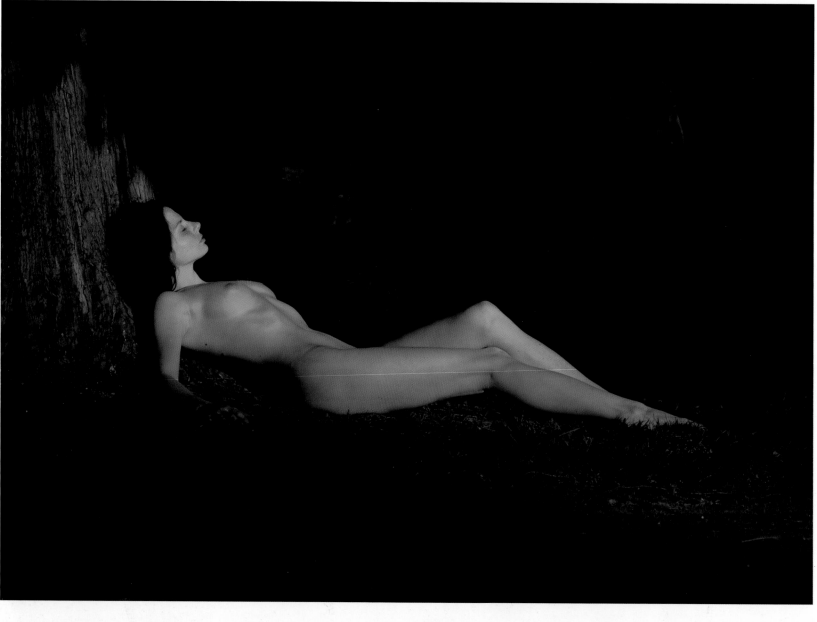

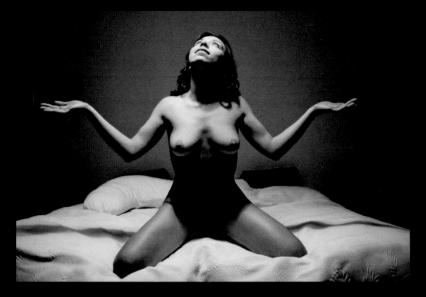

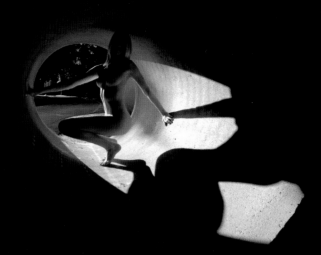

Veronica on a bed

This pose is the inspiration of the moment. A lamp was hanging just above Veronica's head, as you can see by the way the light diminishes. The pose creates an almost metaphysical connection with the light coming from above.

An unexpected advantage

Water pipes had spoilt the setting where I'd intended to shoot, but I decided to turn the problem into an advantage. At first I tried the shot from the other side, but shooting against the light gave me this beautifully graphic image.

A simple prop

It's amazing how one seemingly insignificant prop can form the basis for a whole variety of pictures. This little table was sitting unnoticed in the corner of the room until my model began to pose with it. Soon she was dancing and moving around on her mini stage and I got a nice set of sensual images.

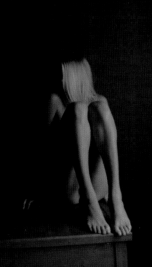

overcoming limitations

I like to think of limitations not as a handicap but as a gift; a framework for creativity. Working with limited resources will give you a positive attitude: you'll look at the possibilities offered by any model or location instead of focusing on imperfections and restrictions. You'll find the beauty and charm of every model, every place, and every light – and that will make you a happier and better photographer. If you can learn to work in a humble way you will be better able to make the most of any photographic opportunity and meet any challenge that comes your way.

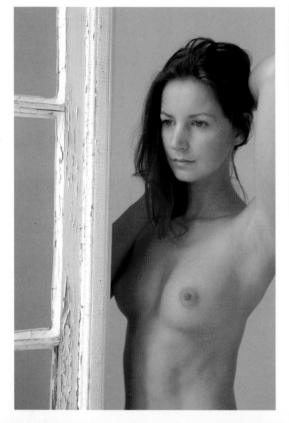

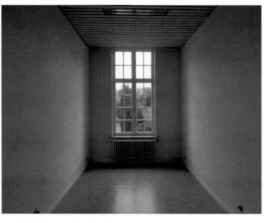

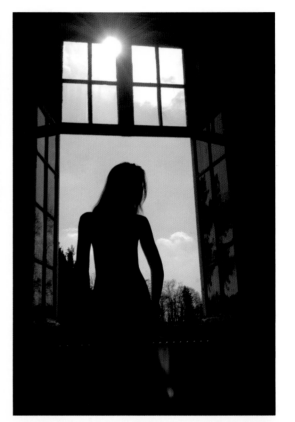

One room, no props

Here are two images taken in this simple little room, with no additional light. Just a room and a window offers plenty of opportunities for a successful session. Get your model to gaze out of the window, shoot into the light to make silhouettes, ask her to lay on the floor and shoot all around her, get her to curl up in a corner... If your location is limited, let your mind be free!

Cluttered backgrounds

Perhaps you don't even have an empty room like the one above. Household clutter can be a distraction in an image, but there are ways of working around it. In the image on the far right I simply used my model to obliterate the view of the living room, and in the one on the right I placed her in the lightest spot to draw the eye to her. However, a cluttered environment is often an authentic one, and can be great for nude portraits.

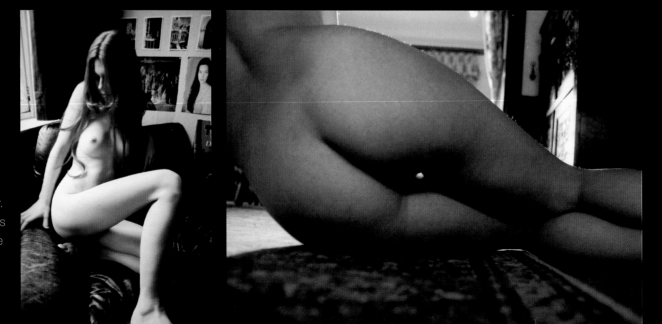

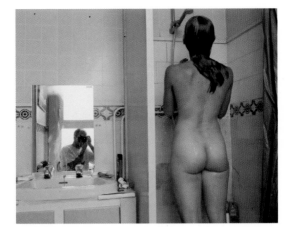

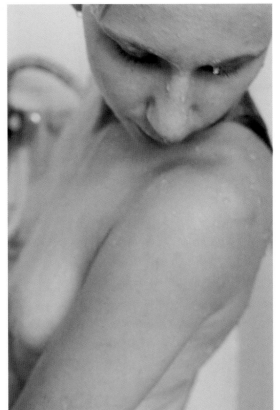

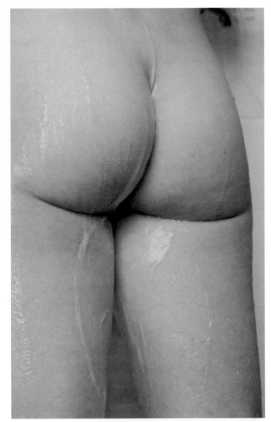

Limited space

A good way of dealing with small or unattractive spaces is to go for details and close-ups. In these shower shots I cropped right in to avoid showing the cubicle, although the running water shows the model's connection to her environment. A word of warning: be careful that your lens doesn't get steamed up – it might result in a nice soft-focus image but it's not good for your camera!

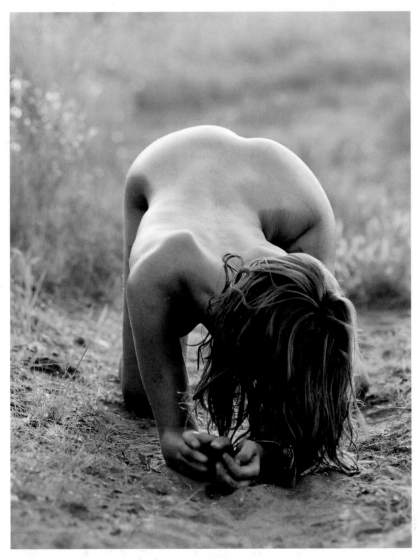

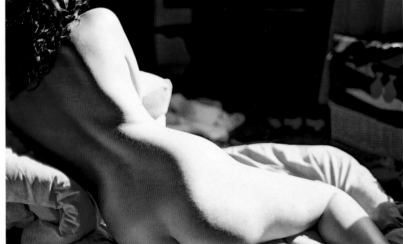

Anonymity

Some models prefer to remain anonymous. Of course, there are many ways of taking nude photographs without showing the model's face – these are just three of them. Taking anonymous images also helps you if your model has difficulty expressing what you want with his or her face (and also – although this was not the case with these pictures – if you do not consider their faces attractive).

choosing and using a setting

Choosing a setting is similar to choosing a model – you make your decisions based on what will best suit the style and atmosphere of the image you want to create, from the best alternatives you have at your disposal. A setting can be an important part of the image so give it the consideration it deserves. It can help to give your model a storyline inspired by the setting, so he or she will act a part that relates to or is inspired by the setting. You might go for a strong contrast, such as a vulnerable model in a threatening setting, or for harmony – a model relaxing in a tranquil setting. Whatever you choose, make sure every element matches the mood: the model's pose, make-up, props, and accessories.

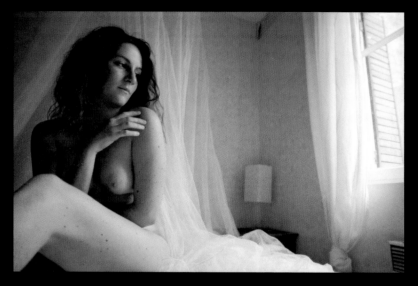

Canelle in a thoughtful mood

With your model placed to one side of the image you leave a space that he or she can look into, creating a connection with the setting. Here the melancholy mood is enhanced by the mosquito nets and the protective position of the arm.

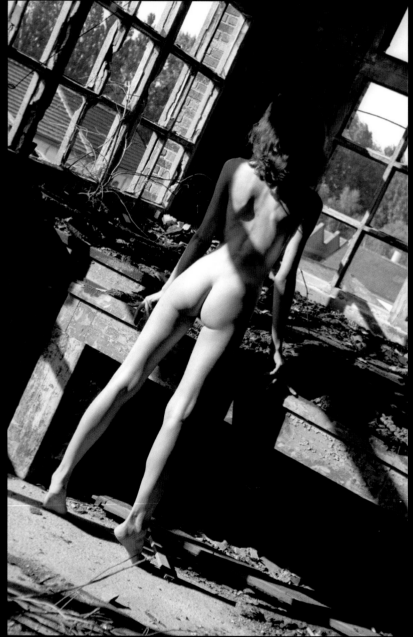

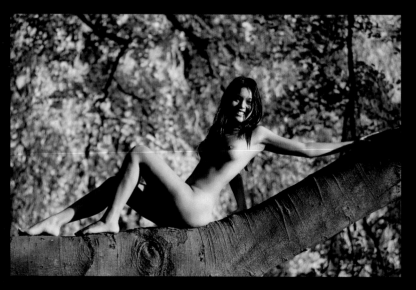

Mitali in a tree

Instead of "girl in front of tree" (or building, or whatever place of interest), I often try to put my models right into the setting. Here Mitali expresses the joy of nature on a late sunny afternoon. The low sun coming from the side sculpts her body well, and her smile belies the fact that this was actually a cold day!

Abandoned industry

This old factory has been my favourite setting for years. Industrial buildings provide such a beautiful contrast with the soft forms of a female model. Here, my camera is at eye-level, pointing slightly downwards. A lower viewpoint would have made the model look stronger and the image more sexy.

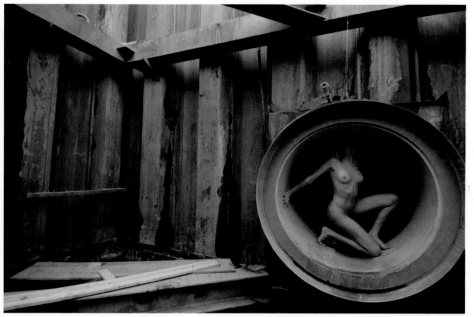

Beauty in unlikely places

Last year the city authorities dug up the beautiful park that I often shoot in to instal a new drain network. At first the place just looked a mess, but when they brought in the pipework and metal structures I saw that there might be scope for an interesting shoot. As you can see, the pipes were not big enough to pose in comfortably, but we made some great compositions, with the model emerging from the dark tunnel, striking a pose inside the pipe, and echoing the pattern made by the metal girders. And I love the colours of the rust and paintwork.

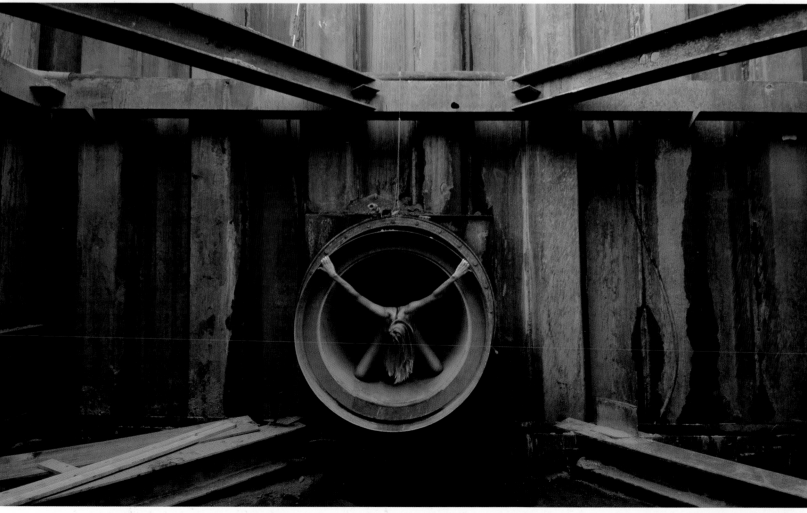

using props

Props are elements that are added to an image to give it more strength, more interest, and more impact. They have to belong in the picture, to feel authentic, even when they provide a contrast – so include them as if they were one of the actors in the scene. You might use them to create graphic compositions, to adorn your model, or to make a statement, but if there's no role for them to play, leave them out. Remember that make-up can also be considered a prop, so think very carefully about whether it's necessary.

Draped fabrics

The most frequently used prop in nude photography is light, semi-transparent fabric, and just these three images will give you an idea of its versatility. When wet it clings to the body beautifully, without obscuring the model's form. It adds colour and movement, and can be used to create romantic, dreamy effects.

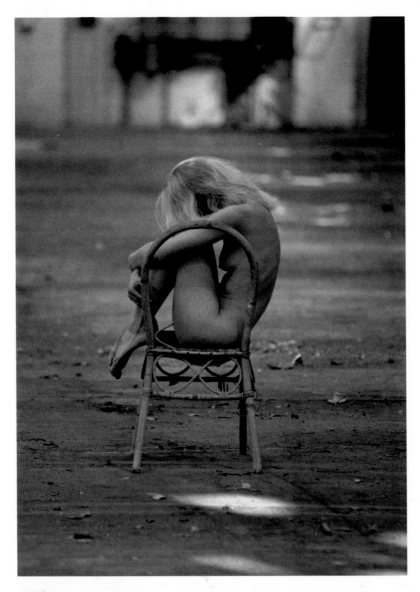

Matching the mood

I found this battered old chair in the abandoned warehouse where we were shooting. A new chair would have seemed out of place, but here the pose, the environment, the prop – and the model's dirty feet – are all in harmony with the melancholy feel of the image.

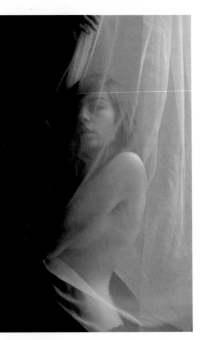

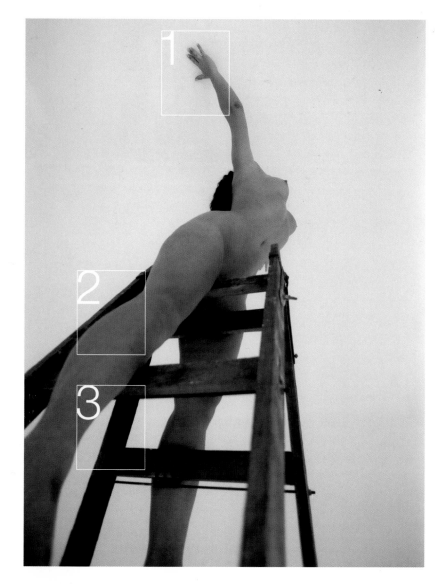

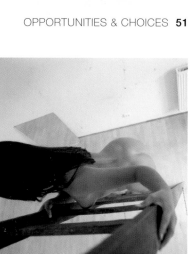

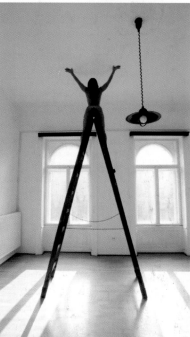

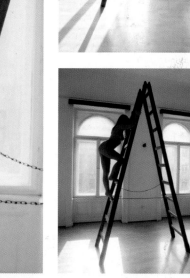

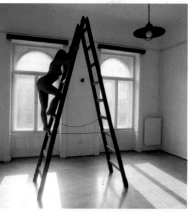

Exploiting a prop

I was surprised to find a set of stepladders in the empty apartment where we were shooting, but as soon as I saw it I realized that it presented a great opportunity to have some fun with poses and compositions. This set of images shows how, between us, the model and I fully exploited our unexpected find.

1 All the lines in the image lead the eye towards the model's hand reaching up to touch the ceiling. The camera angle adds to the dynamic feeling of height.
2 Using a wide-angle lens caused distortion, but here it adds to the image.
3 The model's legs, combined with the legs and rungs of the ladder, create a strong graphic pattern that works particularly well in black and white.

Essential props

A voluptuous ballerina may be a contradiction, but it was a gift to me. I'm not keen for my models to wear shoes unless there is a good reason to do so, but here they are intrinsic to the images.

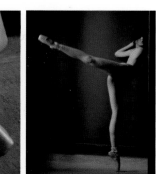

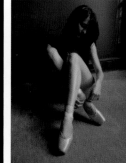

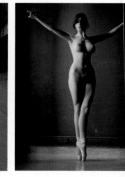

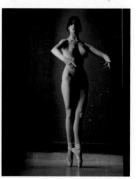

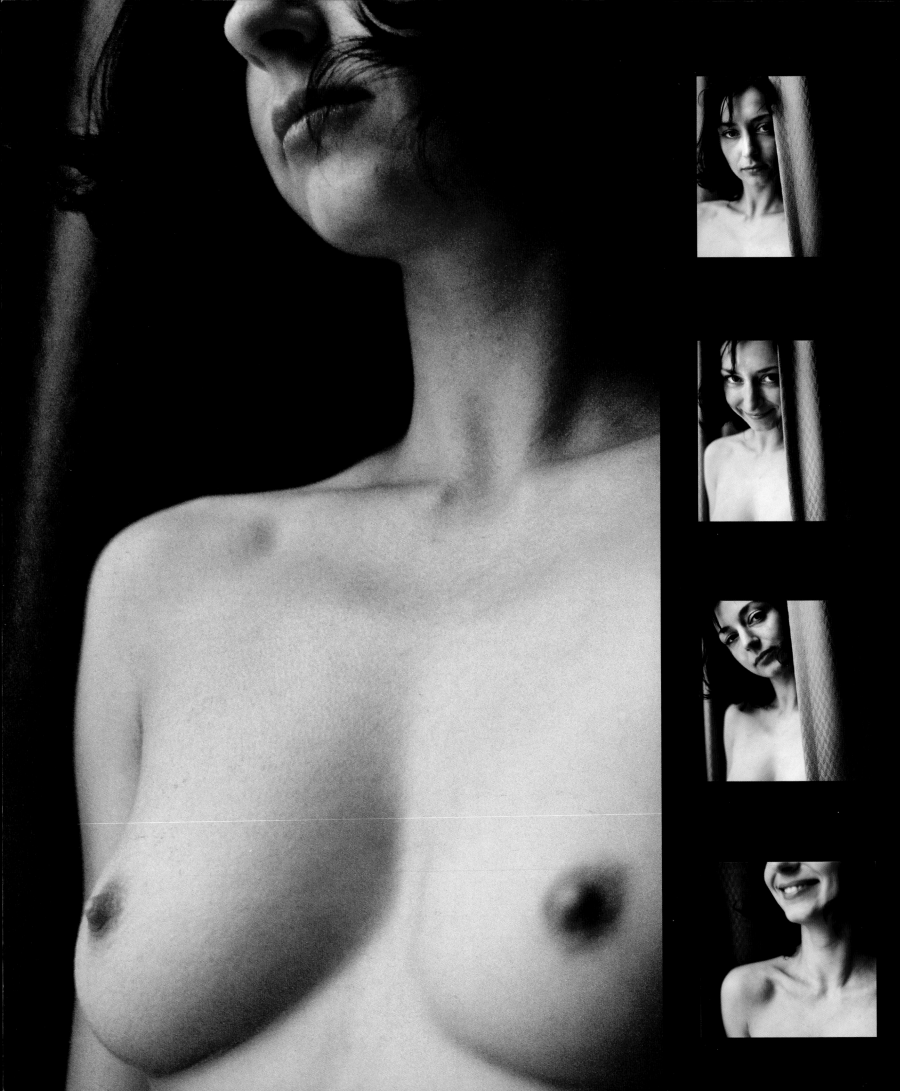

working with models

The best nude images are created when the model and photographer work as a team. Photographers can choose from a multitude of styles and approaches, so your model needs to understand exactly what you want to express, which means you have to find a way to get your ideas across. Clearly, the first requisite for a successful working relationship is open communication.

Some photographers – professionals as well as beginners – can forget that the model isn't a prop, but a human being with values and expectations. By revealing themselves in front of a camera, they give part of the control over their bodies to you as photographer. They place themselves in a very vulnerable position and must be able to trust you to handle the session with tact and respect. Nothing is guaranteed to ruin a session more quickly and irretrievably than tension. Hidden agendas kill the atmosphere, so you must be entirely honest with your model about the type of image you are intending to create.

" You have to send your concept out through your model "

So, these are all issues that you need to keep in mind when you're working with models, but how do you find your model in the first place? You may be surprised at how easy it is. When you're just starting out, your partner or a friend might be your first muse. Or ask at your local art college – most will have details of models who pose nude for life-drawing classes.

Once you have a portfolio of your work, you might do what I do – approach photogenic strangers and ask if they would consider posing for you. If you're friendly and polite, your motivation is clear and honest, and you have examples of your work to show them, there's really no need for anyone to feel embarrassed.

Of course, there are also plenty of model agencies, but the internet can also be useful as most countries have web communities of models and photographers, often a mix of amateurs and professionals, with online photo galleries of their work that you can assess.

choosing a model

While I wouldn't encourage anyone ever to think of models as objects, when choosing a model you can apply the same criteria as you would when choosing a car: go for the best you can to suit your purposes and your means. For many people a partner is initially their only option – in most cases a wonderful option. But as you begin to progress you may wish to look further afield. If you have the opportunity to choose, go for a model that inspires you, that you consider to be perfect for the shot you have in mind. And always remember that your motivation for choosing a particular model should be entirely photographic – never let personal feelings influence you in any way.

Athleticism

Annelies is a dancer who really knows how to perform – in fact, she is such a performer that if I'm not careful she will take over a session and have me running to every corner of the studio. Her strength and suppleness allow her to hold poses that many models would find impossible. I always ask models if they dance or play sport since it can really open up a lot of possibilities.

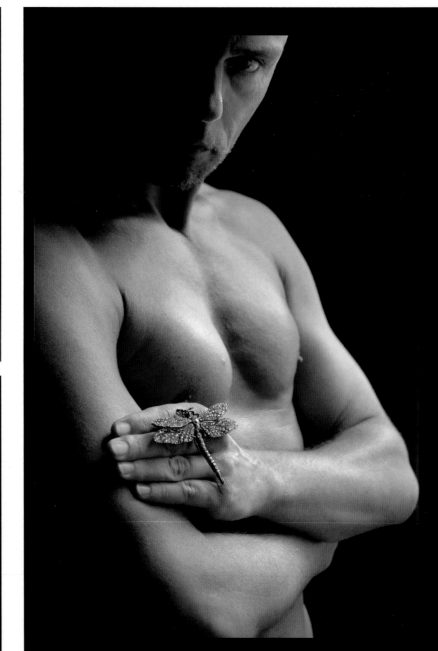

Juxtaposition

You might choose a model to create contrast in your images. Here, Johan is sporting a woman's brooch. The contrast creates a puzzle, a story. Is this his own jewellery or a gift for you, the viewer? It would have been a very different image if I had chosen a female model, or if Johan had been holding, say, a gun.

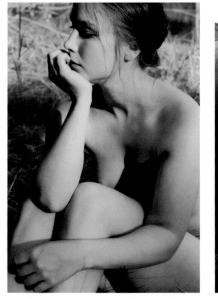
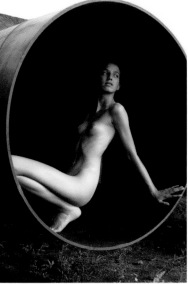
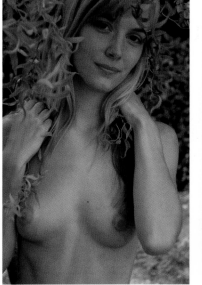
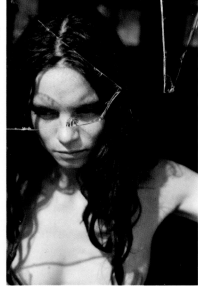

Body shape

Depending on the type of image you want to create you might go for a long, slender model, or someone who is more rounded. Classic agency models are mostly of the tall and slim type for women, and muscular and athletic for men.

Looks and facial features

Hair colour, skin tone, face shape – it's really a matter of personal taste, but some images suit certain looks more than others. For example, square faces aren't ideal for romantic images, while dark, brooding looks often work well for cinematic shots.

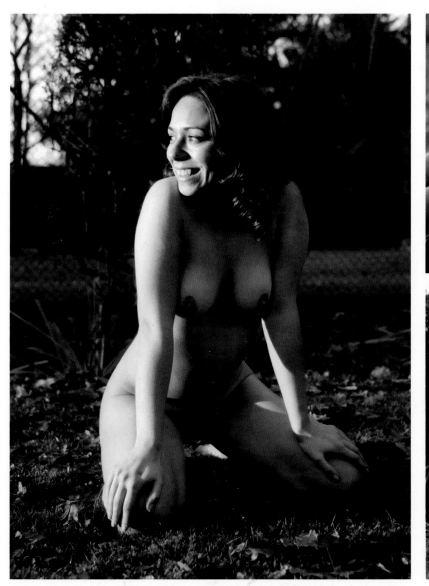

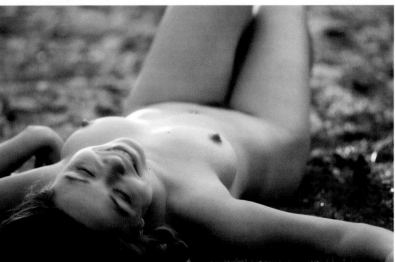

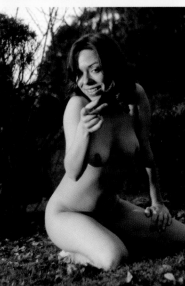

Personality

For me, personality really matters. Outgoing, communicative models make photoshoots so much easier, even for more intimate images. Often, though not always, I will try to put the model's character across. Models who can be themselves are not only a joy to work with, but the viewer can feel their personalities through the image and really make a connection.

directing your model

Before I start a session I begin by explaining my concept. I describe the visual effect that I want to create and also, more importantly, the atmosphere of the image. The key to a good image is the impact it has on the viewer, rather than technical perfection – so, for me, emotional expression is the most important element. Light plays a major role in creating the mood of a picture so I often ask my model to act towards or away from it. While communication is crucial, I am always careful not to over direct. Discussing every little detail before the shoot can be inhibiting, so build up gradually. Give your model time to warm up and take a break now and again. In this way you will enjoy a focused but relaxed shoot.

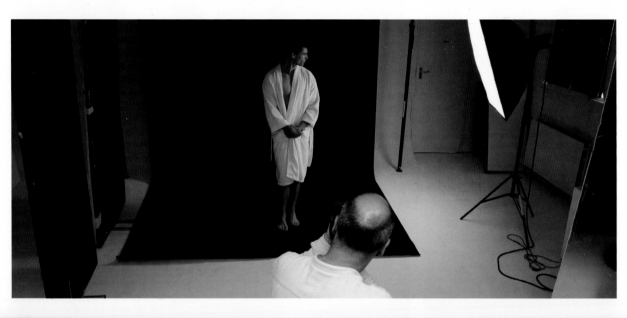

Getting started

Your model should feel comfortable. I ask my models to undress as soon as they arrive (to avoid marks from tight clothes on the skin), but allow them to wear a bathrobe for as long as possible while I am checking equipment and lighting. Once you get started, the clearer the direction, the more focused your model will be. In this case, I first explained, then roughly demonstrated, my idea to Adam. It may look like one-way communication, but it's not – I always ask for and appreciate feedback from my models.

Eye contact and body language

An outgoing, responsive model like Paulina is a dream to direct. She reacts almost immediately to what I say or show. I have trained myself so that I can look at my model with my right eye while looking through the viewfinder with my left, which means I can maintain eye contact through the shoot. At the same time I use my face to express the mood I would like my model to adopt. As you can see from the pictures, my hands and body do the rest.

conveying a mood

Giving your models the confidence to express themselves openly or to play a part convincingly in front of the camera is all about interaction and communication. For an introspective mood it is best to work quietly, taking pictures without seeking a reaction from your model, moving slowly and speaking gently if adjustments are needed. For more exuberant images you may need to move about more, chatting to your model, teasing, and joking. Of course, what works for one model may not for another – but I find that, by giving them an active role in the shoot, between us we find a way.

Facial expression

We read a person's emotions first and foremost through the face. The slightest changes in expression can convey a multitude of moods and nuances of mood – happy, sad, angry, thoughtful, excited, bored, fearful, proud, lonely, playful… the list is endless. In a photograph, the way that a model looks at the camera – or indeed whether he or she looks at the camera at all – has a direct impact on the viewer, raising questions and inviting interpretation.

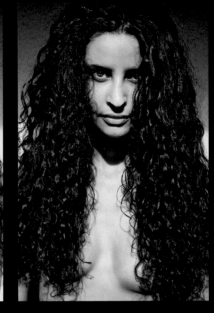

Direction of the eyes

In this set of images you can see how something as simple as the direction of the model's eyes makes a big difference to the feel of the image. With her eyes downcast, Shanya's expression is thoughtful – perhaps sad. She is lost in her own world and makes no connection with the viewer. In the middle image she raises her eyes to the camera – shyly? Or is that a challenging look? With direct eye contact she makes a strong connection with the viewer, who may now feel that she is the one asking questions.

Acting a part

Shooting in an abandoned hospital I wanted to play on the ghost stories that surround the place. Between us we invented a scenario that Shanya would act out. These images were taken in the chapel, using available light. During the shoot we went running through corridors, crawling in tiny rooms, and shouting in the silence. I chased, teased, and comforted her character with my camera. At the end of the day we had a good laugh, some good images, and wished each other a good evening!

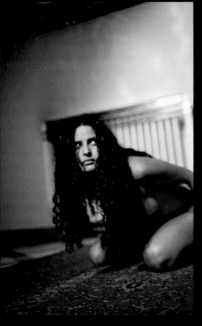

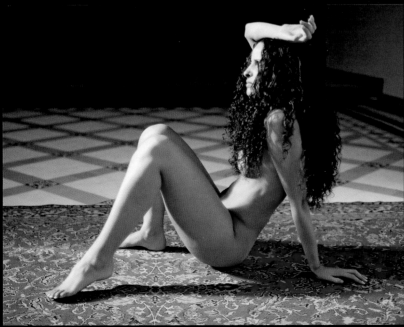

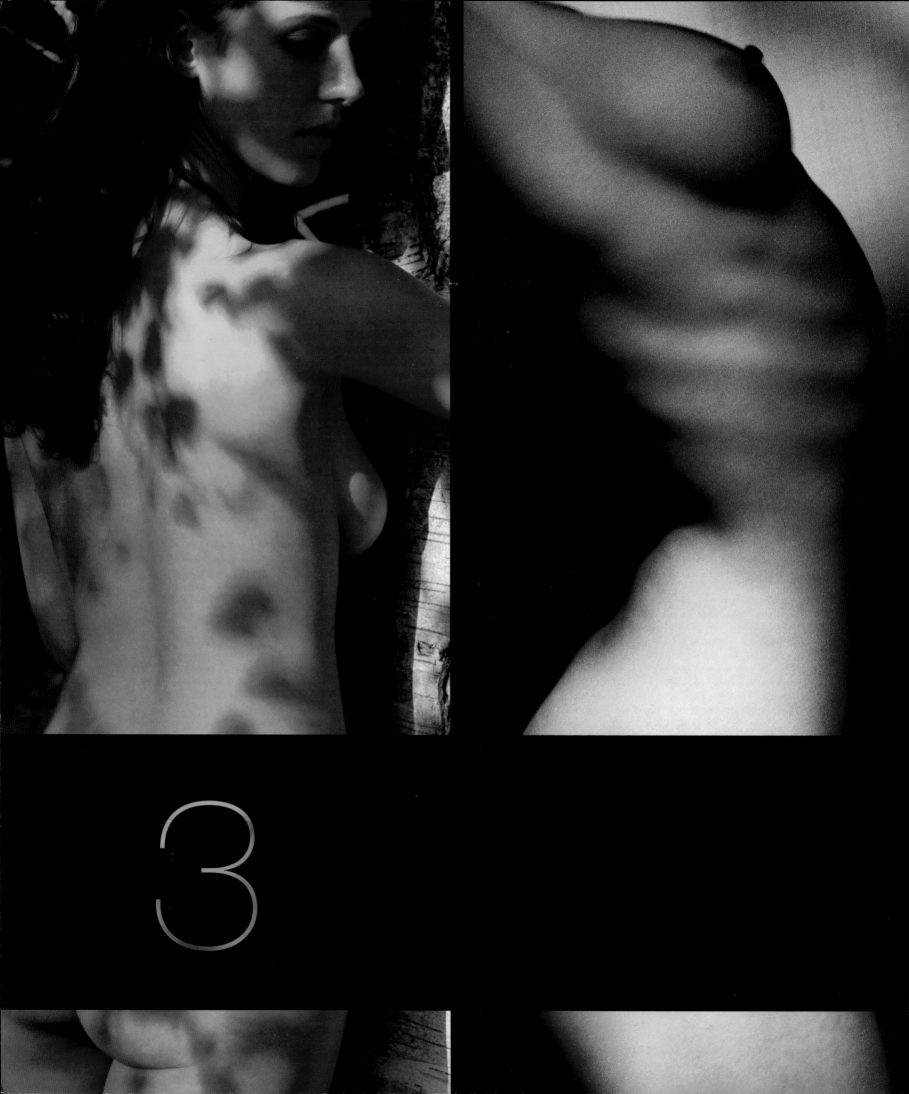

3

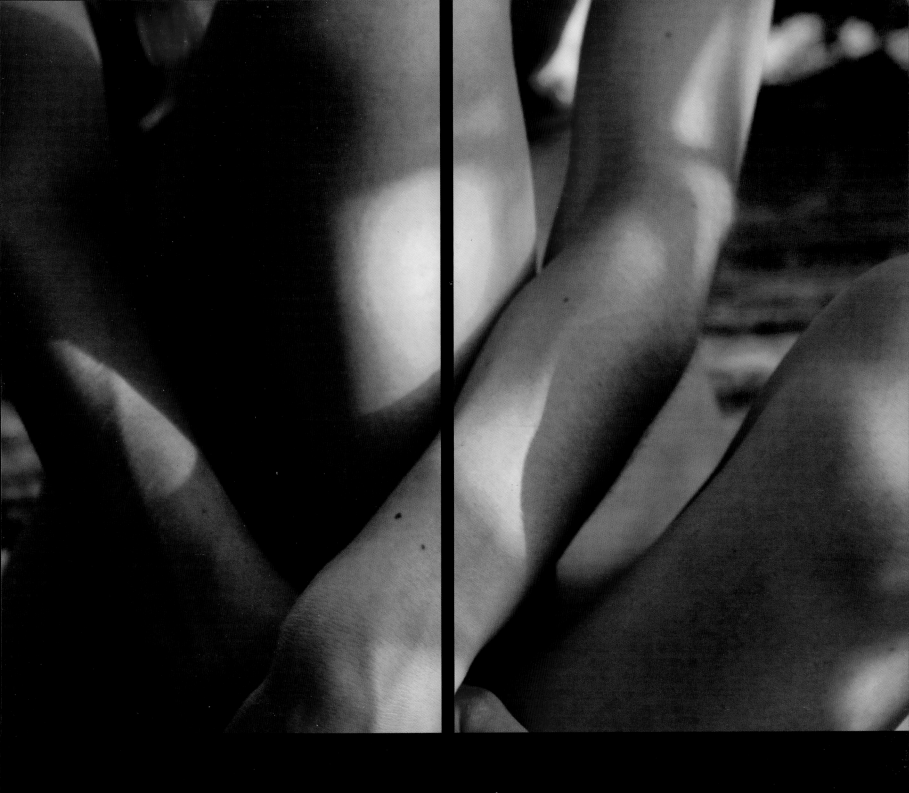

exploring
techniques

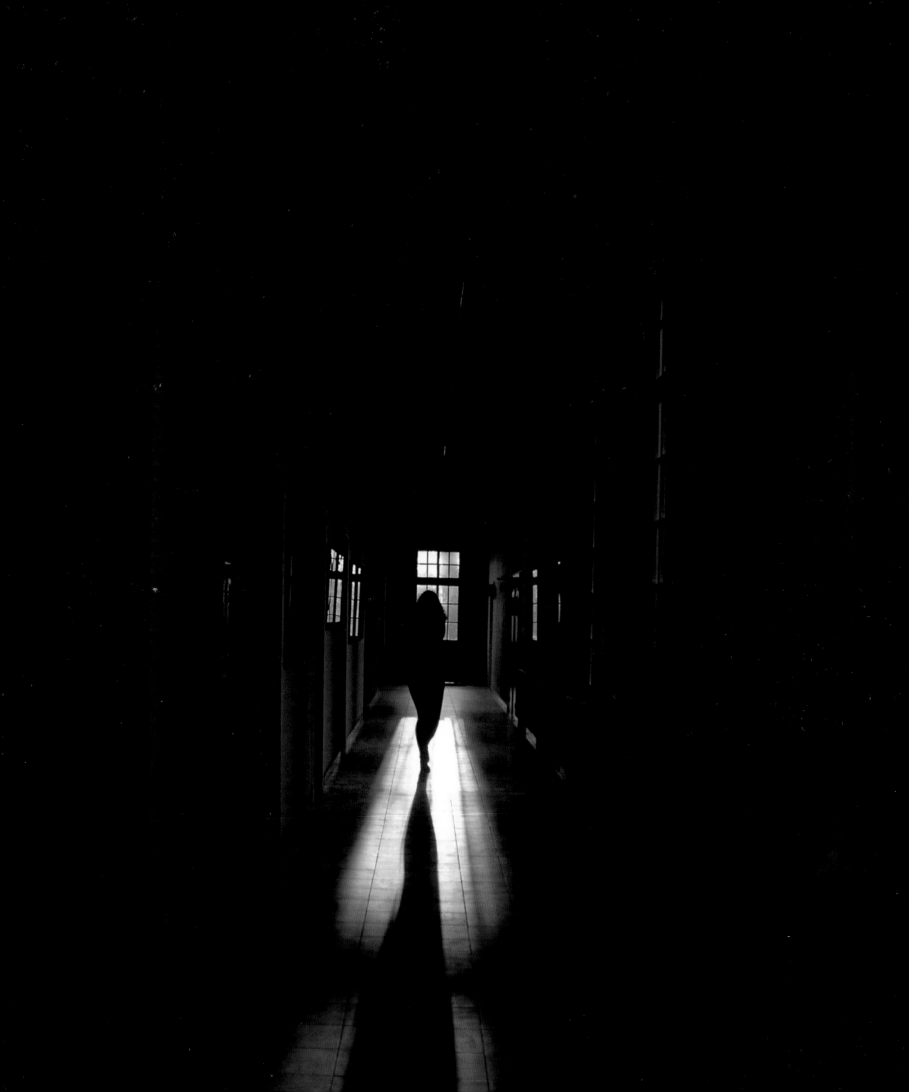

Once you have defined your concept and your approach, you can look at the options you have to improve your image. This chapter offers you a wide variety of technical and creative choices: learn to make the right choice according to the way you want your image to look and feel.

The first subject is light, the very reason for photography's existence. How are you going to use the light, to find or create interesting light effects? Will available light be enough, or will you need extra lighting equipment? In the studio, what effects are possible? How do you position light and model to sculpt the body or make intriguing plays of light and shadow? What effect does the direction of light have on the mood of the image?

introduction

The second section focuses on the model – the person who is going to reveal your vision through his or her pose and expression. Learn to adjust a pose when it looks awkward or unnatural, and to judge whether it suits the atmosphere of your picture. Find out, too, how lighting affects the pose.

The section on sharpness and blur teaches you that you can take pictures in any kind of light, and that sharpness is no longer a premise for a successful image. Once you know how to apply selective sharpness or blur, a whole new world of image-making will open up for you.

Then we move on to composition. What is the difference in effect between placing a model centrally in the image or to one side? How can you create dynamism by your choice of framing? What effect does your perspective and viewpoint have on the emotional impact of the image? Will you use abstracts and distortion effects in your photography?

And finally, make all those technical choices in relation to the location, creating a visual or emotional connection between your model, the setting, and the viewer.

All examples shown here have been realized with simple means, techniques, and equipment. You don't have to be a technical wizard to imitate them, because what matters is the feel and the impact of an image, not its technical complexity. The simpler the technique, the more energy you'll have to focus on the graphic and emotional strength of your imagery – remember this and you will be on your way to building a strong and distinctive personal style.

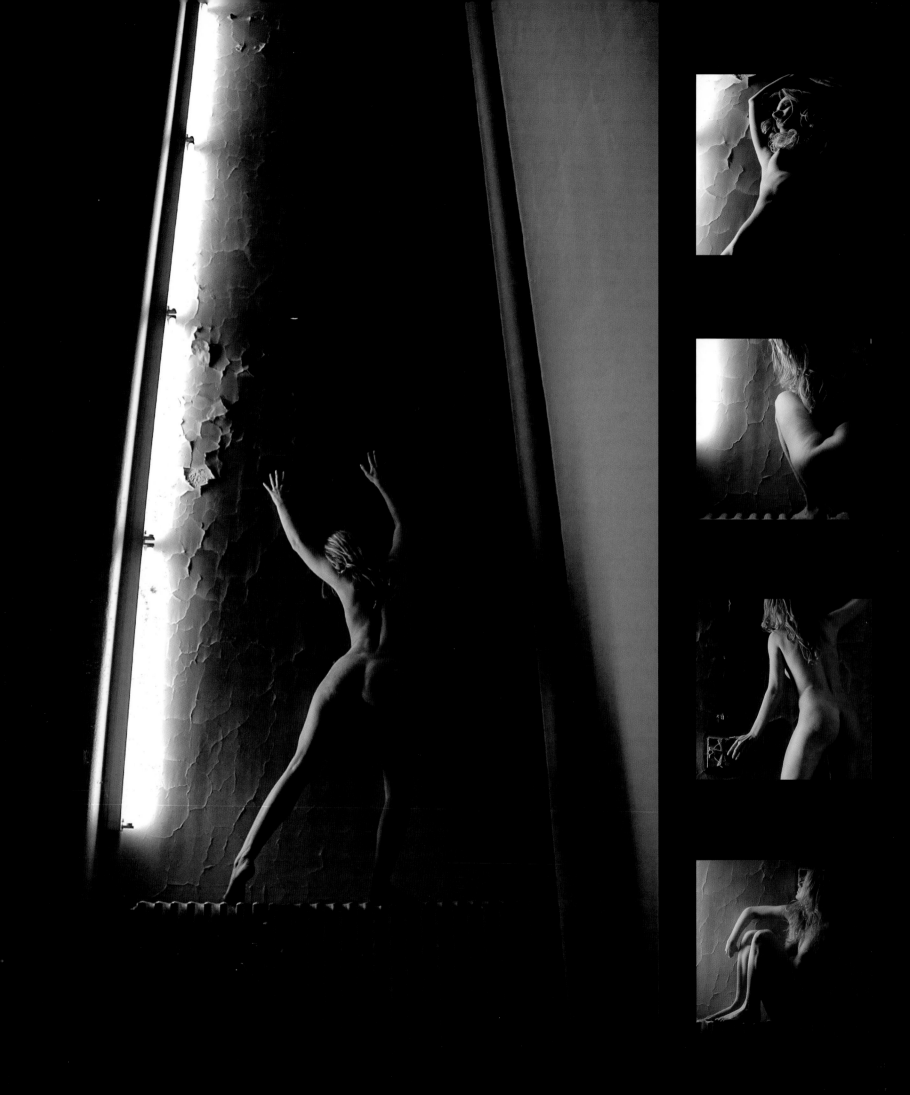

lighting

Light is photography's very reason for existing, but there's no single type of perfect light; different types of imagery demand different types of light. Hard, one-directional light wouldn't suit a soft-focus, romantic portrait, but you can use it to create graphic abstracts. A spotlight from below might create an atmosphere of mystery, but would usually be completely inappropriate for glamour images. This section will show you how you can make use of daylight, both indoors and outdoors, and how to use basic studio lighting.

There are many variables in the nature of light: its intensity, brightness, direction, and colour, the number and size of light sources, and so on. Your perception of light changes, too. Put yourself in the middle of a room and look at the light in front of you. Turn around and look again. Where does the light come from, where are the shadows? Look up and down. Move to a corner, a doorway, a window. Each time the light will look different.

If you're able to recognize and analyze light, you'll be able to choose what will best suit your image, initially using available indoor or outdoor light, and then moving on to experiment with

" Try to go with available light, or just a single light source "

studio or other forms of artificial lighting to create the atmosphere you want.

There's light wherever you can see your surroundings – and wherever there are light switches! For the most natural, authentic feel to an image, try to go with available light or just a single artificial light source.

Light dictates the overall look and feel of your image. But it can contribute in other ways too. Use the interplay of light and shadow to dress your model. Sculpt the body with light. Highlight some areas, hide others. Look for ways to create intriguing special effects with just natural light. Learn to understand the possibilities presented by every kind of light, and experiment even if there is hardly any light – in a moonlit meadow, for example. You can still create arresting images when faced with poor light – you may not achieve what you had originally planned, but you might be pleasantly surprised at the results.

Some effects you just can't create with available light, so try studio lighting too. Hire equipment, try it out, and only buy it when you're sure you're going to make frequent use of it.

daylight indoors

Daylight creates many opportunities, even indoors – all you need is a room with a window. Direct sunlight is interesting, but may be too contrasty with the shadows inside the room. I prefer to work with the light from a north-facing window, which creates enough contrast to play with light and shadows without the problem of burned-out highlights and areas of solid black shadow. These images were taken with direct sunlight in the room, but I positioned the model either directly or obliquely in front of the window and used a reflector when needed to throw light back onto her. Another way to cope with direct light is to shoot in early morning or late afternoon, when the sun is not so bright.

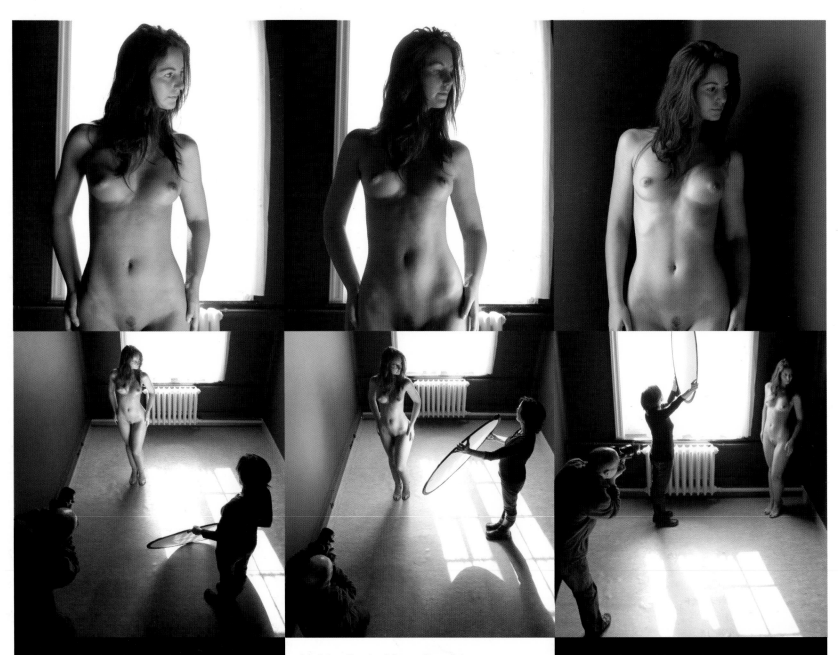

Light reflected from below
The light is reflecting on the lower part of the model's breasts and belly. Because of its unnatural direction, this kind of light gives an artistic look.

Light reflected from the side
The model's face is not catching much light as the top of the reflector is out of the sunshine. Moving the model or the reflector would solve this, but the shadowed face adds mystery.

Light reflected from above
The reflector now creates a natural effect, as sunlight mainly comes from above us. The reflector softens what would have been hard shadows on the face, belly, and arms.

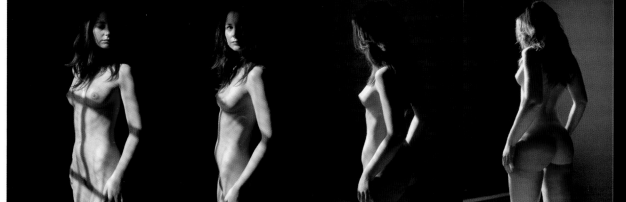

Moving around the model

Discover the different effects of available light by moving around the model, noting the way the light falls on the body from different angles. This gives you many lighting options even in just a small room with one window. These contrasty images were taken in direct sunlight.

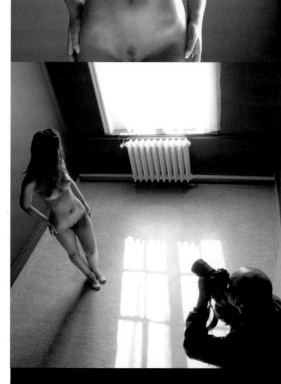

Metering the mid-tones

Here the light is reflected from the floor. I metered the light on the model's belly, which meant that the light coming from the window and falling on her left side is overexposed.

Metering the highlights

This time I took a meter reading on the lit left side of the model's body; the result is underexposed, as the floor wasn't a sufficiently good reflector to overcome the differences in light.

Side light from the window

The model is turned towards the window, allowing side light to fall on her curves. The ideal angle for the face with regard to lighting is between the camera and the main light source.

creativity with indoor light

The easiest way to be creative with light is to use what's available. You don't have to go far to find wonderful lighting opportunities – all the images here were taken at my home. I'm lucky that my building has lovely old windows, but interesting plays of light can be found everywhere, you just have to keep your eyes open and your imagination unfettered. Timing and mobility are important factors when you are working with ephemeral lighting conditions. The colour, intensity, and direction of light shifts throughout the day, so you have to react quickly to changes. And you must be able to move around, to find the best angle to catch your model in the light, to get in close, and move further away.

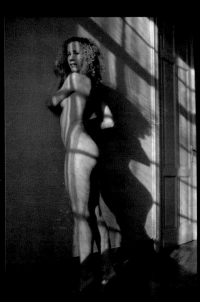

Marion in the afternoon

The late afternoon sunlight, just before sunset, falls into the room almost horizontally. It would have been impossible to realize these images in the summer because the sun would set further north and the leaves on the trees outside would prevent the sunlight from entering the room directly. The images above are in chronological order: the first is a classic shot with the light falling directly onto Marion's body creating shadows and patterns on her skin; the second makes use of light reflected in a mirror behind her, while the third shows how the sunlight changes colour just before it disappears.

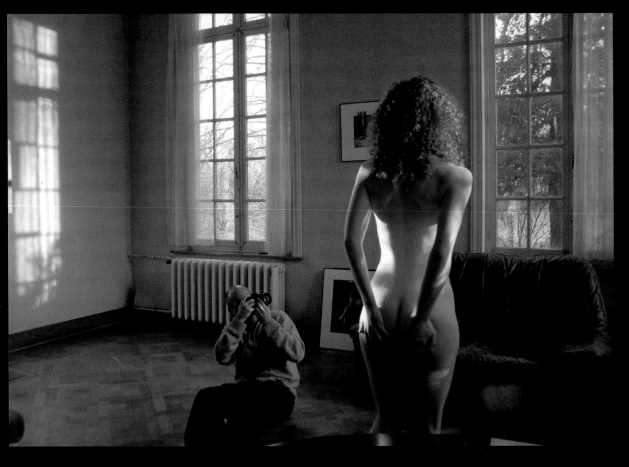

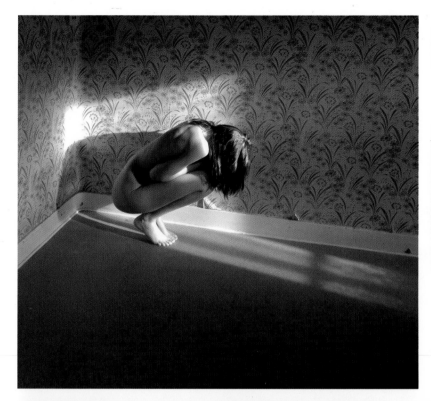

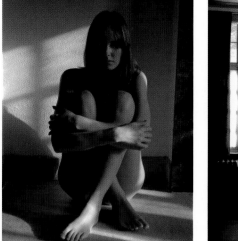

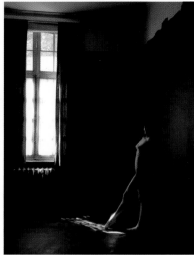

Patches of light

For each of these images I asked my model to find a small area of light falling into the room and to imagine why she is looking for the sunlight: comfort, warmth, or memories? As ever, I tried to ensure that the light, composition, and pose were all in harmony with the atmosphere I wanted for the image.

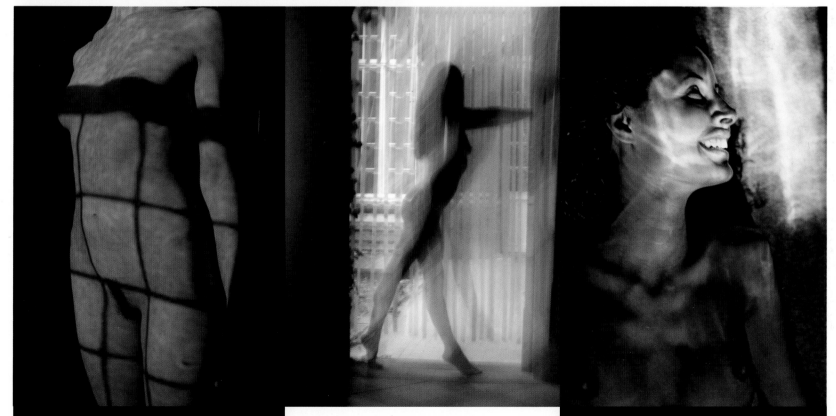

Stained glass

This picture was taken in the late afternoon, when just a small area of the room was lit by the sun through a stained-glass window, leaving the rest in deep shadow. This effect can be easily achieved wherever light falls directly through coloured glass or any other transparent material.

Bounced light and movement

This image makes use of the bright midday sun, which is bouncing off the tiled path outside and creating a shadow of the model on the plastic strips hanging in the doorway.

Reflected light

The light falling through the old blown glass of my studio windows comes from beneath the model's face. This is only possible because she is lying down. I could have had the light coming from her left or right, or from above, each of which would have created a different effect.

studio lighting

Working with studio lighting can be a frustrating exercise if you find yourself adjusting and readjusting a number of lights, unable to get them right. I find the easiest way is to put the lights in place one by one, beginning with the main light. I position that to get the overall effect I want, and only when I am completely satisfied that I have got everything

I can from it do I go on to put a second light in place to soften the shadows or highlight another part of the image or the background. When this feels right, I then add a third light, and so on. If you set up too many lights at once you risk confusion as to exactly what each light is really contributing to your set-up.

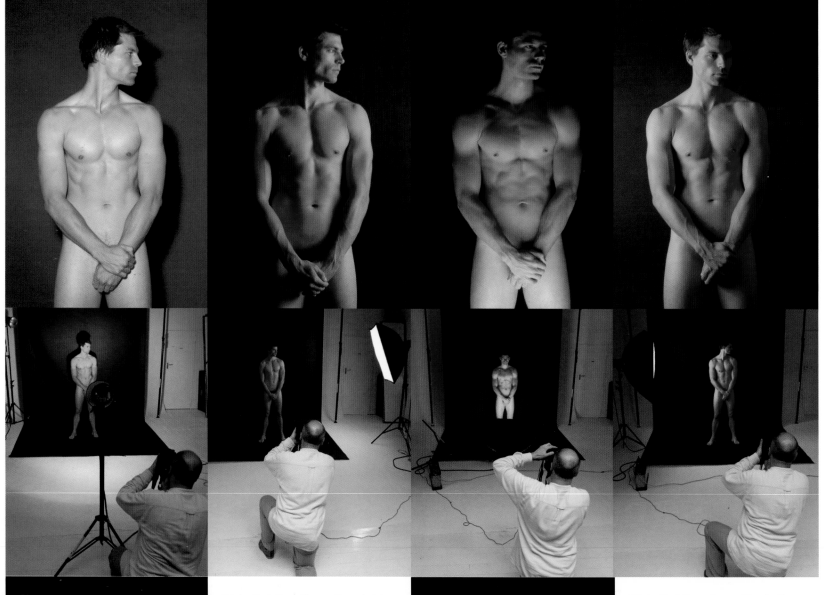

Frontal lighting
One frontal spotlight gives a similar effect to an on-camera flash, rather like police mugshots and amateur snapshots, and for this reason it is used for grunge and deliberately "amateur" images.

Side lighting from the right
One softbox placed at the right side of the model sculpts his body and lights his face. This is ideal lighting for fine art nudes, but looking into the flash may be uncomfortable for the model.

Lighting from below
Light coming from directly below the model gives a dramatic, cinematic, and rather sinister effect. It is most often used to give the immediate impression that the subject is someone to be feared.

Side lighting from the left
With the model in the same pose, this gives a similar but reversed effect to lighting from the right. Because the model's right hand is on top of the left it is fully lit, but his face is now lost in shadow.

Lighting the face

Directing the model's face towards the light, wherever it may be placed, means the eyes will be immediately visible, which helps to make a connection with the viewer. Choose the body pose, position the lighting to sculpt the body, then direct the face accordingly.

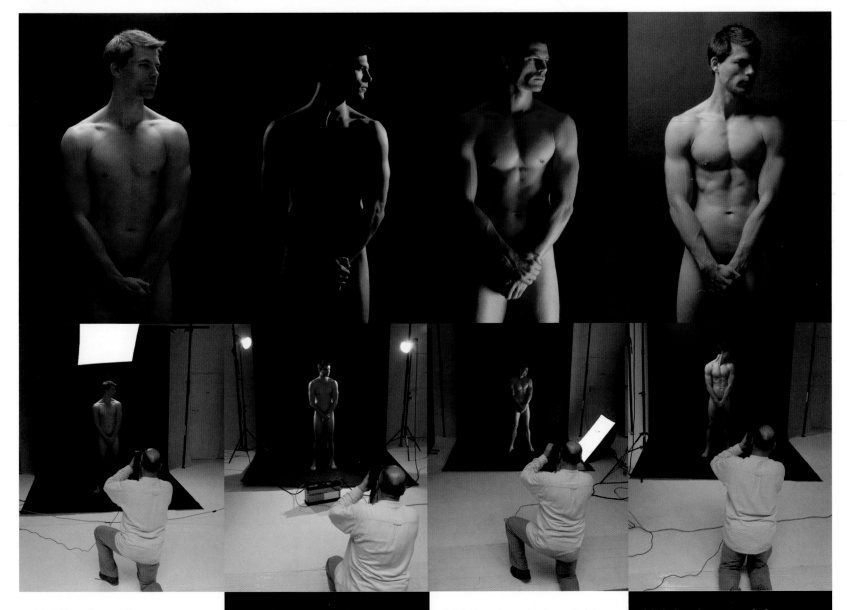

Lighting from above

Here the light source is above and also slightly behind the model, creating a mysterious, ethereal glow which is often used in films when angels or extraterrestrials enter the scene.

Lighting from behind

Two spotlights behind the model are performing a different function: the one on the right illuminates the model's profile while the left, weaker, light helps to separate him from the background.

Lighting from below right

A softbox set low and to the right of the model gives a dramatic and beautiful light. The model's expression, though it hardly differs from the other images, gains strength and impact.

Lighting from top left

Leaving the face in shadow creates intimate images. Here the light is thrown on the model's torso and shoulder, emphasizing his strength and masculinity in spite of his averted gaze.

Even in a very basically equipped studio you can create a great variety of lighting effects. All you need is one or two lights, a few basic accessories, and a little imagination. The lights don't even have to be special studio lights – there are plenty of interesting effects that can be achieved with just ordinary household lamps – even with just torchlight – so there's no excuse not to have a go. It doesn't have to be complicated or excessively time-consuming, either. All the images here were realized in a two-hour session. However, a cooperative model and good preparation will be essential.

Projecting a pattern

The effects can be stunning, but the technique is simple. For these images, I cut some shapes out of a piece of black card and got my assistant to hold it in front of a spotlight so that it cast patterns of light and shadow over the model's back. The closer the card is to the model, the sharper the pattern will be.

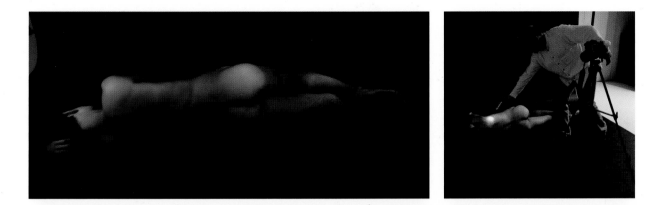

Light painting

Keeping my shutter open for 30 seconds at f/22, I lit the model with a torch. The model has to be able to keep completely still in the pose, so lying down is a good option. However, it's important that you are in constant motion yourself; if you keep part of your own body in the same spot for a few seconds it will show in the image.

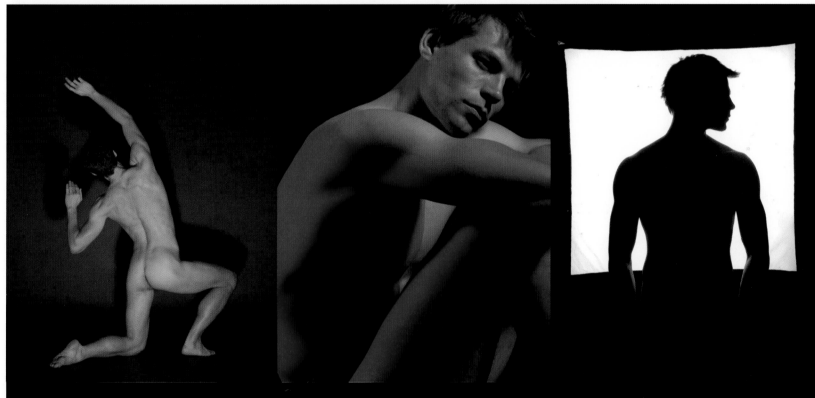

Tall shadows

I wanted to create shadows that would seem to tower over the model, so I put my lamp on the floor and used a metal rack to prop it in position, pointing upwards towards him. I chose an energetic pose and placed the model close to the wall so the shape of the shadows would show up well against the dark background.

Coloured lights

Red and green gels (coloured acetate filters) are the basis for this image. I positioned the two spotlights opposite each other, either side of the model. Because the red light was stronger than the green I had to make some adjustments to match the light intensity. Another way to do this is to move the model closer to the weaker light.

Graphic silhouette

With a single softbox you can create wonderful, sharp silhouettes. I asked the model to turn his head to the side, since a profile works much better in silhouette than a face-on pose. Using a softbox in this way is great for creating the perfect white background; a larger softbox would have given me even more possibilities.

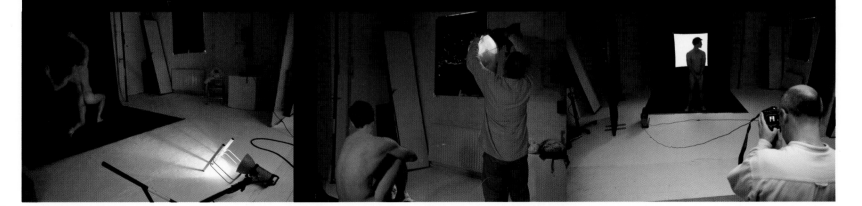

lighting outdoors

Nature offers a huge range of lighting possibilities. Just as in a studio, you can choose to work with front, side, or backlighting, but with outdoor light there's so much more. The colour, direction, and intensity will change constantly. Morning and evening light are different, as are winter and summer light. Sunny days are different to cloudy ones, and shadows, too, change throughout the day.

As an outdoor photographer you have to remember that guarantees of light and weather don't exist, so you must be able to adapt to changing conditions. You can also, whether through necessity or just for effect, supplement outdoor lighting with lamps, fill-in flash, and reflectors.

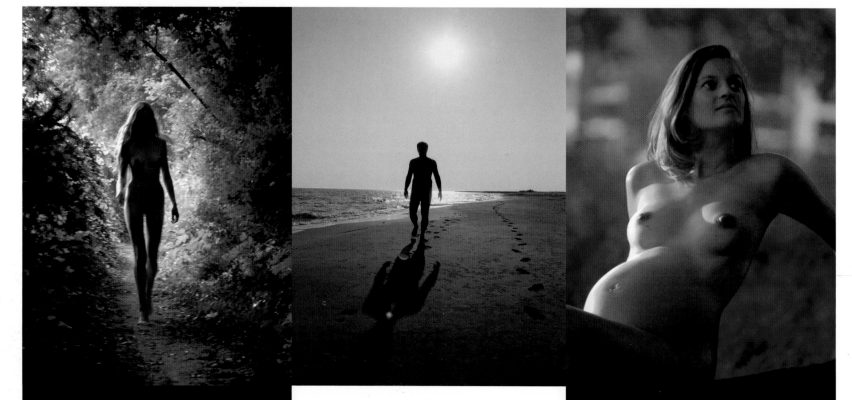

Jella in the woods

I can understand why some people would question this image. The unsharpness – caused by movement of both camera and model – is obvious. But not one of the other, sharp, images from the set had anywhere near as much atmosphere as this.

Having the model walk along a path suggests a direction, a story. The hazy unsharpness, backlighting' and anonymity of the model add to the mystery of the image.

Front lighting would have made this a completely different, less atmospheric image. The halo of backlight surrounding the model makes her appear to glow.

Frank on a beach

Sunrise is a good time of day for a shoot on the beach, since the beach tends to be empty of onlookers and the light can be wonderful.

The footprints in the sand are a major element in this image. The set on the right are intriguing – who do they belong to, where are they leading?

Shooting into the low sun gave me a silhouette and a wonderful long shadow that stretches to the edge of the frame.

The spot of flare in the middle of the shadow could be seen as a mistake, but in this case I think it adds to the image.

Barbara pregnant

The last light of the day envelopes Barbara with a warm, dark orange light. The shadows have already begun to turn blue.

A wide aperture allowed me to blur the background so that it's part of the image without being obtrusive.

Barbara is looking away from the camera, as though her thoughts are with her baby, rather than me, the photographer. If you are taking a picture like this of your partner, you may want to include yourself in the picture by having her make eye contact with you.

Additional lighting

I'm not keen on using heavy equipment outdoors; it reduces working space and reaction speed. But, at the same time, it can open up a lot of possibilities. Here, I used a softbox and adjusted aperture and exposure times to create a variety of effects.

1 The environment is well lit but the model is overexposed, giving her an ethereal look.
2 To create a night effect I lit the model correctly and underexposed the background.
3 Less overexposure of the background and more light on the model gives an impression of evening light.

Using reflectors

Popular in portrait and glamour nude photography, reflectors can greatly improve the lighting in your images. They can be used to bounce and direct light so that you can target specific areas such as the face, and to fill in dark shadows. They are very useful when working in full, hard sunlight.

1 The reflector has brightened the light on the model, separating her from the background.
2 Hard shadows are softened.

sculpting with light and shadow

Shadows give depth and interest to a two-dimensional image. The angle of the light in relation to the camera determines the effect on the body, with very slight changes creating huge differences in the shadow-play. If I was in a studio I would move the lights around; here, in the two main images below, I am using natural light, so there is no moveable light source. Instead, I have altered the angle of the light by altering my position. The small images at the bottom of the page show how small variations in pose, position, and light direction sculpt the shape of the body.

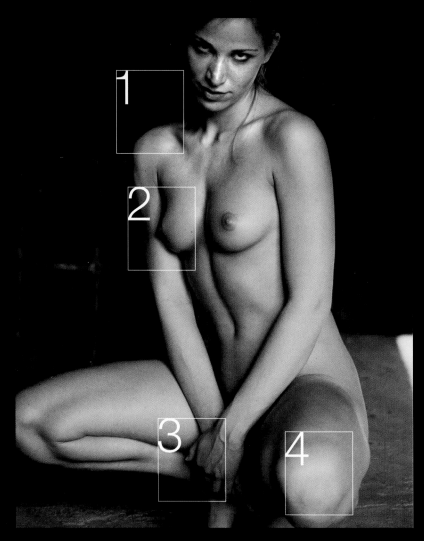

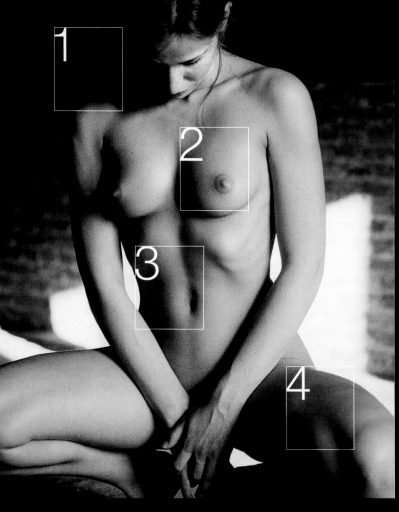

Zuri with front lighting

In this image the light is almost behind me, lighting Zuri from the front.

1 The subtle light defines the collarbone and the curve of the shoulder.

2 Fine shadow lines give the feel of a delicate pencil drawing.

3 Areas where parts of the body converge are clearly defined.

4 A slight adjustment would avoid the knee facing the camera and being overlit.

Zuri with side lighting

Here, the light comes from the side, creating bolder, more dramatic shadows.

1 The dark shadows blur the boundaries between the body and the background.

2 Broad brushstrokes of shadow giving the image a painterly quality.

3 Background light accentuates Zuri's hourglass figure.

4 By adjusting my position, the knee no longer faces the camera directly.

dressing with shadows

You can emphasize the beauty and fragility of a model's body, and add a touch of mystery, by dressing the model with shadows. Wherever there is light, there are shadows, and wherever you put an obstacle between a direct light source and a body, you create shadows on the body. You can play with different forms and patterns, with light direction and light intensity. You can create a mood with your use of shadows, suggest a story with them, or make a statement – the possibilities are endless. Shadows are the most simple, inexpensive, and effective props available to the nude photographer. By using them in this way you stimulate the viewer to look beyond the nudity of the model.

Laure-Anne at a window

Here, the pattern of the light and shadow is confined to one side of the body, focusing attention on the breast and belly area.

Light is filtered through the blown glass of an old window. Modern glass doesn't produce the same pattern, but slatted blinds or lace curtains can also be used to great effect.

The lines resemble a sweeping brushstroke – narrower and more defined at the top, blurring and broadening as it travels down the body.

Cropping the image in this way almost gives the body the shape and proportions of a face, inviting the viewer to look at it.

Alexia under a tree

Leaves create a wonderful mosaic pattern on the model's skin. I took this picture on a late summer's afternoon, when the light had become warm and soft.

The time of day is crucial for this kind of image. Around midday the hard, contrasty light would have turned the shadows into unattractive black spots.

The direction of the model's eyes reinforces the gentle, romantic nature of the scene. Here, Alexia's dreaming eyes follow the light direction, into the empty right half of the image.

Marion in bounced light

Here, the model is caught in the last moments of daylight, bounced via a mirror on her right. The sun's position is on the left.

The position of the model was critical to the success of this shot. I positioned Marion very carefully to capture the dot of light on her right nipple and the bold stripe of shadow down the centre of her body.

A degree of anonymity is achieved by allowing the lighted area to begin just below her eyes. Sometimes this can help the image, making it easier to appreciate the subtle forms.

playing with shadows

In the same way that you can use the play of light and shadow on the body to create beautiful effects, so you can play with the shadows cast by the body itself. In doing this you can add depth and atmosphere to an image and also, perhaps, bring in an element of tension between the shadow and its "master". You don't need elaborate lighting set-ups to achieve great results: the images here were created simply with a lamp or available light. Shadow figures can appear substantial and ominous or light and delicate – you'll need to experiment and reposition yourself and your model in relation to the light until you find your desired effect, both aesthetically and emotionally.

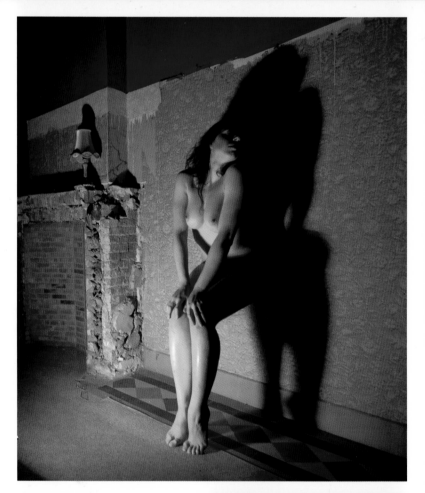

Different effects

Each perspective – shooting from above, below, at eye-level, and so on – creates a different atmosphere. You may need to lay right down on the floor or climb on a chair or ladder to get the most interesting effects. The amount of light on the model's body will vary according to your position, so move around and experiment.

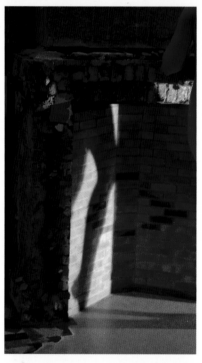

A simple set-up

Here, the light is provided by a halogen lamp of the type that builders use, which can be bought cheaply from most DIY stores. By placing the lamp on the floor pointing upwards you create the kind of dramatic, looming shadows favoured by the makers of thrillers and horror films.

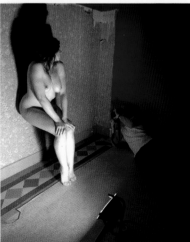

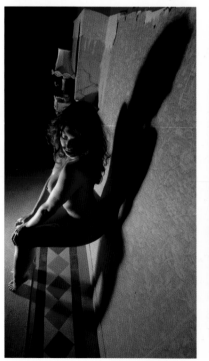

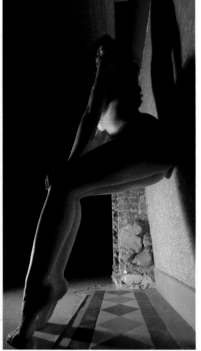

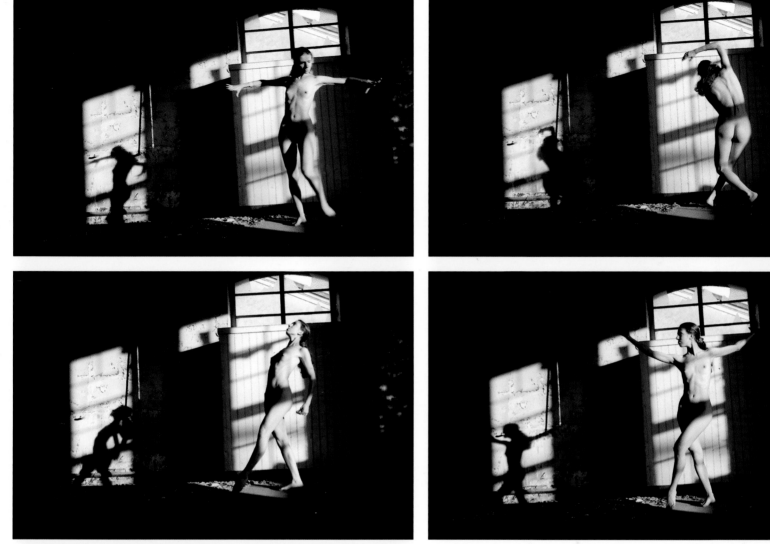

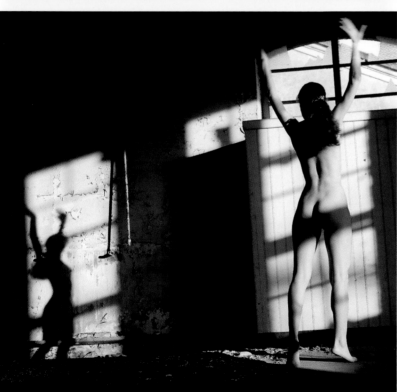

Dancing with shadows

These images were shot just before sunset in an abandoned railway outbuilding, in France. It was quite difficult to find the angle that showed both the model and her shadow in an interesting pose, as if dancing together, and I had to clearly define the area in which she could move without losing the shadow. But we persevered and the result was a set of pictures with a charming, fairytale quality.

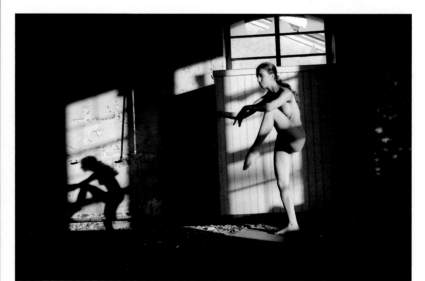

...to be spectacular. The main rule is to try and avoid shooting with the light behind you, as this will make the lighting look flat. Light coming from the side or from behind the model creates the wonderfully strong lighting effects on this page. I just used direct or indirect sunlight, or the lights in my...

the setting; doing this stimulates your improvis... I also tend to consider that studio equipment s... in the studio. On the facing page are some ide... sources, used as props in the images. Let it h... imagination; the possibilities are endless.

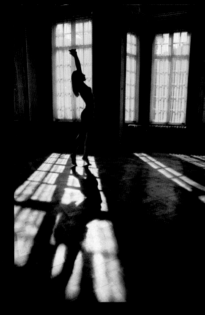

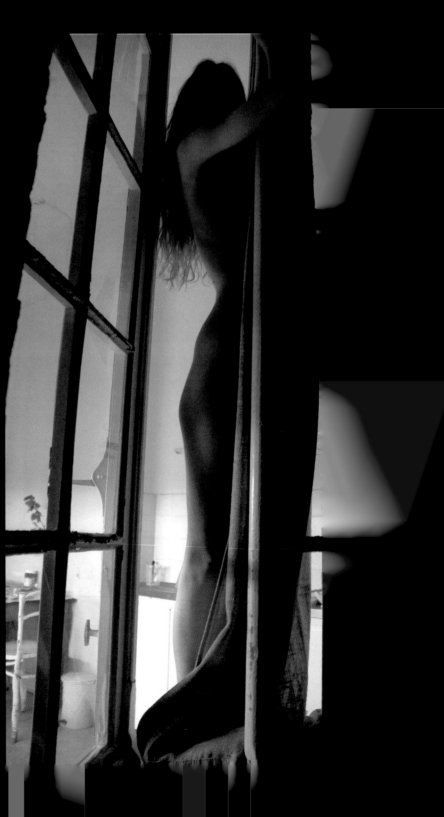

Windows

Early morning or late afternoon sunlight, or winter sunshine, creates lovely long shadows. Find out which windows catch the light at different times of day, and plan your photo sessions around that. There are also options for you on cloudy days; fluorescent ceiling lights can give surprisingly good results. For the photograph on the right I just used kitchen lights to create a backlit effect.

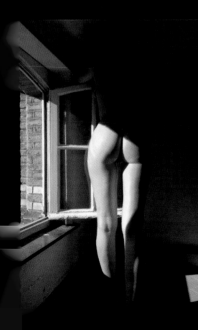

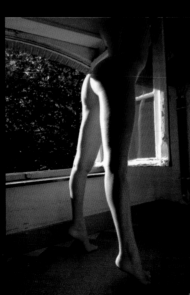

Alternative lighting

Bringing a light source into an image automatically creates a link between the source and the subject. If, in addition to this, your model can make a connection with the light source, you then have the basis for a good image. Builder's lamps, candles, desk lights, sunbeds, torches – even street lamps – can be used creatively to make this link. In every home or every type of environment you are bound to find some kind of light that can contribute to your image.

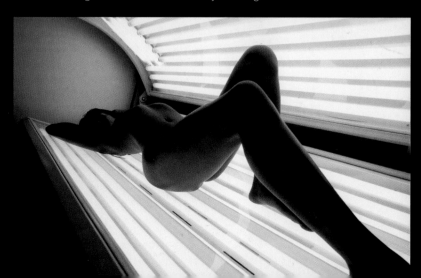

lighting gallery (continued)

Lighting from below

In these shots there is a big round lamp lighting the model from below. This kind of light can easily produce unsettling, almost melodramatic, effects, but the soft expression and fragile figure of the model gives the pictures a dreamy, mysterious look. Remember always, though, that lamps – especially halogen lamps – get extremely hot, so make sure everyone keeps a safe distance from them.

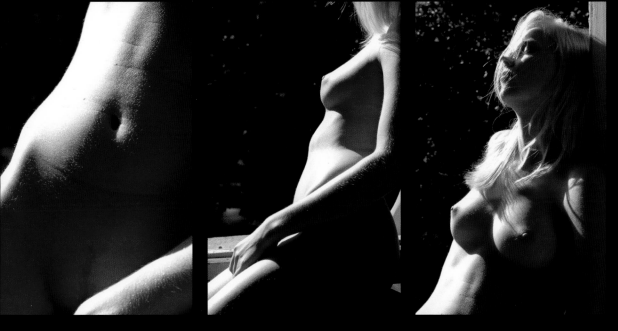

Side light

Here sunlight is falling directly on the model. The light seems to be coming almost horizontally, and sculpts the model beautifully. Look at her belly button in the image on the far left, the light on her breast in the middle image, and the light on and under her eye in the image on the right. This kind of light is ideal if you are looking for strong, graphic effects, and is also my favourite light for black and white photography.

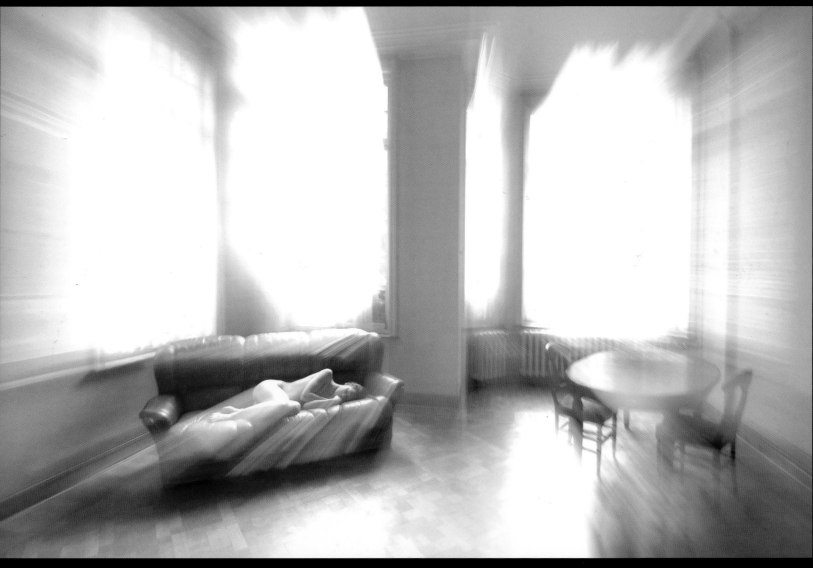

Radiating light

To create this image, I zoomed at the end of a long exposure from wide angle to telephoto. The point from which everything radiates is the pillar in the middle of the shot. I have overexposed by two stops to enhance the effect.

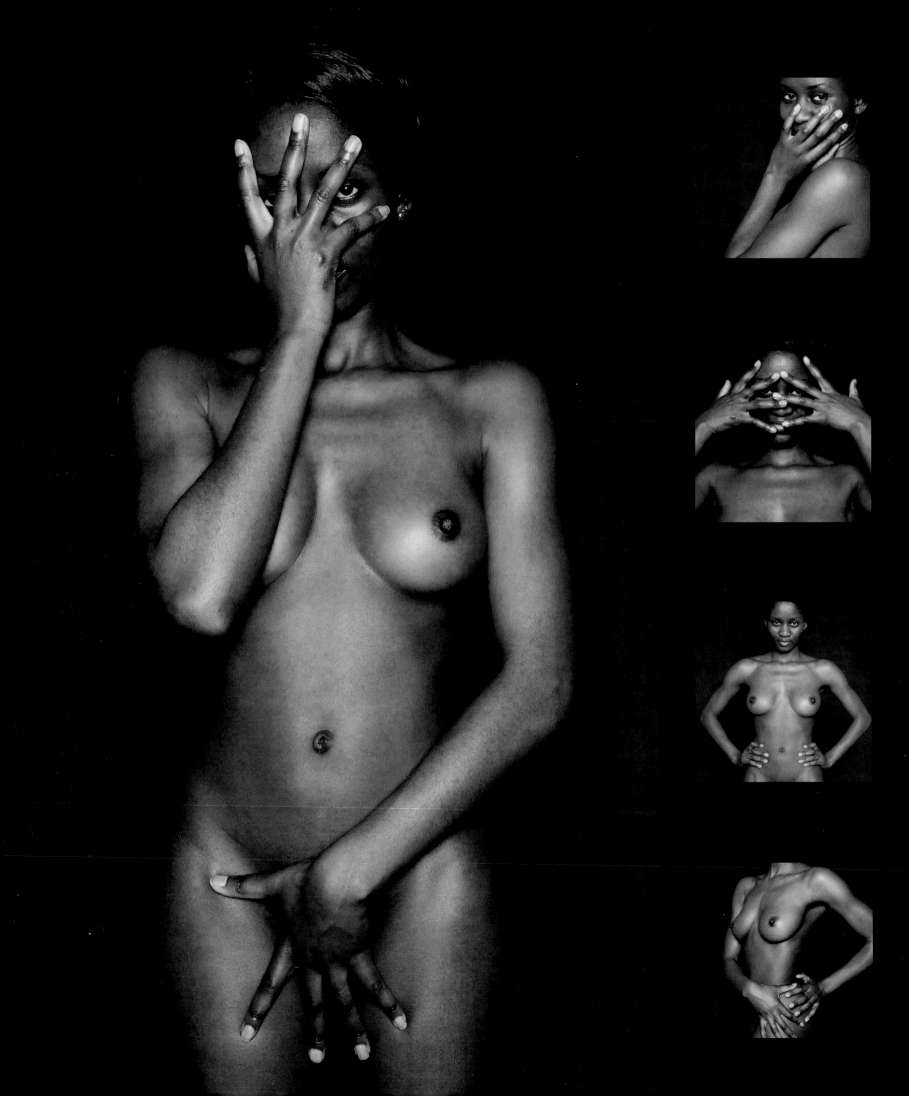

poses

Although "posing" is the generally accepted word, I don't much care for it. It is such a static term; it suggests that your model is as inanimate as a shop-window dummy. I prefer the word "acting". It assumes that the model is playing an active role, that he or she is a living (and moving) being. It also implies that the model is playing a part, which means that there is a concept behind your image – you have not just set out to photograph a nude body with no thought as to what you want to express.

Poses are not right or wrong. A pose can be elegant seen from one angle and inelegant from another, appropriate in one setting and inappropriate in another. A certain position can work with one model and not with another of a different body shape. Not only do body types differ, but so do skin tones and hair style and colour – all of these elements will affect the look of the final image.

In general, I tend to think in terms of curved shapes when I am working with female models and of triangles with male models, but this of course depends on the type of image I want to make – it's a mistake to stick to invariable rules. You may be able to book a model who fits the exact physical shape you have in mind for a particular shot, but if not, keep an open mind and don't impose an idea that simply won't work with the model you have. Top photographers can cast exactly the model they want, but while you are still on the lower slopes of the profession, learning to adapt is a useful exercise that will hone your skills.

In order to communicate what you wish to express to the viewer, you need to employ your understanding of body language. A turn of the head or body can transform a strong and confident pose into a protective, vulnerable one, for example, emphasized by the angle you choose to shoot from; and within those poses you will need to look for small adjustments that create a beautiful line from a mediocre one. In this chapter, you'll find out how to create aesthetically appealing, dynamic poses that will convey your message powerfully to the viewer.

> " You need to employ your understanding of body language. "

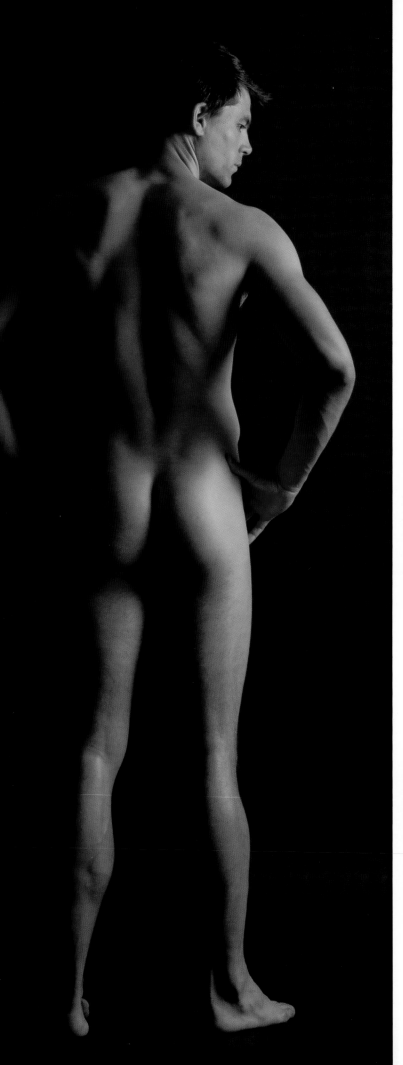

from head to toes

An understanding of the human body is a great asset for a nude photographer. Not just the mechanics – our forms, the way we're put together, how we move, and so on – but also the language of our bodies. The best way to learn is to study people, even when they are just standing doing nothing. Look especially at people's feet. For example, the pose on the left – starting with the outward-pointing feet – is confident and outgoing, ready to face the world. For a more intimate, introspective atmosphere, the model's pose will usually be more closed and protective.

Head position
When the head is turned away from the direction of the body, the pose gains dynamism. Turning the face into the shadows creates intrigue.

Protective stance
The arms folded across the chest combined with the lowered head suggest a hint of vulnerability.

Hands
The position of the hands can set the mood of an image. Here, side light creates hard shadows – generally less flattering to women's hands.

Athletic pose
The muscles of an athletic back are great for playing with light and shadow. Try shooting from different angles and with different light settings.

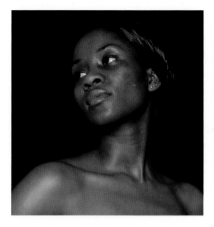

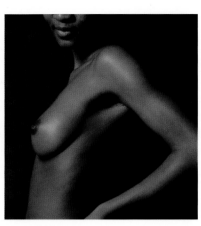

Shooting upwards

When you look up to your model you make him or her appear strong and confident. Position your light carefully to avoid looking straight into the nostrils.

A side view

The shoulder, breast, and arm can create beautiful shapes, especially when shot from the side. Shoulders often look better pulled back a little.

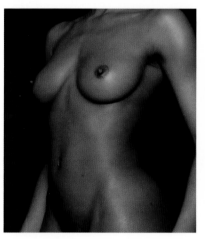

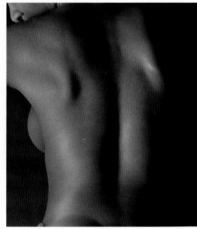

Using torsion

An hourglass shape is enhanced by twisting the shoulders towards the camera, while turning the hips slightly the other way.

Soft shadows

As muscular as a male back can be, so a woman's can be soft and smooth. Here, the shadowy abstract effect is sensualized by a glimpse of breast.

Making contact

A hand touching the face intensifies the expression. This kind of gesture isn't easily posed, but works best when it comes from the model.

Posture from the feet

Look at the feet first if a pose seems awkward or unnatural since, with standing poses, they have an impact on the posture of the whole body.

adjusting the pose

Poses shouldn't be considered in terms of good or bad, but rather elegant or inelegant, suited or not suited to your picture. As a photographer you have to be able to analyze a pose quickly. Always start with the point of impact (the feet if the model is standing, and so on). Remember that a change in your position will change the pose visually, and that you should also adjust the pose in relation to light direction and image composition. Thinking in terms of the atmosphere of the image also helps. If the model "feels" the image he or she will find an authentic-looking pose almost automatically.

Kneeling position

In the first image the front foot is positioned awkwardly under her leg, which is pointing forwards, causing a foreshortening effect. The back foot is visible and spoils the lines of the pose. The second pose is more streamlined and relaxed.

Avoiding a double chin

If your model is lying on her back, arms above her head and looking to camera, there is a danger that her shoulder, neck, and chin will be too close to each other. Often, just relaxing slightly and looking to the side is enough to avoid this effect.

Arching the back

There is one very simple way to improve the pose if your model is lying on her back. In the image above, Paulina's feet are almost flat against the ground, and so is her back. In the image on the right I asked her to raise her knees slightly and point her feet so that only the toes were in contact with the floor. Immediately her back arched up, creating a much stronger and more shapely pose.

S-forms

Curves not only add elegance, but also dynamism. In the shot on the right the pose is completely symmetrical, very still, and very static. I asked Annelies to curve her back and look to the left, into the direction of the light, and you can see that the image below has much more energy. If I had asked her to look to the right it would have added an extra curve and she would be looking away from the light, resulting in a very different effect.

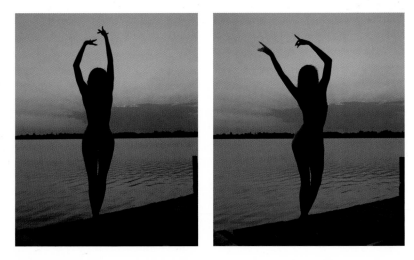

Silhouettes

With silhouettes it is especially important to get the pose just right. In the shot on the left there is no space between the model's head and her arm, which spoils the shape of the pose. In general, it's better if all the major body forms are defined.

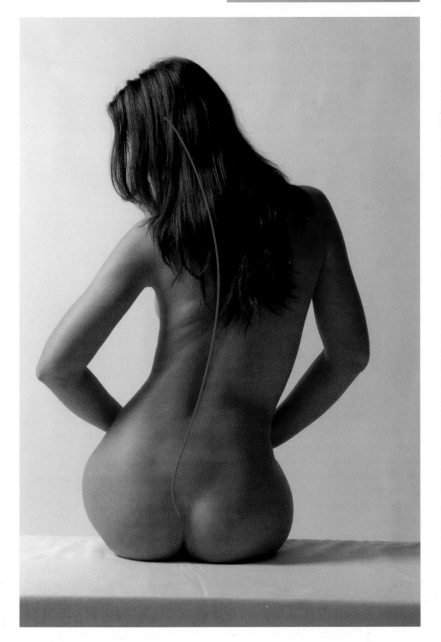

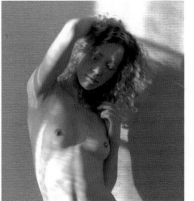

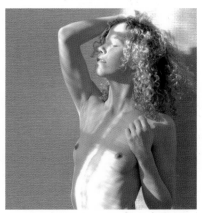

Facing the light

The best way to show your model aware of and connecting with her environment is to have her face the direction of the light. In the image on the right also notice how the elbow looks more graceful when it's not pointing directly to the camera.

An all-over lift

Standing on tiptoes puts tension into the calves and thighs, lifts the bum, and brings the shoulders back slightly, making even the position of the head more elegant. This is one reason why high heels are so popular in glamour photography.

lighting the pose

Pose, expression, and light are the three key elements in nude photography, in fact in any "people" photography. When these elements support each other the images gain strength. You can either adapt your light to the pose you want to shoot, or adapt the pose and expression to the light that you have available: soft light for romantic poses, hard light for drama, and so on. Look at the intensity of the light, its direction and colour temperature, and experiment. Sometimes simply asking the model to turn towards, or deliberately away from, the light source will improve your image.

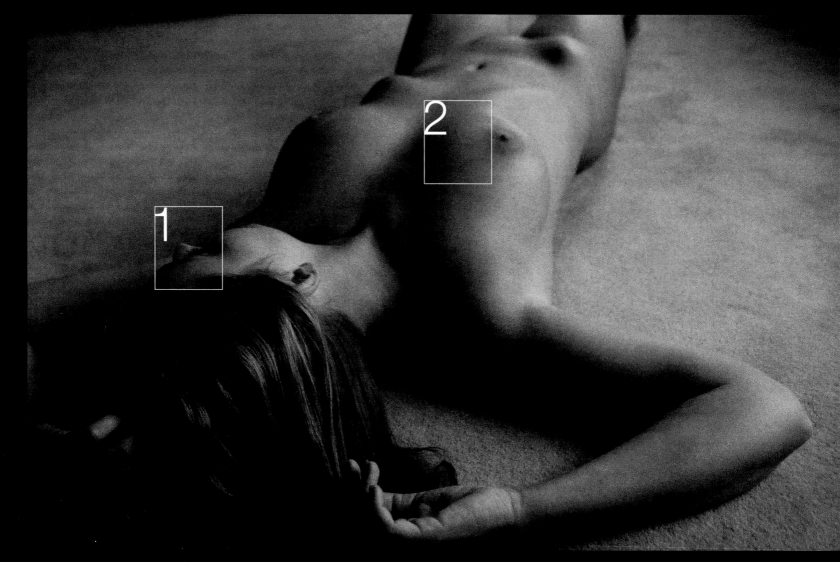

Romantic poses
Here I have used the light from a large "softbox", in this case a window with northern light (light entering the shadow side of a building, with no sunbeams). I used only one light source; using a second would not only have killed the nice dark shadows, but also the natural, authentic feel.

1 The model's face is turned away from the light, strengthening the dreamy, introspective nature of her pose.
2 The soft light, falling at 90 degrees, creates a discreet play of muted light and shadows on the body.

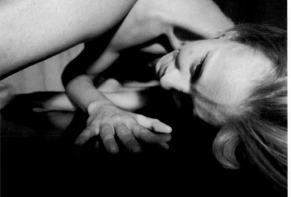

Angular poses

These moody and dynamic poses have been caught with the hard light from a halogen spot. I took the image on the left using a wide-angle lens to get in really close, so you feel you are almost part of the scene. The cluttered background in the image on the far left disturbs me as much as it gives me a feeling of authenticity.

Dramatic expression

Shanya's intense expression is enhanced by lighting her from below so that her face receives the strongest light. She is making direct eye contact with the viewer, whose own eyes are immediately drawn to hers. In this image you feel that the light and model have been brought together especially to create this theatrical effect.

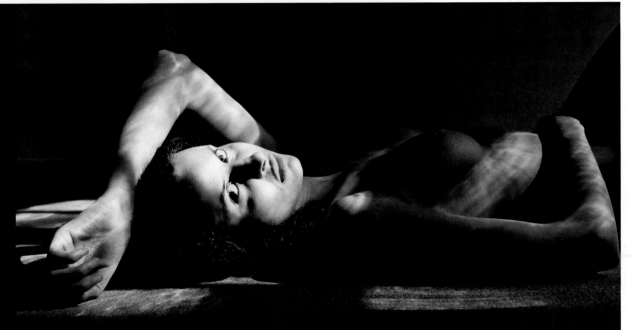

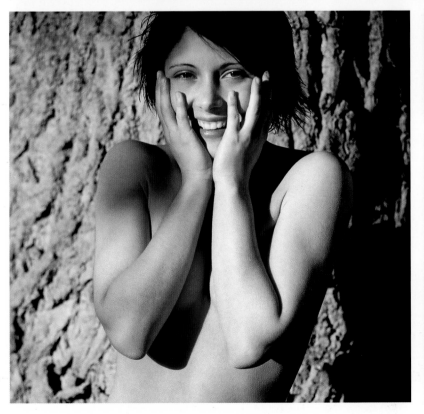

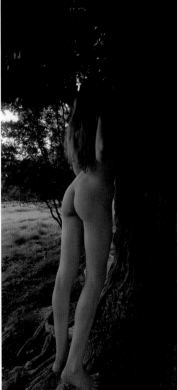

Adapting the pose

Similar subjects can be lit very differently to create very different images. Bright, sunny light on the far left enhances the model's happy, outgoing pose, while the soft, unobtrusive light on the model on the left suits the more mysterious feel of the image. When I am working on location I always ask my models to adapt their poses and expressions to the changing light conditions.

poses gallery

Posing models becomes easier when you begin to think in terms of encouraging them to "act", rather than making static shapes and poses. It can be useful to give your model a short story and get them to play a role – this way you'll gain authenticity and variation. I always begin a session telling my model the feeling I want to evoke, and where my idea came from. A storyline makes the session fun, and posing becomes more natural – after all, every human being has a well-practised range of body positions and facial expressions that match his or her emotional state of mind.

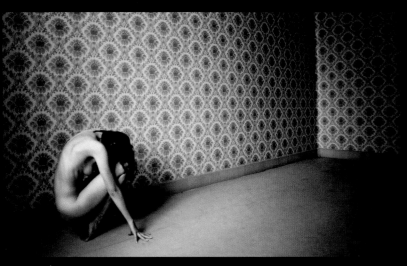

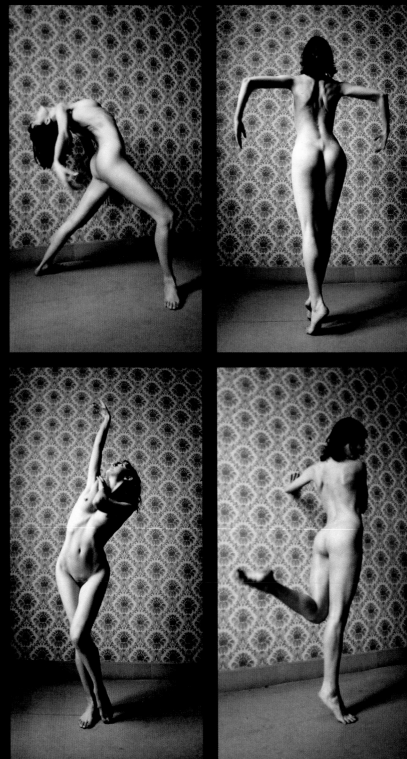

Aline dancing

I love working with dancers. They have excellent body awareness and are able to execute difficult positions with precision and expression. Here, Aline's strong, dramatic poses are a perfect foil for the colourful decor of the room.

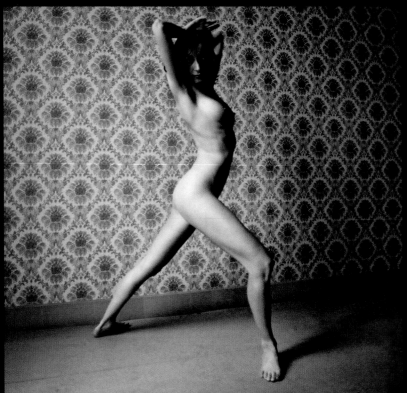

Frank crouching

Standing poses can be difficult, especially if your subject is new to modelling – he or she may feel awkward and unsure of what to do. Sitting, kneeling, or crouching positions give a sense of reality and approachability, with the model more in touch with his or her body. They can also produce interesting shapes and make the composition more compact.

Focusing on hands

Hands are great tools for expression. We all use them all the time, but mostly subconsciously. It can be quite difficult to "pose" a model's hands, so often I suggest that models imagine being in a specific state of mind and let them move their hands intuitively.

Anonymity

This is a classic pose – the reclining nude. Anonymous poses such as this create a more allegorical feel – the model can represent "Woman" or "Beauty" more easily than an indentifiable character. This pose evokes a warmly human atmosphere, and is very easy for the model to hold. It is also a gift to the photographer – you can move around your model, carefully choosing the best distance and angle from which to shoot.

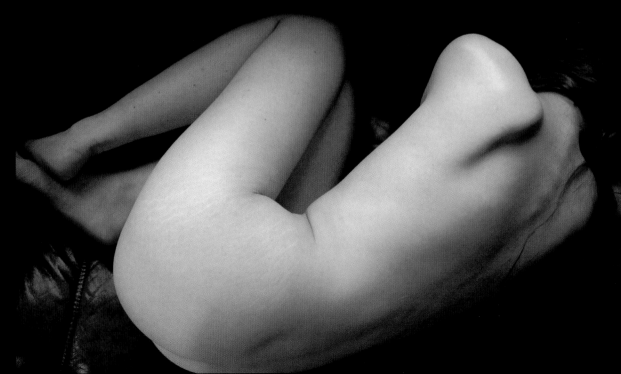

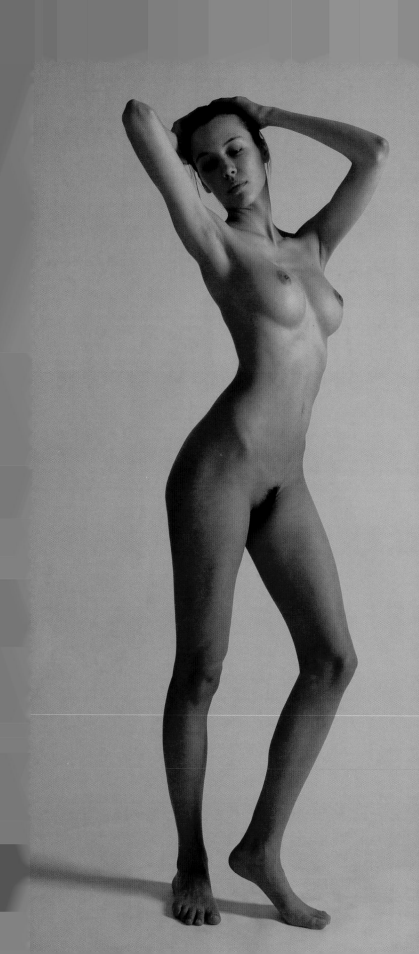

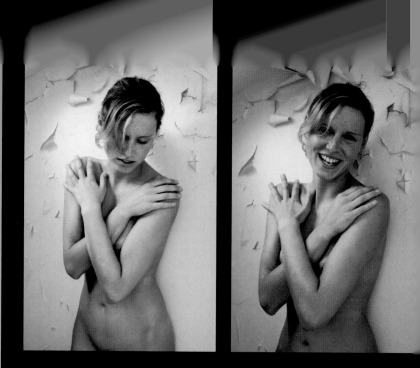

Linda against the wall

The model's expression is more important for the atmosphere of an image than her pose. With introverted images, the model focuses on her inner self, and there is no need for her eyes to make contact elsewhere. With extrovert images the focus will be outgoing, looking for a connection outside herself.

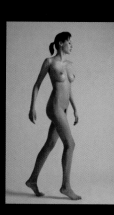

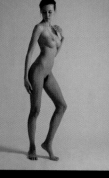

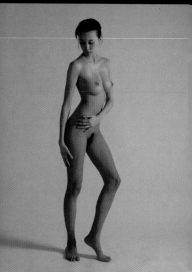

Moving while posing

Here, Sofie is changing position slightly with every shot. This works well for movement or anatomy studies. The white background and the white walls of the studio make the light bounce, softening the shadows. To show the model's beauty, strength, and pride, I positioned myself low down, so I was looking up to her. Her half-closed eyes and averted gaze reflect her slight shyness at the beginning of her first nude session.

Fran and baby

The secret of photographing couples – here, Fran and her baby Jade – is to define the relationship between the two people and let them make the connection. The northern light falls gently on Fran, accentuating the emerging form as she holds her baby in a protective pose. She doesn't look into the camera, as her full attention is on her baby. In the image on the left I was shooting slightly downwards to emphasize the belly, whereas on the right I included the eyes so the focus is on the feelings of the mother.

Sofie at the window

Not looking into the camera lens is one way of retaining privacy, especially if the eyes are kept closed. However, if the model looks elsewhere, make sure that the composition gives the model enough space to look into. I have positioned myself a bit higher than Sofie in this sequence, looking down on her, which enhances the vulnerability she expresses here.

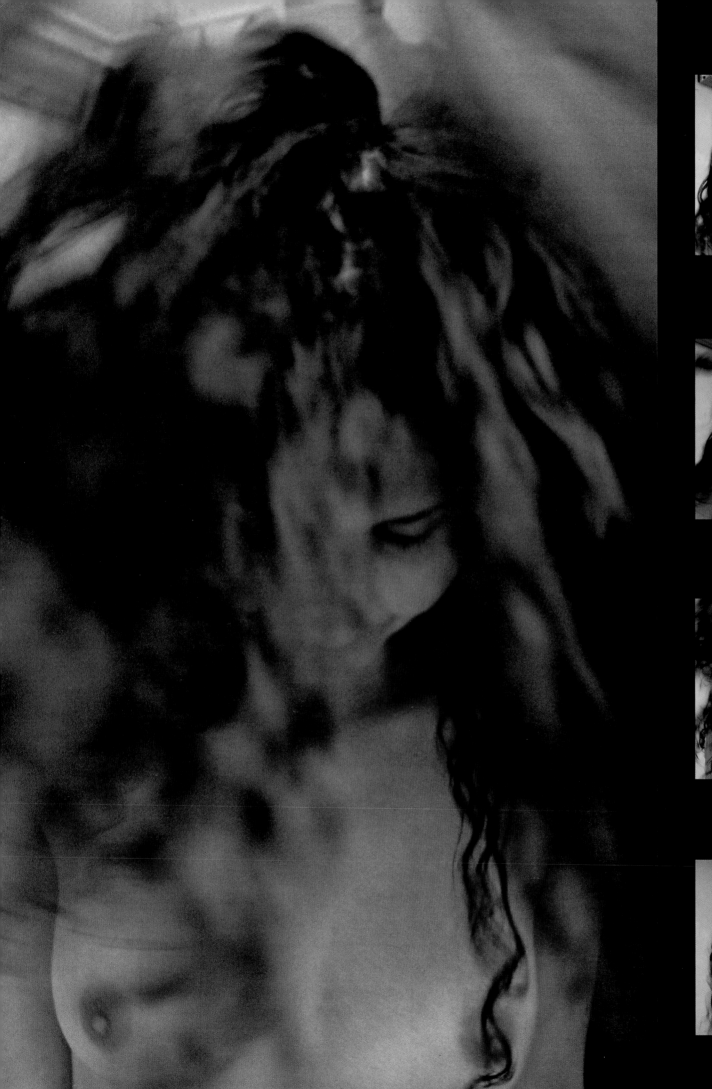

sharpness & blur

There are many factors that influence our response to a photograph. A picture will mean different things to different people, but for me the key element of an image is its emotional impact.

Of course technical excellence is important too, but as a photographer you shouldn't let technical concerns restrict your creativity. One of the ways that we judge the quality of an image is its sharpness. But does every picture need to be sharp? I don't think so. Just look at the work of the pictorialists in the history chapter – they were actively searching for techniques to avoid sharpness. Portrait photographers often use soft focus in order to mask imperfections and to create romantic, dreamy effects.

Sharpness, unsharpness, or partial sharpness is a technical choice, but a technical choice has no value unless there's an idea behind it; you have to have a concept, to know the why as well as the how, or the image will lack authenticity. You might choose to make your image completely unsharp, to create mystery or to abstract the subject. This can be achieved through movement of the model, the camera, or both, or by simply defocusing. Partial sharpness, where the subject is sharp and the setting blurred, is achieved by using a wide aperture to reduce depth of field. This draws attention to a specific area of the image and is an effective way of creating a connection with the viewer. It is often used in portraiture, with the focus on the eye closest to the camera. Another type of partial sharpness, where the setting is sharp but the subject is blurred, is created when the subject is moving. The degree of unsharpness depends on whether you keep your camera still, or follow the movement of your subject. This effect can suggest dynamism, energy, or restlessness. Sometimes, the sharpness of the image is determined by circumstance, for example, when you lack light. On these occasions, understanding the effects of unsharpness and what it can add to an image will enable you to turn a disadvantage into an opportunity.

However you use unsharpness you should always ask yourself: what is this going to add to my image, is this the best way to create this effect, and will it create the emotional impact that I'm aiming for?

> " A technical choice has no value unless there's an idea behind it "

focus and depth of field

Selective focus is the best way of drawing the viewer's attention to the element in the image you want to highlight. By making just that area sharp and blurring the rest, you ensure the viewer's eye goes immediately to it. You can push this effect to its maximum by using a telephoto lens set to its widest aperture, for example f/1.8, to create a very shallow depth of field, or you can decide to use a smaller aperture to allow more to be visible and give the viewer a chance to interpret the image in different ways. Working with a wide depth of field, keeping both subject and setting sharp, invites the viewer's eye to wander around the image and discover the different elements within it.

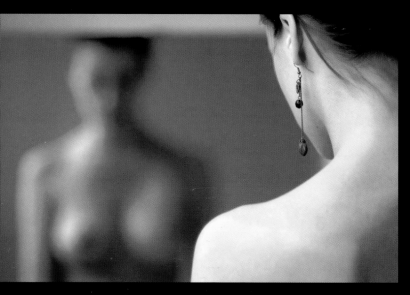

Foreground focus at a shallow depth of field
Here the earring is the main focus of the image, shot at f/1.8. As her reflected image is unclear, the model might be looking at her own face – but because I chose to make her earring the key element of the picture, the viewer is led to suppose she is looking specifically at that.

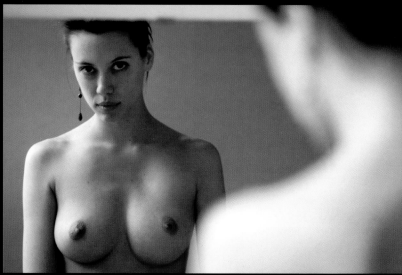

Background focus at a shallow depth of field
The focus is now on the model's reflected image, specifically her eyes. At an aperture of f/1.8, the earring close to the camera is now so blurred it's indistinguishable, and there is no indication whether the model is looking at herself or at me – and thus out of the picture towards the viewer.

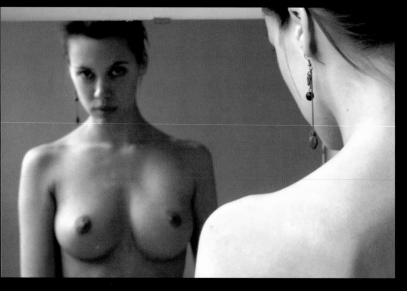

Foreground focus at a wide depth of field
The focus is again on the earring, but, at f/16, it is no longer the only subject of the image. The model may be looking at it – or at me, forming a three-point relationship between the earring, the model, and myself (or the viewer).

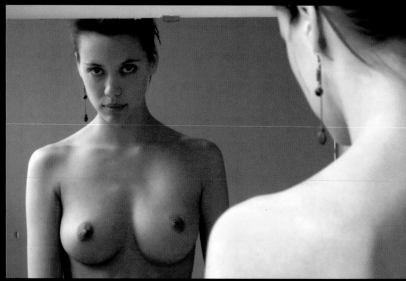

Background focus at a wide depth of field
At f/16, with the focus on the model's reflected face, the foreground earring is visible but the viewer's attention is directed to her eyes and her expression. The image is now mainly about her emotions.

Creating mystery

In one of these images, the viewer is in no doubt as to its content: the model is standing by a window looking out. The other might be taken to be a mistake on the part of the photographer, but it is not. In the case of a high-contrast, blurred image the lighter areas will tend to diminish the darker ones and in this instance making the model look like a wraith at the window. The flesh-and-blood girl has been transformed into a creature of dreams.

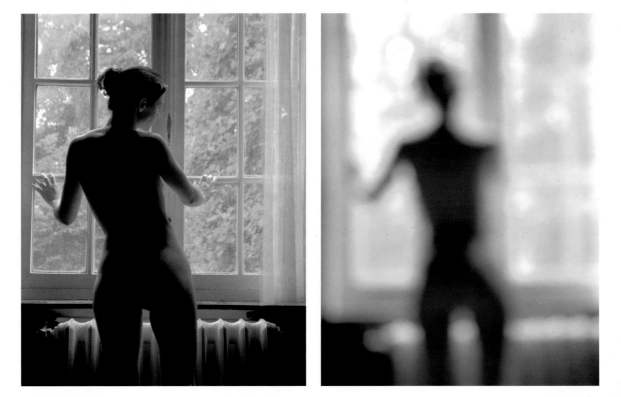

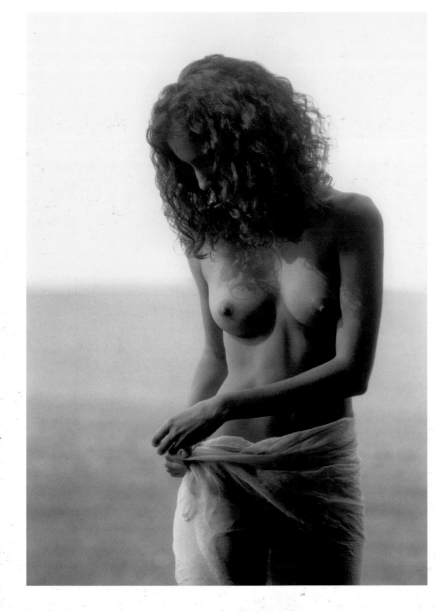

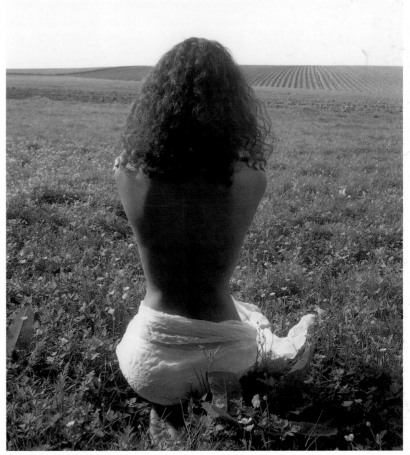

Tricking the eye

Many people have believed that the image on the left was taken on a beach but in fact it was taken in a field (above). I used a long lens with a wide aperture to blur the background, and the beach location is suggested only by the model's sarong and pose.

capturing movement blur

Images where movement is blurred imply a narrative with a beginning and ending; you are capturing a mini-story rather than a precise moment. This kind of image is difficult to control, as your model is moving during the exposure time – you will need to experiment, and even when you think you have worked out how to get exactly what you want you may still be in for surprises. Practise releasing the shutter just before the movement reaches its climax and try using several shutter speeds; 1/10th of a second is a good place from which to start.

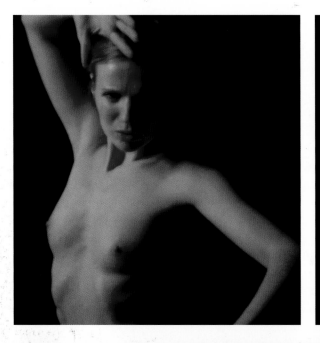

Varying the approach

The degree of movement blur depends on the range of the movement, and the type of lens. The two photographs shown left were taken at different shutter speeds. At a slow shutter speed the image may also show evidence of camera shake, which may or may not improve the final result.

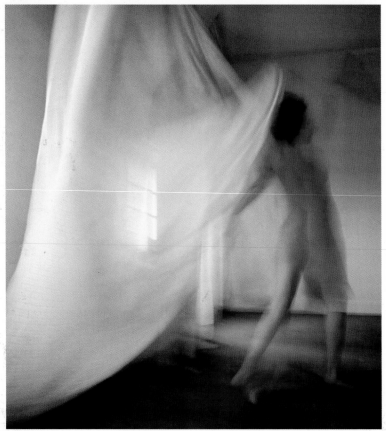

Imaginative blurring

These blurred images of Maite dancing stimulate the imagination, the floating fabric adding to the dreamlike effect. A slow shutter speed allows you to work at ease and it's exciting that you don't know exactly what you have shot. When I am shooting images of movement I tend to position myself at about knee-height as the focus on the lower part of the body accentuates the movement.

freezing movement

In images where the movement is frozen, time seems to be standing still. It is the kind of treatment often used in sports photography, where the viewer can analyze every aspect of the movement. Unlike blurred movement, this kind of image shows you the model exactly at the moment you opened your shutter, with no ambiguity. You will need to practise releasing the shutter at the right moment to catch the movement at its climax, but once you have mastered this you will know exactly what you have shot. Freezing movement requires a short shutter speed (about 1/250th of a second or faster in the case of a dancer), a fast film or digital ISO, and a wide lens aperture or strong light.

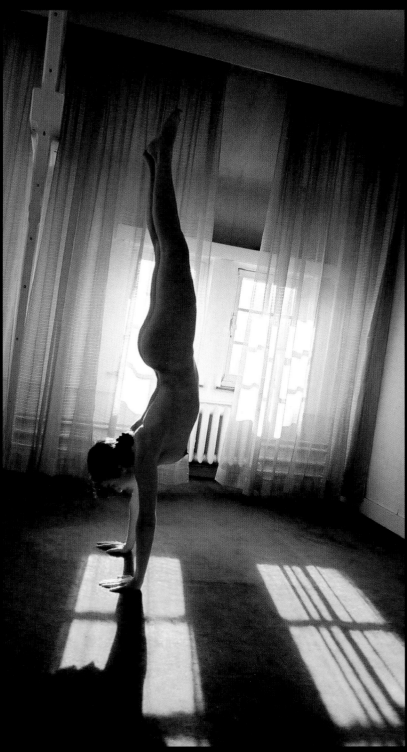

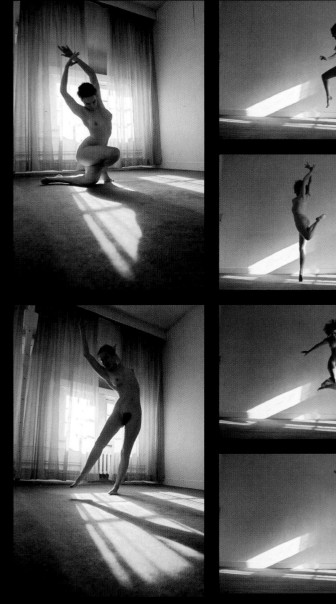

Frozen moments

These clean, clear, and joyful images show a model who knows how to move. With this type of image I tend to position the model in the middle of the picture, because central focusing is easier when you need to react quickly and don't have time to reframe. An alternative is to define a spot where your model will reach the moment of the movement that you want to photograph.

moving the camera

When I am photographing moving subjects, I like to be able to react instantly and change my composition to suit the model's actions. Using a tripod in this situation isn't practical, but this means that it's difficult to get a sharp picture. One of the best ways to deal with this is to follow the direction of the model's movements with your camera, deliberately blurring the background. By moving the camera in different directions it is also possible to create a range of special effects, which will vary according to the speed of both the shutter and the camera movement. Keep in mind that an effect should only be used to enhance the overall feel of the picture, otherwise it will simply be a gimmick.

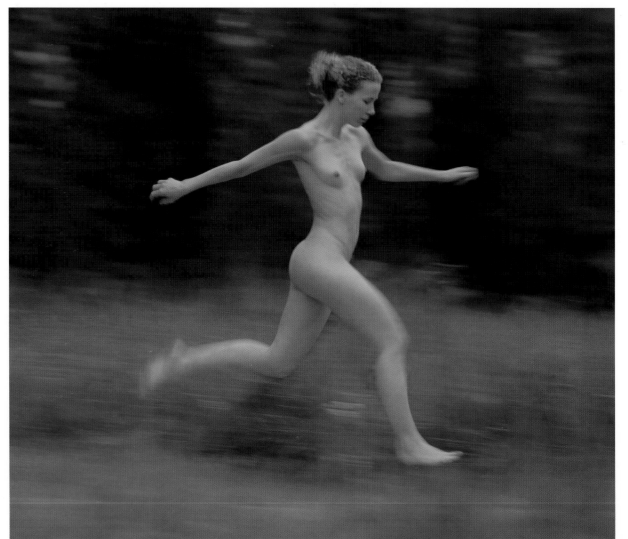

Movement across the picture
Following your model with your camera creates a dynamic look which, combined with the use of a long lens, gives the atmosphere of sports photography. Any part of the model's body moving at the same speed as the camera will be sharp, while the rest will be unsharp to a greater or lesser degree, depending on the speed of movement.

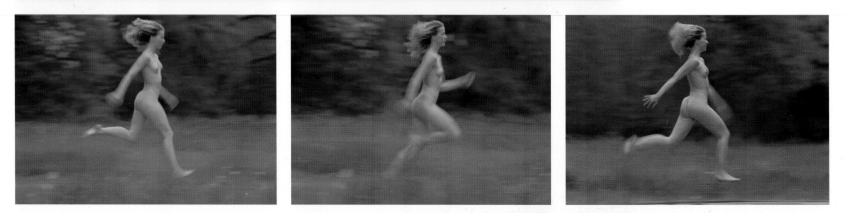

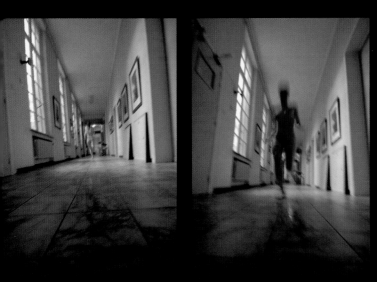

Movement through the picture

You can either run with or behind the model, or, as above, choose a specific spot and ask the model to run towards or away from you. In the image below, the model came from behind, jumped over me and carried on down the corridor. To exaggerate her energetic movements, I moved the camera quickly and sharply, to create a dramatic, lively blur.

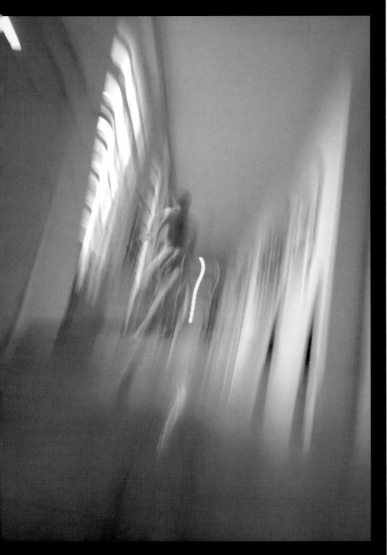

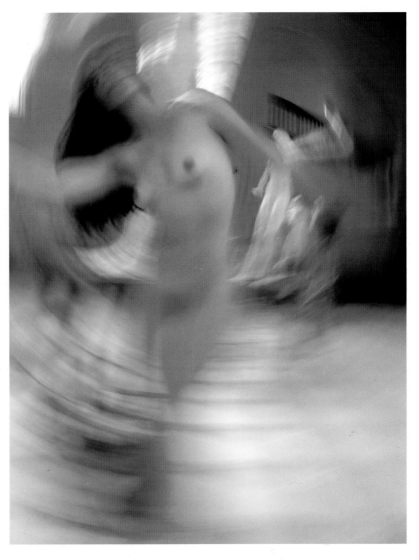

Turning your camera

Using a long exposure time, you can move the camera in specific ways to create a variety of special effects. Here, I turned the camera around, which gives a circular blurring with a central point of sharper focus that attracts the viewer's attention. The ripple-like effect works well with the model's dynamic pose – it looks as though she is defining the direction of the motion blur with her body.

Using longer exposures

These images were taken with a wide-angle lens and a slow shutter speed. As with the outdoor images opposite, I followed the model with my camera, but the increased blurring and the use of a shorter lens has reduced the appearance of sports photography and made the effect more impressionistic.

sharpness & blur gallery

These images have little classic sharpness, but I hope none of them would be rejected on the grounds that they are "out of focus". Each has been deliberately blurred to a greater or lesser extent in order to create or enhance a particular mood that I felt appropriate at the time. Whether they impart dynamism, mystery, fantasy, or romance to an image – eac effect plays an intrinsic role in the overall impact. As with mos techniques in this book, these are easy, and there is no nee to buy filters or expensive lenses, nor to become an image manipulation expert – they are all in-camera effects.

Natalie, Palo Alto, 2003

Using maximum aperture on my old 35mm f/1.4 lens enabled me to get very sharp focus on Natalie's nipple. She is lying with her face tilted to the light, enjoying the sensual feel of the water and sunshine on her skin. The way that the image drifts into a soft blur perfectly matches the dreamy mood.

T., Arles, 2006

The model's huddled pose is emphasized by the zooming effect, for which a relatively long exposure time is needed – in this case, ½ a second. To me, this image expresses some pain and a search for protection, but others might make their own, perhaps very different, interpretation.

Emmanuelle, Saint Remy de Provence, 2005

This effect of "standing still in motion" was obtained with a long lens and a lon exposure time without a tripod. The picture might tell you about Emmanuelle's insecurity and doubts as to which direction she should take, or perhaps she is simply enjoying the environment?

Daisy and Donna running, Lovenjoel, 2005

Daisy and Donna running, Lovenjoel, 2005

Here I was using a long exposure time and following the models, holding my camera as low as I could – it is hard to look through the viewfinder when you are hurrying, so I have learned to "shoot from the hip". For me, this image shows two giggling girls enjoying life and heading towards a bright future.

Spooky series

I captured these mysterious, supernatural effects by using really long exposures in available light at night without a tripod The image on the left appears to be a double exposure, but in fact it was a single shot achieved by zooming in during a 2-second exposure.

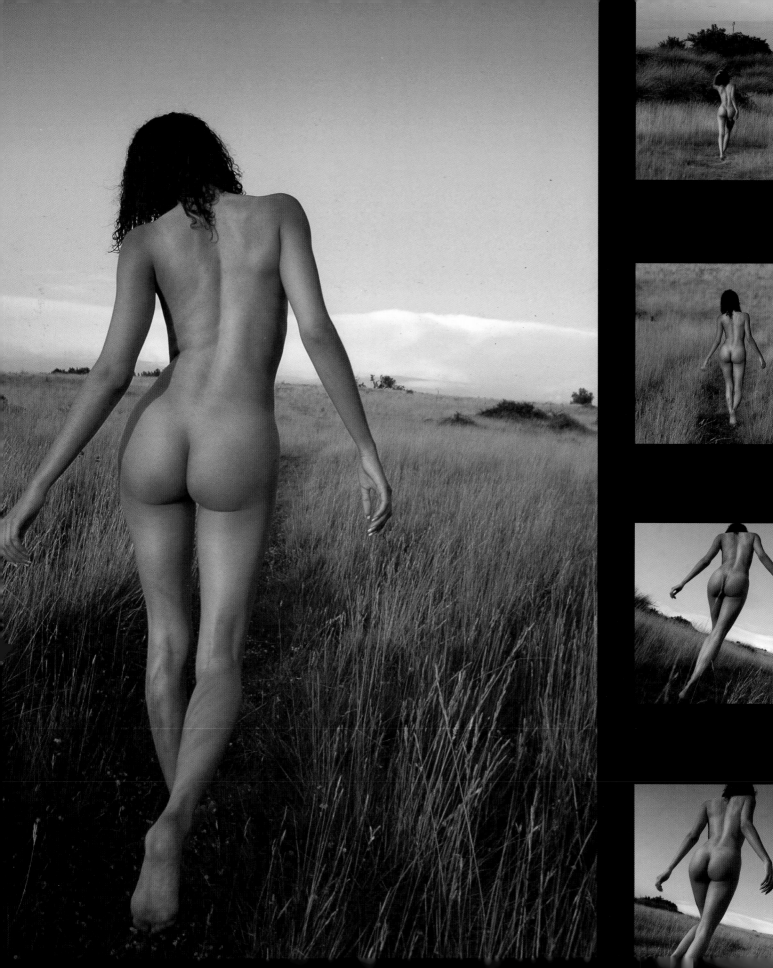

composition & perspective

Your choice of composition and perspective is how you show the viewer your way of seeing the world. While there are basic rules of composition, how you follow them – or, when you are skilled enough, break them – will help you to establish your own recognizable style.

Successfully translating a three-dimensional object, landscape, or person into a two-dimensional image is all about training your eye to recognize elements that might serve to strengthen – or weaken – the overall impact of the image.

The main thing is to explore possibilities – don't simply accept what's in front of you at face value. Don't just look at your model – consider him or her in relation to the background and foreground. Move closer and see how your model becomes more important in the frame and how the relationship between model and environment has changed. Take a few steps to the left or right, and notice how both distance and angle change the

" Don't simply accept what's in front of you at face value. "

perception of the subject. Look at the examples later in this chapter on the differing effects you can achieve from the same spot, depending on whether you kneel down to shoot up to your model, climb higher than your model, or shoot from the same level; at each point you create a different psychological relationship. So you can choose to create a particular emotional effect simply by changing your perspective. The length of lens and the aperture you set also influence the viewer's response, by affecting the apparent distance between photographer (or viewer), model, and setting.

These principles are not difficult to grasp. If you consciously consider why you're choosing a particular composition every time you go to press the shutter, and think about what that choice will add to the visual impact or narrative of the image, it will soon come naturally. It's so satisfying to look at a picture and think "yes, that captures exactly the feel I was aiming for".

basic rules of composition

The perfect composition doesn't exist; a composition works, or doesn't, as a result of a combination of different elements. There are many rules of composition – too many to include all of them here. Nevertheless, a grasp of the basics will take you a long way. The rule of thirds, central placing, diagonals, converging lines, spirals, ovals, triangles, squares, and circles are often used to compose an image; various devices are employed to draw attention to the main focus. The aim is for the viewer's eye to travel around the picture, finding points of interest along the way. Studying compositions that appeal to you in books and at exhibitions will help you to develop your own image language.

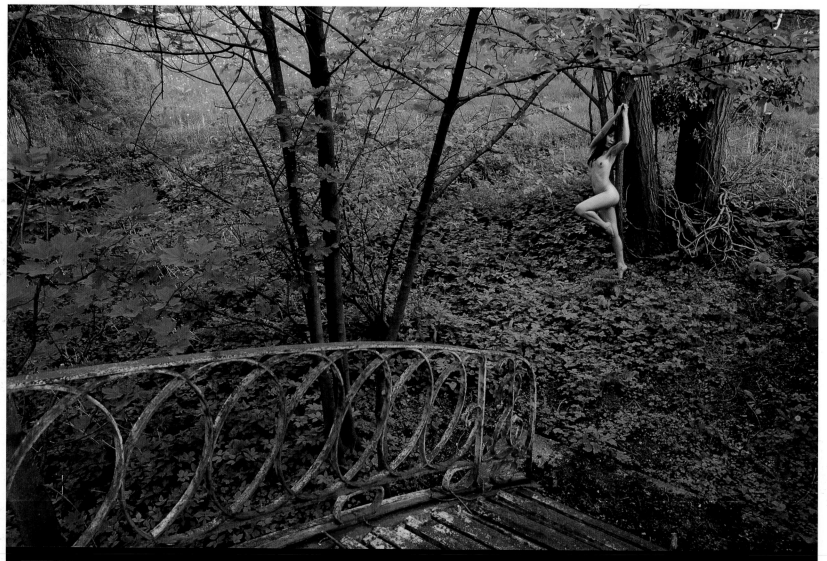

Rule of thirds

The strongest areas of the picture plane in which to place your subject are the four intersections of horizontal and vertical lines dividing the picture into thirds. In Western cultures the eye reads from left to right, so the right-hand thirds are visually stronger than the left. An image can have several compositional elements; in the photograph above there is also a diagonal thrust from top left to bottom right, intersected by the arrow shape of the railing and the model's legs.

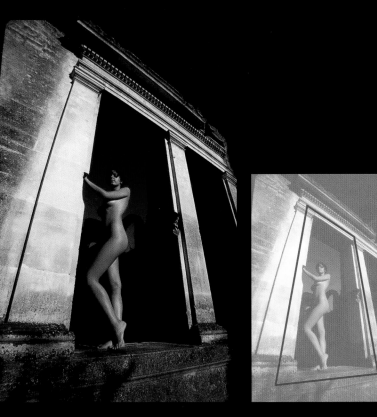

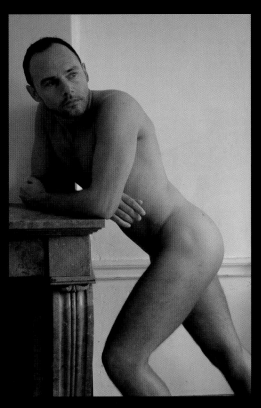

Framing

Placing your model within a frame makes her a stronger focal point.
The apparently unbalanced framing works here because the model is
perfectly vertical and it emphasizes her strength. The lightest part of her
body, beneath her arm, is the exact middle point of the image.

Diagonals

One of the easiest ways to create dynamism in an image is through the use
of diagonal lines. These can be achieved either by tilting the camera or
through the pose. Here, Johan's leaning pose divides the picture into bright
and shadowed areas. Note that his eyes are looking towards the light source.

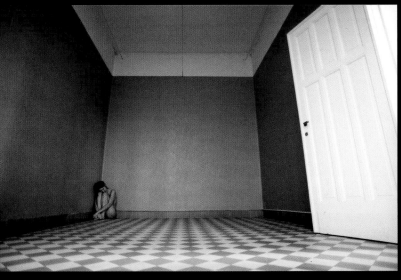

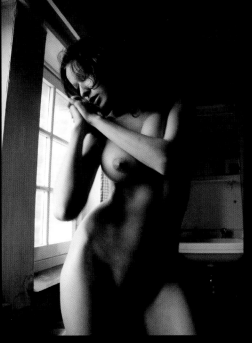

Empty space

Don't be afraid to leave empty
space in an image – it can be a
powerful compositional tool when
used to create an atmosphere or
a story. A small figure in an empty
space can be used to suggest
loneliness or to emphasize how
small the human figure is in

Converging lines

The converging lines of the window frame and bars are repeated and
extended in the model's arm and the direction of her face. A soft, caressing
light falls on her body, while her face is turned more towards the full light.

positioning the model

One of the first things to consider when you are taking a photograph is where in the frame you are going to position your model. Should he or she be small or large, centrally placed or to the side – or even partly out of the frame? Working with a tripod may help you to search for the composition, especially if you want to include particular elements of the background; set up your camera, and then adjust your model's position in the frame. Alternatively, you can move your camera while the model remains in position. In this case a tripod can be a disadvantage, as it slows down proceedings and potentially disrupts communication between you and the model. I avoid using a tripod as much as I can, as I prefer to be able to move around quickly and easily, and keep the model's attention focused on me.

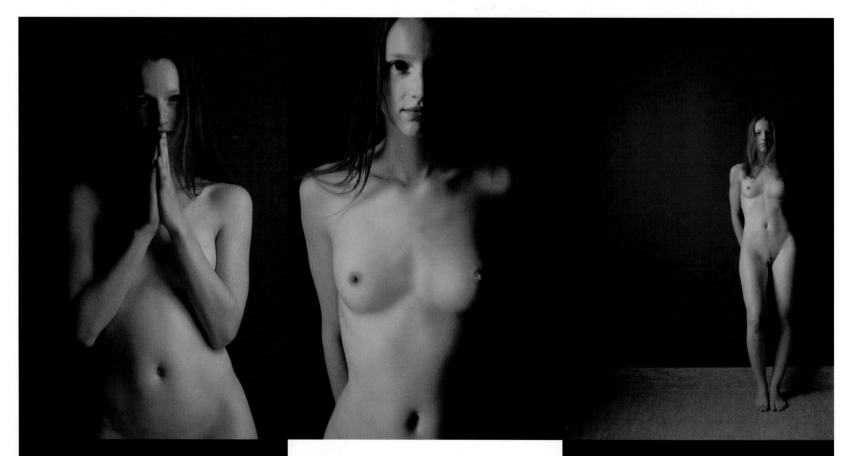

Central framing

Daisy is placed in the middle in a symmetrical position. The background is framing her, but it is not important; the upward composition of her arms attracts attention to her face, making a strong connection with the viewer.

This image has been flipped to make it work better with the adjacent images. When you are hanging a set of photographs, remember to consider them in relation to each other.

Daisy has a very symmetrical face, so few people who know her would notice the change.

Cropped framing

Again, Daisy is placed centrally, but now she is so dominant in the frame that the top of her head is cropped, making her seem very close.

As Daisy now occupies nearly all of the frame her environment is of no importance.

This image is more restless than the one on the left. Her whole body demands the viewer's attention, with a triangle formed by her red lips and nipples and another, inverted, triangle from her nipples to her belly button, emphasized by the shadow slanting down her body.

Asymmetrical framing

Here Daisy is positioned in the right-hand third of the frame, which is visually the strongest part of the image.

Her environment is now visible, but the light falling on her keeps her the main focus of the viewer's attention.

She now appears more detached from the dark green wall, an effect heightened by her pale skin. The subtlety of the colours gives the image the resonance of a classical Flemish or Dutch painting.

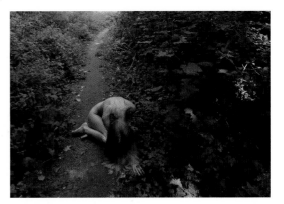
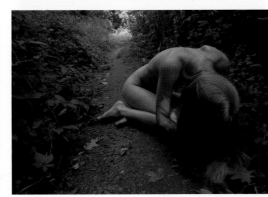

Getting in close

At first glance, it seems that the camera has zoomed in on the model. In fact, I was changing my position in relation to her. At first I shot her from a high angle to emphasize her vulnerable position, but the large image, taken from ground level, is by far the strongest. The wide angle allows the viewer into the scene, and the glow of the sunlight on her arm embodies the intensity of her (presumed) state of mind.

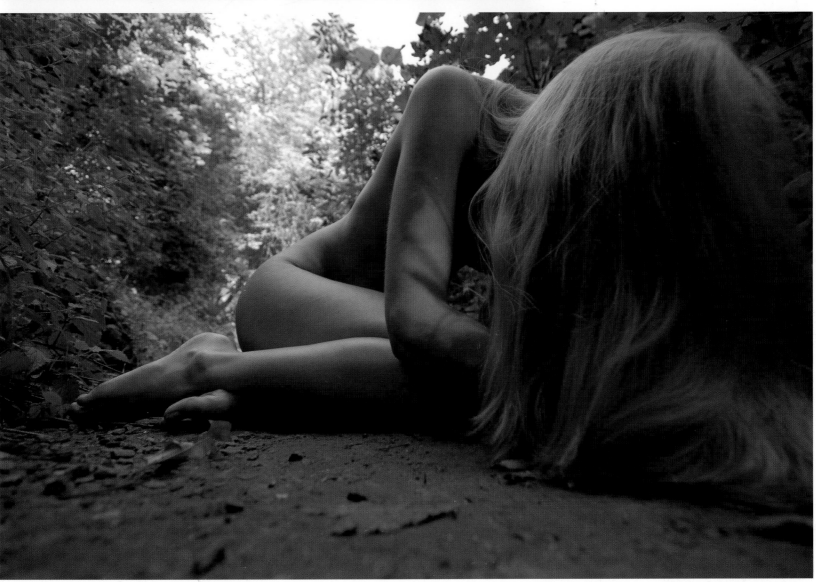

exploring perspective

For me, the perspective from which I am going to shoot my model is one of the most important choices because it has a direct emotional impact on the image. You can look up, look down, or position yourself at the same height as your model. Shooting upwards makes the subject appear strong and confident – as if you are a child looking up to an adult world. Shooting from above makes the subject seem smaller, weaker, and more vulnerable. When you shoot from an equal height you create intimacy and understanding; you are on the same level as your model. Once you understand the implication of perspective you can use it consciously to enhance the atmosphere of your images.

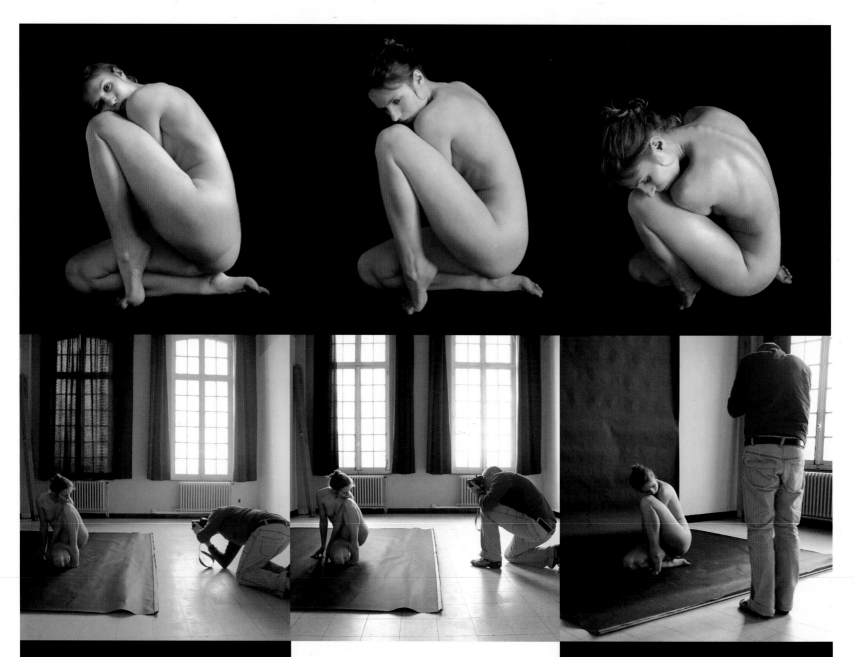

Shooting from below
Even in this contained pose, shooting upwards makes Annelies look unreachable behind the "fence" of her legs. To get lower I would place my camera on the ground, or Annelies on a box.

Shooting on the level
By positioning myself so that I am face to face with Annelies I create a connection with her, even though she is not looking into the camera.

Shooting from above
The closed nature of the pose is enhanced by an overhead view. Notice how the foot and leg lose prominence through the three images, while the head and shoulders become more dominant.

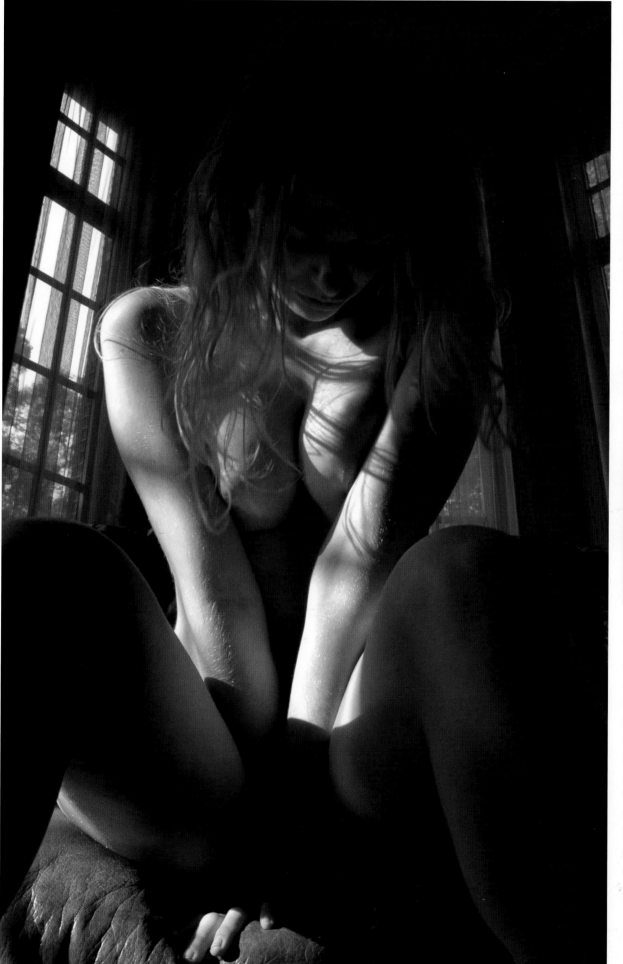

Relative viewpoints

The two images above show a confident woman – her strong character captured by shooting upwards towards her face and upper body. In the large image on the left, although I was shooting up towards her face in absolute terms, the perspective is different in relative terms – her head is bent down so much that the effect is the same as if I was looking into her face from above. So, although taken from the same position as the other two, in this image Annelies appears vulnerable.

abstract close-ups

I love working in close-up – it's so easy to create really interesting images. It's also an ideal way to start photographing nudes as you do not need to worry so much about directing your model. Once he or she is in a comfortable position you can take your time experimenting with lighting, perspective, and framing. It's a good idea to have your model on a seat or bed with wheels so that you can turn it around easily, and if you are using artificial lights it helps if these are movable too. When light follows the main direction of the pose it has a "caressing" light and shadow effect. Move around your model, changing your relation to the direction of light to make the shadows more or less pronounced.

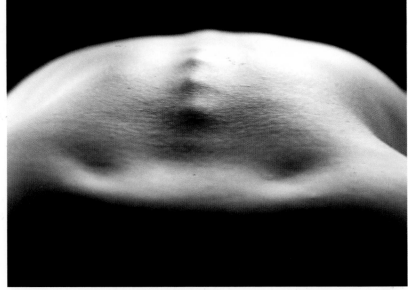

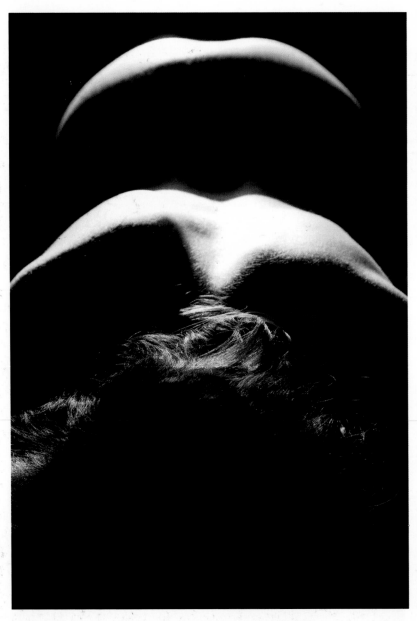

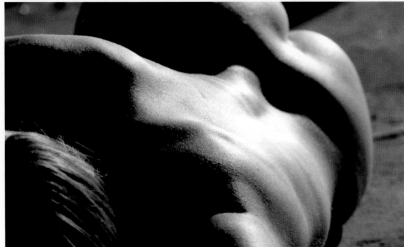

The body as a landscape

These images were realized using a telephoto zoom lens. Notice how the backlighting gives a very graphic effect, dramatizing the forms of the model. I tend to measure the light from the lightest part of the body to create deep, dark shadows and may use a directed spotlight when I want hard light.

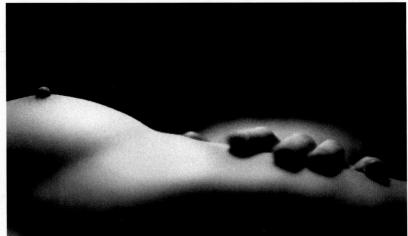

Soft-focus details

Here, the light source is a large, bowl-shaped lamp
placed behind the model. While she relaxed I moved
around her trying out different angles and exposures.
The large image is deliberately out of focus to create
a very soft, abstract effect. I chose a point of focus
close to me – I find that focusing behind the model
is less effective. Large light sources, such as a
softbox or a cloudy sky through a window, provide the
subtle light that works so well for this type of picture.

the effects of distortion

Distortion in an image has a great impact on the viewer – especially when the subject is the human body. Photographic distortion alters the original shape of an image and its effects are surprising, sometimes shocking, views of what is usually so familiar and predictable. Distortion is usually considered undesirable, but it can be used in very effective ways; for example, to create intriguing bodyscapes, or to exaggerate a pose. A wide-angle lens is the ideal tool for creating distortion; the elements closest to the lens will automatically appear enlarged and the subject will be stretched towards the edges of the frame. You can also create interesting effects simply by experimenting with unusual viewpoints.

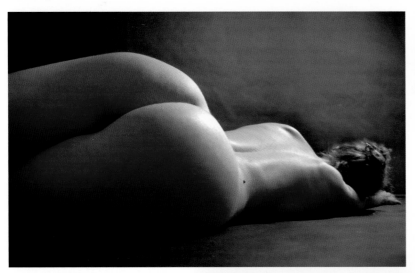

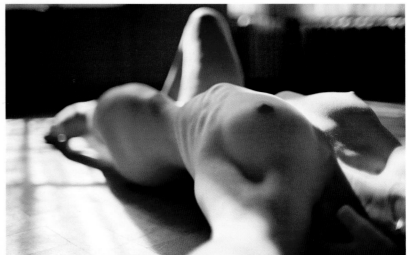

Unusual aspects

Here, a low and close-up viewpoint has the effect of exaggerating different parts of the model's body. By positioning myself so that one element became the foreground of each image, she takes on a strangely unreal quality. It doesn't matter if an element is so close that the lens is unable to focus sharply – this is exactly what happens with the human eye, and only adds to the overall effect.

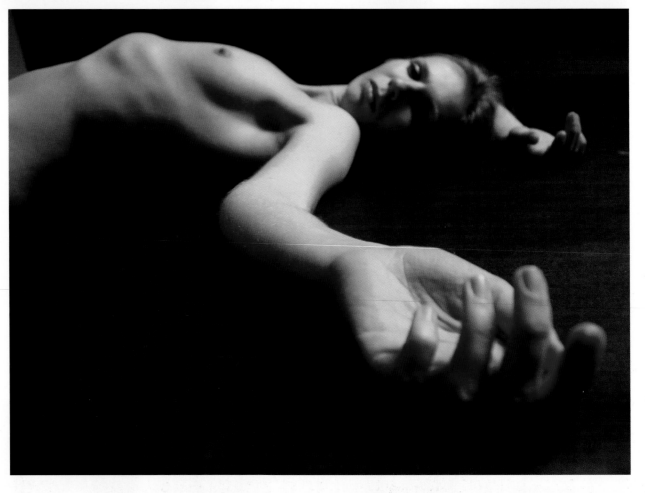

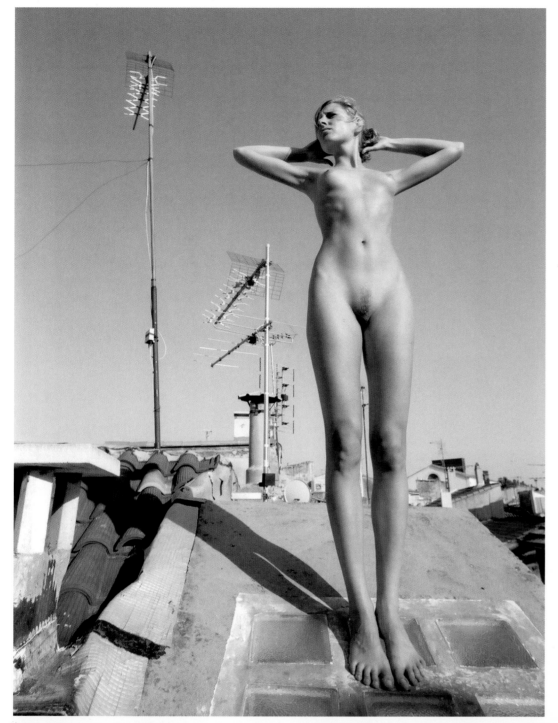

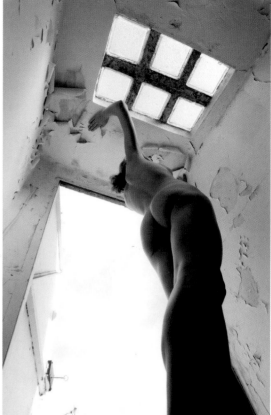

Elongating the body

For these images I got down very low with my wide-angle lens in order to elongate the model's legs. This technique is sometimes used – in a more subtle way – by fashion photographers, to make their models look taller. Distortion can also be used to create graphic abstraction, to emphasize unusual viewpoints, and to focus on interesting connections between elements within the image.

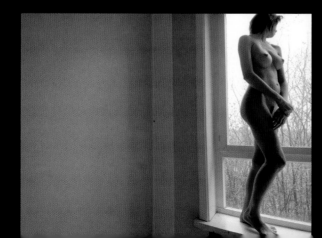

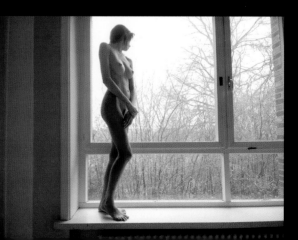

The widening effect

Some distortion effects created by wide-angle lenses are best avoided altogether. Because this kind of lens "pulls" the subject to the edges of the image, it can widen as well as elongate the body. In the image on the left the model is positioned to one side, and so has been pulled outwards to that side. To avoid the worst of this effect, place your model more centrally in the frame, as I did in the image on the right.

composition & perspective gallery

This whole book is a gallery of compositions – just look at the images in the history section and the work of our international photographers, even the page layouts: it's all about composition. Of course there's no such thing as the perfect composition. Following the rule of thirds will bring harmony to an image, but may be too classical for some; a centrally placed model may draw the eye, or obstruct the connection with the environment. The best way to understand what makes a successful composition is to study pictures and find out what works for you.

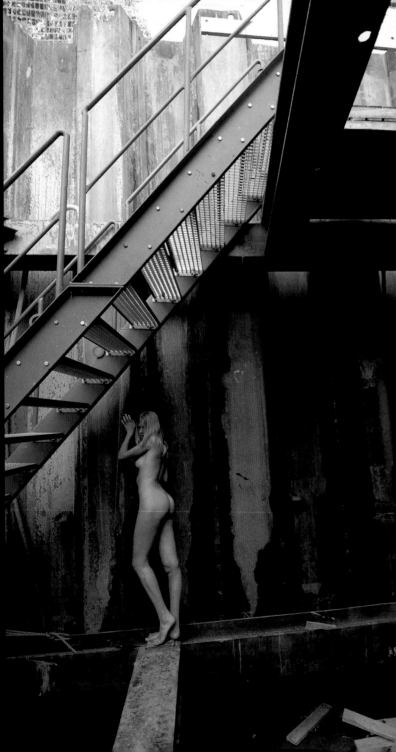

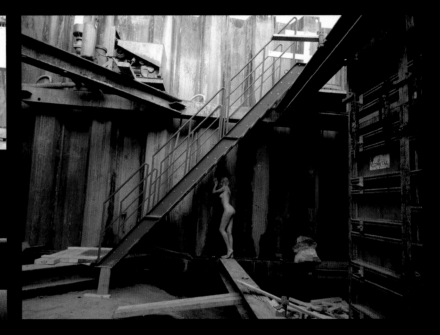

Bold bisecting lines

The only difference between these three images is the framing, but each has a different feel. The top image makes full use of all the linear elements, which lead the eye to the model in the centre, while the one below is divided diagonally, with the model seeming to hide in the shadows. The image on the left has a more threatening atmosphere, with the overhead girders pressing in from the right.

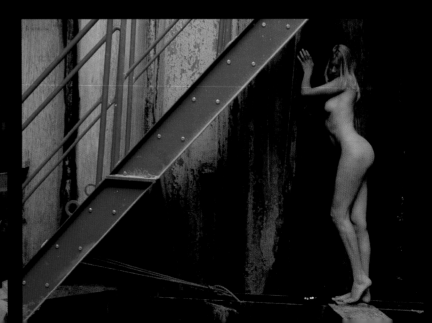

Abstract effects

In this image the extreme distortion caused by using a wide-angle lens combined with a close-up view renders the body almost unrecognizable – at first glance the viewer is confused; what am I looking at here? The graphic abstraction is enhanced by the play of light and shadow on the model's back.

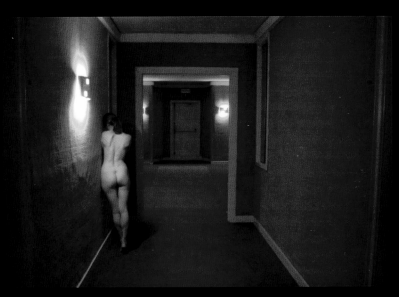

Interrupted symmetry

An almost perfectly symmetrical composition is broken up by the position of the model to one side. The viewer's eye stops at the model, then proceeds down the corridor to the door at the end. Notice the banding effect in the glow of the wall light: this effect is caused by overexposure with early digital cameras.

Tilting the camera

Dynamic, diagonal lines in an image don't have to be created with the pose or other elements in the scene. The easiest way to create them is simply to tilt the camera. Tilting to the left gives a different effect to tilting to the right – try it for yourself.

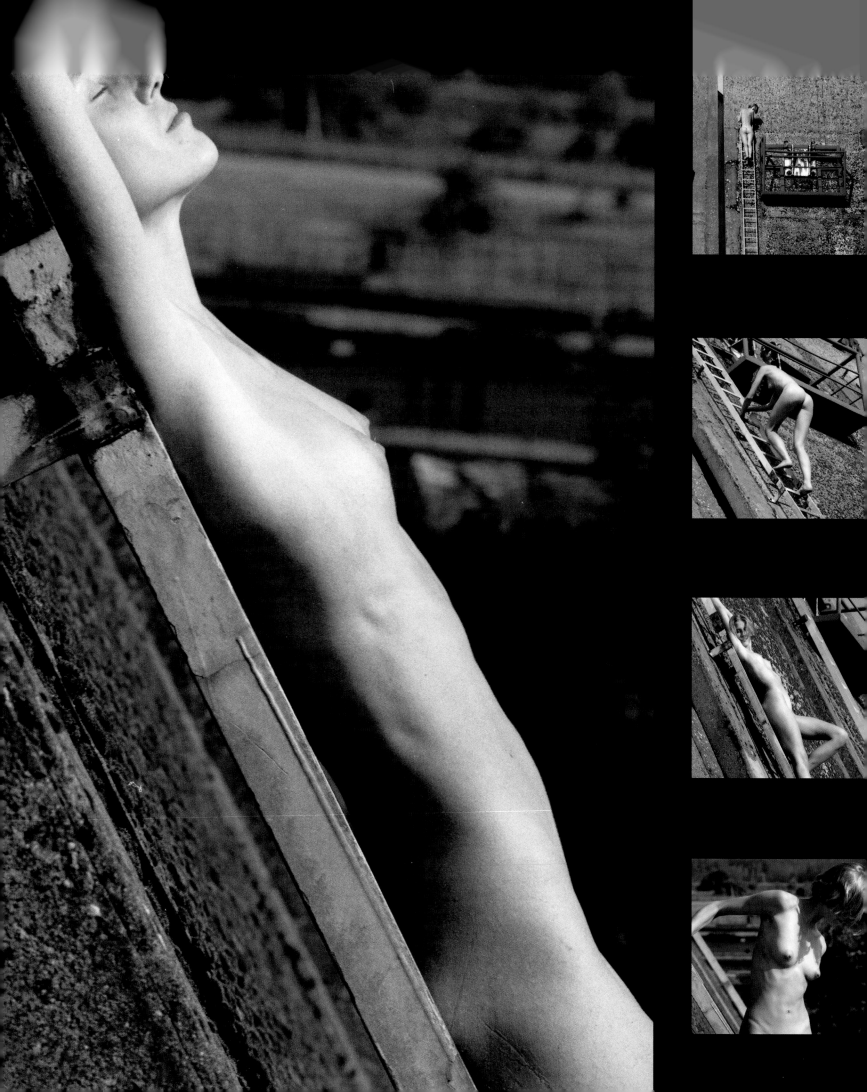

locations

Finding a location is easy; every place is a location, and keeping an open mind will allow you to explore your creativity. Imagine your favourite model against the rough, weathered wall of an old barn, lying in soft, long grass, or in sophisticated mode in an elegant hotel – each location will tell a very different story to the viewer. Of course, stunning white beaches, deserts, mountains, and castles have an immediate appeal, but don't be deterred by a lack of them, for a small room with a window is enough to create pleasing images – or even just a door, stairs, or a seat. You can always find things that are not beautiful, but look instead for what is beautiful, even if it's only a tiny part of a place.

Everywhere you go, be alert to interesting possibilities for the future and if you spot a likely location make notes or take a photograph. Research practicalities such as ease of access and whether you might need permission, a ladder, additional lighting, or some form of shelter for

privacy. A library of locations will prove invaluable when you are keen to explore an idea or are commissioned to carry out a shoot.

As a rule, the more enclosed a location is, the better: your model will feel more comfortable, especially if he or she is an amateur. It's a good idea to make a few visits in advance, at different times of the day, to find out how many passers-by there might be; try to go on sunny days so that you can also see the angle of light. If this isn't possible, take a compass so that you can judge whether, for example, a late afternoon shoot will give you the backlighting you want in a landscape.

Don't forget that the permission to take photographs is not the same as permission to use them. If you are shooting on private land or premises, don't publish the images unless you have obtained written permission to do so – and be aware that including paintings, statues, and other forms of art in your image may raise issues of copyright and royalties.

> " Look for what is beautiful, even if it's only a tiny part of a place. "

making the most of a location

As with most things in life, all locations have their advantages and disadvantages, but I prefer to think in terms of interesting challenges and possibilities rather than focusing on limitations and restrictions. When I am investigating a place before a shoot I look at its east-west orientation so I can work out where the sun will be during the day and try to find out whether there is likely to be anyone about. I look at every location in as many different ways as possible – my eyes are like little radars, always searching for photogenic corners – and I try to get a feel of the place to work out what kind of atmosphere I can create.

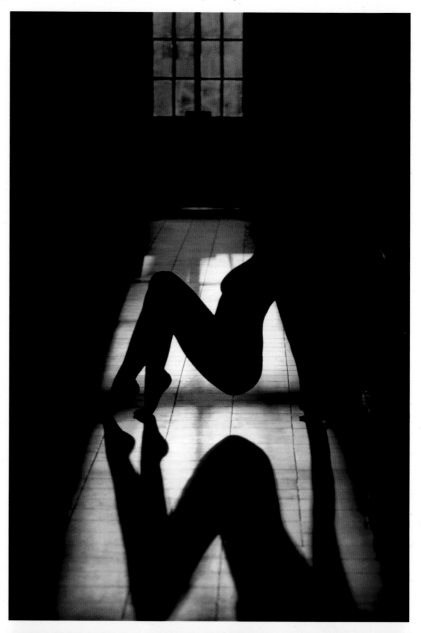

Exploring every angle
I like to explore a location photographically and will wander around for a while, changing my position and my lens, from wide angle, to standard, to telephoto. Once I have found the right spot I give it the time and energy it deserves.

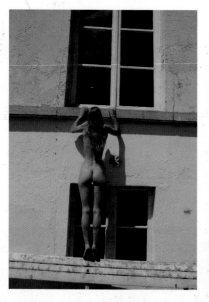

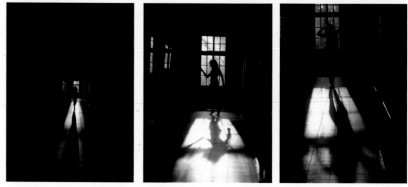

Working in changing light
Sometimes, as a photographer, you have to seize the moment or you'll miss it. These images, shot around sunset, were captured in just a few minutes. We had just finished the shoot when I noticed the light in this corridor, so Klara quickly undressed again and we were off! Moments later the light was gone.

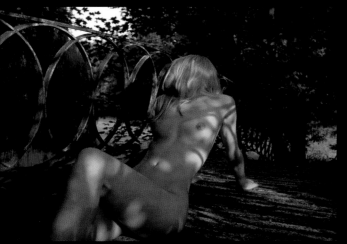

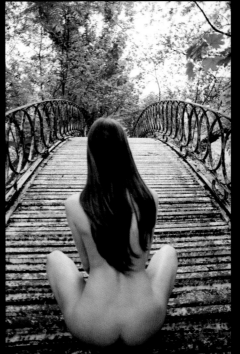

Looking for graphic compositions

Some locations are just so rewarding to work with that you have to keep returning. This little bridge with its lovely shape and lines provides many opportunities for great compositions, from above or below, focusing on details, or taking in the full sweep of its form.

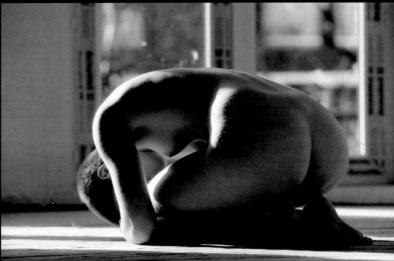

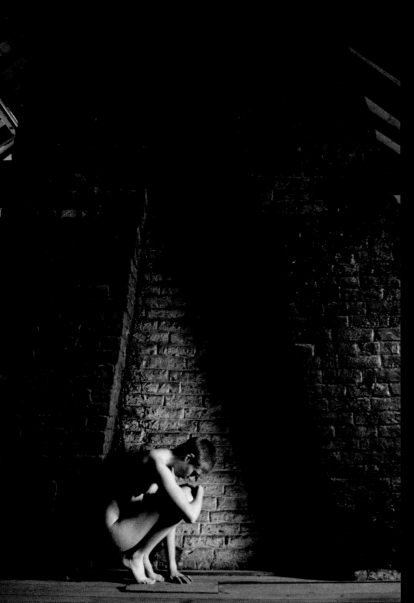

Working out a location

It really pays to spend some time taking in every aspect of your location before you start your shoot. Very often the most immediately obvious area to work in will turn out not to be the most photogenic, while other areas that at first seemed unpromising can be transformed by a change in the light. Look out too for any interesting architectural features – they don't necessarily need to be beautiful to offer possibilities.

stairs and doorways

Almost every building has them and they provide endless scope for photographic exploration. Stairs and doorways are gateways between two places, and as such are rich sources for creating intriguing visual stories. They suggest a past and a future – a person on a stairway or passing through a door is leaving something behind and moving on.

Of course, they are very useful as purely compositional devices too. A doorway can be used to frame your model, or he or she might use the door as a prop, to hide behind, or enter through. Stairs by their very nature are wonderful for creating compositions with strong diagonals and leading lines, which automatically bring dynamism to an image.

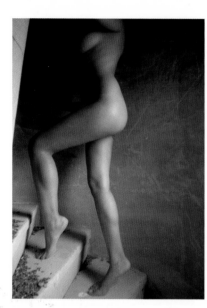
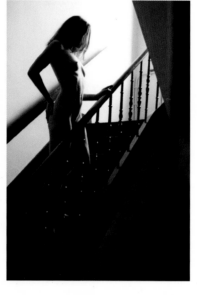
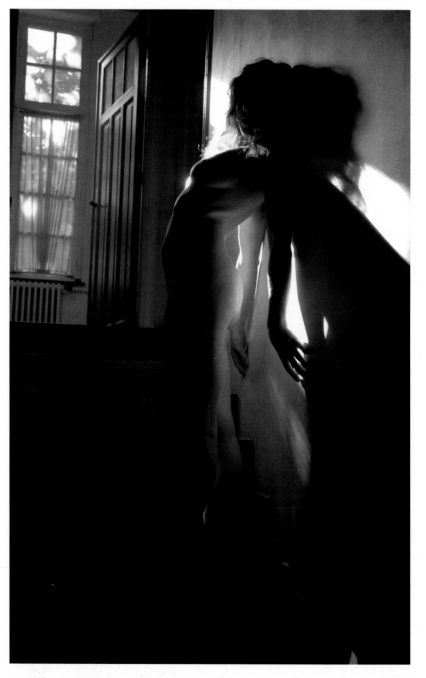

Working on stairs

Stairs can be tricky because you may have to manage differences in level between you and your model, and space is often cramped. I might use a wide-angle lens to overcome the problem, in which case I will shoot upwards to avoid the wide-angle distortion shortening the model's legs. Here are just a few examples of the many different moods you can create using stairs as a location.

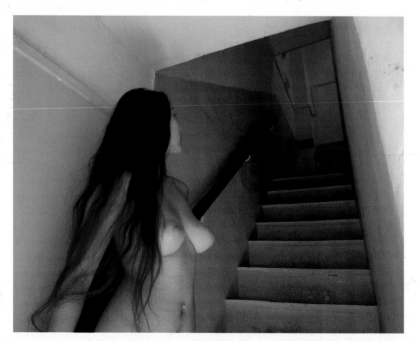

Light and shadow

The spectacular contrast of light and shadow and the combination of elements make this a very dramatic image. The dark, sinister stairs lead to a door that opens onto a brightly lit window, with the model caught between the two environments.

Contrasting styles

These two images demonstrate the great versatility of doors as a component in a scene. The image on the right is light, bright, and fun, the model playful and teasing. In contrast, the image on the far right feels moody and mysterious, with the model striding purposefully through one doorway towards another. To enhance the feeling of tension, I tilted the camera slightly and allowed the model to disappear from the top of the frame.

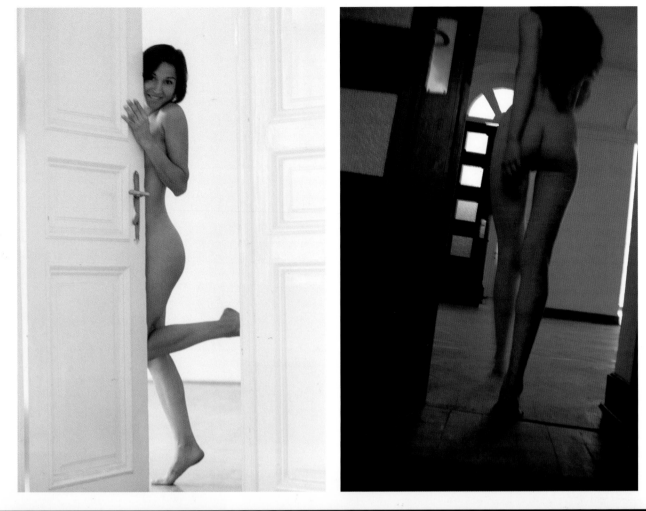

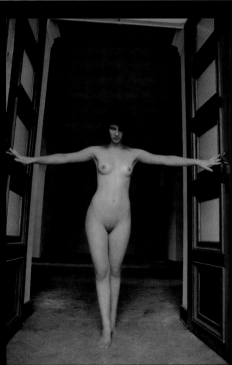

Playing with doors

Doors and doorways are a great setting for a mini story. Here the model uses them to seduce, confront, confuse, and tease the viewer. By changing your viewpoint and your lens, and combining close-ups with full-length shots, you'll have a rich variety of images in a very short time.

connecting with a location

Why bother to photograph a model on location if the place has no context in the image? In Belgium we have an expression "looking as a cow to a train", which perfectly describes the meaningless, disengaged expression and body language that you sometimes see when someone stands in front of a point of interest for a photograph.

A successful connection between subject and environment creates a stronger impact on the viewer, but how do you make that link? You might do it by visually repeating forms or by juxtaposing elements to create tension or contrast. The intensity and direction of light and your choice of lens and viewpoint are also key, so make them support each other.

Repeating shapes

The easiest way to make a connection with a setting is to repeat shapes that you find in the environment, or look for elements in the environment that mirror the body's forms. If you ever wondered about the origins of the heart shape, just look at the image below. In the image on the right, the container envelopes and repeats the roundness of the model's bottom, which is emphasized by her pose.

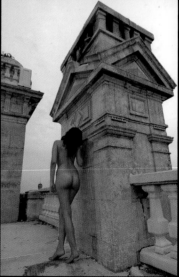

Familiarity

Once your model is comfortable at a location, you should encourage him or her to try to get a sense of the place. Direct your model to touch and feel, and to look into the scene. If your model appears to be familiar with the location you will gain a sense of authenticity in the image.

Dominant locations

With really spectacular locations, the photographer has to act as choreographer too, giving the model a defined role in the setting and creating a duet between the model and the environment.

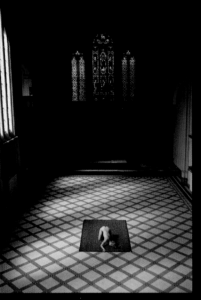

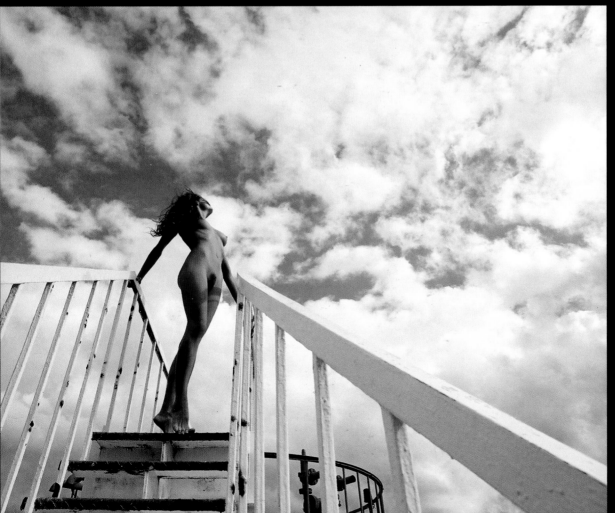

Pose and perspective

The model's pose, and also the photographer's position, contribute to the feeling of connection with a location. In the image on the left I am shooting from below as the model stretches up and looks upwards and outwards into the huge sky. In the image above, the girl gazing out across the water is positioned to the side of the frame. This emphasizes the expanse of water and also allows us to share the view with her.

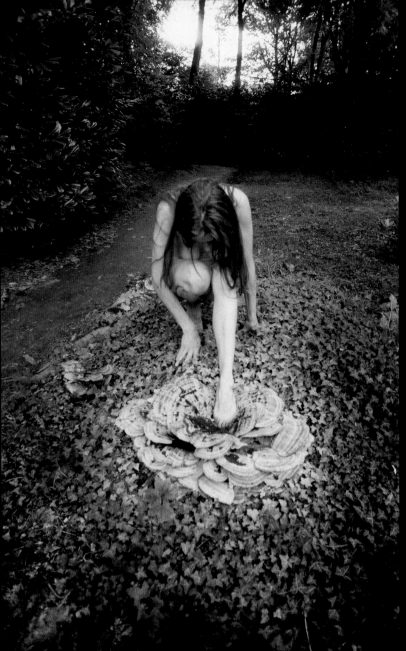

nudes and nature

What could be more inspiring than photographing outdoors, surrounded by the beauty of nature? It's one of my favourite ways of working – but there are plenty of challenges involved. It's completely different from working inside, not least because you are frequently at the mercy of the weather, so being well prepared is essential. In certain environments there will also be insects, dirt, and untamed vegetation to contend with – so it won't always be a comfortable experience for your model! It's important to remember that simply putting your model into a natural setting is not enough, you have to create a relationship between them.

Making a link

I often try to use the shapes found in nature to create a link between the model and the environment. In the image on the left I framed the shot so that the oval of light between the trees mirrored the shape of the plant. The connection is made differently in the image above, with the pose following the curved lines of path and plant.

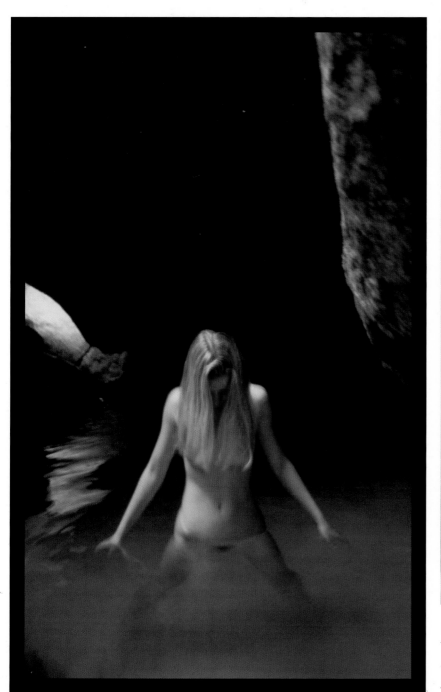

Natural props

The most authentic props are those that are directly related to the subject or the environment. In both these shots, nature herself clothes the model. Above, a fallen leaf is the perfect shape to create a natural bikini thong, while below, the feathery ears of corn make a wonderful grass skirt.

Water effects

For this shoot I had hoped that rays of sunshine would pour in between the rocks, turning the water turquoise. But cloudy skies thwarted that ambition, so I worked with the contrast of the dark rocks and the pale, milky water instead. Notice how the water distorts the proportions of the body – in the image on the right the model's legs are shortened unattractively, so it's important to adjust the pose.

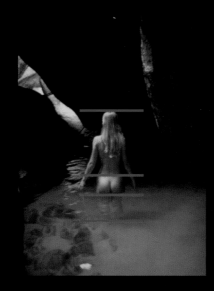

locations gallery

I'm convinced that anywhere has potential as a location, and I do shoot just about everywhere. Of course, I have favourite places, but I'm always on the lookout for new opportunities. As a general rule, the more dramatic the location, the stronger its impact in the image, but wherever you are, it's important that the model and the setting don't fight for attention. It's quite a subtle thing – there's a fine line between the model seeming completely detached from a location, and overacting with it. I always start with the idea that the model and I really belong in the location – even that we live there. I find this gives my images more authenticity than if I were to just concentrate on the visual impact of the place.

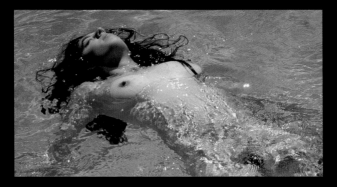

Swimming pools

A pool is a fantastic place for a shoot, with its ever-changing ripples and reflections. The trap that many photographers fall into – myself included – is to just have the model in the water, looking at the camera. Think about why people love being in water. If you are swimming, would you look at the camera? If you are relaxing and enjoying the sensation of the water, would your eyes even be open?

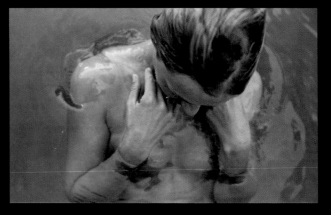

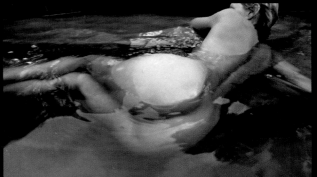

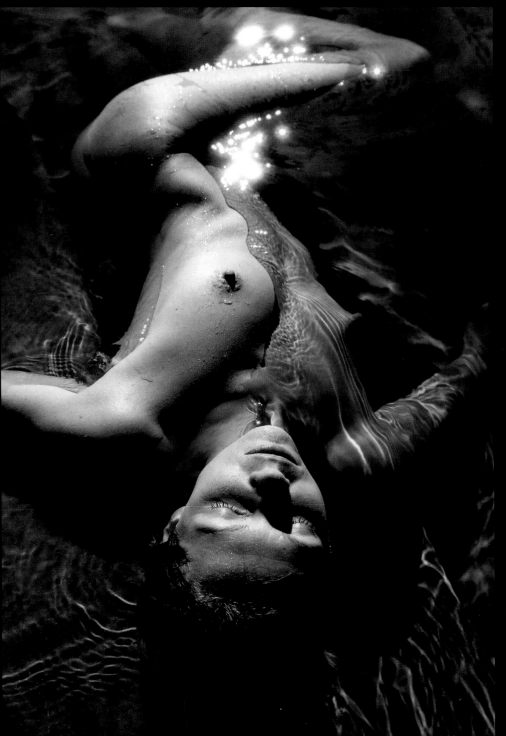

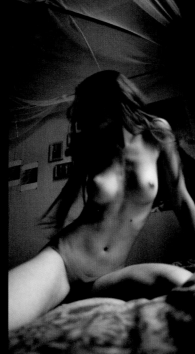

Domestic interiors
Ordinary rooms in unexceptional buildings might seem a rather dull proposition, but every place has its charm, and images taken in this type of setting can have a very honest, sometimes almost poignant, feel.

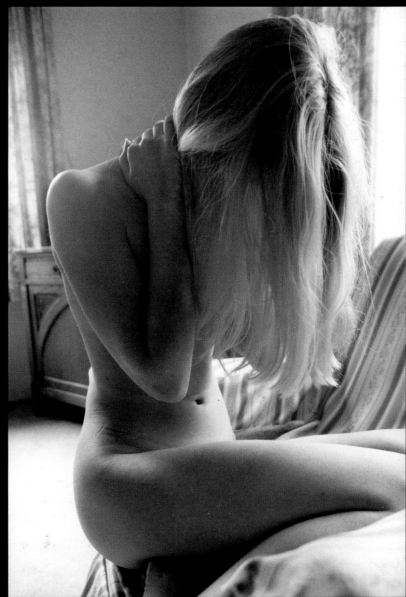

Words and pictures
Locations can offer unexpected opportunities, but recognizing them is one thing, introducing them successfully into an image is another. I love the graphic effect of the graffiti and the lettering in the images above and right. By only showing the model's shadow against the graffiti, she seems to become a part of it. In the "foto" image, I especially liked the way the lettering was reflected in the marble fireplace, so I made sure I included it in the shot.

4

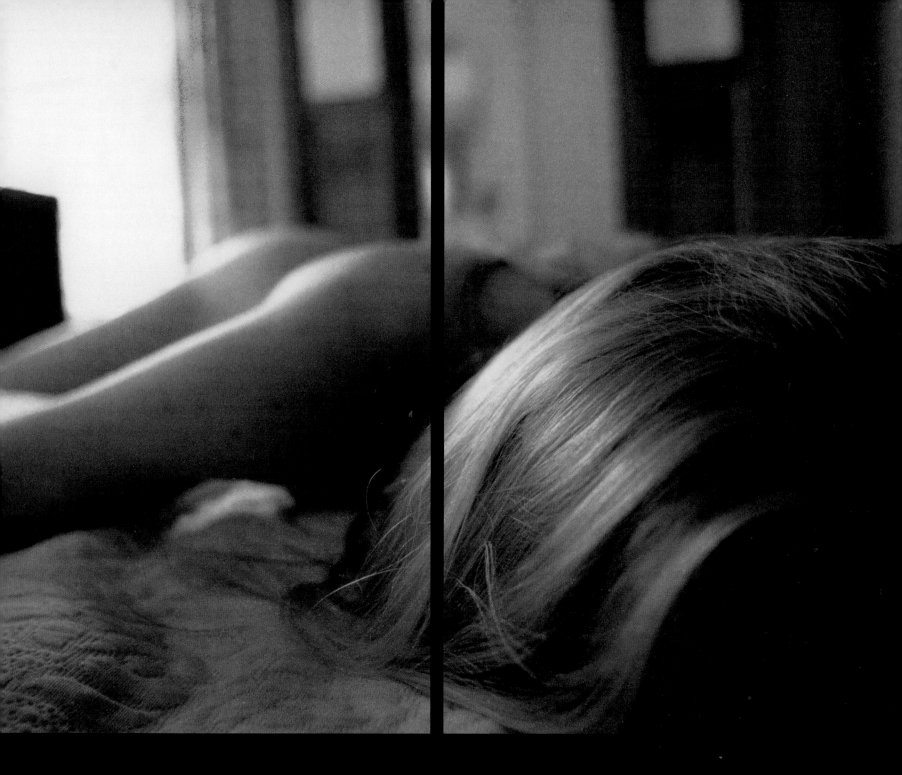

postproduction

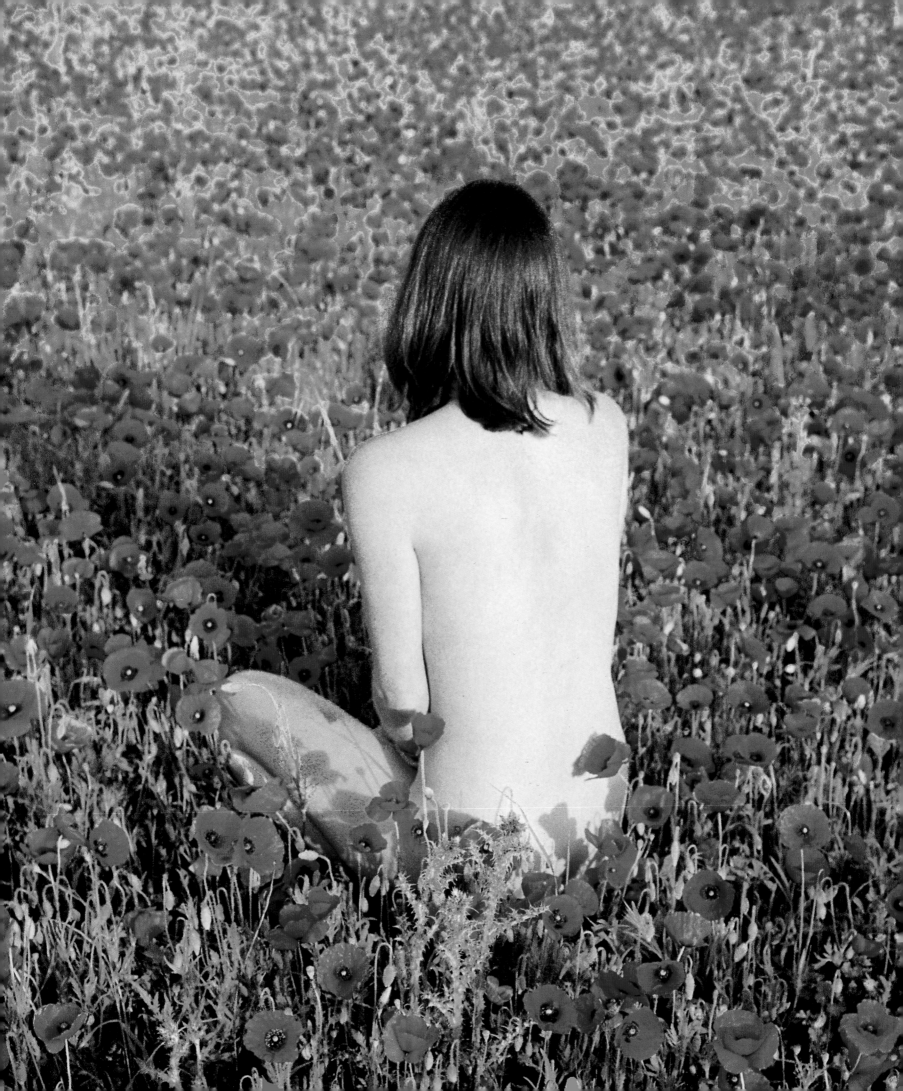

introduction

In the digital era, postproduction has become a key element of the picture-making process for many people. It's not a new thing – even at the dawn of photography, people were experimenting with darkroom and printing techniques, either to find better ways of doing things or for creative, artistic purposes. The difference today is not just the ease with which we can make adjustments to our images, but the astonishing results that can be obtained, even by enthusiastic amateurs. Although I am not a great believer in intrusive postproduction and haven't made much use of it in the images of mine you see in this book, you will find interesting examples of what can be done in the final chapter, the photographers' gallery.

There are so many different ways in which images can be improved, enhanced, adjusted, embellished, and invented, and so many ways of doing it, that this chapter can give only a brief overview of some of the most basic and effective techniques commonly used in nude photography postproduction. Cropping and reframing is a simple way to improve a slightly unsuccessful composition, or to remove unwanted elements from an image, while a complete digital makeover of a model – used extensively in commercial photography – requires a great deal of skill, time, and patience. In between are the fundamentals. To be able to convert a colour picture into a successful black and white one means having the best of both worlds, and is all about understanding how different hues work when converted to a grey scale. And if you're working with colour, it's great to be able to adjust colour balance, and/or intensity if you want or need to – especially over a series of images. Some people feel that tampering with a photograph digitally is somehow "cheating". But most of the techniques at our fingertips today are directly descended from traditional processes, and so surely still have a place in modern photography.

Finally, perhaps the most important thing to consider is how to conserve your images, so that once you have finished the creative process you can keep them for ever.

cropping and reframing

You may want to remove a distraction or some other element at the edge an image, or you may simply wish to get closer to your subject, or reframe. This is where cropping comes in. Experimenting with crops is a good exercise even if you are perfectly happy with the original image, as it helps to build your awareness of composition. The images below show three successful crops from the same original. One way to explore crops is to cut two L shapes from card and lay them on the print to form rectangles of various sizes and formats; on screen, you can use image editing software. Remember that, whether you're using a negative or a digital file, enlarging a small part of a frame will make the image less sharp.

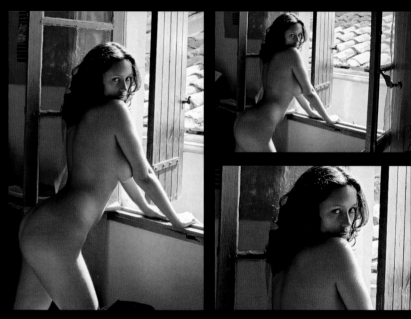

Image quality
Definition is lost if you want the cropped print to be the same size as the original.
1 72 dots per inch (dpi) is suitable only for on-screen viewing.
2 150 dpi is adequate if the picture is not to be viewed from close quarters.
3 200 dpi is sufficiently high resolution for a picture with no close-up detail.
4 300 dpi is the optimum quality for print.

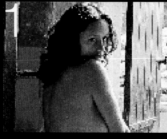
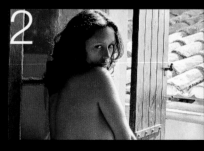
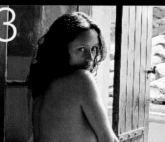
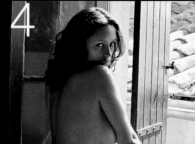

Adjusting tone

The density range of a photograph refers to the range of tone from light to dark. If your images have a low density range and are looking a little thin and flat you can boost the overall contrast both in the darkroom and digitally. Dodging and burning are time-honoured darkroom practices in which you lighten and darken particular areas by exposing them to less or more light. You can do this with a special tool, or with a piece of card. In the digital darkroom, you can simply use the dodge and burn tool in your image editing software, but a more refined way is by using adjustment layers, selecting the area of the image that you want to work on and lightening or darkening it using Levels.

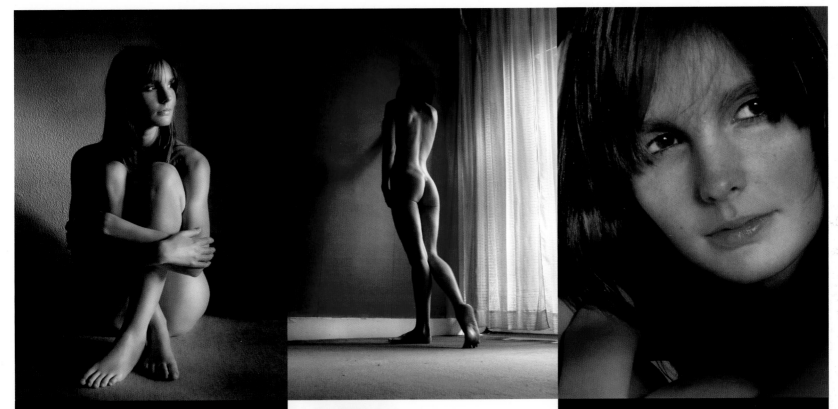

Traditional black and white

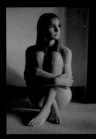

The small image shown left looks rather flat and dull. In the larger one above, the image has been printed at a higher contrast overall to give it more punch. The background around the model has been burnt in to create a vignetting effect that draws the viewer's attention to her face and body. Dodging her eyes has made the whites more brilliant and given them liveliness that animates her face. To dodge or burn in small areas like this, cut masks from black card and glue them to lengths of fine fuse wire that won't leave lighter stripes where they are held above the print.

Digital shadows and highlights

To enhance contrast in the image on the left, I used selective colour to bring out highlights in the curtains and darken shadow areas. Using Curves, I brought out the highlights on the model's body to emphasize its shape. The light falling on her back and bottom is now much more evident and you can clearly see the graceful line of her spine, which in the original image was rather lost in shadow.

Portrait dodging and burning

The low contrast of the smaller image means that the face lacks definition and her eyes are nearly lost in shadow. In the image above, the contrast of the whole image has been boosted and now her face is full of life. Her eyes have been dodged to make them brighter, and the upper left side of the image has been burnt in to emphasize the soft diagonals formed by her eyes and mouth.

converting to black and white

Photographers using black and white film will often employ colour filters to enhance or soften contrasts and to alter the appearance of items in particular colours. A red filter will lighten all the red areas in an image because it absorbs all the colours except red, and it will darken the sky and give dramatic cloud contrasts; a green filter will lighten foliage and alter skin tones. Once in the darkroom, it is only possible to play with the overall contrast in certain areas of the image. On the computer, however, you can mirror the effects of using filters at the time of taking the shot.

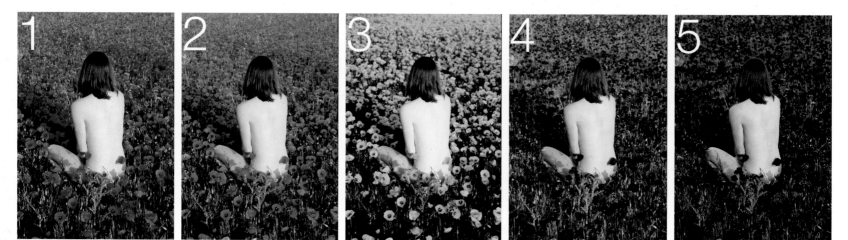

Using channels

The easiest ways to converting a colour picture to black and white are to change it to grayscale or to desaturate it. However, these methods lose a lot of the potential of the picture. With your channel mixer set to monochrome you can change the proportions of red, blue, and green to replicate the effect of lens filters.

1 The original colour image is composed mainly of flesh tones and reds and greens.

2 Here, the image has been changed to grayscale. Desaturating it or using the channel mixer with a value of about +33% on each channel would produce a similar result.

3 The channel mixer has been set to +100% red, 0% green, and 0% blue. The effect is the same as using a red filter: the poppies and the skin tones have become lighter in relation to the green foliage, which is now darker.

4 A setting of −130% red and +160% green and blue has made the reds almost black and the greens lighter.

5 At −40% red, +80% green, and +70% blue, the image is well balanced, with a clear difference between the flowers and the foliage.

Pushing the limits

The effect shown here was produced by using +110% red, +120% green, and −200% blue. The image looks almost like a solarized darkroom print, especially in the outlining of the model's body. The dark shadows underneath her arm have become white because they contain no blue light.

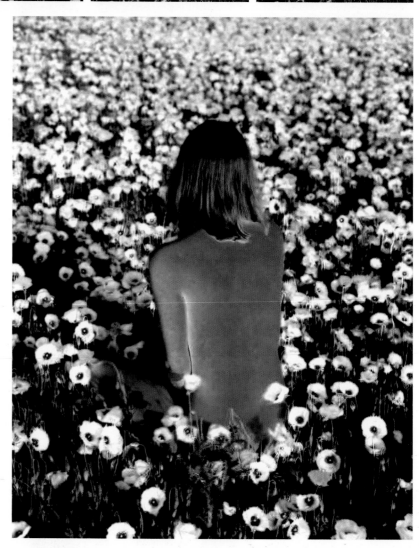

colour adjustments

The look and feel of a picture can be completely changed by adjusting the colours. Enhancing saturation levels gives strong, "zingy" colours, while desaturating them turns them into soft pastels that give a romantic feel; changing or strengthening colour casts allows you to create warm, cool, or neutral images. If you are shooting on film, you can achieve colour casts by using filters on your lens, while image editing software allows you to alter colour wherever you want to in the image. Playing around with colour is fun, but remember that your goal is to enhance the image, not to create effects for the sake of it.

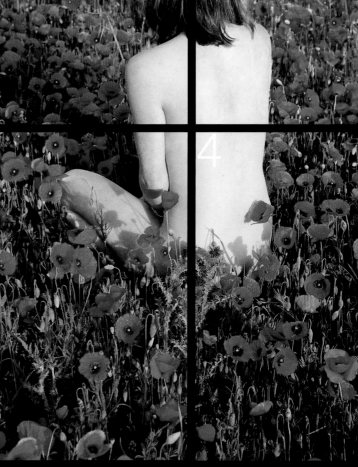

Saturation

In this image the model is seated amid the reds and greens of a poppy field.

1 Undersaturated images create pastel tones that are ideal for soft, nostalgic images.

2 Oversaturated images are visually startling, but here the colour is overwhelming the image and the viewer's attention will soon be lost. Yellow has appeared round the poppies and the model's hair has shifted towards blue.

3 Here, the saturation has been only slightly enhanced from the original and the effect is more comfortable to look at. The colours are more natural and less aggressive.

4 The image has been completely desaturated to black and white.

Selective colour and hue

The selective colour option in your image editing software allows you to individually affect specific colours. From left to right: all the yellow has been removed from the original red tones, turning them magenta; neutral tones have had all cyan removed, producing orange; all the magenta has been taken out, leaving the poppies yellow; the model has been masked and the rest of the image desaturated.

adding backgrounds

One of the advantages of digital technology is that if you lack an interesting location or attractive background for the shoot you can introduce one later on the computer. The setting has a huge impact on a subject, so it must be chosen with care. Even if it's beautiful, it won't enhance the image if it doesn't suit the model's pose or appearance. Here, the orchids emphasize her delicate skin tones and demure expression.

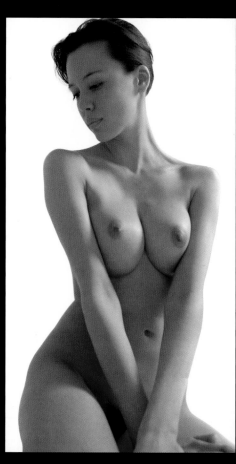

1 Using the magic wand and the lasso tool, I made a selection round the model and converted it into a mask. This removed the model from the background. At the same time I decided to "cut off" her ponytail, to give a nice smooth line down her neck.

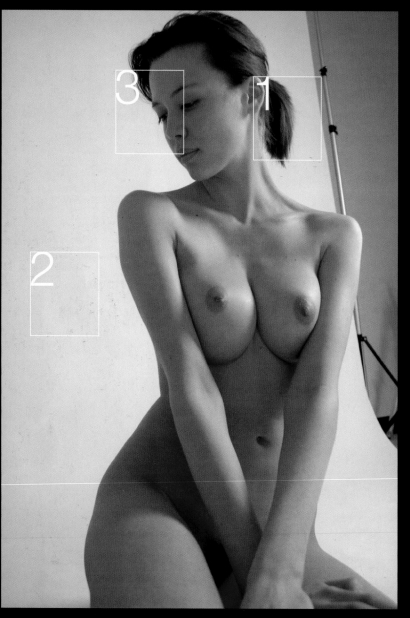

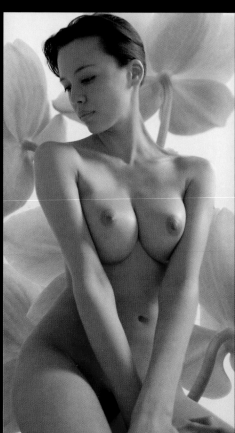

2 I copied a desaturated image of orchids into a new layer and made it invisible. I then selected the model layer and used the magic wand and lasso to select the background. At this stage I refined the background layer, adjusting the colour saturation and blurring it slightly.

Refining the image

I took this shot of Sofie against a plain white background. This made it easier to define the lines of her body clearly. The basic stages were removing her from the background, adding a new background, and making colour adjustments.

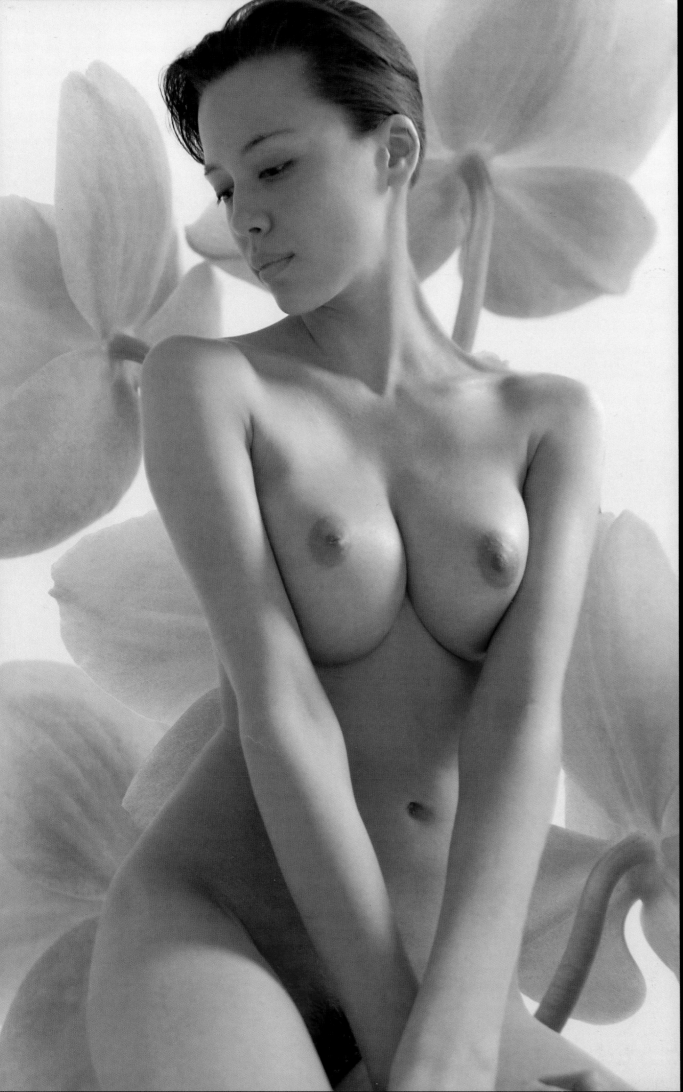

3 Finally, I enhanced Sofie's make-up using low-opacity brushes to keep the natural look. To create a satin glow on the skin, I then used a fill layer with a pastel colour at 10% opacity in luminosity blending mode.

The decisions you make about retouching a photograph are very much a personal choice, but in general it's best to avoid extensive retouching that results in a model who is so perfect that he or she no longer looks real. There are some retouching steps that will invariably make an image look better, but beyond those I try to keep a natural look and only remove real flaws that detract from the image.

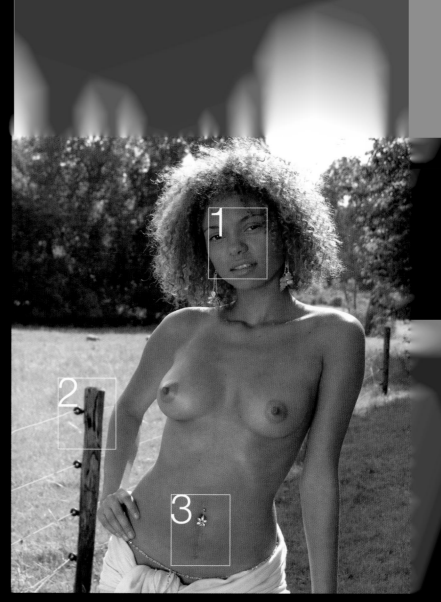

Minor and major adjustments

1 Sandra's left eye was partly closed, so I copied it into a new layer and used the transform tool in warp mode to widen it slightly. I then fitted the new eye over the original, and flattened it with the previous layer. The spot healing tool was used to remove skin blemishes.

I burnt in the shadows and brightened Sandra's hair, to emphasize her face and used the free transform and warp tools to slim her waist slightly. The main tasks were to open her left eye and even out skin tones, and to remove the fence post, belly jewellery, and scar.

2 The fence was distracting, so I removed it using a combination of stamp tool, patch tool, and healing brush. I tend to look for big areas to copy with the patch tool, then try to restore a natural

3 I removed the piercing by using another model's belly button. With a bit of free transform and rotation it fitted over the area. In a new working layer, I used the healing brush to retouch, and

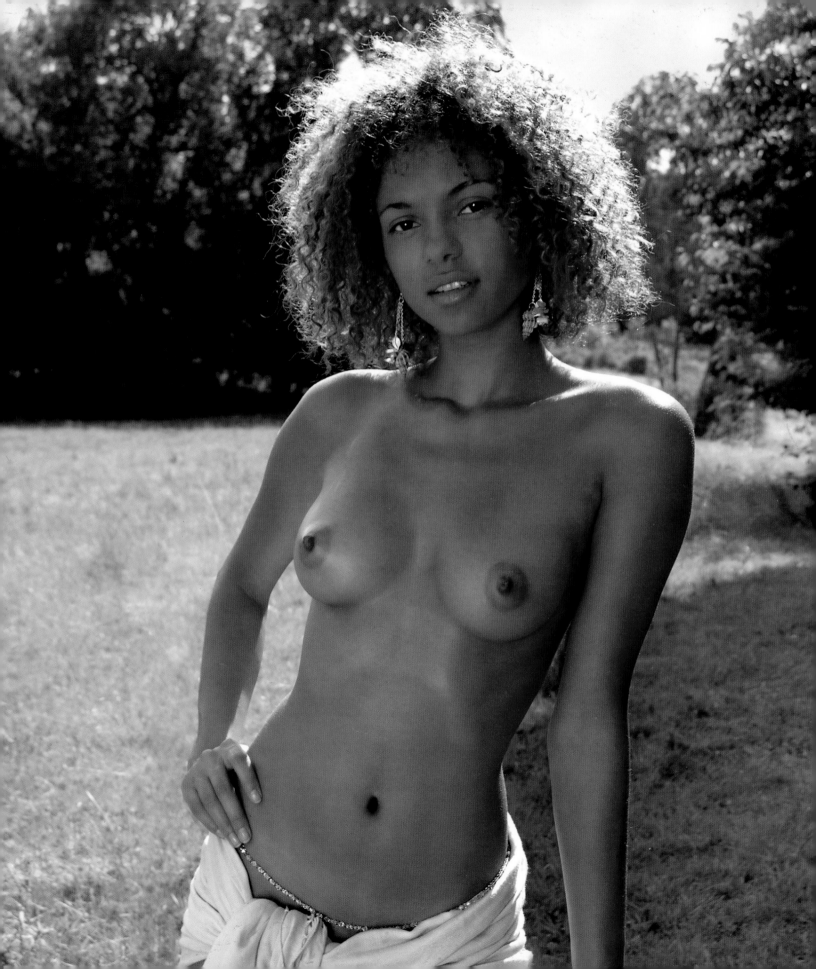

applying filters

Most image editing software offers a huge range of filters for creating subtle, unusual, and sometimes dramatic effects. These are derived from lens filters, darkroom practices, and other art forms. Filters can be great fun to play with, but, as with most effects, they should be used in moderation, and with a clear idea of how they can enhance the image. When you find an effect you like, make a note of what you did or save it in your software program so that you can replicate it.

Choosing filters

To experiment with filters, select an image with a strongly graphic quality and a play of light and shade.

1 The solarization effect is based on the darkroom technique, but is created here with cyan colours.

2 The film filter adds grain to an image. It works especially well on smooth surfaces.

3 Try using the stained glass filter and printing onto clear film to produce an image that can be hung on a window to imitate real stained glass.

4 The fresco filter looks most effective when printed onto rough art paper.

5 Here, a series of different effects have been used; red and yellow have been increased by 50% each; saturation has been pushed to the maximum; contrast has been increased; and, finally, a watercolour filter has been applied on top.

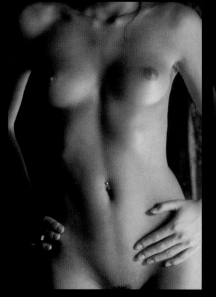

conserving your images

Once you have made an image you are proud of, you will want it to last. Always store films and prints in a cool, dry, acid-free environment, preferably in the dark. Prints hung on the wall should never be in direct sunlight, and the mount and barrier card at the back of the print should be of acid-free materials. If you wish to sign your pictures, use a soft pencil, rather than a pen. In the case of digital images, make back-up files of your originals before post-processing them. Standard CDs and DVDs have limited lives, in some cases as little as two years. Look for archival ones, which will last ten times longer – they are more expensive, but you will save a lot of time by not having to reburn them so often.

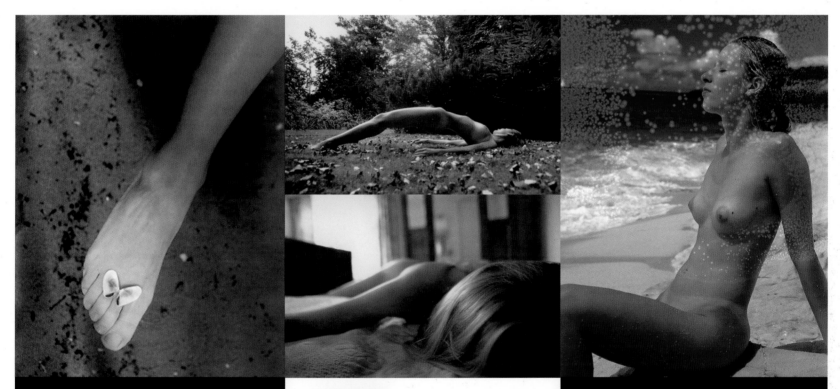

Fixing film

The small image shown left is scanned from a postcard I made years ago from this photograph. The large image above shows a print made recently from the negative as it is now; it seems that not all of the negative was fixed properly. The problem was that I didn't rotate the developing tank sufficiently, or there wasn't a sufficient quantity of fix. This shows just how essential it is not to cut corners in the darkroom.

Making archival prints

Exposed to light on the wall, these prints have begun to degrade; you might think the effect looks quite nice, but they will continue to deteriorate. They have suffered from insufficient fixing or washing. Follow the manufacturer's instructions carefully, and don't make the mistake of thinking that doubling the stated fixing time will make an image last longer; instead, the fix will penetrate the paper base, from which it will be very difficult to remove.

Repairing damage

My camera, loaded with transparency film, was dropped in the sea. I had the film developed, hoping for the best, but here you can see the damage done by the salt water. Digital restoration was possible, with skill: the face was repaired with skin tones from the chest, using the clone tool and healing brush, and larger areas were repaired with selections from undamaged skin, put into a separate layer, and brushed over the damaged area. The same technique was used for the sea and sky, and the overall colour was repaired with selective colour.

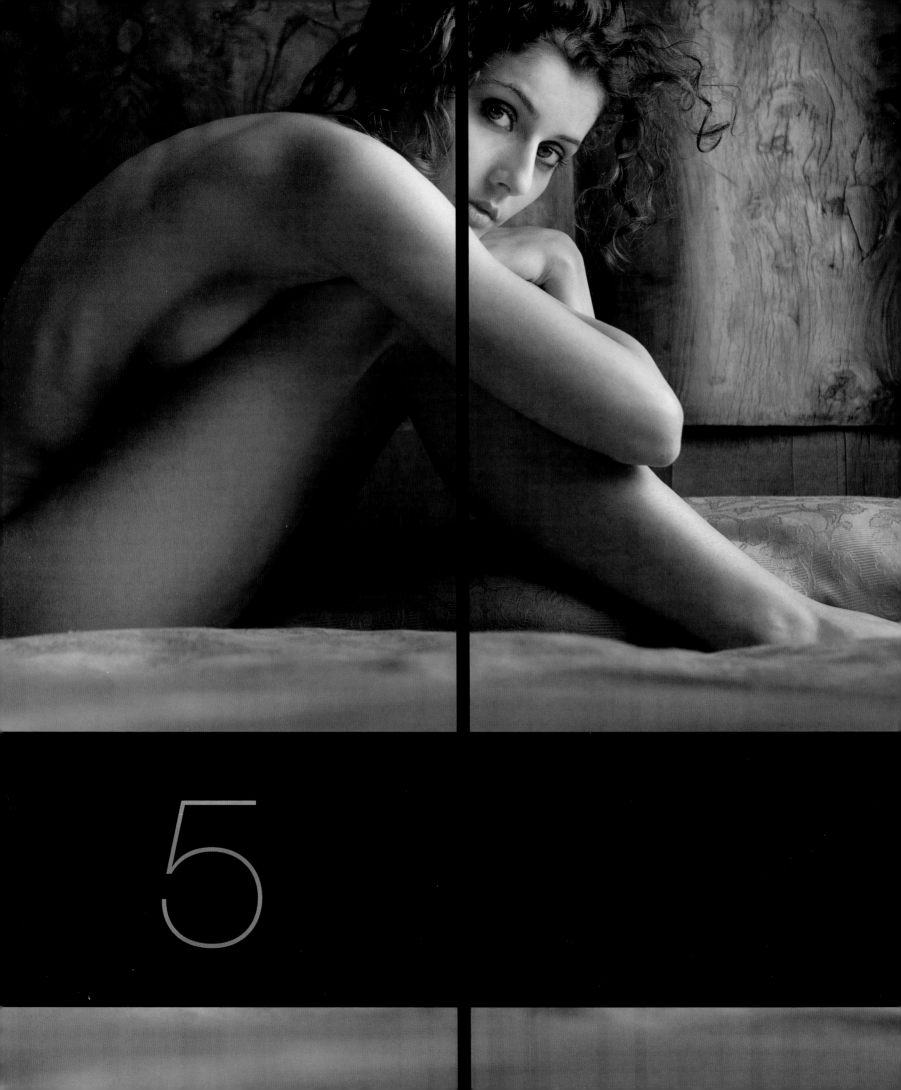

5

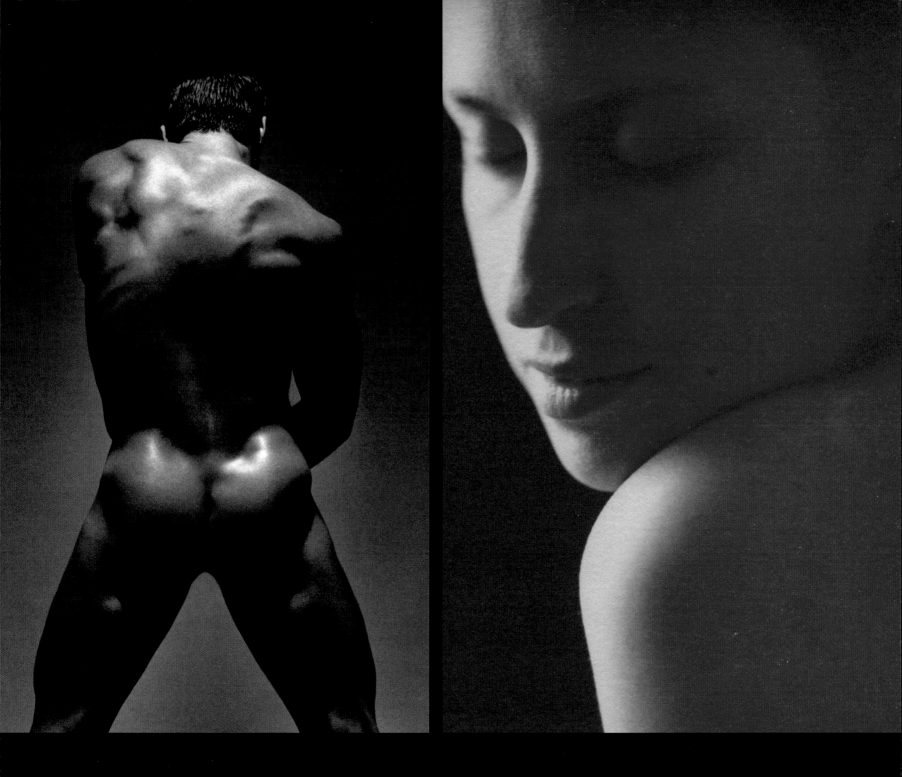

photographers'
gallery

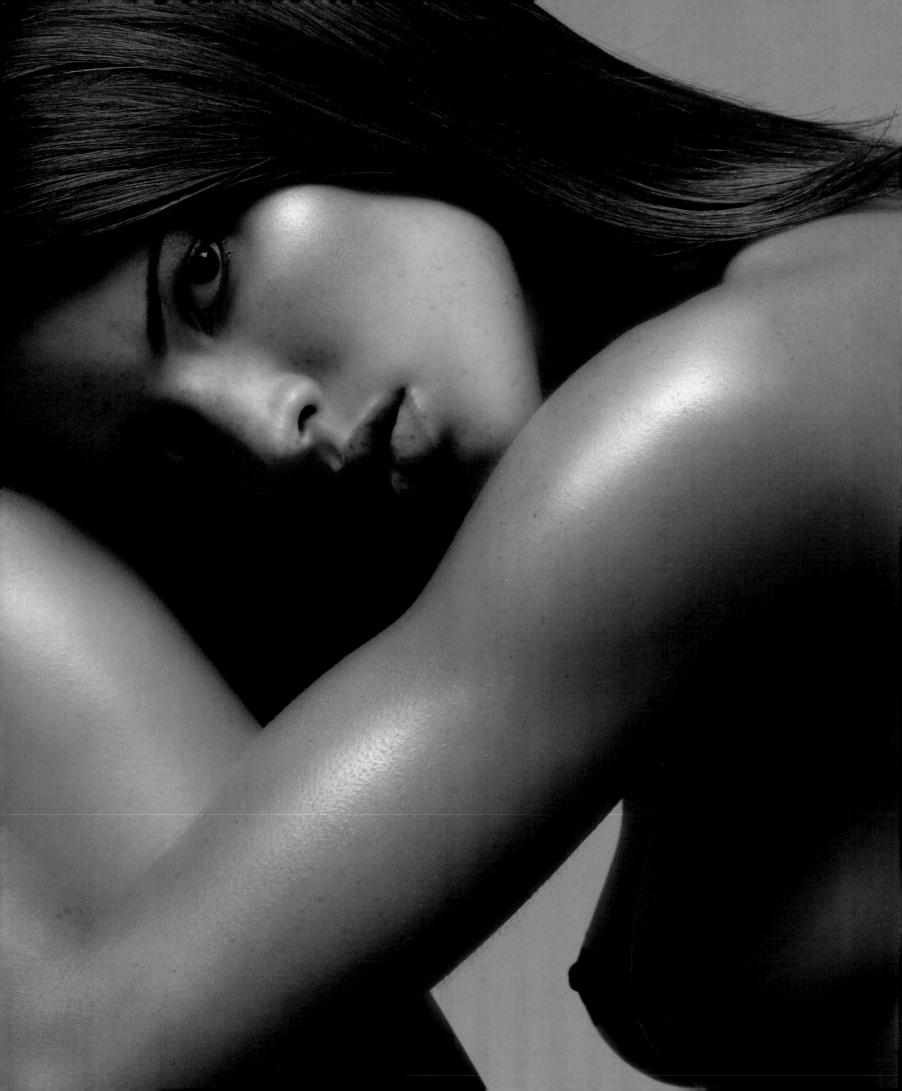

Welcome to the world of 10 top photographers renowned for their nude images. Each of them has created a picture specially for this book in the style they are known for, and has then explained how it was achieved: their concept, the preparation for the shoot, the equipment they used, and the way they worked with their models. With their variety of visions and approaches they demonstrate that photography can go in a number of equally valid directions.

introduction

A careful study of their different styles will pay dividends. You will notice how every photographer chooses to fit every element of the shoot to his or her concept. Some, like Andreas Bitesnich, Sylvie Blum and Giorgio Gruizza, use the studio itself as a setting, while Gavin O'Neill gives his bare studio the feel of a location. Ocean Morisset puts his model at a window and uses only natural light, while others – such as Gabriele Rigon – use an extra light source to emphasize the location's atmosphere. Ragne Sigmond conjures up the atmosphere of the classical world in her studio, while Allan Jenkins comes so close to his model that the environment has completely disappeared from his image.

Have a look at the different lighting directions used to sculpt the models, how light sources are combined, and how rarely the main light comes from the front. You will see that few models look into the lens, and that many even hide their faces. And when they do look into the camera, study the expression they convey to the viewer. There are also good examples of how dynamism is created through athletic poses, and stillness through relaxed, natural poses.

Listen to the way the photographers communicate with their models and assistants, and look at how they try out different possibilities till they find the final images. Some, like Almond Chu, vary their styles, whereas others, like Lyn Balzer and Tony Perkins, clearly choose a consistent style.

Learn from these great masters, analyze their imagery, and read their stories. However different their styles might be, what they all have in common is a passion for photography and for the beauty of the human form, and a quiet determination to create strong, personal images.

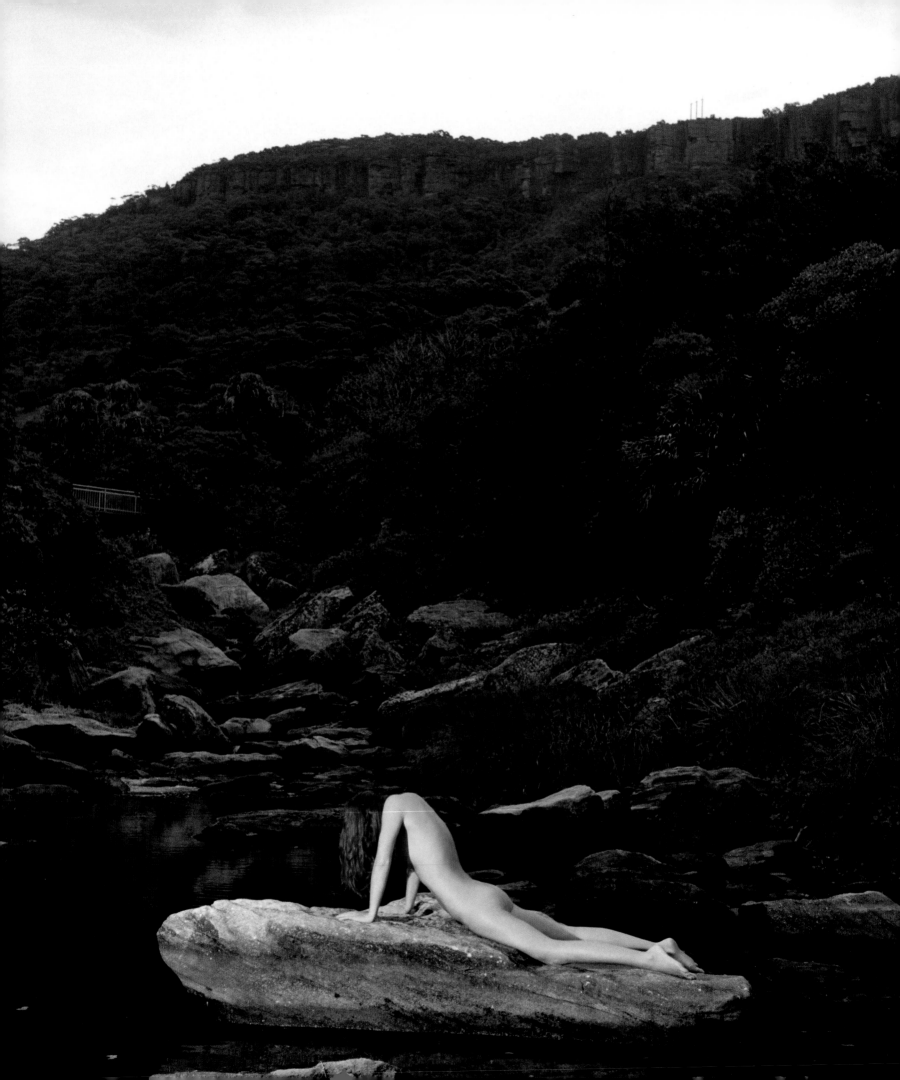

Our fascination with the Australian landscape stems from an upbringing on Australia's east coast near the idyllic rainforests and beaches of Byron Bay. "The Ravish of Nature" is a recurring theme in our exploration of the nude. Inspired by diverse visual sources such as Rodin's sensual watercolours, Marcel Duchamp's masterpiece *Given*, and the surreal qualities of David Lynch's *Blue Velvet*, we explore the erotic tension between the potency of nature and the implicit sexuality of the naked female. *Strangelands*, our evolving series, is the world that we enter in our images. It is a world that exists between the boundaries of the everyday and the exotic – marginal places such as abandoned quarries, deserted beaches, or swamps.

Our models are a mix of professionals and amateurs, chosen as much for their spirit as their physical presence. We like to work with girls who both understand our vision and are keen to collaborate on exploring our visual language – our muse has an inherent, unfathomable presence.

We shoot exclusively on medium-format negative film and have developed our technique through years of experimentation. We find the format provides the perfect balance of high-quality images with an ease and freedom of movement, which is important when shooting in some of the harsh locations in which we usually work. We choose films that enhance the surreal qualities of our images, embracing the startling strong colours of our country – vibrant blues, greens, and reds. A combination of flash and available light amplifies an abstracted, otherworldly state – impossibly blue skies, raw textural flora, and pale ethereal forms.

Our images are all created in camera, with little, if any, post-production; it is the small imperfections that emphasize the apparent fragility of the feminine form in the face of nature.

lyn balzer & tony perkins

Nationality Australian
Main working location Australia
Photographic method Medium-format film

Lyn majored in photography while studying for her Arts degree, developing a strong individual style that brought her a significant client base even before she graduated; Tony studied Environmental Science. To balance their studies and commercial work, Lyn and Tony set up their own small studio in an old factory in Darlinghurst, the creative heart of Sydney. They have exhibited in London, Barcelona, Sydney, and Melbourne, and their work has appeared in magazines internationally.

www.lynandtony.com

behind the scenes

The initial conception for our shoot sprang from the discovery of a location that possesses an incredible sense of beauty and drama. Our model, Siannon, was chosen especially for this shoot as her pale skin and red hair were an important element in allowing us to create a striking contrast of the body within the environment. Her enthusiasm and energy were critical to achieving the image we created; our work is very much a synergy between us and our model. Grant, our producer, was in charge of the logistics of spending a day in the harsh and isolated landscape.

10:30 **The first step is to assess** the location for light direction and landscape features.

10:35 **Meanwhile Katie,** the make-up artist, applies sunscreen and moisturizer to Siannon.

10:40 **We do little retouching,** so Katie disguises tan lines with a little body make-up.

10:45 **Tony and Grant wade carefully** into the water, carrying cables and the flashlight.

10:30

10:35

10:45

10:55

10:40

10:55 **With the flash in position,** Siannon takes her place within the selected framing of the landscape.

11:05 **Siannon begins to progress** through a variety of poses, her brilliant red hair making a stunning focus.

11:09 **Tony checks the framing** before progressing to Polaroid.

11:09

11:20

11:05

11:30

12:33

11:20 **We assess the initial Polaroid** to see if we are happy with the composition and lighting.

11:30 **Having seen the Polaroid,** we discuss adjusting the position of the flash.

12:33 **We shoot another Polaroid** after making a slight change to the lighting.

12:53 **After a few more minor adjustments** to the pose and lighting we reach our final decision.

12:53

the shot

To enhance the surreal atmosphere and drama within the picture, we used a directional source of light provided by our portable flash to highlight Siannon's body, while the hard midday sunlight emphasized the depth and colour in the landscape. Our medium-format Bronica camera not only provides high-quality images essential for large-scale exhibition prints but is also incredibly durable for rugged locations such as this one. As usual, we used ISO 100 colour negative film, which gives a high degree of detail, resolution, and saturation to our images.

Strangelands (South Coast)

FOR THIS SHOT
Camera: Bronica ETRsi; 75mm lens
Aperture: f/22
Shutter speed: 1/60th of a second
Sensor/film speed: ISO 100
Lighting: Lumedyne 400 watt portable flash

Comparing Polaroids

Polaroids are an essential feature of the shoot as they not only provide a guide to the composition but also a technical assessment of the lighting. This is a critical element when you are working with a combination of strong sunlight and flash.

Tough locations

Just as our models often have to suffer being scratched, grazed, and sunburnt when working with us, we too have to deal with the problems of outdoor photography in the challenging Australian environment.

Sharing the images

Polaroids also provide an important dialogue with the model, so that she can see immediately what we are aiming to achieve in the image.

portfolio

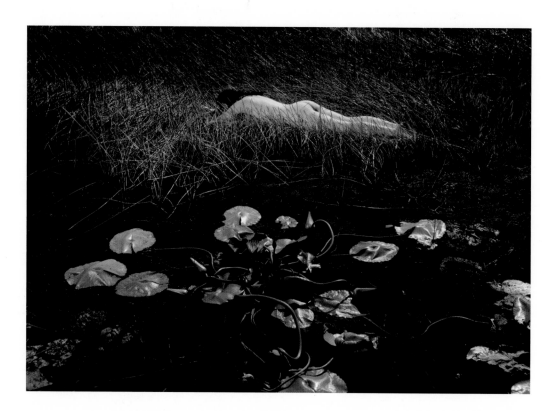

△ *Strangelands Series #1*

This image was inspired by our discovery of a dried-up
waterhole littered with the fragile beauty of waterlilies.
The model was highlighted with flash, achieving a strong
contrast against the dark grass, while brilliant sunlight
provided additional highlights within the environment.

▷ *Strangelands Series #2*

The soft white body echoing the hard black boulders
in the foreground emphasized our comparative fragility
within nature. Hard, direct sunlight, accentuated with
flash, provided the strange, monumental quality of the
figure, silhouetted against the saturated blue sky.

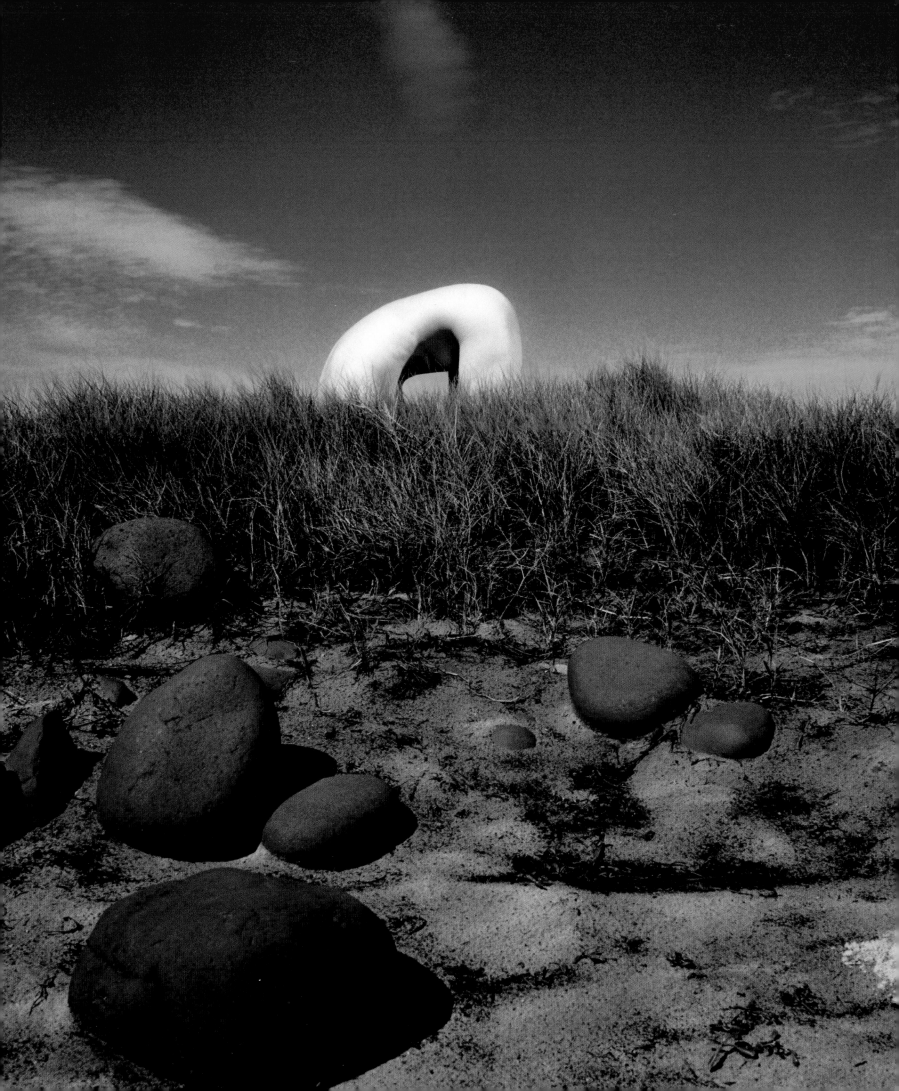

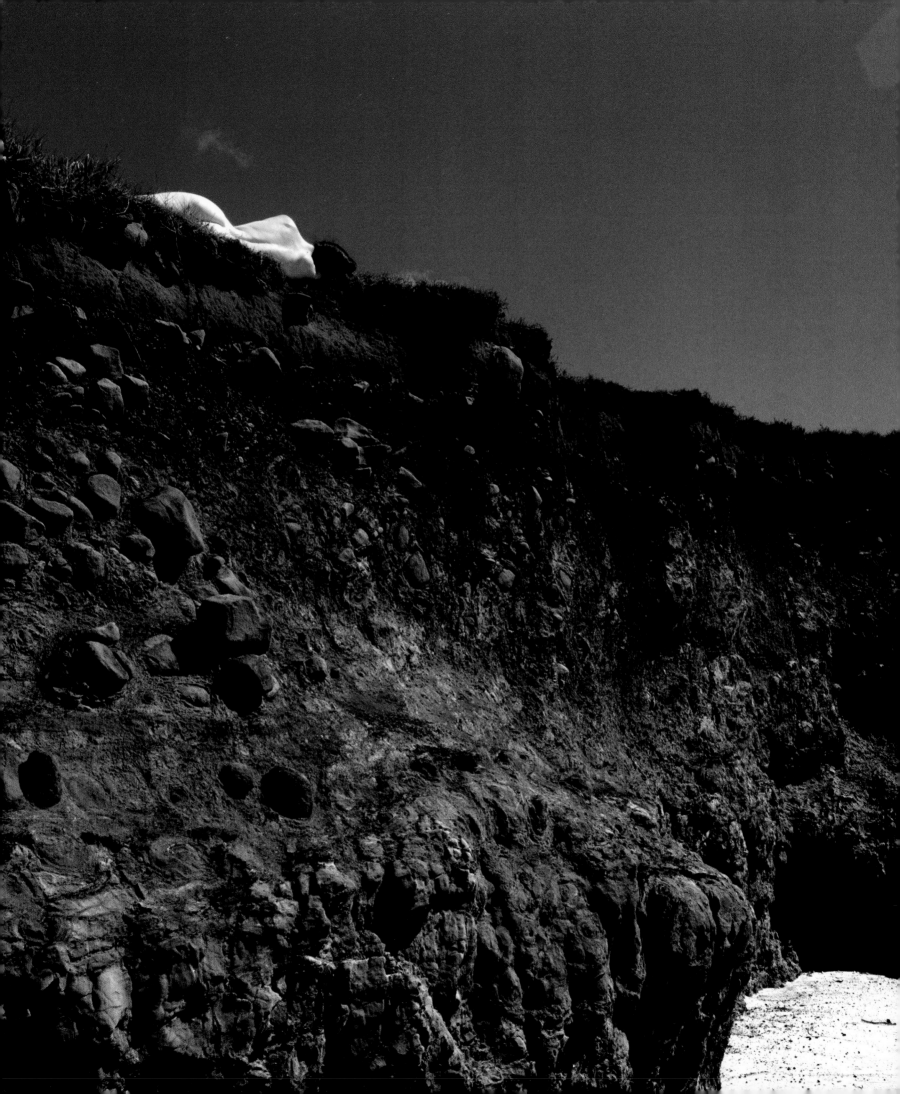

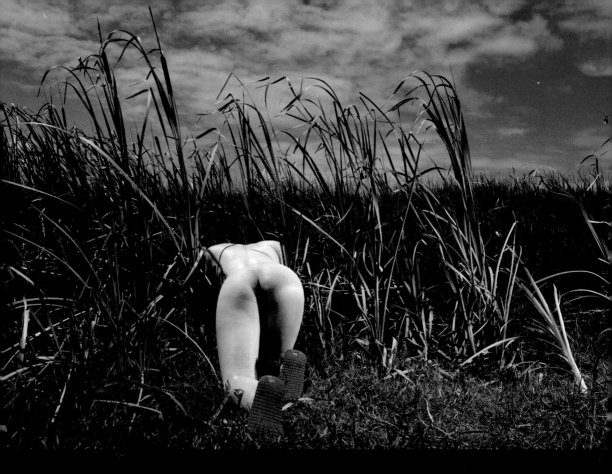

△ *Strangelands Series #4*
Vulnerable and exposed, the milky-white figure is
engulfed by nature, swallowed by a sea of razor-sharp
grass. The azure-blue sky, with eerie white clouds,
appears strangely foreboding despite being shot on
a "perfect summer day".

◁ *Strangelands Series #3*
Compressed between earth and sky, the body is a focus
within the landscape. The sky, usually associated with
airiness, has achieved a dramatic weight countered by
that of the clifftop. Shot in direct hard sunlight, colours
and contrasts are heightened cinematically.

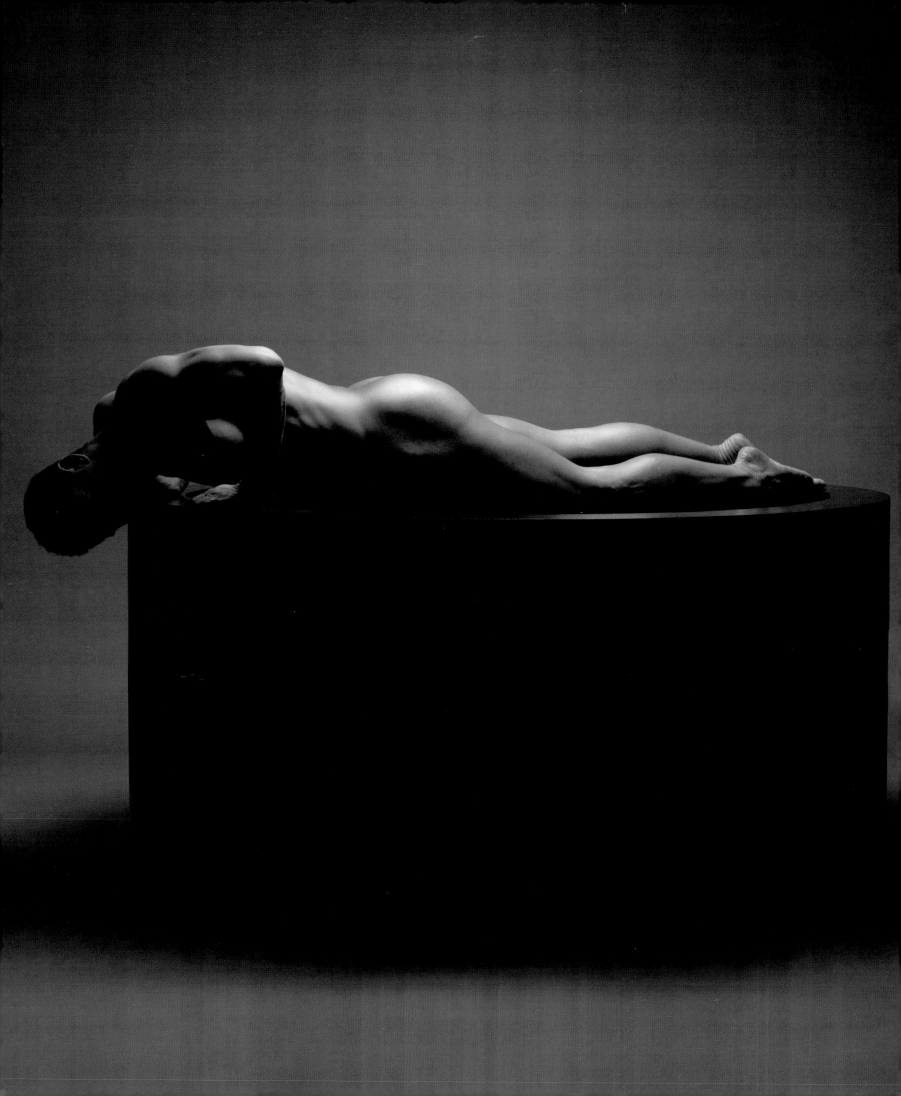

andreas h. bitesnich

Nationality Austrian
Main working locations Austria, Germany, and Italy
Photographic method Digital

Andreas H. Bitesnich's first career was in retail, but it was seeing a fashion photographer's portfolio that sparked his interest in photography. He bought his first camera the next day and for two years sold electrical appliances by day while immersing himself in photography at night. In 1989, fuelled by a belief that any ambition can be achieved through hard work, he made photography his profession. He is now one of the world's biggest names in the field of nude photography.

www.bitesnich.com

When photographing the nude, the key word for me is respect. If someone is prepared to take their clothes off in front of you, they are demonstrating a lot of trust in what you will do, and it's important to let them know that you appreciate that and will treat their vulnerability with care. In the studio the model can't even see you, just the lights, and because they are naked it's a very fragile situation. You have to direct the model loudly and clearly, and make sure they are happy with what you are asking them to do.

It doesn't matter whether the model is a professional or an amateur – what matters is that they want the same thing that you want. In my experience I find I always create the most beautiful things that way as there are two people creating the image, rather than just the photographer deciding what to do. This can take place much more easily in the age of digital photography as you can look at the picture together, make any corrections, and work as a team.

I feel really comfortable in the studio. When I first started I had the opportunity to use a studio for two or three years, so lighting became second nature to me. When I'm working on location I either have no technical help at all – not even a reflector – or I go to the other extreme, with two or three assistants changing the film, holding big flashlights, and dealing with cables and generators. If I'm up to my chest in water for a shoot in the sea I need to have people helping me! So for practical reasons it's sometimes good to have a team, but for the first four years of my career, when I worked for the German edition of *Playboy* magazine, I just had an assistant to change the film; it was all done very simply. You really don't need a lot of equipment to take a good picture.

behind the scenes

I photographed Italian television stars over a long period, so I became used to walking into rental studios that were quite bare and having to make do with whatever was there for props. It was good practice – you could put me in an empty room and I would start creating something. I had the prop shown here made for another job a few years ago, and it occurred to me to paint it black for this project and turn it upside down. I asked Micky to model for me – he's a professional dancer I've worked with often, and I knew he would really try to come up with something to inspire me.

10:12 **Micky swaps his clothes** for a bathrobe as soon as he arrives.

10:32 **My assistant Werner and I** set the light on a boom and attach a softbox.

10:44 **The next stage** is to put the prop and lighting into place.

10:48 **The hair stylist** attends to Micky's hair and puts some oil on his body.

10:12

10:32

10:44

10:48

11:09 Micky gets into the prop while Werner is still positioning the light inside it.

11:18 I take the first shot with my Hasselblad to test that the exposure is correct.

11:38 Micky accustoms himself to the dimensions of the prop.

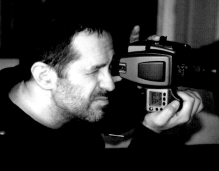

11:09

12:45

11:18

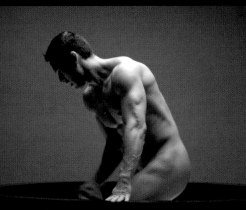

11.38

12:33 As the shoot gets under way I begin directing Micky into the different poses I want him to try.

12:45 We start off with a few poses, mainly to do the first light tests.

13:13 Micky, Werner, and I study the images on screen to see what corrections might need to be made to them.

13:13

the shot

Throughout the shoot there was one flash head with a softbox on a boom about 3m (10ft) above Micky – my studio has a very high ceiling which gives me the ability to set my lights high, thereby reducing the contrast of light and dark. In the shot that I liked the best we had replaced the flash head inside the prop to give minimal light from below. Werner stood next to me, holding a black panel to prevent the overhead light shining into my lens; the grey paper backdrop was 4m (13ft) wide, allowing us plenty of room to move about.

Micky, Vienna 2007

FOR THIS SHOT
Camera: Hasselblad H2D with Phase One P45 back; 80mm lens
Aperture: f/11
Shutter speed: 1/750th of a second
Sensor/film speed: ISO 100
Lighting: Hansel flash heads, 4000 watt and 1600 watt

Digital choice

I had bought a digital Hasselblad about a year previously, and got used to it very quickly. The advantage of digital over film is that I can view the result straightaway and decide what to change much more quickly than was possible doing Polaroid tests.

Studying the results

At the end of a shoot I get all the images up on screen, edit them and consider what retouching needs to be done to them.

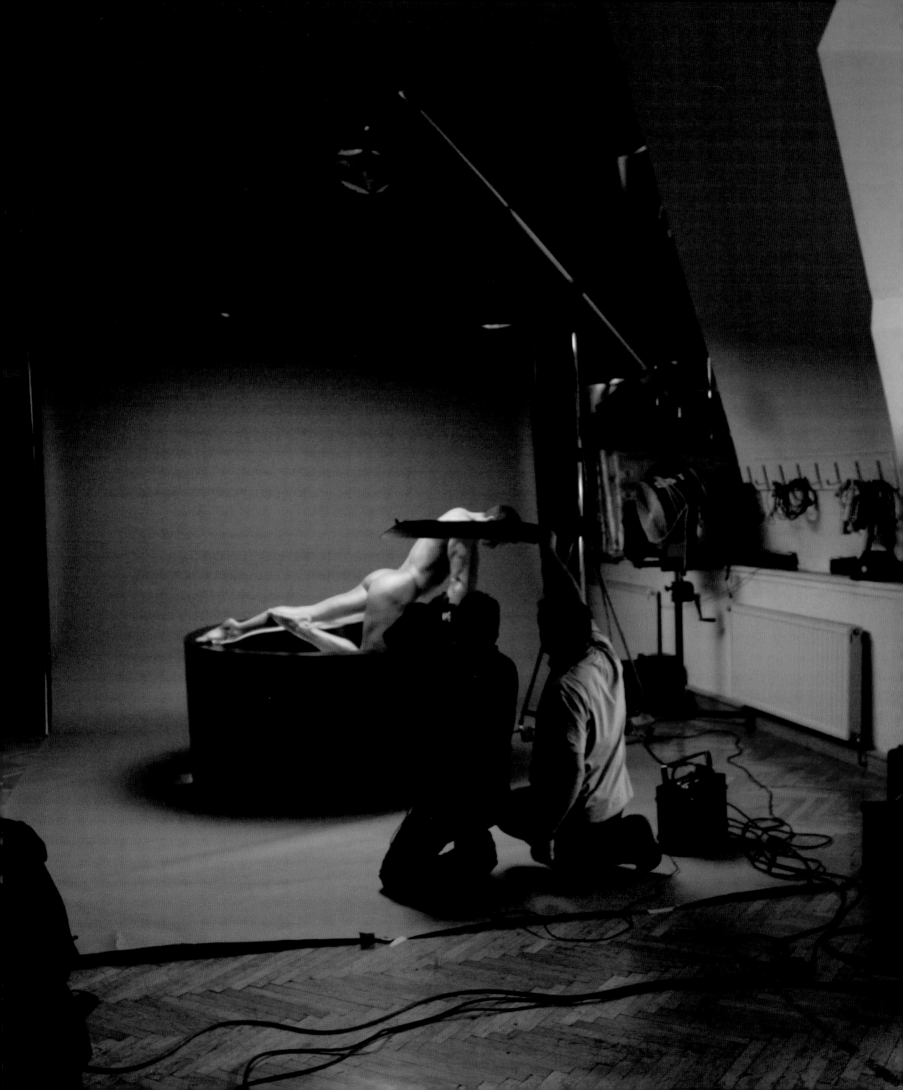

portfolio

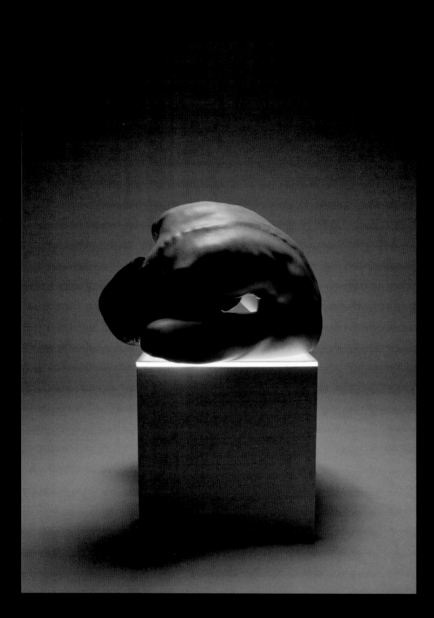

△ *Ingrid, Vienna 2002*
I've worked a lot with Ingrid and every time I meet her she
inspires me to do something new. I had just had a box
made with a light inside, and I thought it would be great
to test it out with her. I used simple lighting – just the light
in the box and one light above her.

▷ *Anthony, Vienna 1995*
Anthony is another favourite model of mine. I put up a
grey paper background and we played around for a while
trying out various poses, with just one light directly behind
him. I wanted a hard light, so I used a flash head with no
umbrella or softbox.

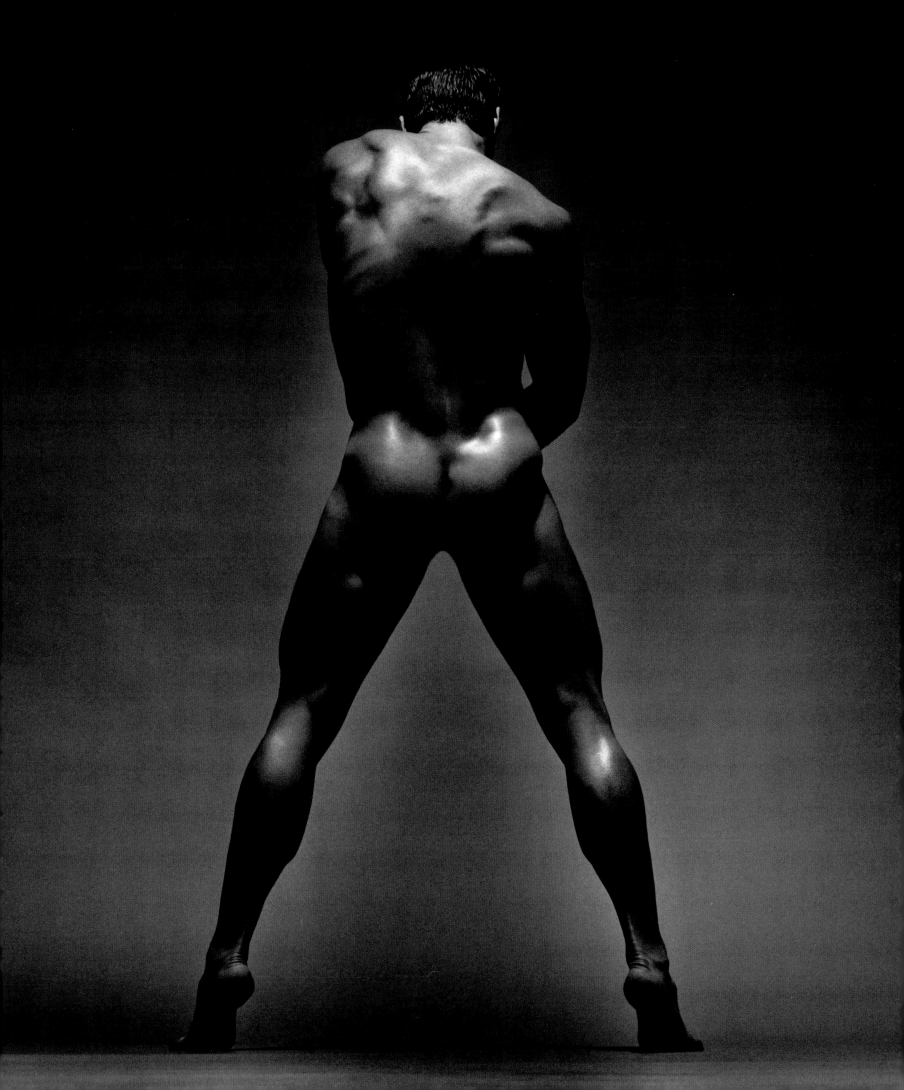

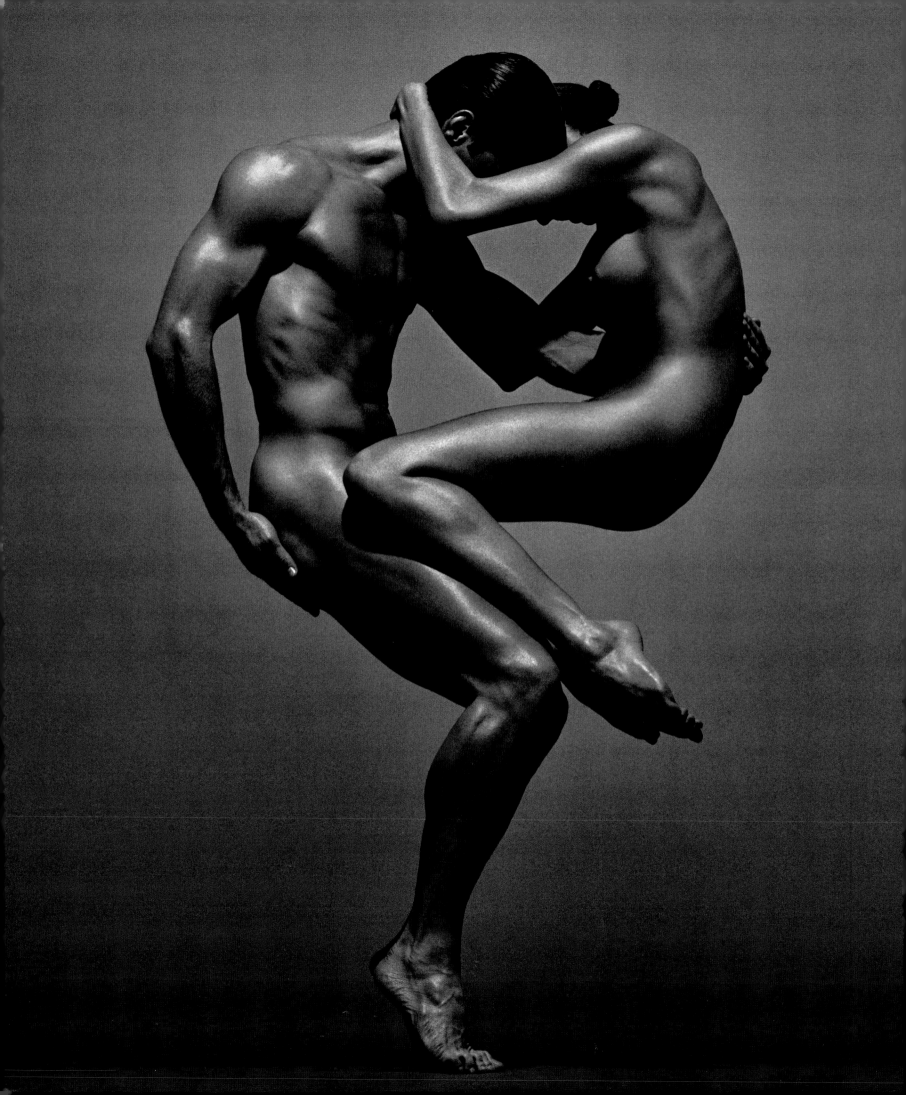

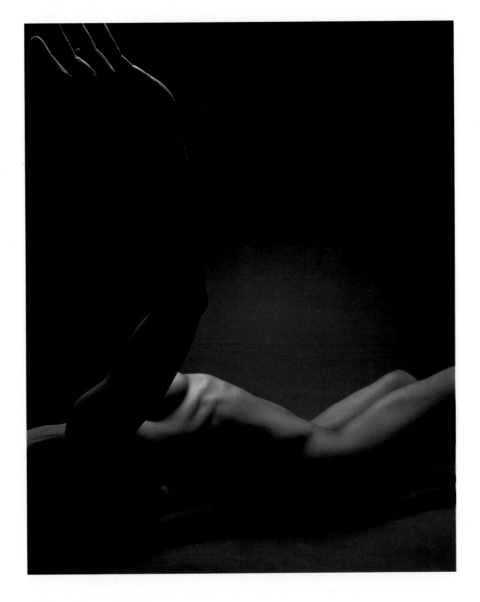

△ *Sara, Vienna 2003*
I met Sara, a dancer, at one of the workshops I run in
Tuscany. The way she moved so inspired me that I invited
her to come to Vienna, and the shoot resulted in some
amazing images. Here there is just one overhead light
casting a strong shadow.

◁ *Sina and Anthony, Vienna 1995*
I don't usually plan my shots but this came to me as a
vision one night. I have a whole contact sheet of pictures
where Anthony's feet are flat on the ground, and he rose
onto his toes for just one shot – I had to take it fast. They
are lit with one hard light.

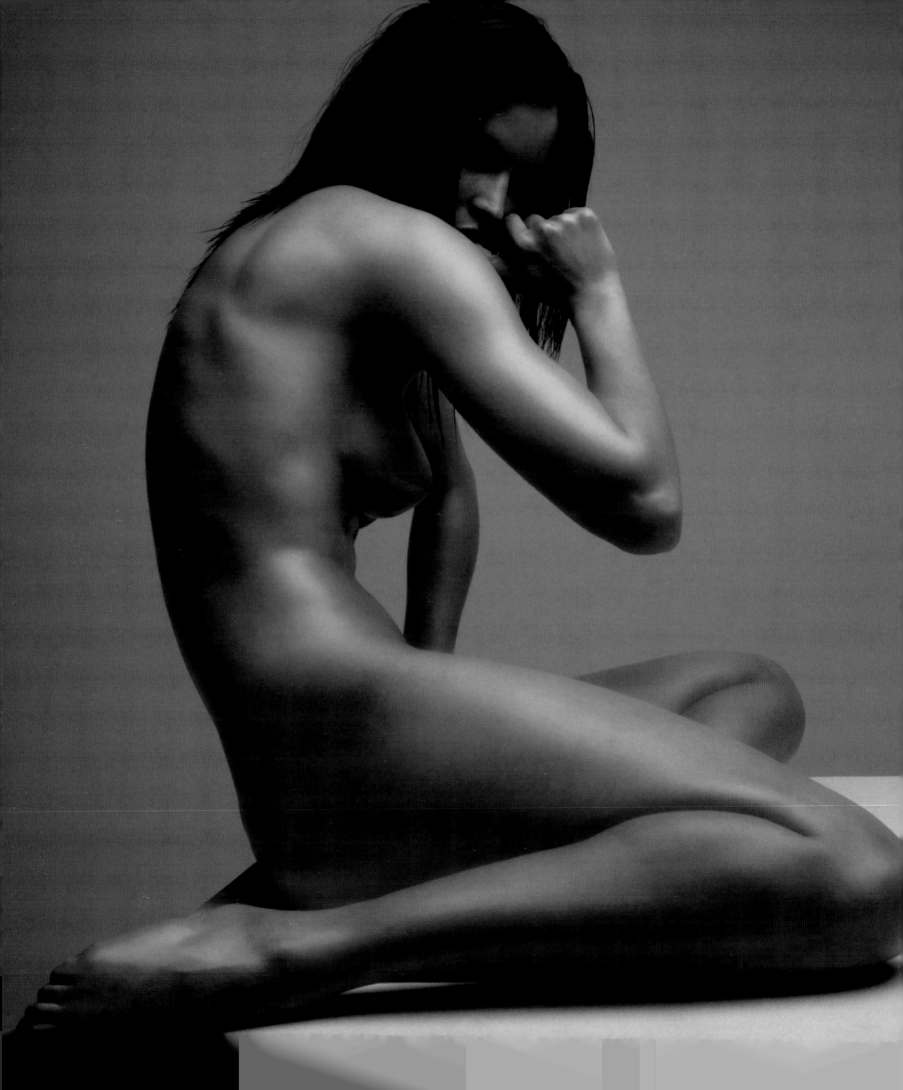

Inner beauty is always first in my mind when I take photographs of someone. I often ask myself what the definition of true beauty is: what is beautiful and at what moment does the beauty shine through a person and cause me to see it? The next step is to consider how I can capture this beauty so that it is reflected and absorbed by people viewing my work – and what could be more beautiful, fragile, and luxurious than wearing your own skin? It is my obsession and passion to tell stories with my camera; it allows me to make a statement about myself, my dreams, my vision, and my story.

For me, photographing a nude body is to isolate a moment and place it in a timeless space by reducing the body to the essentials and playing with skin tones, light, and shadows. Both studio and location shoots offer exciting possibilities. In the studio I plan every detail, and I love the technical aspects; the more cables, generators, and tools there are around the happier I am. On location, the spontaneous nature of things makes it very inspiring to play with the daylight, hurry to catch the right movement or gesture before it changes, and find the endless possibilities the location has to offer.

Making my own prints is an important part of my work – galleries selling my prints offer small limited editions with the character of a unique handprint, bearing my knowledge of time-intensive darkroom processes and my own secret mixture of chemicals.

I love people, and when someone is in front of my lens it is almost like a short-term love affair. For the moment and for the reason we came together, I want them to give their all to achieve the perfect result at the end. And I want to be known and recognized for my style, as each picture is also a statement about myself.

sylvie blum

Nationality Austrian
Main working location USA
Photographic method Film and digital

Sylvie Blum spent more than 10 years as a model, working with internationally known photographers, artists, and film-makers. She was the muse and wife of the renowned photographer and artist Guenter Blum, who taught her all aspects of photography. During Guenter's life and following his death in 1997 Sylvie organized many exhibitions and publications of his work, and also began to compile her own first book. Today she is represented by international galleries and has published four books of her photography.

www.sylvie-blum.com

behind the scenes

I am always excited by the buzz of a new team of people coming together, but I take care to focus on the model as she might be feeling shy and nervous. In this case the model was Ashley, with whom I've worked many times before, and as she is nice, natural, and a bit goofy we both knew this would be a fun day. I was also confident that I had a good team, which is just as important as the model, light, and location. Usually we all find ourselves lying on the floor in front of the model, discussing poses and angles – I like to be inspired by ideas from everyone on the set.

09:00 **Setting up at the Miauhaus Studios** in Los Angeles – a cool place with a great feel to it.

10:00 **Make-up artist Jennifer Fiamengo** begins preparing Ashley for the shoot.

10:45 **I set up my laptop** so that I will be able to check the pictures on screen.

11:00 **I begin exploring angles** from which to shoot preparatory poses.

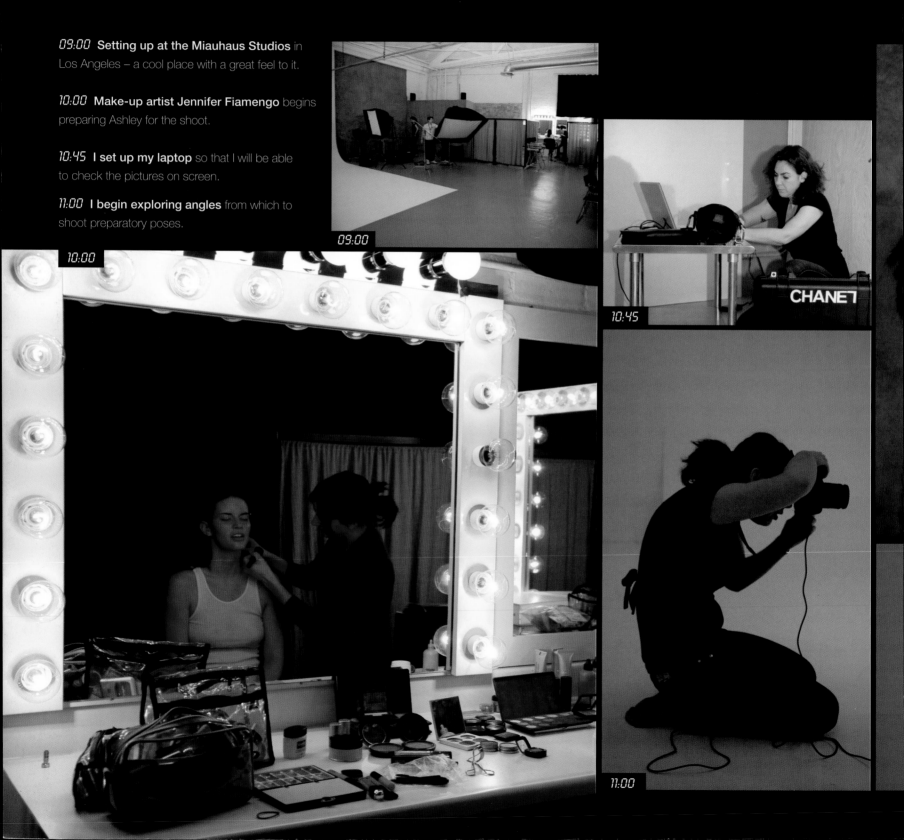

09:00

10:45

10:00

11:00

11:15 **Jennifer applies oil** to Ashley's body – I love to see the effect of light on oiled skin.

11:45 **When I see Ashley** in the light I ask Jennifer to make a few small adjustments to her make-up.

12:00 **I explain to Ashley** how I wanted the pose to look.

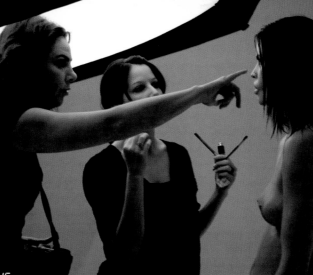

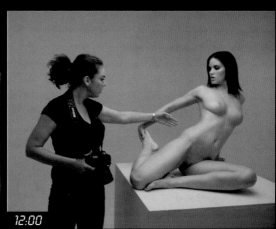

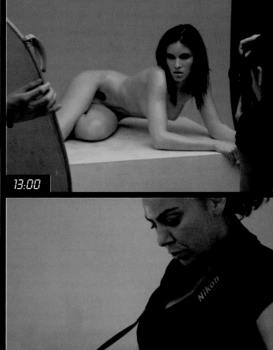

13:00 **My assistant holds a reflector,** angled to bring some structure into the shadows of another pose I want to shoot.

13:15 **I check the pictures** on my camera screen to see if the pose worked well.

14:00 **Looking at images on the computer** too helps me to remember the poses we have already done. I don't stop working until I feel I have got everything I can out of the day.

the shot

I created a very flexible lighting set up because I wanted to focus on Ashley's movements rather than caging her in a fixed light position. Asking her to freeze while I changed the lights would have been more tiring for her, and I wanted her to work very hard that day. I decided to use a huge softbox for the main light, which could then be combined with a strip light, smaller softbox, or reflector. Jennifer stayed at my shoulder throughout, ready to retouch the make-up or make any changes I wanted as the shoot progressed.

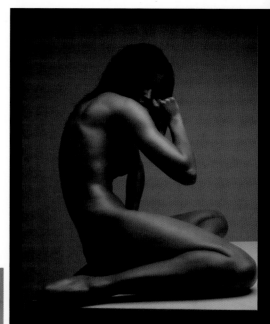

Getting down to it

As usual, I spent a lot of the time lying on the floor amid my cables and generators, giving instructions to my team and the model.

Ashley on the Box at Miauhaus

FOR THIS SHOT
Camera: Nikon D2X; 85mm lens
Aperture: f/22
Shutter speed: 1/250th of a second
Sensor/film speed: ISO 125
Lighting: Profoto Studio light, two Profoto Pro-7 flash heads with softboxes

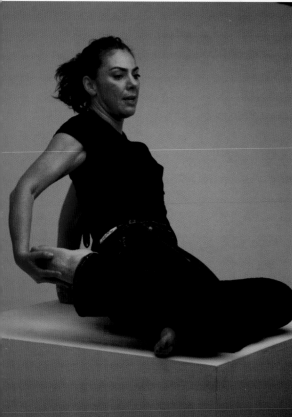

Demonstrating the pose

As I used to be a model myself, I'm apt to explain the pose I want by simply putting myself into the set and showing how it's done. It also allows me to find out if it is even possible!

Viewing a pose

As this was one of my favourite poses I checked that the lighting was correct before moving on to the next one.

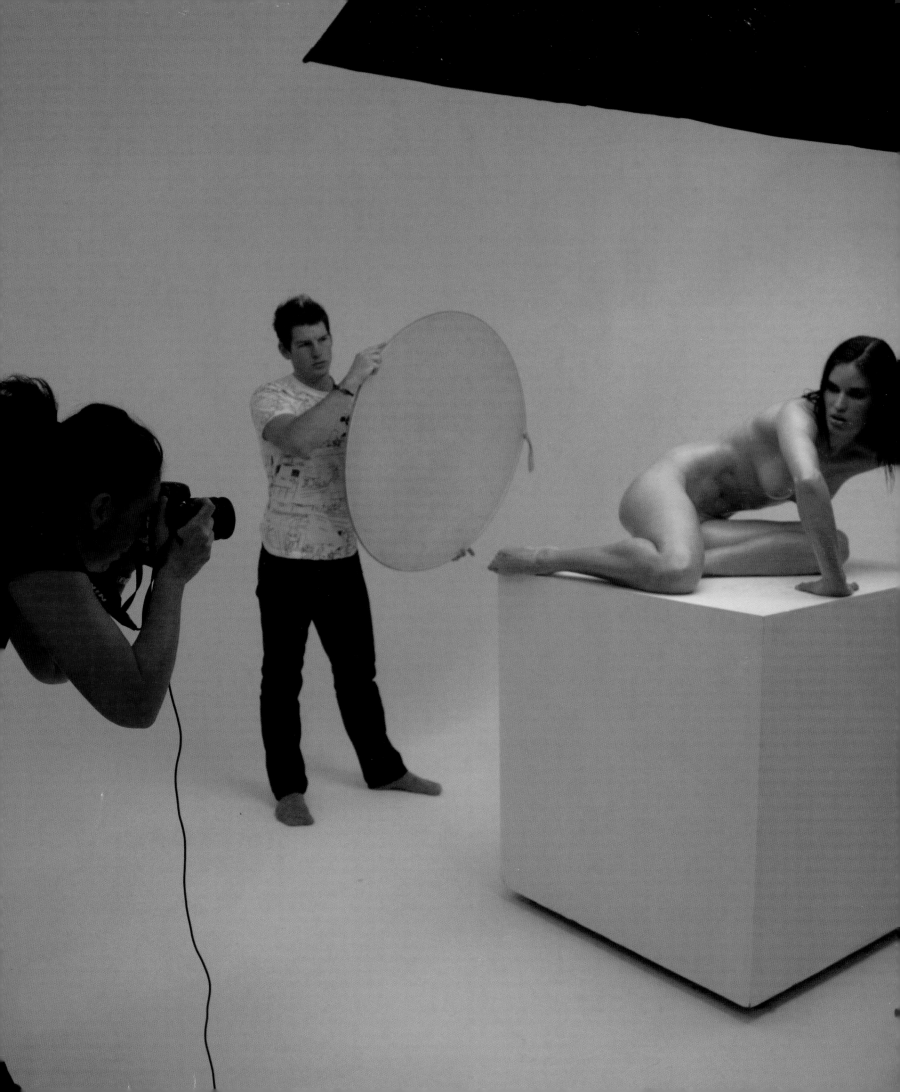

portfolio

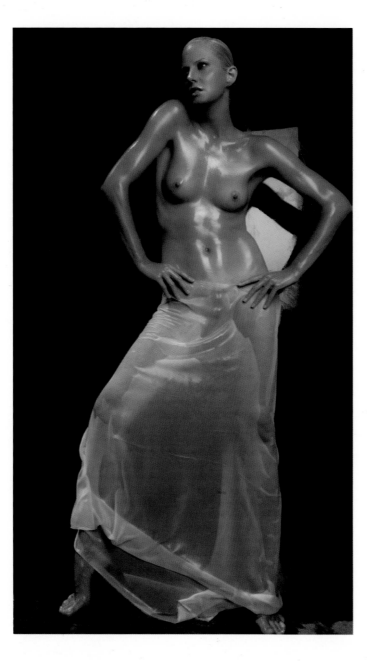

△ *Standing Nude*

I decided I wanted to make a stylish picture of this model,
so I draped some fabric around the lower half of her body
rather than showing her fully exposed. We did the shoot
in my outdoor studio, mixing sunlight with flash. I used an
85mm lens on my Nikon D2X.

▷ *Nudesoup*

I found this bowl in a shop and it gave me the idea of
doing a picture with big hair. I liked the combination of
forms and also the unusual take on showing someone
nude. It was taken in an outdoor studio with a mixture of
natural and artificial light.

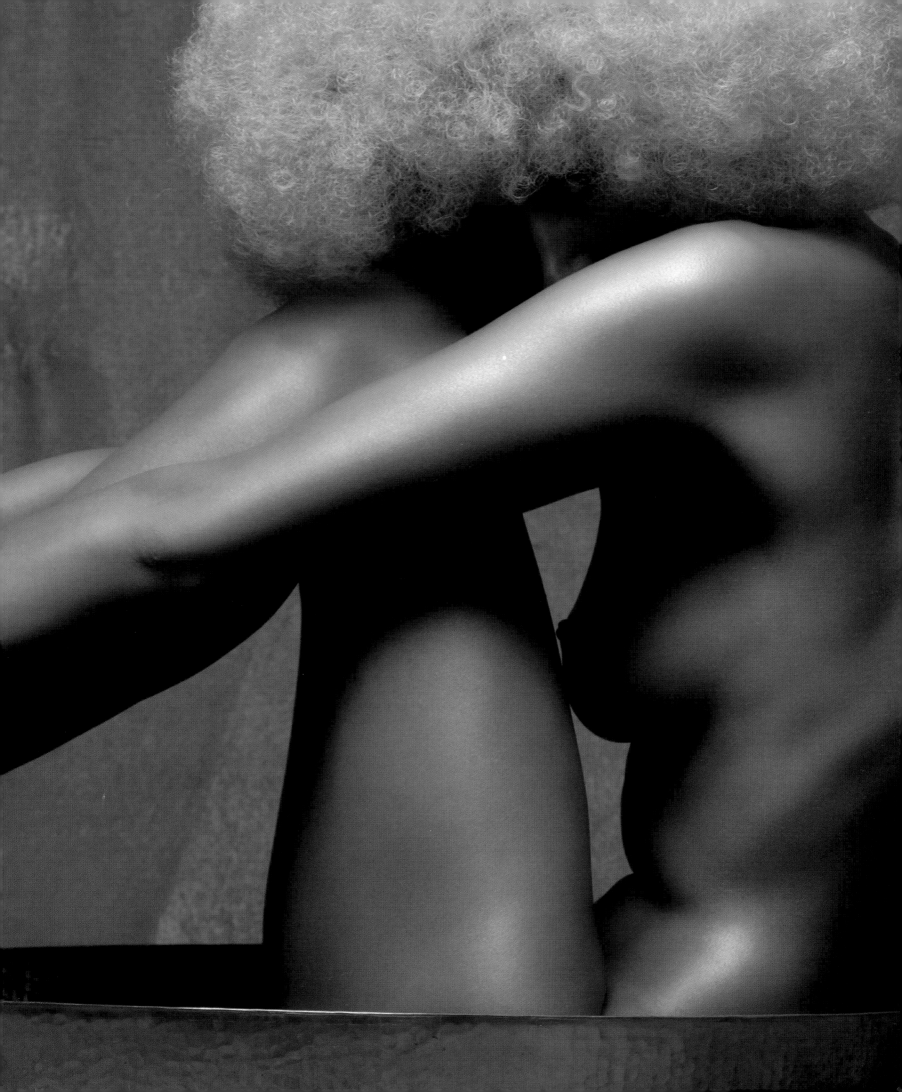

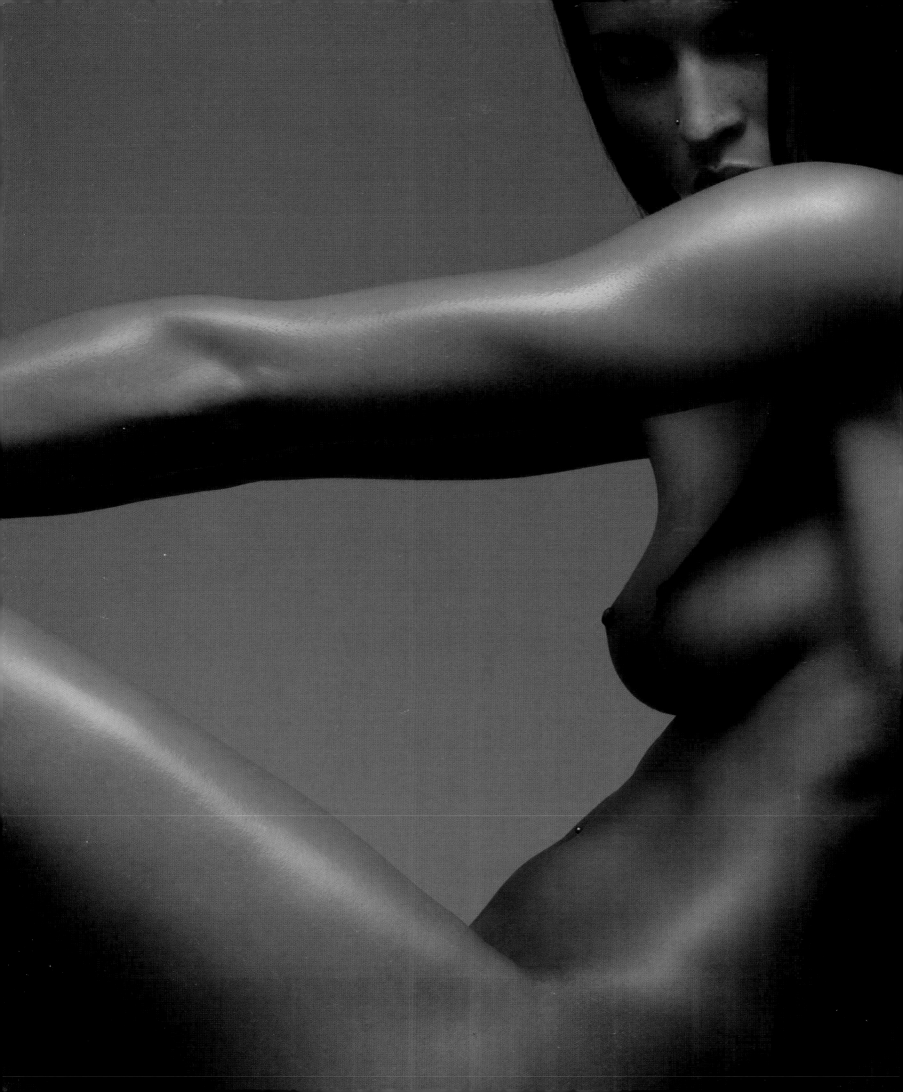

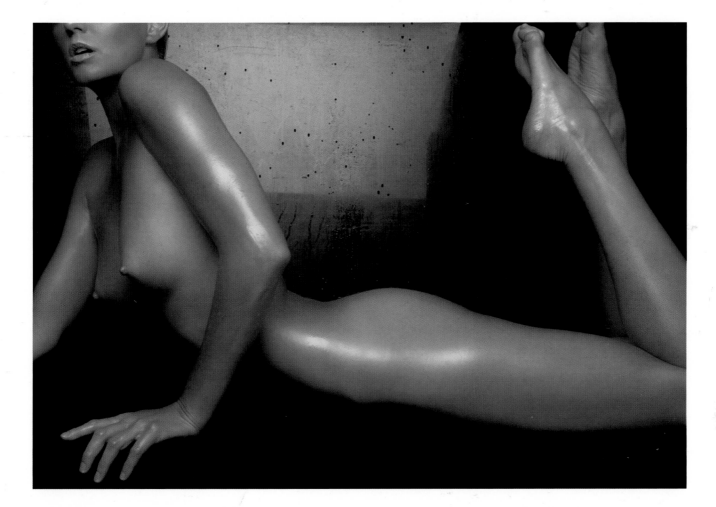

△ *No Face*

Sometimes I love to do crazy crops, and this one, in
which I've cut off the top half of the model's face,
focuses the viewer's attention entirely on her body. This
photograph was shot in the outdoor studio, using my
Nikon D2X with a 22mm lens.

◁ *Ashley*

Ashley is my favourite model and this studio portrait of her
nude is reduced to the essentials to show her beauty. I
loved playing with the highlights and shadow on her skin
in the diffused light. The photograph was shot with my
Nikon D2X and a 220mm lens.

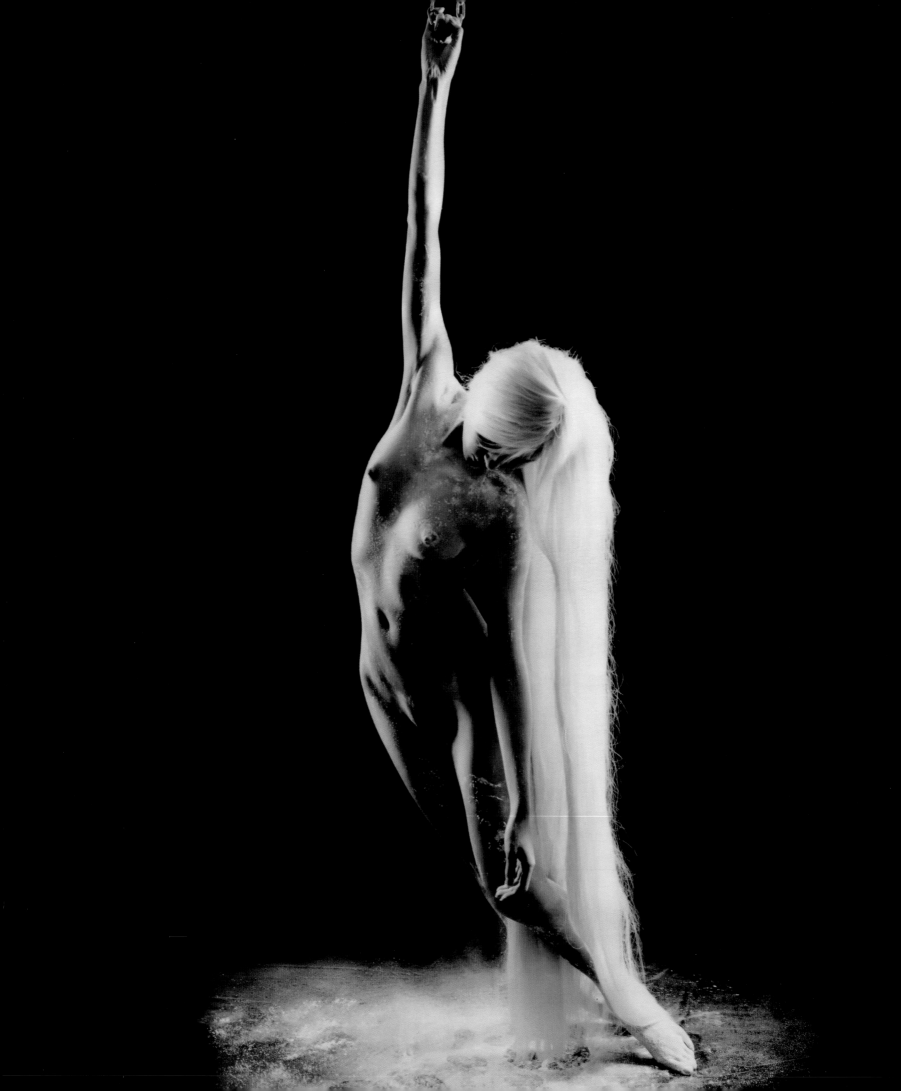

almond chu

Nationality Chinese
Main working locations Hong Kong
and mainland China
Photographic method Large-format
Polaroid, film, and digital

Almond Chu studied Graphic Design
at art college in Hong Kong, where he
rekindled a childhood interest in
photography. In 1982 he took the
decision to study art and photography
in Japan, and went to Tokyo College
of Photography, where he concentrated
on portrait and nude photography. This
has been his ongoing project for over
20 years; he remains fascinated by the
creation of a living still life, using human
bodies to sculpt his photographs.

www.almondchu.com

I work with both professional and amateur models, depending on the
ideas I have in mind and the approach I want to use. I first rough out some
sketches to develop the ideas, and show the sketches to the models to
explain how I want to approach the photo shoot. This usually helps me
gain their trust. I like to work with a variety of models because each one
will give me different ideas. The things that most inspire my imagination are
books and movies, as well as everyday people, my surroundings and the
views from my window, travel, and the changing weather.

I use different cameras, and shoot both
film and digital. A Hasselblad with a 120mm lens
is my favourite combination for shooting the
nude, as well as a Japanese 10 x 8 inch field
camera. I like working in the studio as everything
is under my control – lighting, backdrop, timing –
and the atmosphere suits me; I am isolated from the real world! My lighting
set-up depends on the requirements of the layout or the concept, but
I prefer to keep it simple. I sometimes retouch my photographs in
Photoshop, but I feel it is important to avoid overdoing this otherwise it
could dominate the finished work.

I have two main strands to my work: art and commercial. Galleries
in Hong Kong and Toronto represent my art photography, and I work with
advertising agencies and directly with clients on commercial projects.
I have my own studio and always work with my team, which consists
of a producer and assistants.

My own definition of the style that I try to achieve is: artistic, bold,
simple but strong, minimal.

My inspiration for the shoot was a Chinese legend about a girl who couldn't marry the man she loved and whose hair turned white from her emotional suffering; even though I was taking a nude photograph, I wanted the model to have a character rather than just being a body. To add dramatic effect, I decided her hair should be down to her heels, so the make-up artist commissioned a long white wig. As this was strong enough to act as a prop in itself, I kept the background simple – just a big piece of black velvet that would provide contrast with the naked body and the wig.

11:30 My assistant sets up the lights and the black velvet backdrop.

11:44 Alana, my model, has her make-up carefully prepared for the shoot.

11:46 I show Alana my sketch to explain the idea I am trying to achieve.

11:55 The make-up artist, my assistants, and I prepare for the shoot.

11:30

11:44

11:46

11:55

12:05

12:30

12:40

12:50

12:05 **The make-up artist** puts the long wig on Alana's head and adjusts the fit.

12:19 **My heavy** 10 x 8 inch camera is now set up ready for action.

12:30 **Alana is now** on the set and the make-up artist sprinkles white powder all over her body.

12:19

12:40 **Taking the first shot of Alana,** using my cable release.

12:50 **The next stage** is to process the first shot, which was taken on Polaroid 803 film but cross-processed using chemicals for 809 film.

13:30 **Checking and assessing** the first Polaroid is essential before carrying on with the shoot.

13:30

the shot

I used simple lighting for the shot, with three flash heads. My assistants set up one light on each side, one with a large rectangular softbox, the other with a strip softbox, which together outlined Alana's body and lit her hair strongly. The third light was mounted on a boom with an umbrella and placed in the middle next to the camera to act as a fill-in light to put some detail in the shadows. I asked Alana to hang from the chain by one hand, which was quite painful – we tried several shots, and finally she bravely managed to hold the pose long enough.

Processing

I processed the Polaroid film in a dedicated Polaroid processing unit. At room temperature, this takes about 60 seconds.

The Bride with White Hair

FOR THIS SHOT
Camera: 10 x 8 inch Wista field camera; 240mm lens
Aperture: f/16
Shutter speed: 1/125th of a second
Sensor/film speed: ISO 80
Lighting: Broncolor Pulso F4 flash heads

The camera

I bought this camera from a friend in the mid '90s, and although it's not the most expensive 10 x 8 inch camera available, it has helped me to produce many nice photographs.

Adding powder

The powder shaken onto Alana's body and the floor beneath her suggests dust and the idea that, though she is still alive, she hasn't moved or been touched for a long time.

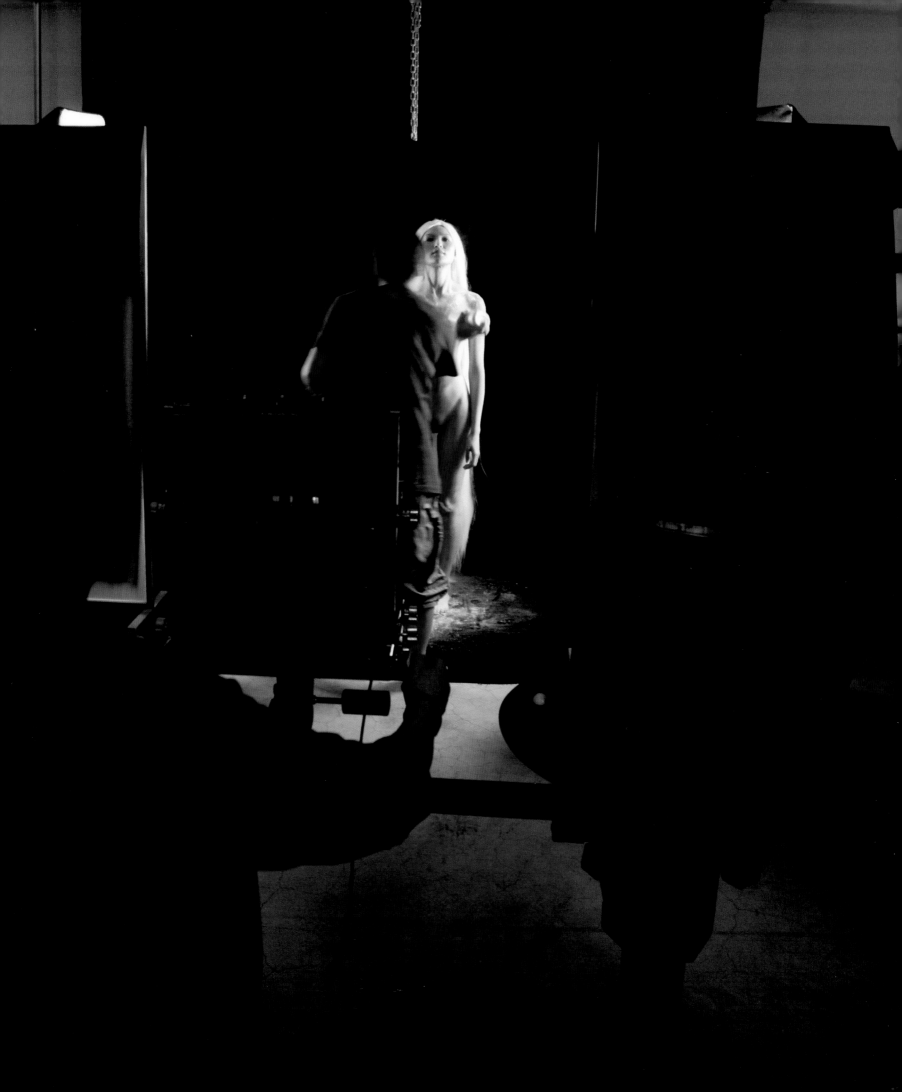

portfolio

△ *Nude No. 5*
The original photograph was in sharp focus, but I used
Photoshop to blur it so that the image became surreal.
People expect nudes to be sharp and clear, but I wanted
to challenge that and make the viewer question what is
real and what is not.

▷ *Laura*
I asked Laura to lie on the floor and adopt some "painful"
poses. I let her move freely and kept shooting until I had
taken more than 20 rolls of film, moving with her. The
interaction between photographer and model sometimes
produces unexpected photographs.

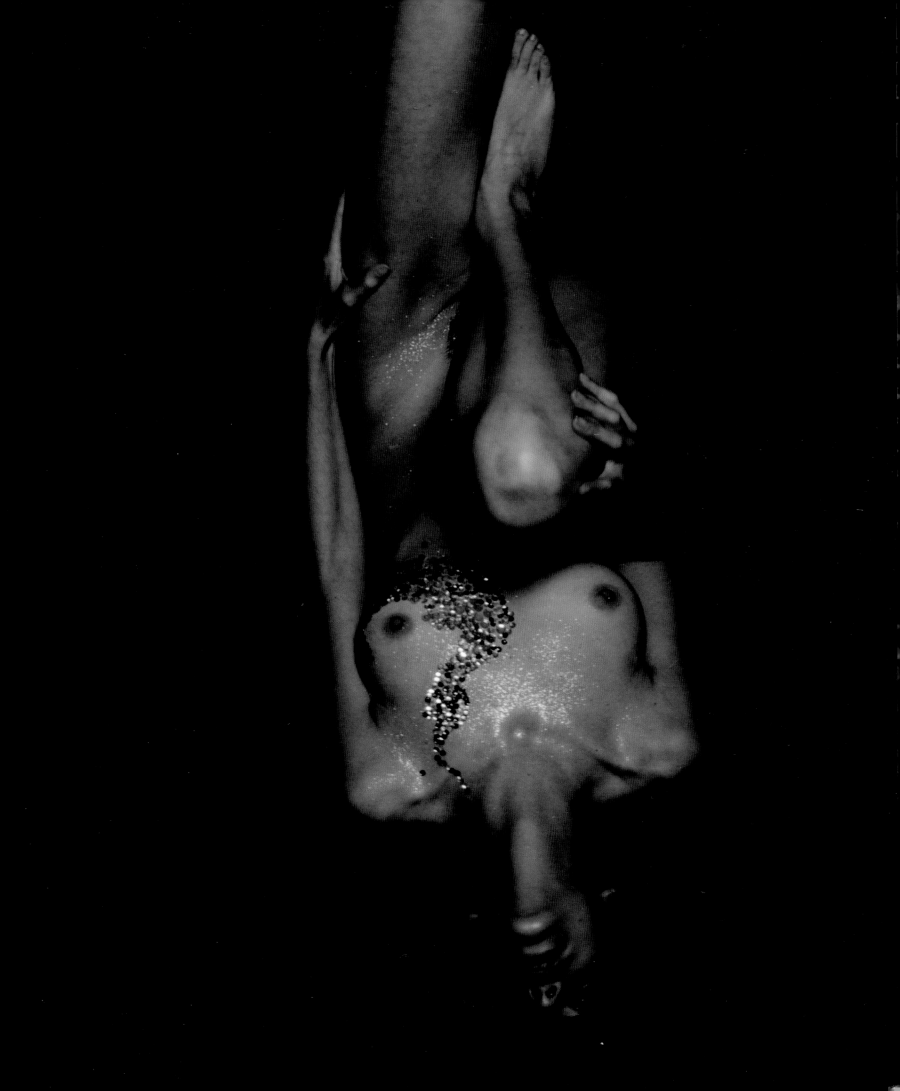

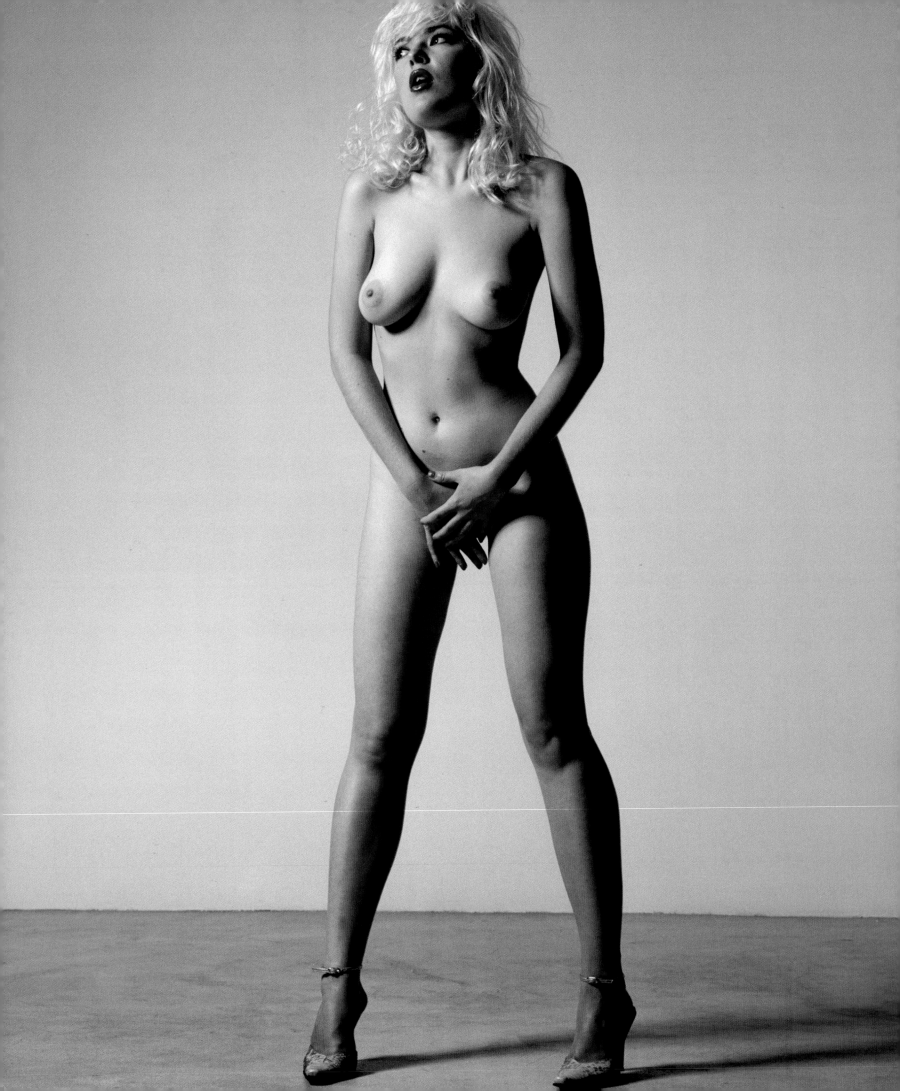

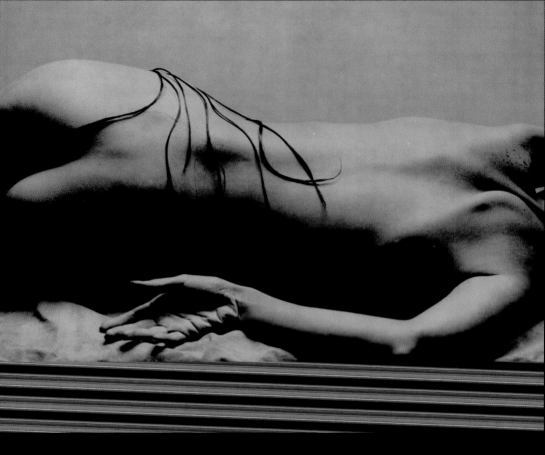

△ *Back*
My aim was to shoot a woman's back in a
disconcerting, abnormal way. I asked the model to lie
on the table and pulled her arm toward her back, palm
upward; she looks as if she has fallen from somewhere
high, her body distorted by the impact. The hair I added
to the lower part of her body contributes to the
unsettling effect.

◁ *Sasha*
I arranged Sasha in the middle of an empty space and
lit her from the left with a flash head with an umbrella.
The simple lighting was just good enough to sculpt her
figure. Sasha was a very shy girl who covered herself
with her hands throughout the shoot, but I find the
photograph interesting.

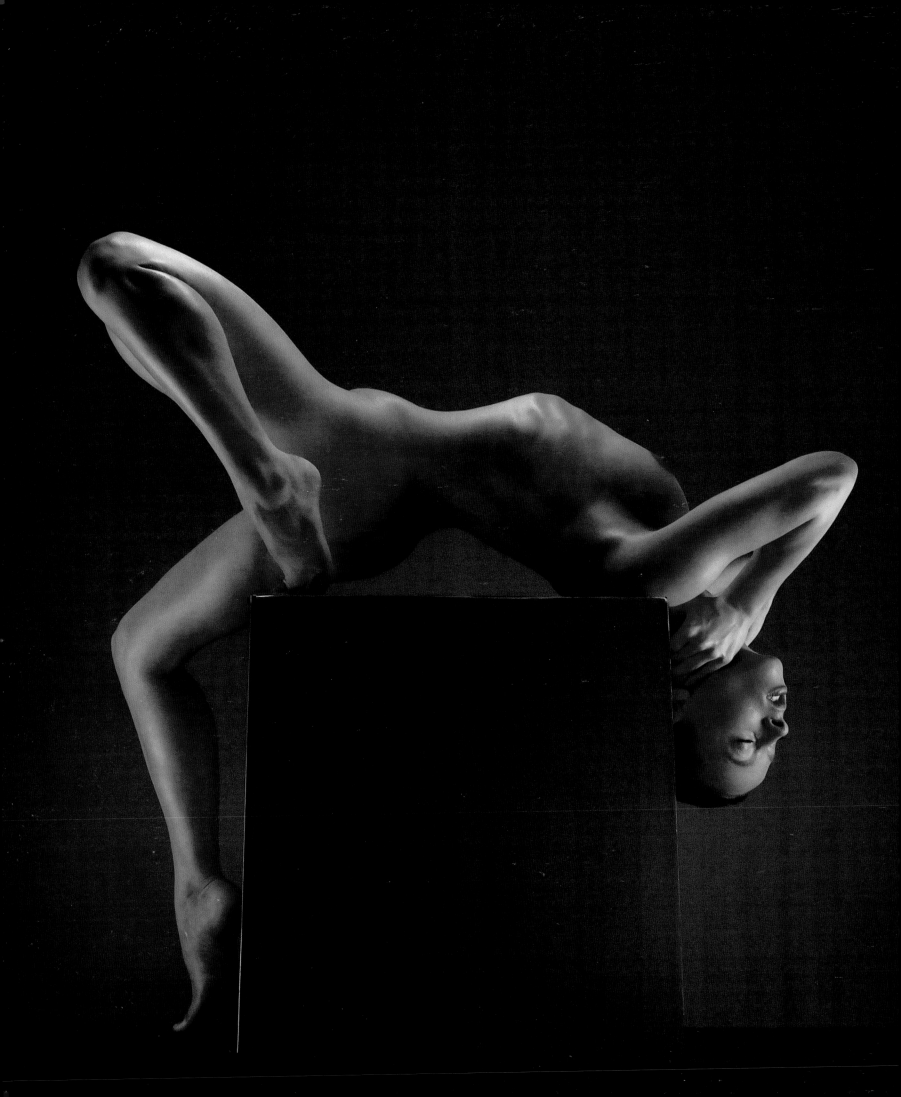

giorgio gruizza

Nationality Serbian
Main working location Serbia
Photographic method Film and digital

At the age of 10 Giorgio joined a local photography club and took a three-month course that was his entire formal photographic education. In the early 1990s he became a freelance photographer, but the political and economic conditions in Serbia brought his career to a temporary halt. However, by 2002, with an increasing number of commissions from magazines and advertising agencies, he set up the Unique studio and is now again a full-time photographer.

www.gruizza.com

As an adolescent, I discovered the beauty of Ancient Greek culture, particularly its sculptures. These, without question, laid the foundation for the aesthetic ideal which I struggle to achieve. I fell permanently in love with the human body, the human face, and human sexuality.

It is precisely that love (passion, even), combined with perfectionism and mathematical precision in playing with light, and having the power to discover and bring to the surface the most beautiful, intriguing, and inspiring aspects of my models' personalities, and then to shape that with the help of my imagination, that I consider my true photographic strength. My artistic work is very personal. There is no question that the final photographs are the result of an interaction, an understanding, and a good relationship between everyone involved. But more than this, they are products of a sophisticated, intimate game I play with my models.

The inner beauty and sensuality of my models, the influence of light and shadows on their bodies and faces – creating sculptural forms in tension, revealing the way I see their hidden sexuality – are much more important than equipment and techniques to me. The emotions that such forms provoke in me – admiration, excitement, and desire – are what I want to share with anyone looking at my photographs. Everything that I do is a function of transmitting my impression of the photographed person as faithfully as possible. I hardly ever plan my photos in advance. Everything usually depends on how the shoot develops, my mood, and the way I am inspired by the model's looks and personality.

Although I try to record my impressions as accurately as possible in order to reduce the need for post-production, I feel justified in using software in the finishing of the photographs. Photography is a modern, evolving art, so the photographer's way of seeing things, capturing images, and producing photographs should be too. However, as far as post-production is concerned, I think it is important that photographers do not cross the thin line which divides them from illustrators.

behind the scenes

I usually choose to work with self-confident, sensual models with fit, muscled bodies and a positive attitude. Bojana is an excellent example; her pierced tongue and lithe body inspired me to daydream and to experiment with some weird positions that required a model who was very flexible, both physically and mentally. I wanted her body to be as tight as a string, in a strong, sexy pose that would push fantasy to the limit in the minds of the viewers. I didn't want her to be on the floor – I needed something more dynamic, so we set up a cube for her to pose on.

10:22 **After some relaxed chat** with Bojana, Jovana starts applying natural make-up.

10:59 **A black backdrop** and extra light stands are ready in case I decide to use them.

11:07 **Next to the heater,** Bojana waits for oil to be applied to her skin.

11:25 **I check that my assistant** has set up the lighting as I requested.

10:59

10:22

11:07

11:25

11:50 **I help Bojana** to get into the initial pose while Jovana makes final adjustments to her make-up.

12:00 **The images** I am getting are so beautiful that I have to share my enthusiasm with Bojana.

12:40 **I conclude** that Bojana needs to get up on tiptoes.

12:00

11:50

12:40

13:00

13:00 **The details of a pose** are of crucial importance. I explain to Bojana where to place her left foot and also her hands, which in the initial pose somehow inclined the composition to the right.

13:25 **After taking a few shots** and viewing them on screen, I decide that the hands will need a final change of position before I shall be able to feel that I have got the right shot.

13.25

the shot

To throw a soft light on Bojana's face I put one 500 watt flash head with an 80 x 120cm (32 x 47in) softbox on the floor to the right of her. I placed another to the left to light the inside of her legs, but it wasn't my intention to make the image very provocative so I reduced the power by two-thirds of a stop. The third flash head went in the middle, fitted with a grid and placed on a boom 1m (3¼ft) above her to light her torso and separate her body from the background. Jovana stayed nearby, ready to touch up Bojana's make-up if need be.

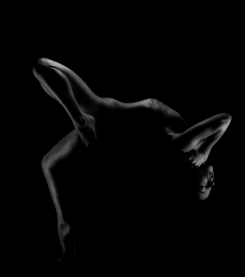

Metering the light

I took an incident light reading on Bojana's leg where the softbox was creating a highlight. There is no point in setting up beautiful lighting unless you also get the exposure absolutely right!

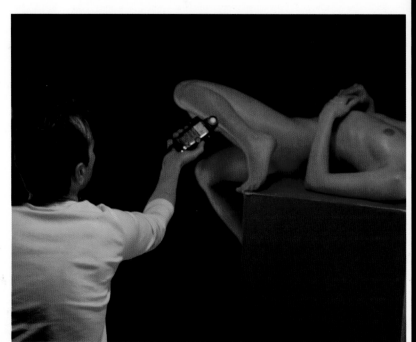

Bojana, Belgrade, February 2007

FOR THIS SHOT
Camera: Bronica ETRsi; 150mm lens
Aperture: f/22
Shutter speed: 1/125th of a second
Sensor/film speed: ISO 100
Lighting: Bowens 500 watt flash heads with softboxes and a grid

Changing to film

I use a digital camera to improve the pose and the lighting – it is faster and cheaper than Polaroids. This was the model's first nude shoot and it helped her to see the photographs as we worked, but for the final shots I then loaded up my film camera.

On-screen viewing

Once I was getting closer to the final lighting and pose, looking at images on the bigger screen made it easier to analyse them.

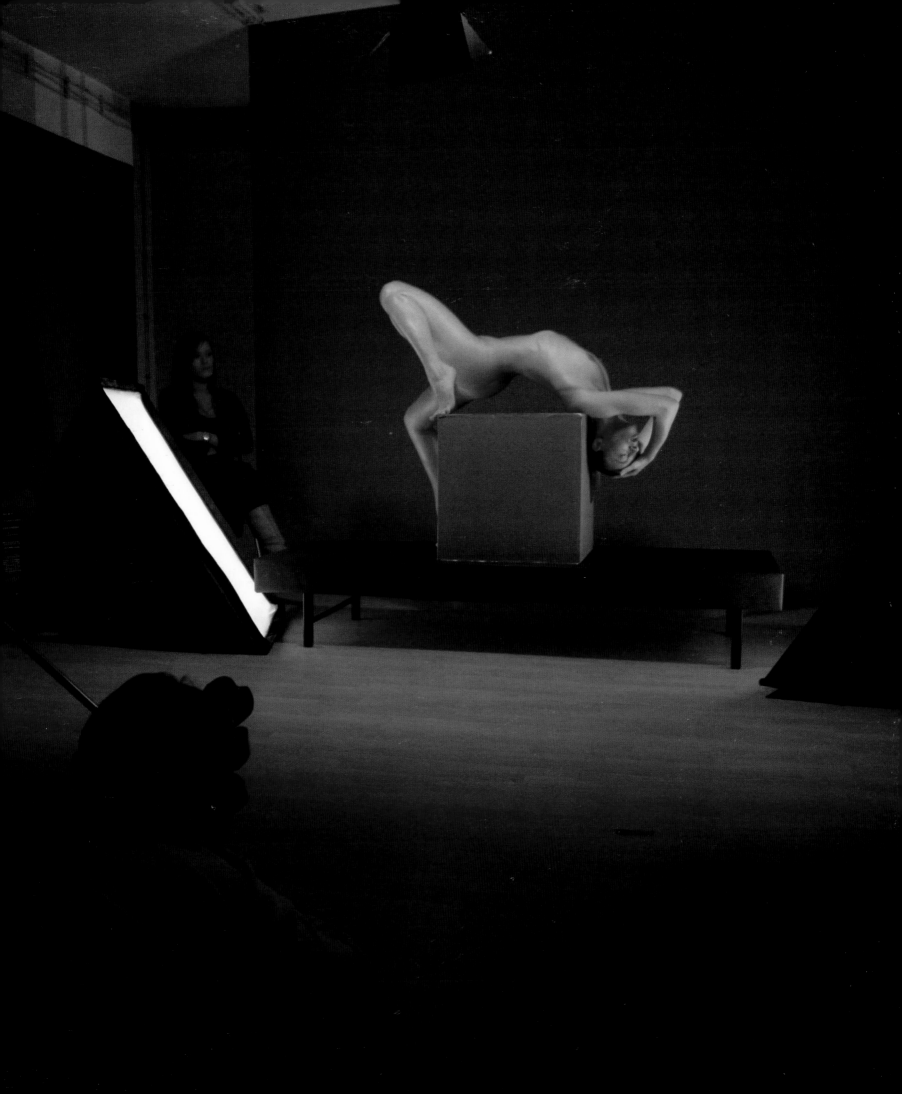

△ *Katarina and Maria, Belgrade, June 2003*
I used two flash heads with umbrellas to give soft,
mysterious lighting, with the models placed a little outside
the light. This was a spontaneous shot – I was
photographing two girls hugging when the beautiful heart
shape they were making grabbed my attention.

▷ *Djura, Belgrade, September 2005*
This photograph expresses my admiration of the strength
and beauty of the muscled male body and its sexuality.

△ *Maria, Belgrade, July 2003*
With her wonderful lithe body and great sexuality and
attitude, Maria was a great inspiration – she was one of
the first of my models and remains a favourite. This
photograph is lit to show all of her body and the pose
reflects her great energy.

◁ *Katarina, Belgrade, Spring 2003*
Shortly after I set up my studio I asked my girlfriend to
pose for me. I experimented with two flash heads with
softboxes to give gentle light. It was the first nude
photograph I was satisfied with and since then I have
been confident about the images I want to create.

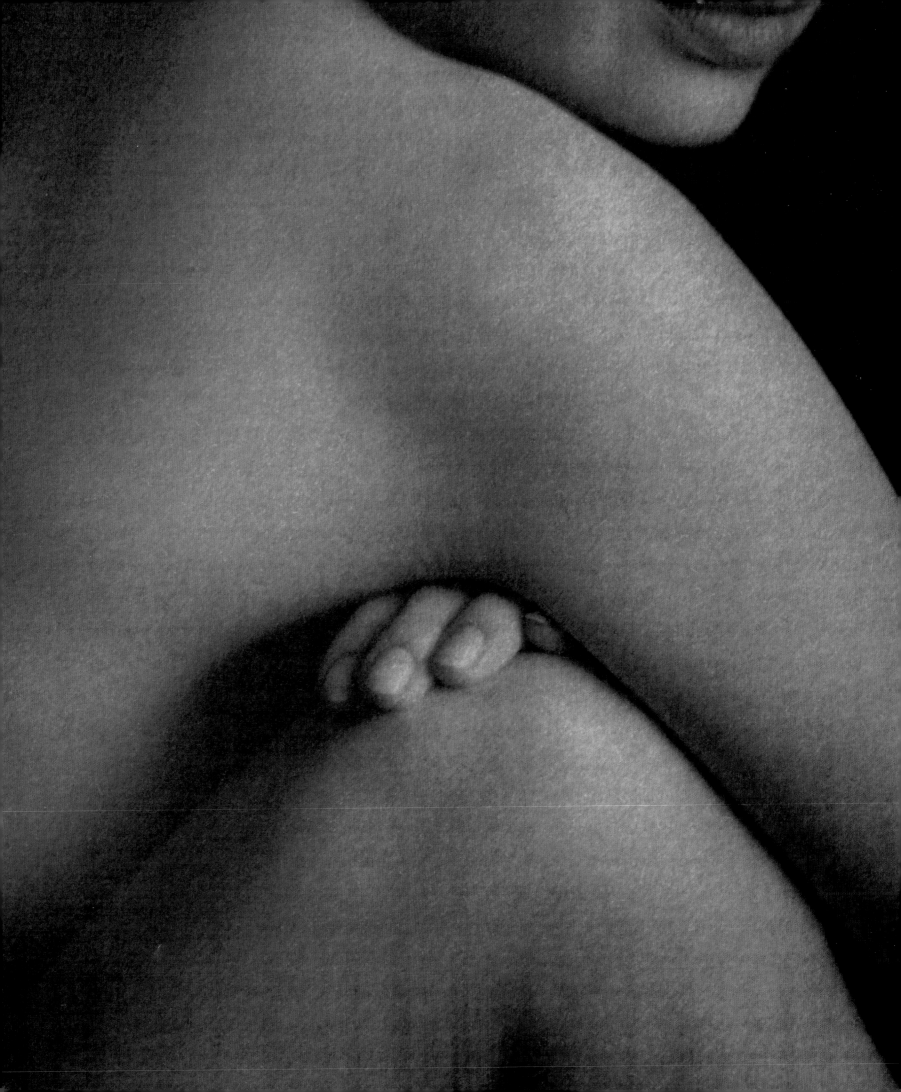

When I was at college a friend asked me for my opinion on a series of nude photographs she had made, and that inspired me to give it a go myself. Since then, I have photographed hundreds of people nude, most of whom are not professional models. In fact, the majority had never dared to pose nude before.

In this age of glossy magazines, supermodels, and aspirational advertising images, most people like to conceal their true selves behind designer labels and other accoutrements of a materially successful life. In contrast, the people who model for me want to pose nude to explore their natural beauty, without a mask. They act as a muse for inspiration and take part in the meditative process of becoming a vehicle for art.

I developed my personal approach instinctively; I didn't really know what style I had set out to achieve until it evolved by itself through trial and error. It's a natural style, taking the majority of its influence from classical art and nature. I'm inspired by the way that light makes the human body look magical and ethereal, and I'm fascinated by contrast: the sharp against the soft, the smooth against the textured, and the bright against the dark.

The women who pose for me all seem to feel incredibly fulfilled by doing so. Whether it be a reassurance of personal beauty or the desire to be recorded, recognized, or simply indulged in a world of art, the response is astounding. I am regularly commissioned to photograph women, and men too, nude, in the style that has become my trademark. I'm delighted by their appreciation of the results and also by their reaction to the experience of posing nude, which, once accomplished, brings a great sense of achievement.

allan jenkins

Nationality British
Main working locations London and Barcelona
Photographic method Large-format film and cyanotype printing

It was while he was studying Fine Art at the University of East London that Allan first developed his interest in using large-format cameras to photograph still lifes and nudes, the subjects for which he is most renowned. His images have appeared on numerous book covers and he has been the subject of several magazine articles on the art of posing naked. Represented in London by the Hackelbury Gallery, he is one of Britain's most respected fine art photographers.

www.allanjenkins.com

I have a very structured approach to a shoot, as there are so many things that could potentially go wrong; I need to work in an orderly fashion to get everything I want from the day. I explore my ideas beforehand in my sketchbook, making images to use as a starting point from which to take

inspiration. For this shoot I booked Valeria, with whom I have built up a very good working relationship. My studio suits my method of photographing and printing; it is homely, with books and bric-à-brac and an intimate atmosphere that is conducive to a calm, contemplative way of making images.

10:00 **I lay out the sketchbook** where I have already worked out some poses for the shoot.

10:15 **Valeria changes into a loose robe** so that marks made by her clothing will fade.

10:25 **I discuss the first pose** with Valeria, who is used to translating my sketches into reality.

10:30 **In the light from the single softbox,** we start trying out the pose.

10:00

10:15

10:25

10:30

10:40

10:40 **Before using** the large-format camera I always take a few shots on my medium-format one.

11:05 **It is now time** to change over to my 10 x 8 inch camera.

11:10 **I examine the** image in the viewfinder of the large-format camera.

11:05

11:30

11:10

11:35

11:50

11:30 **Having developed the negatives of** several poses, I hang them up to dry.

the shot

In one corner of the studio I set up a black velvet curtain and a flash head fitted with a softbox, though I used only the modelling light rather than the flash itself. Immediately beside it was a roomy table covered with a black cloth for Valeria to make herself comfortable on, with plenty of spare fabric that could be used to cover her feet or legs if I wished to exclude them from a pose. We got down to the shoot and, as usual, there were times when we had to work hard to keep the continuity and the feeling and times when everything glided along effortlessly.

Valeria's Fingers

Making an exposure

To expose the film to light I simply took off the lens cap and replaced it again. While I time it accurately, with a long exposure of 3 seconds a small fraction of a second either way isn't as critical as it would be with a fast shutter speed.

FOR THIS SHOT
Camera: 10 x 8 inch Kodak Eastman camera; 320mm lens
Aperture: f/6.3
Shutter speed: 3 seconds
Sensor/film speed: ISO 200
Lighting: Bowens Esprit Gemini 500 watt flash head with softbox

Retouching

There is a small amount of retouching needed to the print, which I do using a fine brush and my set of watercolour pigments.

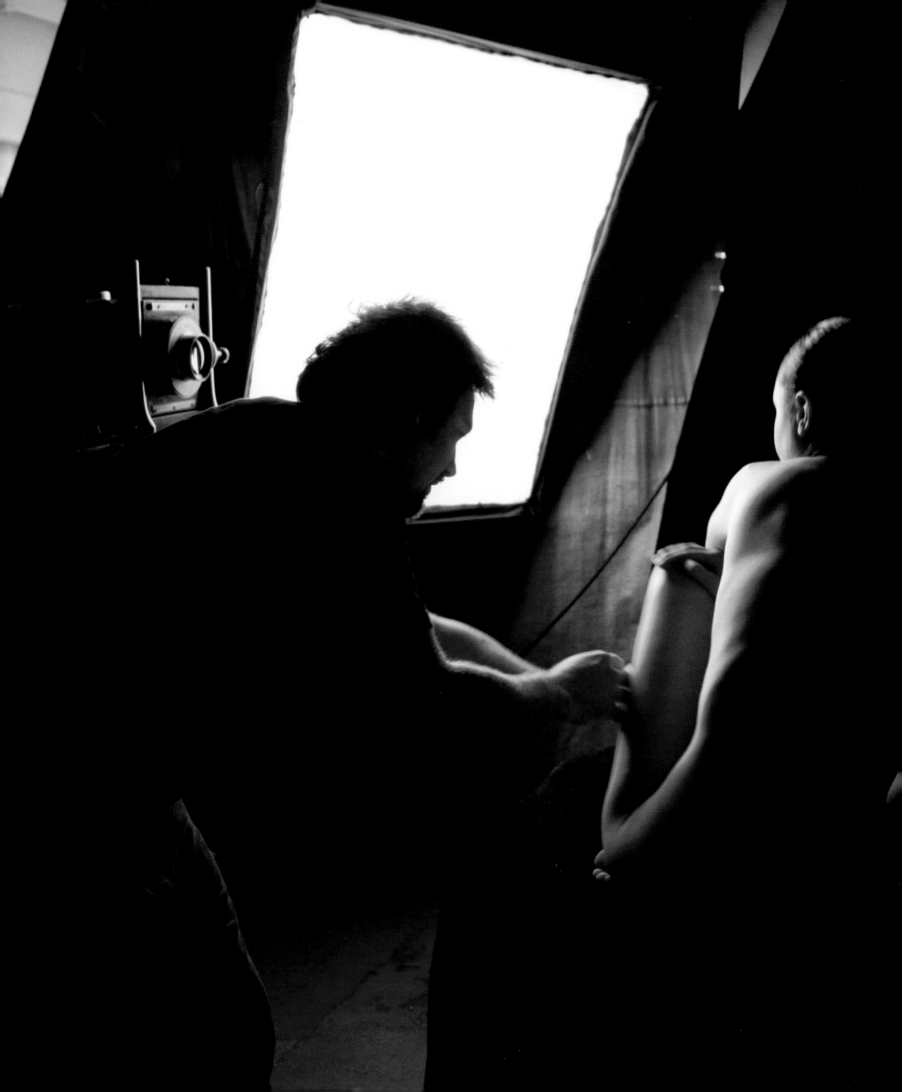

portfolio

△ *Anna's Hand*
This image was inspired by sculptural shapes. I gave it
a still-life effect with a shallow depth of field, using my
10 x 8 inch Kodak Eastman camera and a softbox for
lighting. It was printed in toned cyanotype. Contrast and
form dominate the composition.

▷ *Mel's Torso*
My objective here was to emphasize shape and I
therefore avoided identity by focusing on the body, with
no facial expression to distract from the composition.
Mel's body was lit only by a window to the side. I used
Ilford FP4 film and my 10 x 8 inch camera.

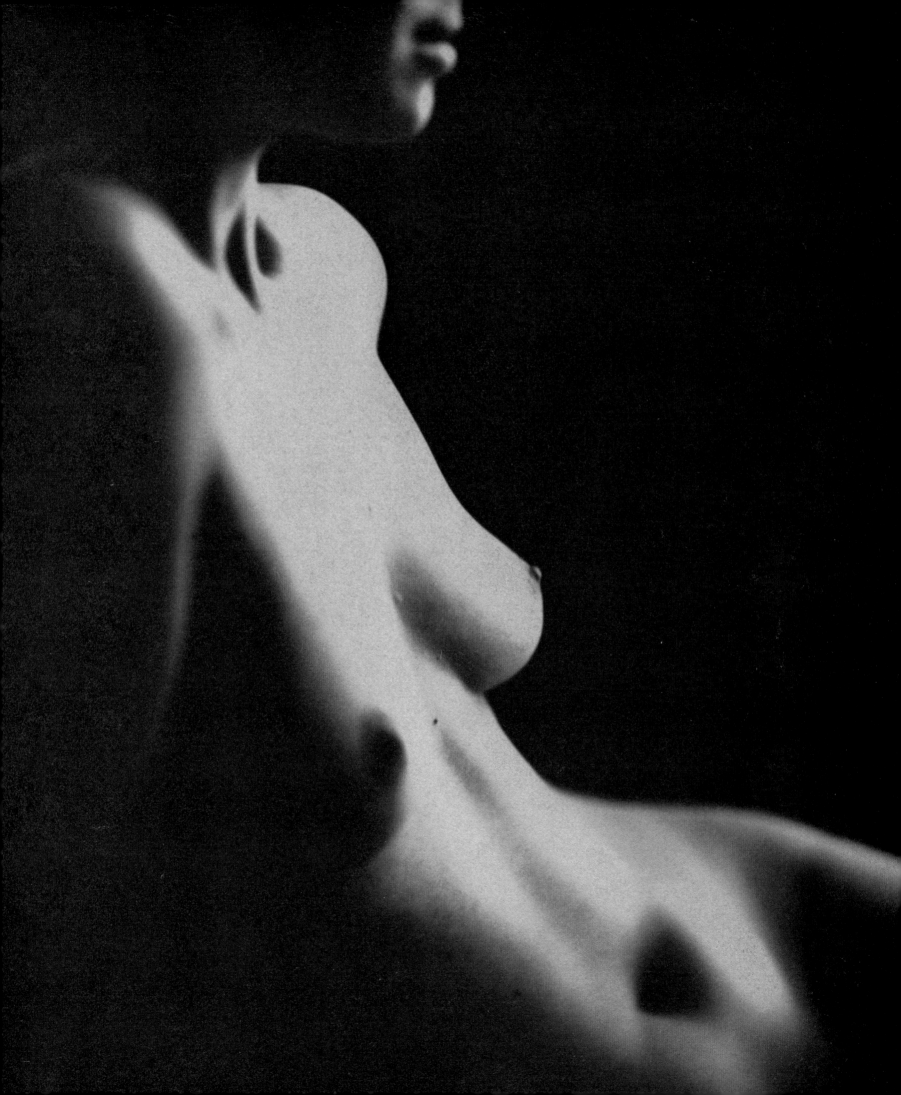

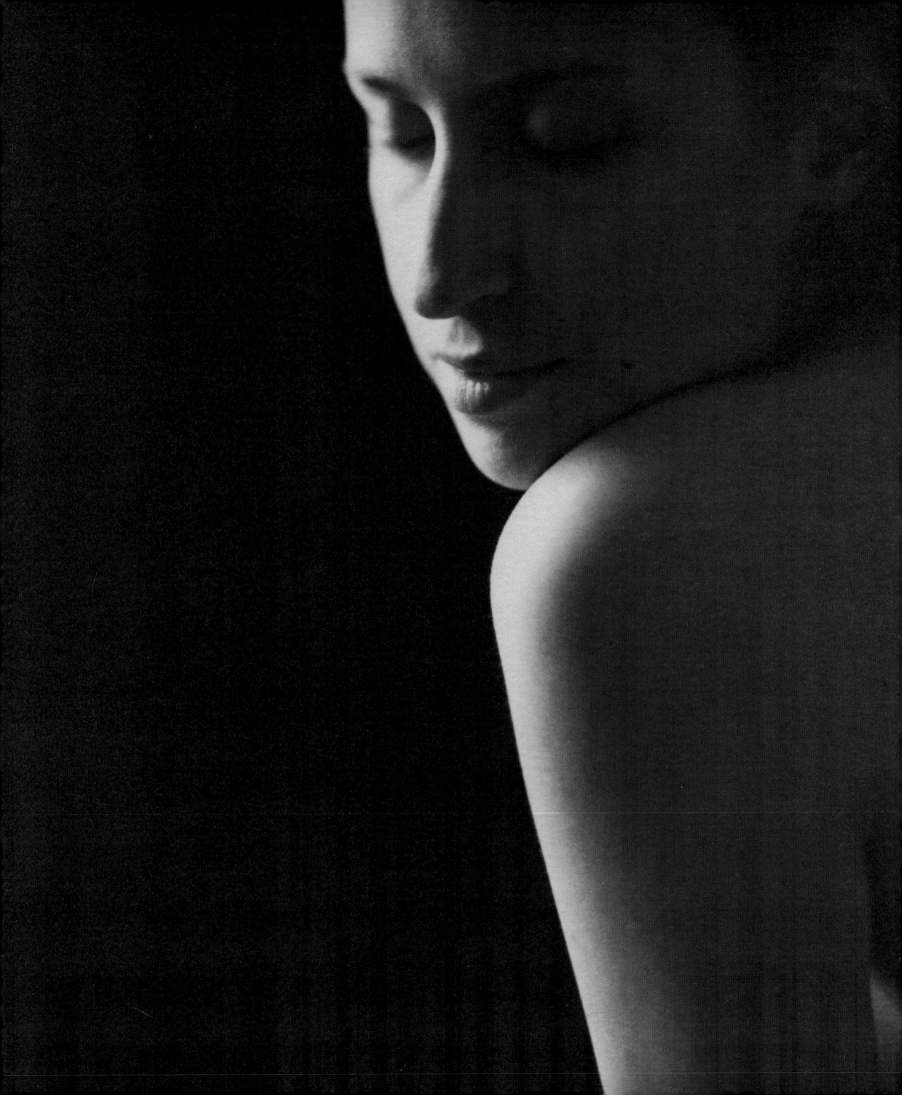

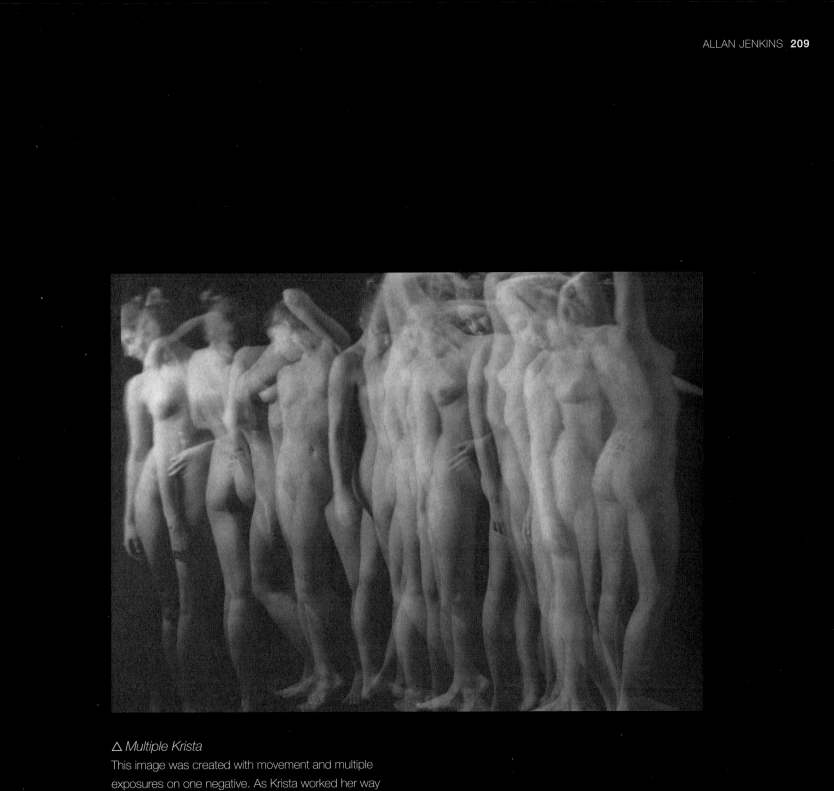

△ *Multiple Krista*

This image was created with movement and multiple
exposures on one negative. As Krista worked her way
across the frame we tried to make sure she fitted exactly

My desire to photograph black male nudes was born out of a need to counter the exploitative images of the black male as featured in pornography. My intention is to offer a point of view that highlights black men's sensuality, and even their vulnerability. Historically, black men have been viewed as a threat, and their sexuality posed an even greater threat, at the same time eliciting much curiosity and desire on the part of others. I aim to show the black male nude as a work of art, neither denying his physical assets, nor flaunting them. I prefer to use amateur models with a sense of adventure because they can possess a raw talent, a desire to be discovered, and will often work harder than professional models to get the right shot. My work is inspired by natural light and by models who have a zest for creativity, and my creative process is very organic in that I have an open mind, and the ideas arise and flow as I shoot. I photograph from an emotional place and I want that to be reflected in my images.

My style is a combination of the classical, sensual, romantic, and erotic. I use both digital cameras and 35mm and medium-format film cameras, frequently working with a combination to maximize my choices. I prefer digital cameras for my male nude photography, though, because of the immediacy that the medium provides. I like environmental interiors and outdoor locations, nearly always relying on natural light to enhance the mood of the photograph. Emotions are everything in my work. They can be the model's emotions as conveyed in the photograph, or the emotions that the photograph evokes within the viewer. Working with natural light makes me feel like nature had a hand in creating the photograph, and gives me a sense of the intricacies of life. The shots are framed in the camera, and I always aim for correct exposure and contrast, so that in the end there isn't a need for any post-production process apart from editing.

I liken my process to that of a painter who doesn't know what the finished painting will look like – each brushstroke is critical to the final image. My photographs are my brushstrokes. Who knows what the finished painting will look like...?

ocean morisset

Nationality American
Main working location Brooklyn, New York
Photographic method Film and digital

Ocean Morisset is a self-taught photographer who has made the transition from a career in the medical profession, having worked for some years as a Medical Technician in HIV/AIDS. He spent more than three years working mainly in the field of journalism and documentary photography before starting to explore the male nude as a subject in 2004.

www.musecube.com/nycphotographer

For this shoot, I arranged to borrow a friend's apartment that has beautiful, diffused light as well as stunning views of Manhattan. Very little preparation was required as I intended to use only natural light, but when my model, Hercules, arrived we sat down for a while with croissants and orange juice to discuss the shoot. No matter how keen I am to get on with things, it's important to spend time answering the model's questions so that he knows what is expected of him and what the outcome of the shoot will be – in this case, a book on the art and craft of nude photography.

11:30

11:50

11:30 I ask Hercules to do some push-ups to get

12:10 Trying out poses – I will often study a range of poses without taking a photograph.

12:15 I reject this image – somehow the body language isn't right.

12:25 However, I am now certain I want to use the kitchen for the main shot and am ready to photograph the first pose.

12:25

12:40

12:15

12:50

12:40 I know I am close to what I want, but although the light is great, I decide again that this pose doesn't work for me.

12:50 The light, body position, facial expression, and incorporation of a coffee mug to add to the mood work really well for me and I decide to base my main shot of the day around this set-up.

14:00 A couple of hundred shots later I am still creating images to make quite certain that I have everything I need!

14:00

the shot

As this shoot took place in an apartment I wanted to create images that reflected a "domestic" nude at ease in the home environment. Simplicity was the key. I positioned Hercules next to the kitchen window, allowing diffused light to fall very lightly on the left side of his body. To enhance the mood of the photograph, and to avoid being too literal, I photographed from the right, shadowed side of Hercules's body, capturing a beautiful silhouette. His position and expression evoke an introspective mood; the mug completes the look.

The human body

One of the reasons why the nude is a subject of endless fascination to so many photographers is the beautiful way the light falls over the body's contours, just as it does here.

Morning Coffee

FOR THIS SHOT
Camera: Canon 20D; 70–300mm lens
Aperture: f/8
Shutter speed: 1/350th of a second
Sensor/film speed: ISO 400
Lighting: Natural light

Composing the shot

Rather than cropping images in the darkroom or on the computer, I take care to frame the composition as I want it when I take the shot.

portfolio

△ *Undressing, 2005*
I wanted to capture the eroticism of a voyeur watching
a man through a peephole doing something as simple as
undressing. To create the effect of the peephole I used
a long lens hood on a short lens and shot at a low angle
to crop the model's head out.

▷ *I Am, 2005*
The low camera position, the model's pose, the drape
of the sheer curtain behind him, and the words "I AM"
all conspire to make this a strong image. It reflects
something regal, proud, and empowering. The diffused
natural light worked to my advantage.

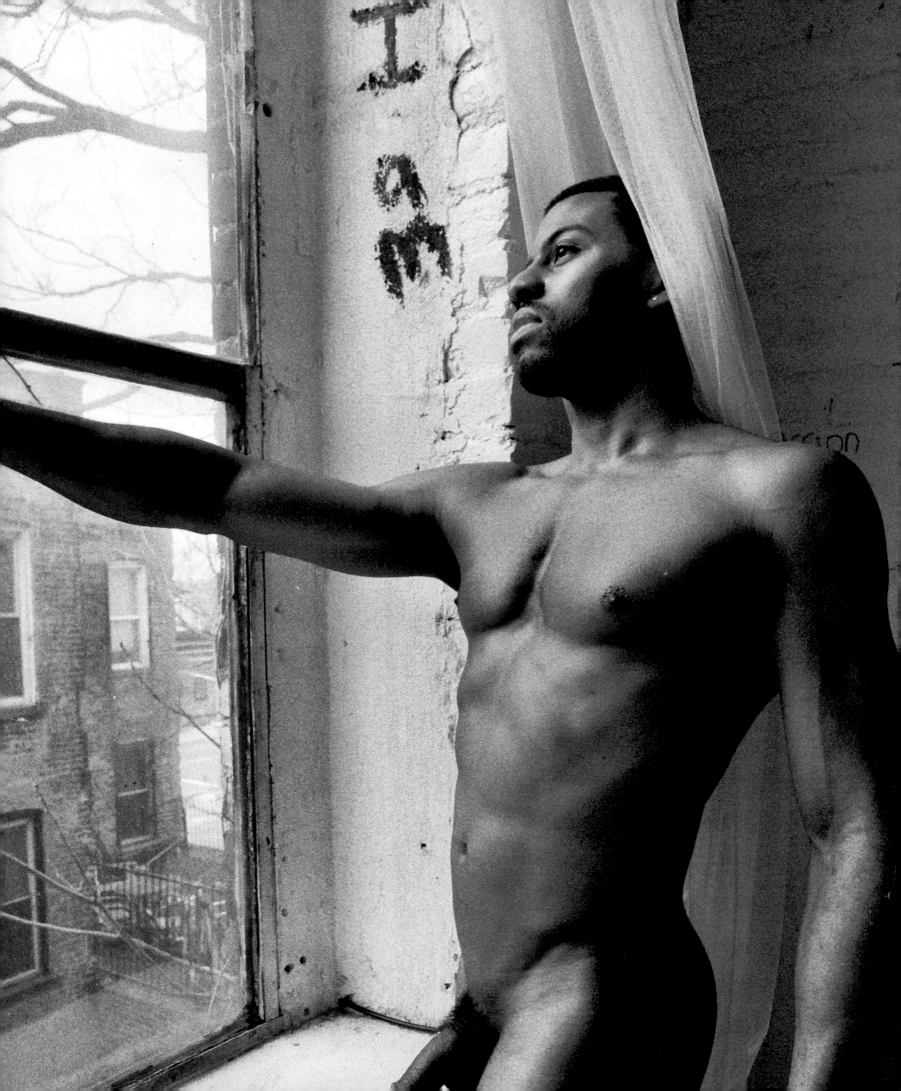

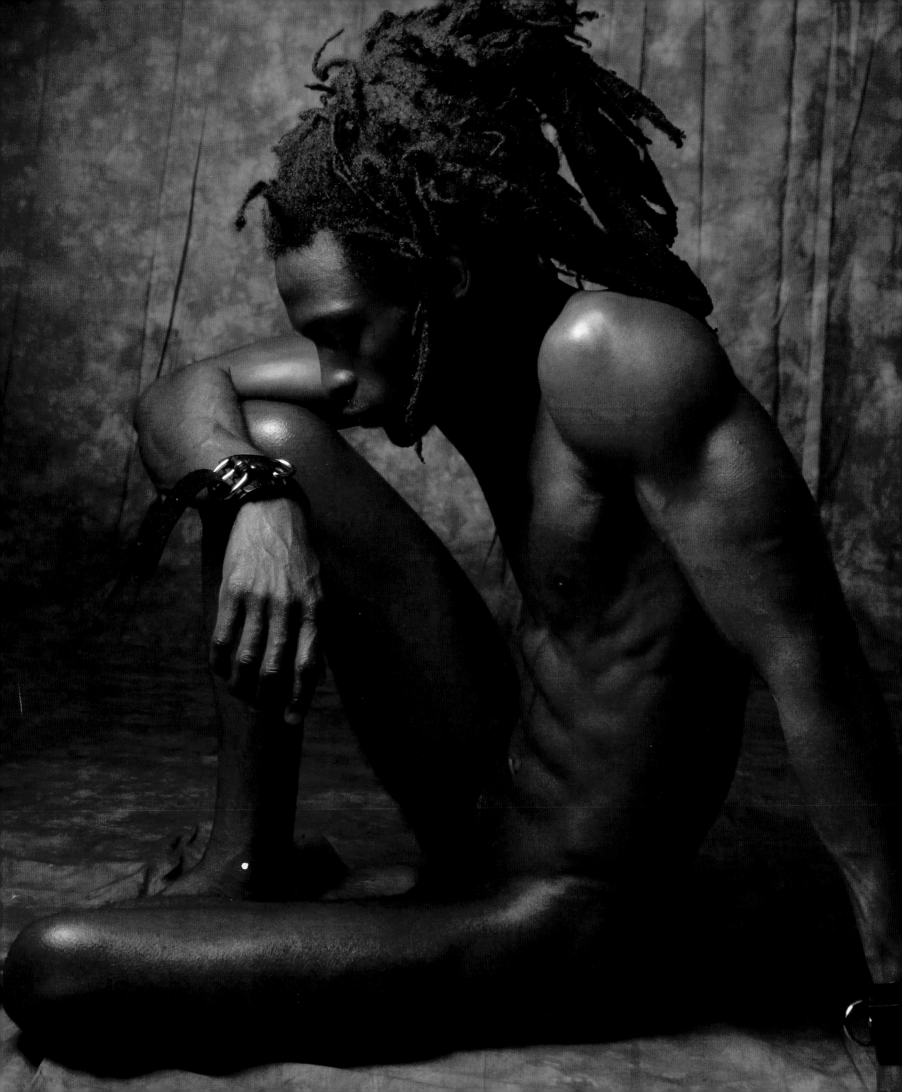

△ *Repose, 2007*
In this more classical and romantic shot the simple use
of light, a plant, and the model's position creates the
sensual mood. I placed the model next to the window so
that the light would bathe about three-quarters of his
body, leaving the rest in shadow.

◁ *Untitled nude dread, 2005*
Here I used one strobe with a spot attachment pointed
at the background and another on a softbox above the
model. The black leather cuffs represent the bondage
of slavery – a strong topic, but the model's position and
soft lighting add a level of sensuality.

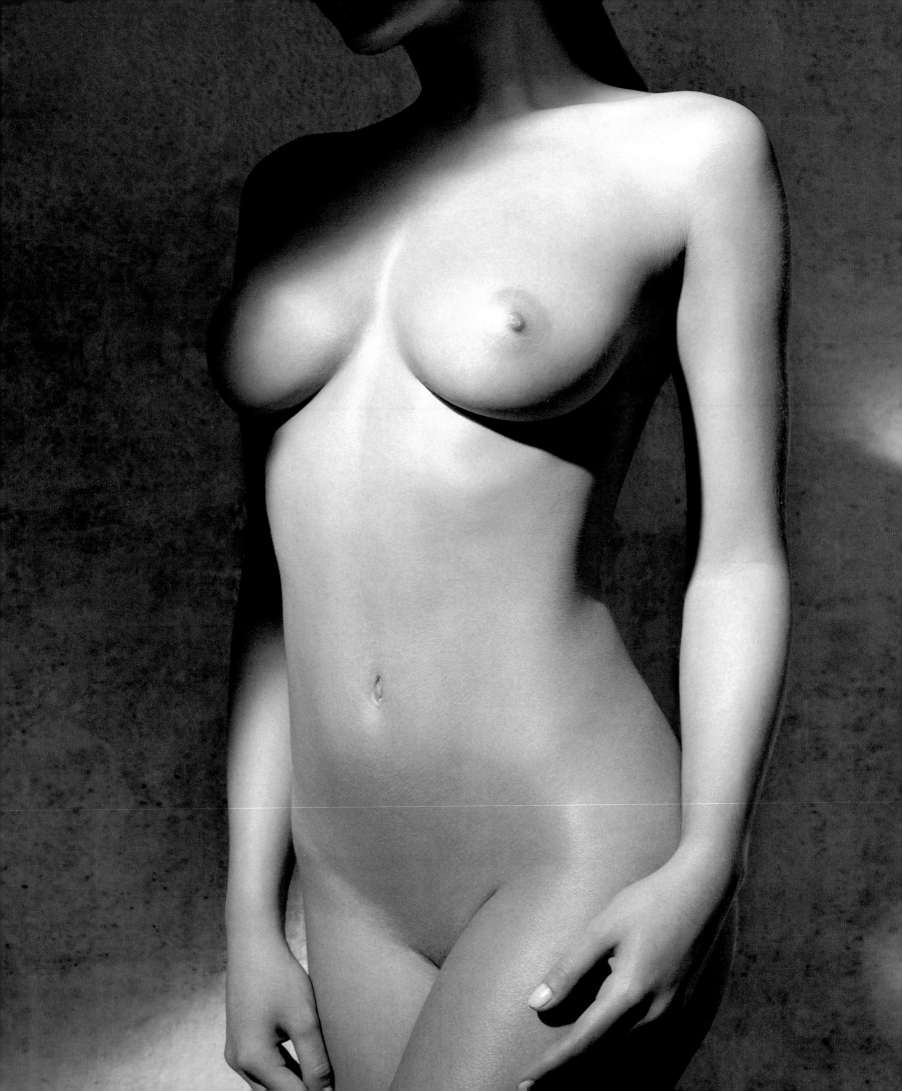

gavin o'neill

Nationality New Zealand
Main working locations Paris
and Sydney
Photographic method Film and digital

Gavin began taking photographs in the
early 1990s as a hobby, his full-time job
being a drummer in a rock band. After
the band split up, photography became
his new creative outlet. He worked part
time in bars while practising his skills,
then went full time towards the end of
the '90s. He currently lives in Paris and
works for a wide mix of clients, mainly
in the field of beauty and body images.

www.gavinoneill.com

My approach to photography in general is quite simple: I consider my main role as a photographer is simply to observe what is in front of me rather than to construct it. For this reason I tend to keep lighting, exposure, and equipment very basic so that I can work intuitively when I shoot, allowing myself space and time to be influenced and inspired by what I am seeing, and what I am feeling, without being caught up in technicalities.

My work with the nude is very much done this way. I don't usually plan anything more than the choice of model and location, so that everything else that happens on the shoot is purely creative and unscripted. The only thing I preconceive is the quality of the picture I want.

I have had no formal photographic training at all, and started quite by accident after I picked up a camera one day and discovered that I could naturally sense the power of shape and structure once I placed a frame around my eye. I was drawn to the nude purely from an aesthetic point of view as I love the human form, and I simply looked for a way to capture it by mixing graphic and fluid composition with interesting photographic concepts in clear and simple images.

I shoot mainly outdoors, because I love working in wide open spaces and finding unique natural textures to use. Variation is a big factor for me too, so I like the fact that two completely different locations might be only metres apart, and also that the natural lighting and weather conditions can change from one day to the next, which also might inspire me in different ways. I always work in remote locations, and with very few people on set – often only myself and the model – as I like to keep the area I am shooting in uninhabited by anything or anyone. I usually stop shooting if someone is nearby as I find it breaks my concentration, and I don't want to attract attention to what we are doing.

My nude work is shot primarily on digital now, although I sometimes still use black and white film – usually TMax 100 or XP2 400 for their minimal grain and smooth tones.

behind the scenes

My preparation for this shoot was fairly simple, mainly the coordination of the studio, make-up artist, model, assistant and lighting. I chose a very old and weathered-looking studio with rough-textured walls to try to create the illusion that we were outside. The main preparation with the model, Alienor, was to make sure she looked tanned as it's very important for the skin tone to be brown – in this case the tan was fake. I had kept the lighting order to the hire company minimal as on nudes I prefer to work with just one light source. I also hired some black panels to control the light.

09:30 **As we arrive at the studio in Paris** (with fresh croissants) it is filled with natural light.

09:50 **Elsa, the hair and make-up artist,** prepares her table for action.

10:42 **After straightening Alienor's hair** Elsa applies her make-up.

11:10 **Applying a bronze body cream** helps to create contrast in a black and white photograph.

09:30

10.42

09:50

11.10

11:35 **I begin to work** with a flag to cast shadows on the wall.

11:45 **Some final adjustments** are needed before I can start shooting.

11:50 **I position the light** at an angle that will replicate the slant of the afternoon sun.

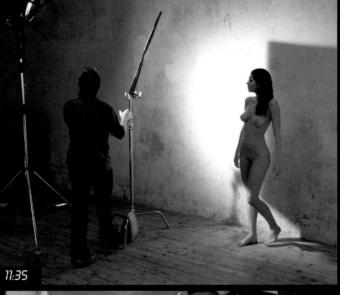

11:35

11:50

11:45

11:55

12:40

11:55 **Alienor starts** to go through some poses while I concentrate on crops and composition.

12:40 **Alienor's hair gets slicked back** for the final set of pictures.

13:00 **I try a new series of shots** to see how the new hairstyle looks.

13:10 **The set closes in** around Alienor as I get the light and shadows the way I want.

13:10

13:00

the shot

I used just one light to shoot this image, with white and silver reflectors in the surrounding areas and a black flag on a light stand between the light and the model, to throw a shadow across her body and darken the background. The idea behind this lighting set-up was to use shadows on and around her to create a kind of vignette, in order to emphasize the parts of her body I wanted to show. I ended up cropping this image quite tightly to maximize subtle lines that would also draw the viewer's attention to certain areas of it.

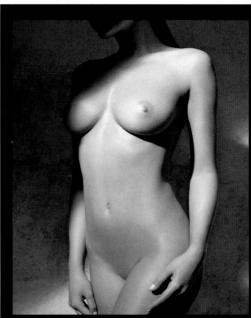

Alienor, Paris, 2007

FOR THIS SHOT
Camera: Canon 1DS Mark 2; 50mm lens
Aperture: f/8
Shutter speed: 1/125th of a second
Sensor/film speed: ISO 160
Lighting: HMI 2.5k

Checking progress

Looking at images on the camera screen during shooting is not only great for checking progress but also for keeping the model inspired. I also check the exposure by bringing up the histogram on this screen.

Using a reflector

My assistant held the white side of a reflector above Alienor's head to fill in some of the shadow details with a bit more light. This is particularly important when shooting digitally, as the shadow area is usually very underexposed, and this makes it difficult to extract detail from the shot.

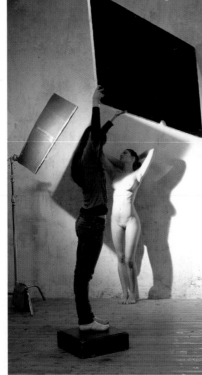

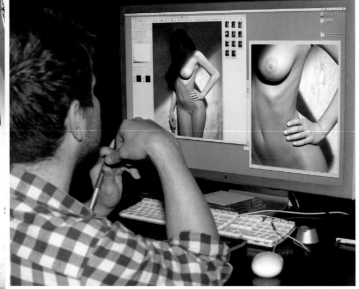

Checking the shots

Following the shoot I checked the sharpness of the images, having applied black and white conversion and contrast effects.

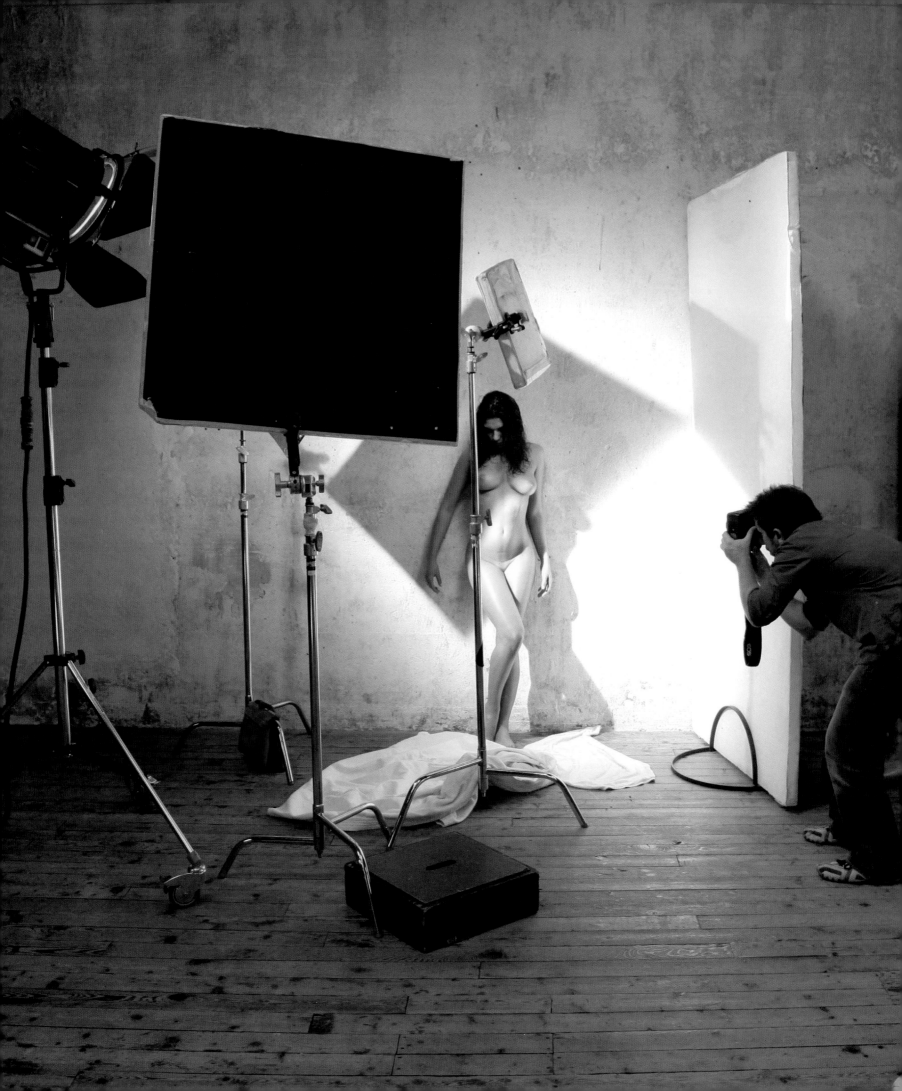

portfolio

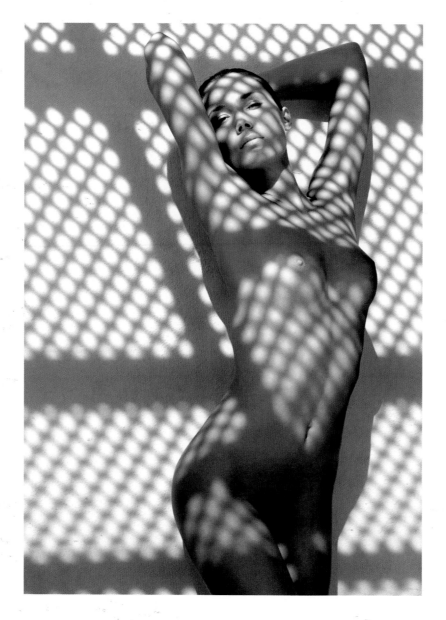

△ *Katie, Formentera, 2006*
This comes from a shoot where I used shadow patterns
over the body for the first time in my nude work. I love
the pattern itself, cast from a sunshade over a patio, but
I also very much like the slim and feline look and shape
that the model has.

▷ *Sylvia, Cape Town, 2002*
There is only one nude shot I have ever completely
preplanned, and this is it. The concept would have been
too hard to get spontaneously, so I shot the model lying
on black material on the ground while I stood high above
her on the roof of my apartment.

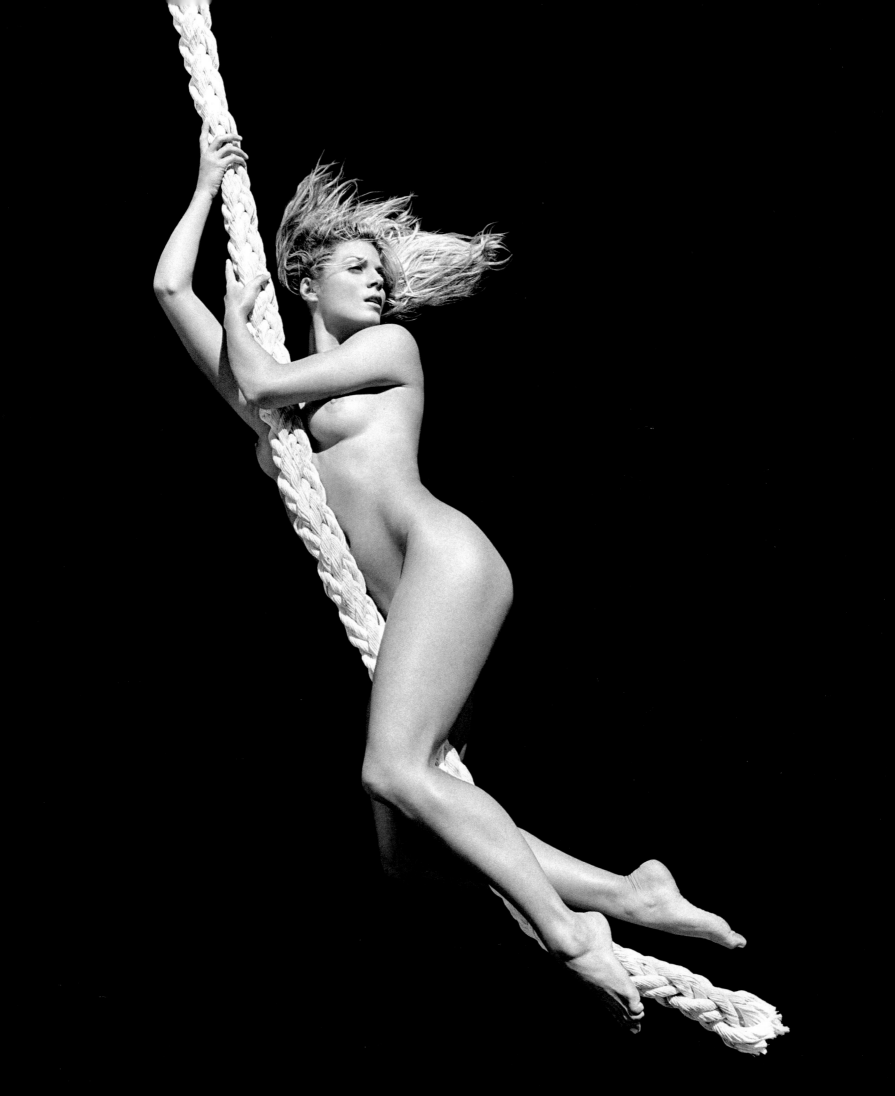

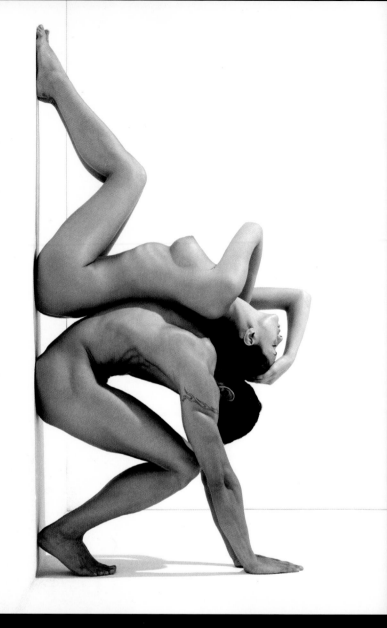

△ *Nick and Ivana, Milan, 2001*
These two models had never met each other before
our shoot but they worked very well together, producing
a series of simple, graphic poses. This one was shot
with my camera turned 90 degrees to one side – they
are actually sitting down.

▷ *Francesca, Ibiza, 2003*
An impromptu shot that I took in Ibiza, this was achieved
by simply running a hose through a rainwater pipe on the
back of our villa and shooting in the afternoon sun. I used
a shutter speed of 1/180th of a second to freeze the
water while still maintaining a fraction of movement.

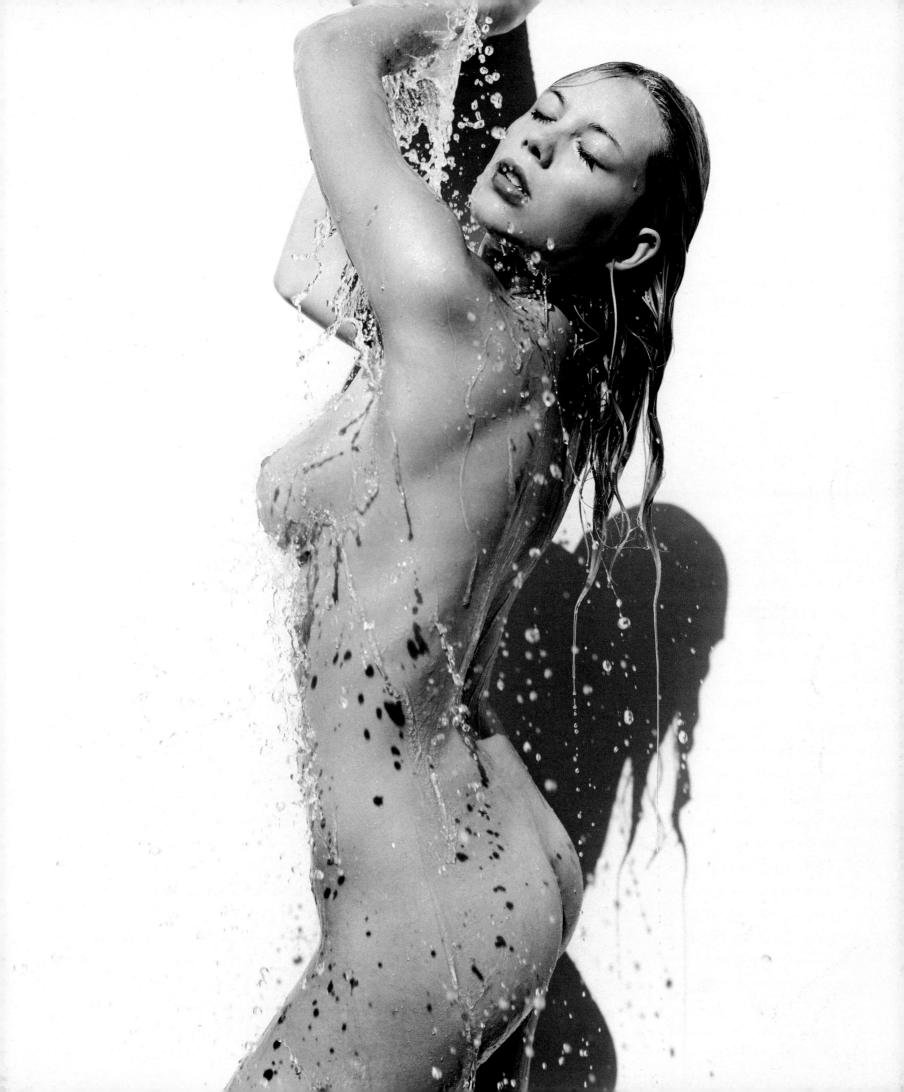

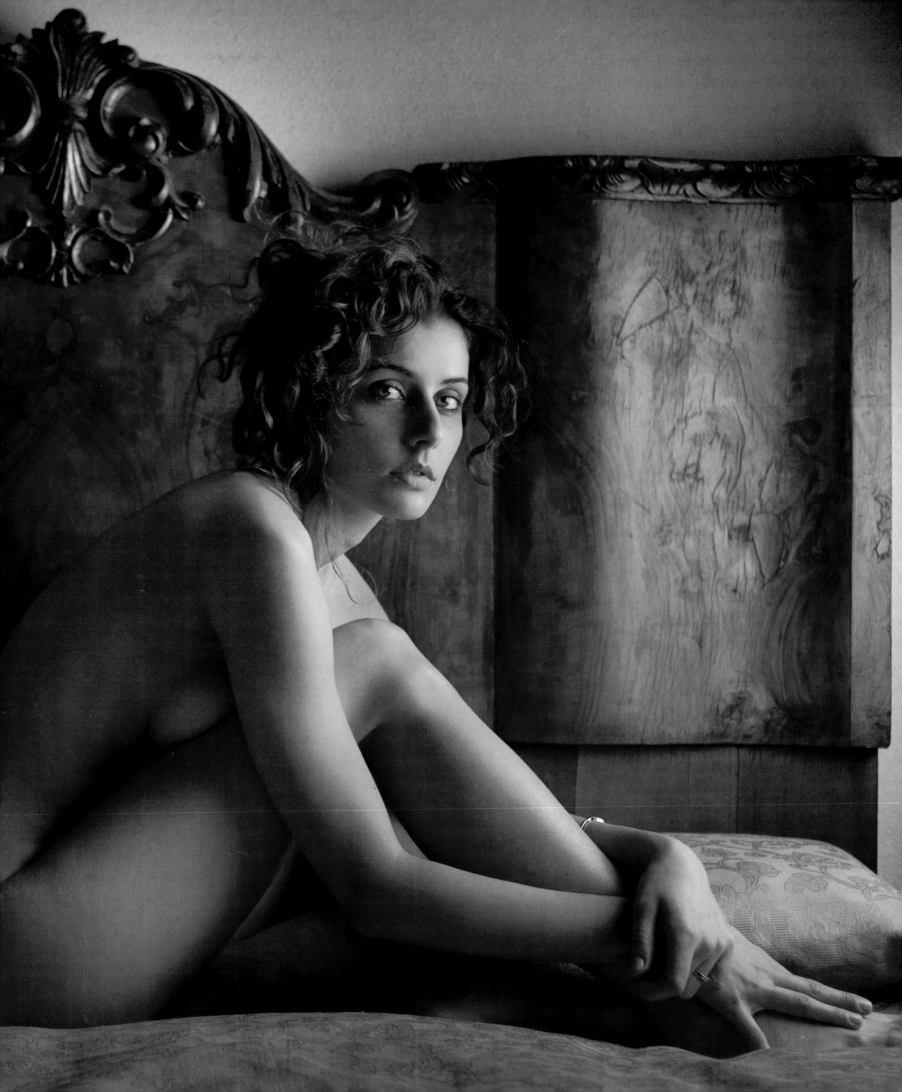

In my opinion, every woman can be a model because every woman has about her a femininity that a good photographer should be able to draw out. But if you don't know the model personally, it's harder to interpret her beauty and, however nice-looking she is, she may not be a good subject for fine art photography. The models I use are all girls that I know and most of them aren't professionals – in fact, some of them have posed only for me. I prefer to work with just a few models and build up a long working relationship, as the better you know your model the better your images will end up being. When a model is used to you she feels less inhibited in front of the camera, she can anticipate the type of photograph you want, and she can give you all her sensuality and beauty. It is a sort of sensual game, and it is your goal to steal a little bit of her privacy – but never more, of course, than she will permit.

Today, most erotic images are fleeting, even furtive, on TV and in films. Fine art photography allows us to enjoy the classical values of the human body as a thing not just of beauty but also nobility. If you look at the statues of Ancient Greece, nothing has changed since then in the way that beautiful women are portrayed. I think the female nude is nature's finest form; I am so moved by it I try to translate what I feel into images. In every photograph I take, I freeze a woman's mood in time and create an eternal symbol of beauty. The truth is that I am a romantic, and when faced with female beauty the only way for me to say something is with poetry, translated into an image.

gabriele rigon

Nationality Italian
Main working location Italy
Photographic method Digital

Gabriele Rigon was born into photography, as his family had run a studio since the time of his great-grandfather. Rather than making it his career he joined the Italian armed services, for whom he is now a helicopter pilot. His first serious foray with his camera was in reportage work, recording a UN mission in Namibia. Today he shoots nudes for many international magazines and his work has appeared on more than 40 book covers.

www.gabrielerigon.it

behind the scenes

I chose Valentina as my model for this project because to me she is a symbol of Italian beauty. We carried out several shoots in different locations, and for the last one of the day I decided to use a typical Italian hotel room to complement her looks. Of all the locations, this was the one that worked best for me. By that time we had spent quite a few hours together and there was a good atmosphere between us. I felt that taking some fine art nude portraits of her on the bed would work well, using the simple poses which seem to me the most beautiful as they reflect the reality of life.

14:30 I prefer my models to have a natural look, so Valentina applies only a little eye make-up.

14:35 The movements of a woman undressing are so intimate and often unconsciously erotic.

14:36 Valentina's mother is also there to watch the shoot take place.

14:48 Though Valentina has never posed nude before our shoot, by now she is entirely relaxed.

14:36

14:30

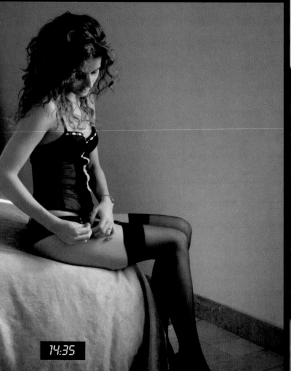

14:35

14:48

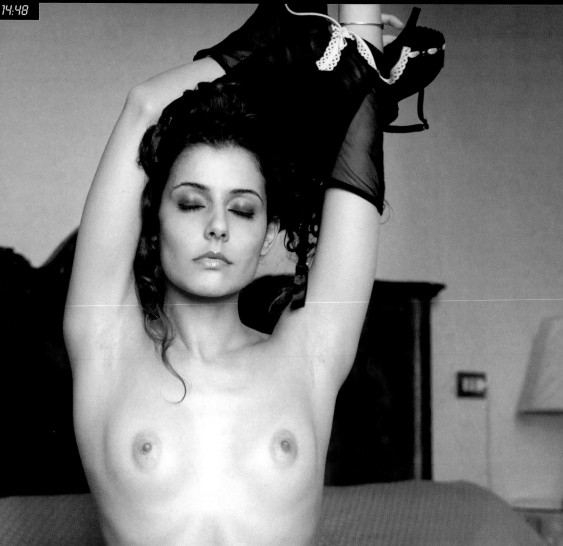

14:55

14:55 I get Valentina to position her hands, a fundamentally important element in fine art photography. Even pretty hands can look unattractive if they are at the wrong angle to the camera.

15:00 I always ask my models to make gestures such as touching their hair or covering parts of their body.

15:10 While I am behind the camera I keep talking to my model.

15:40 I look through the pictures together with my model at the end of the shoot. It is my way of confirming her beauty.

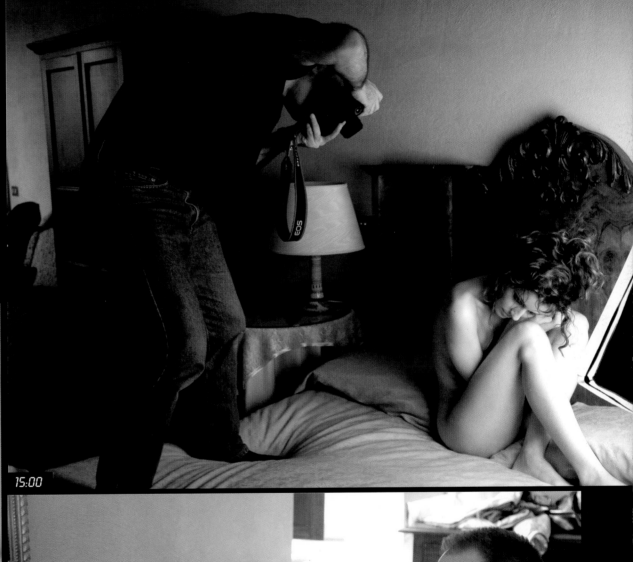

15:00

15:10

15:40

the shot

What I particularly liked about Valentina's position on the bed was the warm colour of the wooden bedhead, harmonizing with the golden-yellow bedspread. I took pictures for about 10 minutes, then started walking around her, getting her to try different angles and poses and talking to her while I did so. I set up a single light fitted with a 70 x 70cm (28 x 28in) softbox to give a gentle, warm light that would suit the colouring of the background and of Valentina herself, then took about 40 photographs of her, asking her to look at me, look down, and so on.

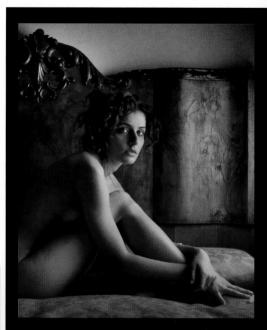

Valentina

FOR THIS SHOT
Camera: Canon D Mark II N; 35mm lens
Aperture: f/2.8
Shutter speed: 1/50th of a second
Sensor/film speed: ISO 400
Lighting: 650 watt IFF lamp continuous light

Finding beauty
The photographs from this shoot are sensual rather than erotic; they are beautiful because of Valentina's eyes and the expression on her face.

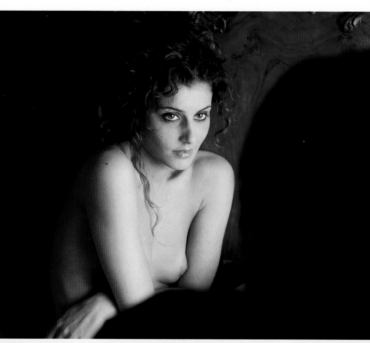

Changing the light
I tried to take advantage of the natural light flooding into the room, but after looking at the shots I was getting I felt that the light wasn't particularly flattering to my model at the angle at which she was sitting. I decided to draw the curtains, which made the vital difference.

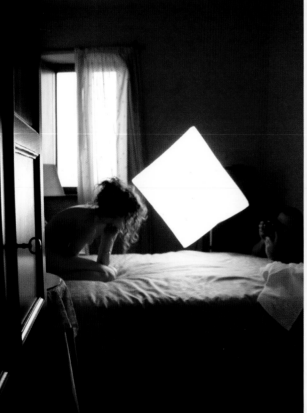

A different angle
This is an attractive pose and the light is falling beautifully on her face but, in the end, it was not my favourite from the shoot.

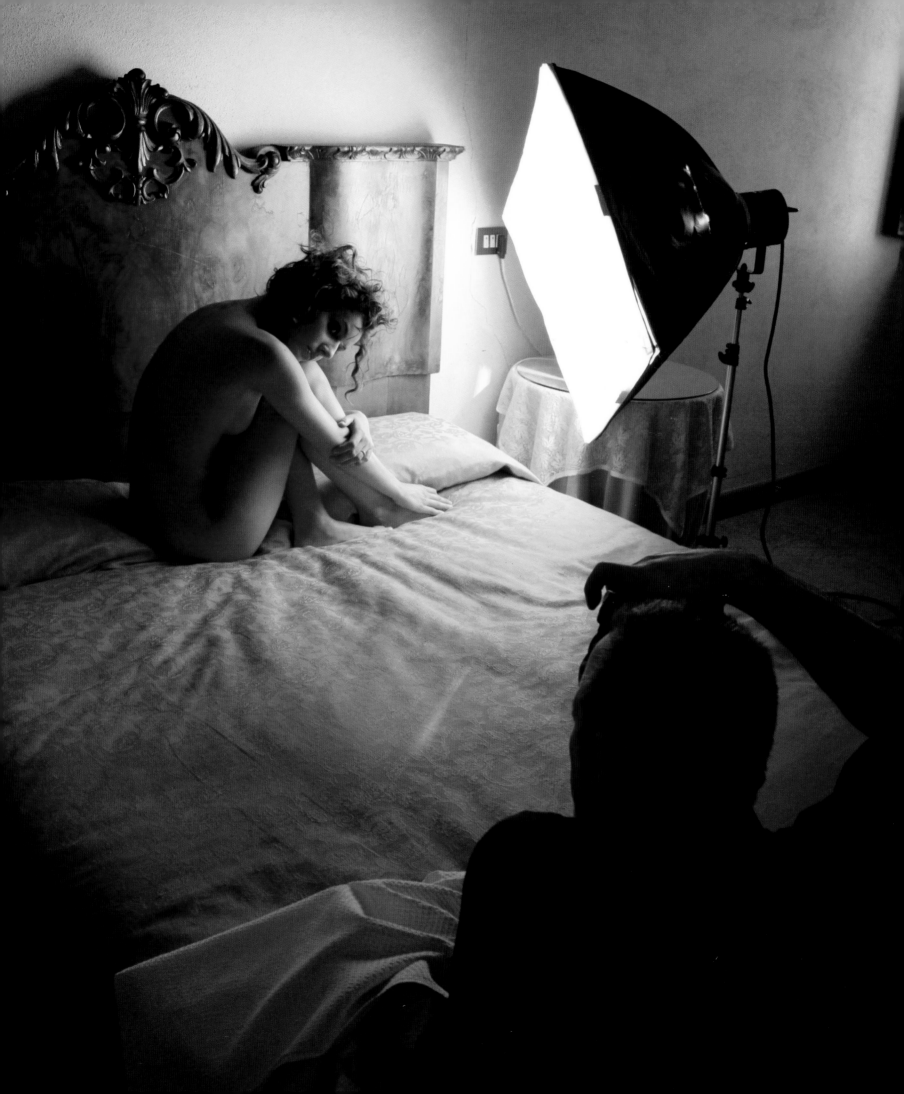

portfolio

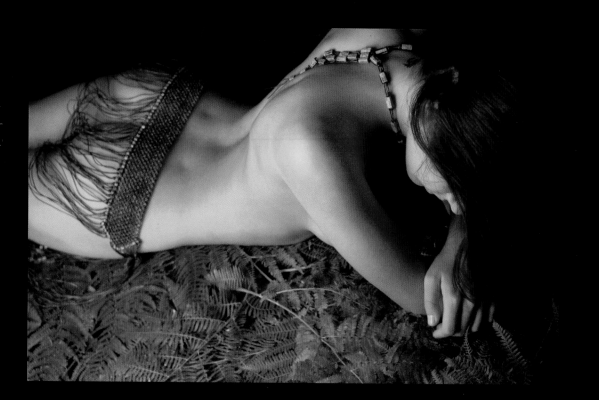

△ *Treasures*

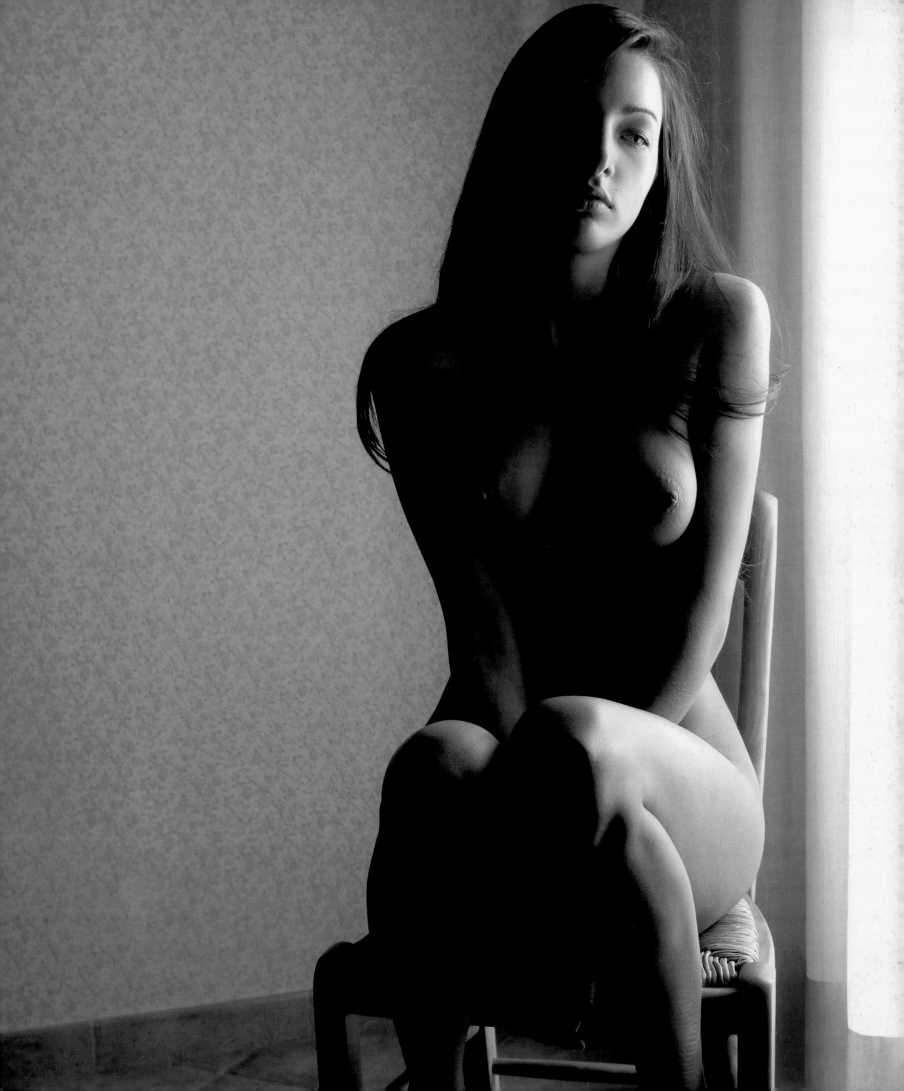

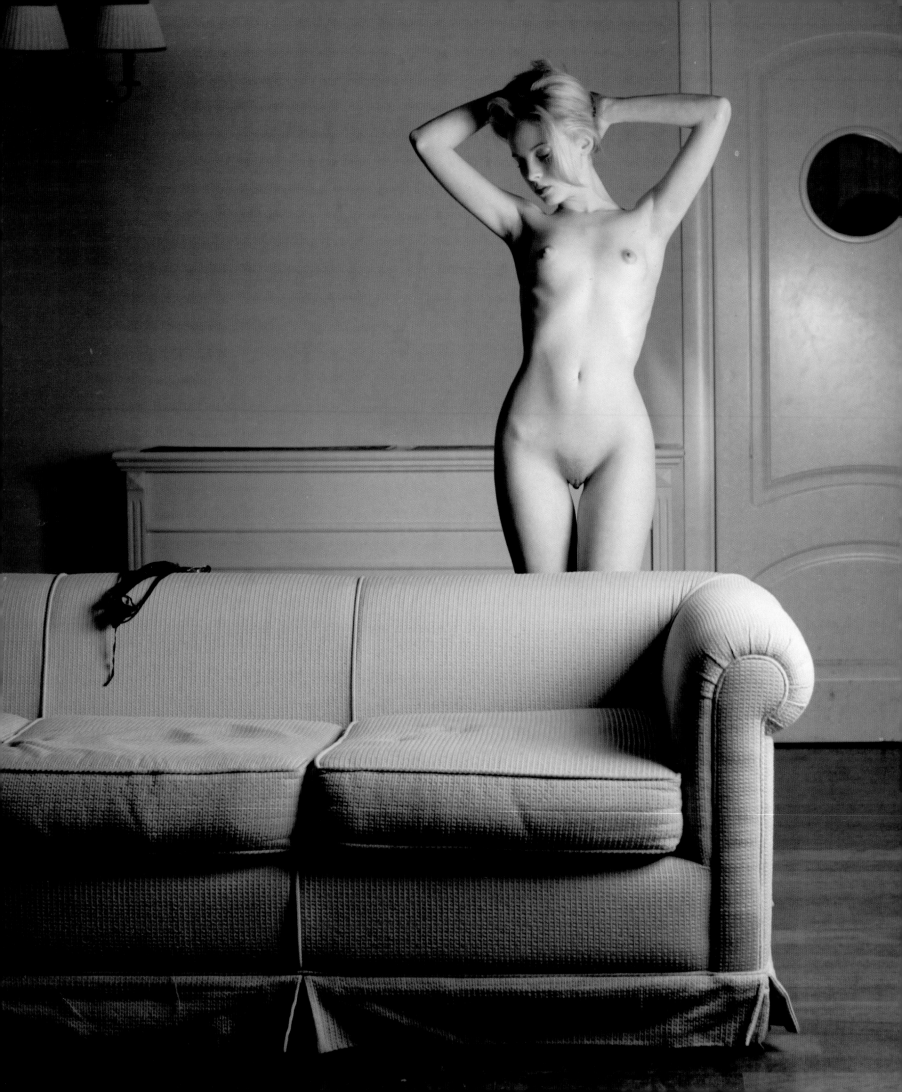

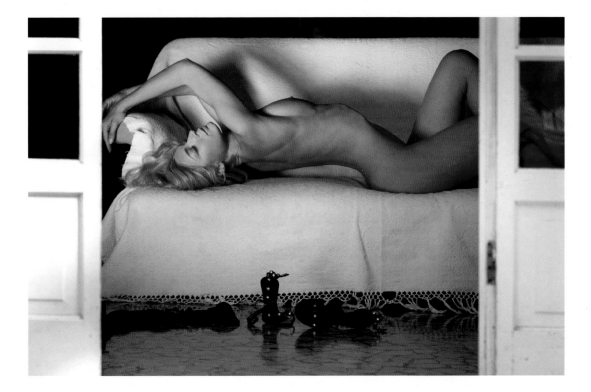

△ *Sofa Sexy*

We were at a beautiful villa in Italy and while I was looking for a good location in the garden I saw this door and sofa. I took the shot from the garden – all I needed to do was to put a white panel in the room to reflect the sunlight on to Federica's body.

◁ *Undressing*

This photograph was taken inside a hotel. There wasn't enough light, so I set up a softbox to the left of Floriana and photographed her undressing. I like the lingerie on the sofa because it encourages the viewer to create their own fantasy around the image.

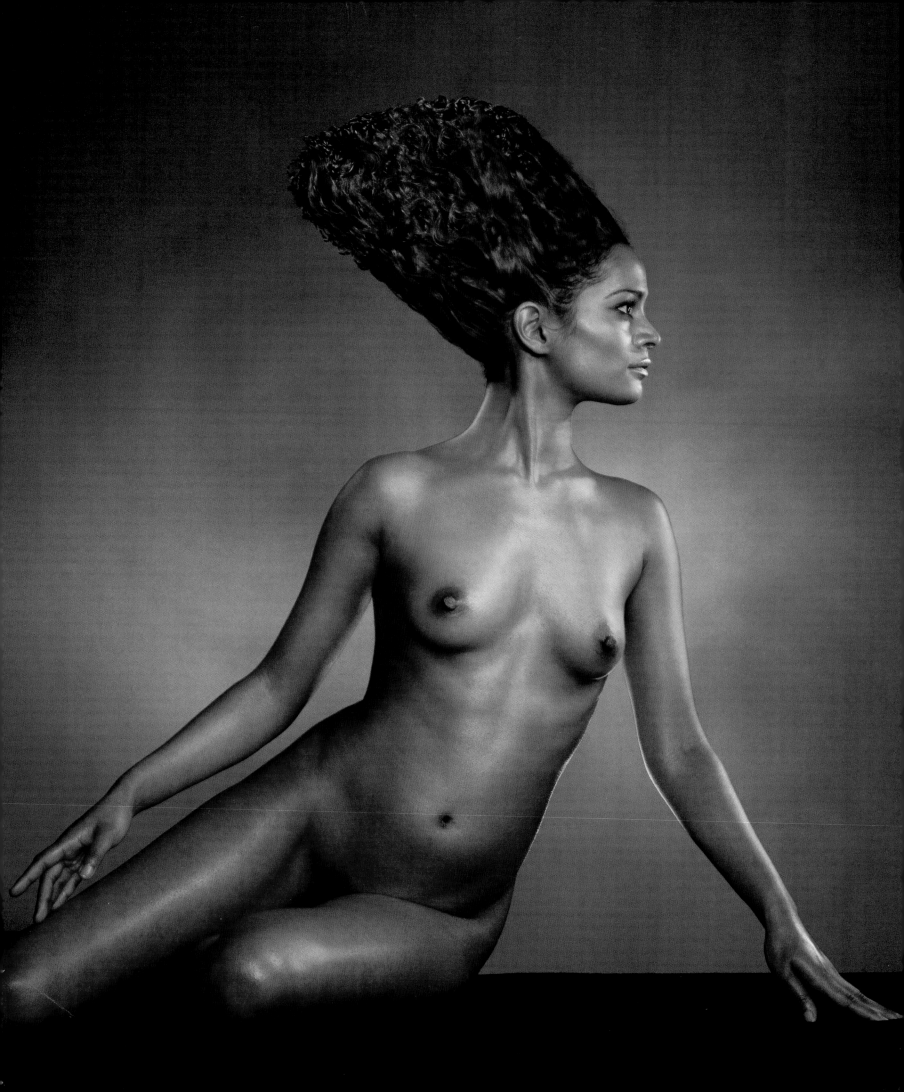

It is the elegance and simplicity of the sinuous female form that inspired me to explore nude photography. As the focus of an image, it gives it a timeless atmosphere that I complement with my choice of location and props. I work with both professional and amateur models, although I find that models who have studied dance are easier to pose. They will also improvise, which in turn can inspire new ideas in me. Being a female gives me a great advantage – I can imagine myself in a scenario or a pose and this makes it much easier to translate my idea to the model.

ragne sigmond

I was lucky to grow up in a very creative household, and was encouraged to study dancing, theatre, and music. Today these interests directly influence my photographic style. Ninety per cent of my work is shot on a digital camera, with the remaining 10 per cent using black and white infrared film. I work in both studio and environmental interiors, where I prefer to shoot in natural light, only adding artificial light if the circumstances demand it. In the studio, the lighting set-up is never completely predetermined – the final lighting choice is a result of exploration, inspiration, and improvisation during the session.

My pictures have been described as creative, mystical, and adventurous. Their style is often linked to the dreamy, fairytale qualities inherent in Norwegian folklore and a romanticized image of Scandinavian culture. I develop my ideas from things that inspire me in my everyday life – people, places, objects – and along with careful selection of locations, models, clothes, and props, I strive to give my pictures an ageless quality. Quite often I use an idea as a starting point, and make conscious use of light, contrast, compositional elements, form, and colour as tools to reach the final result. At the same time, I try to work spontaneously during the session, allowing circumstances to reshape the idea into something fresh and new. This mixture of a conscious and instinctive workflow, with one idea leading to another, is what gives expressiveness to my pictures. I don't end the session until I feel "It's there" (and indeed it's very often the last pictures of the shoot that are the best). These creative shoots give me great satisfaction. They are like vitamin pills – a real boost!

Nationality Norwegian
Main working location Denmark
Photographic method Digital and infrared film

Ragne Kristine Sigmond graduated from the Danish School of Photographers (Medieskolerne) in Viborg, Denmark in 2003, having specialized in fine art photography. After a period working as a portrait and advertising photographer in Norway, she was appointed Professor at her former photography school in Viborg in 2006. She has judged the annual portrait competition held by the Norwegian/Swedish Association of Portrait Photographers, and has exhibited in Norway, Denmark, and Belgium.

www.ragnesigmond.com

I have always been fascinated by Egyptian mythology, and in particular by the beautiful bust of Queen Nefertiti with her majestic crown. Kala, with her exotic, refined, and elegant appearance, seemed ideal as a model, and I knew from another photographer that she would be able to play along and improvise, giving me added inspiration. The night before the shoot I visited her at home, taking with me some florists' oasis, and we shaped this to fit her head and give the outline of Nefertiti's crown so that it would be easy to style the hair over it at the appropriate height.

16:00 **I explain my Nefertiti concept** to Trine, the hair and make-up artist.

16:50 **The hairstyle** combines false hair with Kala's own, arranged over the shaped oasis.

17:15 **The make-up,** with heavy black eyeliner, also contributes to the Egyptian style.

17:30 **A shiny gold-bronze foundation** is applied to give Kala a half-human, half-statue look.

16:00

17:15

16:50

17:30

17:55 **My camera** is placed on a tripod so that I can take sharp pictures at 1/15th of a second.

18:05 **A light** placed at floor level lights Kala's back from behind, giving a nice rim light.

18:15 **Trine holds the reflector** as we prepare for a pose.

17:55

18:15

18:05

18:25

18:25 **I adjust the lights** for a different pose – each one has its own specific function.

18:40 **I have found a pose** that works well. The light on her profile, coming from the back and the side, makes her face stand out.

18:40

the shot

I chose a studio setting for my Nefertiti idea as I wanted complete control over the lighting and a plain backdrop that would not distract the viewer's attention from the model. The ancient Egyptian way of drawing or sculpting people was to show the most interesting part of the body, with the head in profile and the thorax seen from the front, and this is mirrored in the pose I was most pleased with. I used several small light sources to give the image a three-dimensional look and to lift Kala out from the background, giving depth to the picture.

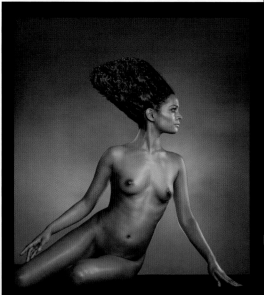

Nefertiti

Checking the details

I zoomed in to check the sharpness of the image and to make sure that she had the right expression in her eyes. I knew now that Kala and I had found the ultimate pose from the shoot.

FOR THIS SHOT
Camera: Canon 5D; 80mm lens
Aperture: f/11
Shutter speed: 1/15th of a second
Sensor/film speed: ISO 100
Lighting: Seven Broncolor flash heads and two Dedolight video lights

Lighting the background

To make the grey background appear more vivid, I shone one of the lights through a cut-out screen. I could have created the same effect in Photoshop, but I prefer to create as much of the finished image as possible in the shoot.

Positioning the lights

I positioned two lights to Kala's left and angled one on her hair and placed the other so as to highlight her neck, helping to separate her from the background.

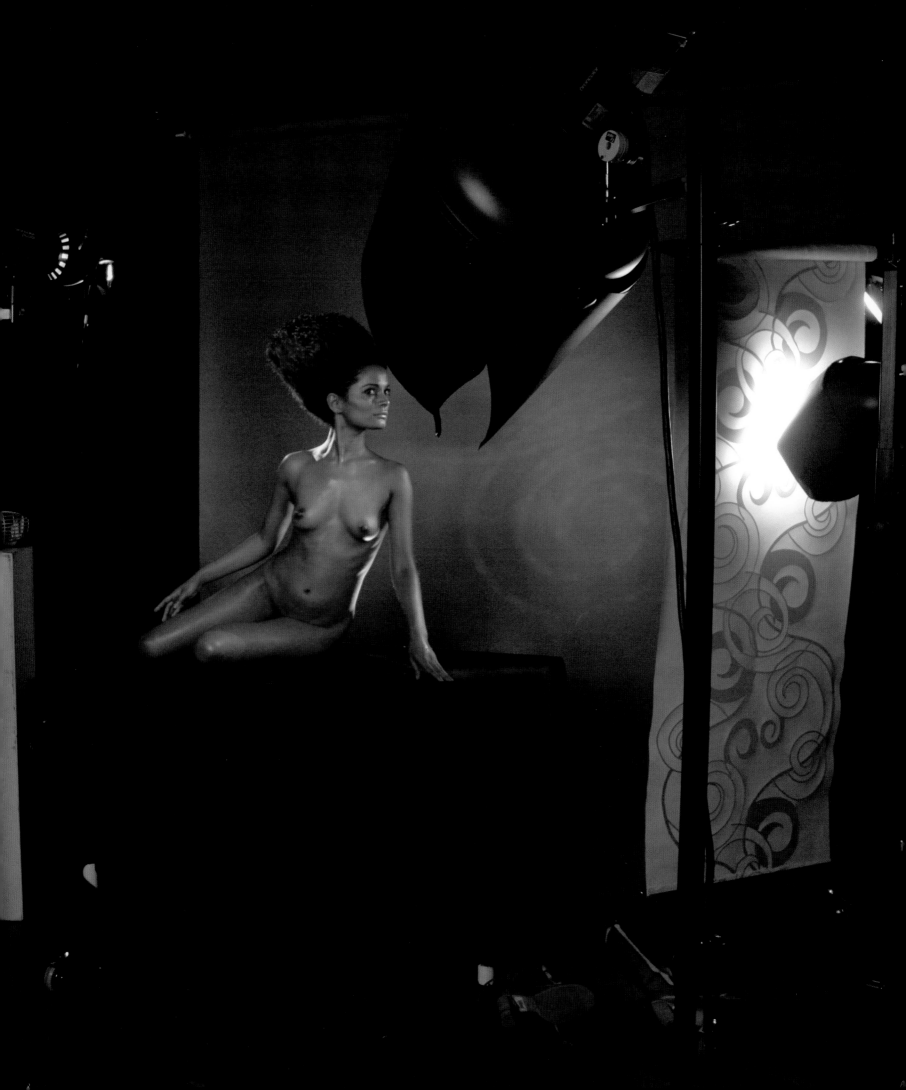

△ *Akt*

The idea for this image was inspired by Ancient Greek sculpted torsos. I took the picture from an angle so that the torso would appear slightly asymmetrical. Studio flash illuminates the model's silky white skin, which was further enhanced on the computer.

> *Kala*

In this photograph I wanted to juxtapose the model with the old painting on a wall at Østergaard, Denmark. The key light that models the body was a soft video light from above left, and the fill-in light was the ambient light coming from a window behind me.

◁ *Elevation*

I made the veils from light plastic sacks that would not become
waterlogged; they were held up with wires which I removed
in Photoshop, but I still had to wait for the wind to make them fly.
It was very early morning, when the sun was still at a sufficiently
low angle to give rim light.

frequently asked questions

People ask me lots of questions about my work – some more sensible than others. I'm not into answering questions such as "What's the best camera, lens, or memory card", since "best" is highly subjective. I prefer to think in terms of "efficient" and "reliable". I want to be myself rather than better than the rest of the world. For me, being a nude photographer is a dream profession: working with interesting people in a positive, creative way. Of course, taking the photograph is only a fraction of the process; location and model scouting, briefings, and so on all play a part. And of course you have to be able to act as a crisis manager once in a while; you are working with human beings!

MODELS

Q I'm just starting out as a nude photographer; where can I find models?

A Potential models are everywhere. Because I'm a professional photographer with published books and a website, it is easier for me to approach someone I'd like to photograph. I can show them my work or give them my website address so they can see what I do and decide whether they would like to work with me. For a beginner in nude photography, this method of finding models is more tricky, but not impossible. As long as your intentions are genuine and you are discreet and polite there is no reason why someone should take offence. If you are already a keen photographer it is well worth creating your own website so people can see your work and take their own time to consider your proposal.

Of course you can always hire a professional model; you'll find lots of agencies on the internet. There are also many internet communities of amateur and semi-professional models and photographers, and these can be a good place to start.

Family and friends are the easiest option if you are just starting out. If you find someone willing to pose for you who you already know well, you can take your time, make your mistakes, and learn your craft in a relaxed and informal atmosphere. This way of working can be very rewarding for both photographer and model.

Q I haven't been able to find a model; what can I do?

A It might sound like a joke, but use a tripod and a timer and take pictures of yourself! Self-portraits have a lot of benefits. You can experiment with light and poses, and you'll understand the chalenges of being a model yourself. Most importantly, you'll have some reference images to show potential models – even if you're not the perfect model yourself.

Q What can I do if my wife/husband/ girlfriend/boyfriend isn't keen on me photographing nudes?

A Having a partner working with nude models can feel threatening. The only thing you can do to reassure someone is to be honest and open. Nude photography, like any other genre of photography, is about making wonderful images, it is not a sexual thing – but sometimes it takes a while for a partner to get used to the idea. Once they see that you are taking tasteful, artistic pictures they will be able to see it as a creative endeavour just like any other.

I'm often asked a similar question by models, and my answer is the same. I would also suggest that the model brings a companion to the shoot – preferably not the jealous partner, but someone the model feels comfortable with and who will stay discreetly in the background.

Q What do you do if you lose inspiration during a session?

A You can't expect every session to be inspiring from start to finish; there are bound to be times when you need to recharge your batteries. Take an inspiration break – have a chat with your model, find out about them, talk about favourite films, hobbies, what sports you enjoy, and so on. I usually find that by sharing thoughts and feelings I find new inspiration very quickly.

Q What if things just don't "click" with my model?

A If you are communicating in an honest, open, and respectful way, it might be that there is something outside the session that's bothering your model. Ask tactfully if this is the case, and whether he or she would prefer to finish the session. If it's a model I know well I might suggest that we try bringing the anger or sadness, or whatever it is, into the session – sometimes expressing your emotions to the camera can be excellent therapy! And if I'm having a bad day myself, I tell my model. He or she might find the key to brighten me up again.

MODEL RELEASES

Q A model agreed to pose for me, but objects to me exhibiting the image. Can she stop me?

A Yes she can! There is a huge difference between permission to take pictures and permission to use them. Don't ever confuse them – it could land you in all sorts of trouble.

Q A model agreed verbally that I could exhibit, but changed her mind. Can she do this?

A A verbal agreement is perfectly valid, but the problem is that without witnesses how do you prove permission was given? The laws surrounding this vary from country to country, but usually the burden of proof will be with the photographer. The only way to be sure that your agreement is legally binding is to ask your model to sign a release.

Q What is a model release?

A A release is the legally valid, written proof of what you have agreed with your model about the use of images. The model expressly waives his or her rights to the images for the purposes specified in the release.

Q Where can I find examples of model releases?

A You will find model releases in most languages on the internet, or you can contact professional

or amateur photography associations who deal with the copyrights of artists and performers.

Q What do information do I need to include in a model release?

A The two key areas are identification of the people and places involved and the permission given.

Model's identification: name, date of birth, address, phone number, and/or email address.

Photographer's identification: name, address, contact details.

Session identification: date, location, subject, dress code (nude).

Purposes: general permission granting every possible present and future use, or specified purposes such as exhibitions, artistic publications, editorial, publicity and so on.

Exceptions and remarks: any additional restrictions that the model wishes to impose. For example, a model may not wish to have the pictures published locally, or may ask that images are framed to avoid full nudity or to retain anonymity.

Place and date of the release.

The model and the photographer each retain a copy of the release, signed by them both.

Q What if a model refuses to sign a release?

A She could be inexperienced and suspicious or nervous about signing legal documents. Or perhaps she's uncomfortable with the images. Any questions about the release should be sorted out before the session, but it should not be signed until after it. If a model agrees to the release before the session but refuses to sign it afterwards, something went wrong during the session. Ask yourself what.

Q I only want to use the images on my website; do I still need a release?

A Yes, absolutely – especially for the internet, where it's accessible to anyone.

Q Do I need a release even if I don't intend to use the images?

A No, but if you wished to exhibit your work some time in the future would you be able to get the necessary releases? I often do private sessions, and those clients ususaly don't want their pictures published. In these cases I have a release stating "no use permitted", to reassure them.

Q I only want to show my images at the photography club. Do I need a model release?

A Yes, you do.

Q What should I do if a model wants to withdraw permission to use the image, although I have a release?

A Legally speaking, he or she is breaking a contract. A model can take the issue to court, but will be liaible to pay you damages. But I would prefer never to let it get that far. There is usually a good reason why a model would do this. Try to find a solution that works for you both – perhaps agreeing to use only anonymous images.

EQUIPMENT AND LOCATIONS

Q What type of camera would you recommend?

A You can take great images with any kind of camera, even the ones on mobile phones. Composition, perspective, light direction, and pose have nothing to do with your choice of camera.

You don't need to spend a fortune, and the brand doesn't matter as long as the camera and lenses match your standards. I use both digital and film cameras – good reliable cameras, but no incredibly costly, top-of-the-range models.

Q What studio equipment do I need?

A As you can see from the pages about studio lighting in Chapter 3, you don't need a lot to create some wonderful effects. While a set of three lights is ideal, you can do a lot with just a neutral background and one softbox. Whatever equipment you choose to use, make sure you know how to handle it – the surest way to lose connection with your model is to spend too much time messing about with the equipment.

Q Can I take nude pictures in public places such as beaches or parks?

A This is a tricky one, since laws about public nudity vary. Find out about your own local laws, and those of other countries if you are travelling. In general, as long as you don't disturb anyone, there shouldn't be a problem. Choose locations and times of day when there are likely to be no passers-by, and make sure that your model can cover up quickly should anyone approach.

Q If I want to use an abandoned building as a location, do I need to seek permission?

A This is another tricky question. Legally speaking you need permission to enter any private property. But of course it is sometimes very difficult to identify the owner. My advice would be that if you have to actively open gates or doors, or literally break in, don't do it. If the place is wide open and it's impossible to trace the owner, enter with care. Check out this type of location for any potential hazards before the shoot. Behave respectfully, even in derelict buildings, never take anything away, and don't leave any rubbish behind.

Q How do I get access to locations such as castles, grand hotels, and so on?

A Ask permission from the owners. Explain your concept and why you want to use that particular location. You might offer to take some pictures of the place for their brochures or website as a way of returning the favour, but in some cases you will have to be prepared to pay a fee.

Q What precations do I need to take when working on location?

A Check your equipment, your batteries and your storage capacity (films, memory cards, and so on). If you're shooting somewhere remote, always make sure someone knows where you're going. Take plenty of food and water with you, and if you're working outdoors make sure you have the necessary insect repellents and sunscreen. It's a very good idea to take out insurance to cover any accidents, for your model, your equipment, and yourself. Both you and your model should also have some form of identification with you.

I'd love to answer all your questions in detail, but that's not possible here. For more information, contact your local amateur or professional photography federation.

I host a weekly slot on www.finearttv.tv, where I answer viewer's questions about nude photography, so please don't hesitate to send your questions to: pbaetens@finearttv.tv

index

acknowledgements

Author's acknowledgements:

I would like to thank everyone who has contributed in one way or the other to this book, and more specifically: The publisher, Dorling Kindersley, for putting an almost exclusively female team on the image selection, design, and text editing, which gives this book its nicely sensual touch; Nicky Munro for her fantastic picture and text editing, and lovely, motivating personality; Simon Tuite, for the endearing way he kept everyone on track; Io Paschou and Diana Vowles for their great input to the history section; and Nancy Verbeke for her retouching and her comments in the postproduction chapter; Su St Louis, Sarah Arnold, Lee Griffiths, Stephanie Farrow and all the others for a pleasant and efficient cooperation; Lynn & Tony, Andreas, Sylvie, Almond, Giorgio, Allan, Ocean,

Gavin, Gabriele, and Ragne, for their enthusiastic participation in the book; my models Adam, Agnes, Alexia, Aline, Anneke, Annelies D, Annelies V, Annelies VH, Annemie, Aurélie, Aurély, Barbara G, Barbara V, Barbara W, Bérengère, Betty, Cindy, Daisy, Daria, Donna, Elf, Ellen, Eloise, Els, Emmanuelle, Erzsi, Fanny, Fran, Frank, Frédéric, Géraldine, Ilona, Ineke, Jade, Jasmien, Jella, Jennifer, Jill, Johan, Jonathan, Joke, Jothi, Joy, Julie, Katja, Kenza, Kim, Kimberly, Klara, Krisje, Kristien, Kylian, Laure-Anne, Leen, Linda V, Linda W, Lotte, Lucy, Maite, Marie-Aude, Marion, Marjolijn, Mitali, Myra, Natalie, Nathalie, Nele, Nelly, Paulina, Sandra, Sarah, Sarina, Shanya, Sindy, Sofie A, Sofie G, Stephanie, Susi, Sylvie, Tine B, Tine H, Thida, Tobias, Vanina, Veerle, Veronica, Virginie, Zsuzsi,

Zuri; thanks also to Lee Griffiths, Iona Thijs, and Andy Mitchell for the 'making of' images; Bert Verlinden and Marnix Vermeulen for scans and prints; Jos Brands (bodypaint); Hugo Gits (Gits Jewellery); Tjonca Siu (Chess Café); Chris De Dobbeleer; Jos van Lierop; Guido Bammens (KU Leuven, Salve Mater); Vic Haenen (Virix); Rony Broun (Cunard Lines), and all the other people who have given me access to wonderful locations; The Belgian and European Federations of Professional Photo-graphers (NVBF and FEP); Adobe Benelux; Belgian Fuji Agency; Nikon Belgium; www.finearttv.tv. And of course a big thank you to Nadia, and my family, the beloved who have supported me during the production of this book, and before!

Gallery Photographers acknowlegements:

Lyn Balzer and Tony Perkins thank Siannon and all their models for sharing their vision; their producer, Grant Navin, for making it all happen; and Katie Lee, for doing Siannon's hair and make-up.

Andreas Bitesnich would like to thank Micky Friedmann for modelling, Werner Linsberger for assisting, and Anthony Gayton for hairstyling.

Sylvie Blum wishes to thank Ashley Ringsletter (model), Jennifer Fiamengo (make-up), and Philip Haban (assistant), and a special thanks to her friend Renée Jacobs.

Almond Chu would like to thank Ann Mak (producer), Ivan Lee (make-up and hair), Alana Wong (model), Chu Chi Sing and Eddie Chan (photo assistants) for their

assistance on the shoot, and Danny Chau of Chaudigital Ltd London for the digital enhancement. Last but not the least, Nude No. 5 is reproduced courtesy of Osage Gallery.

Giorgio Gruizza wishes to thank his associates and great friends Jovana Vranesevic (make-up artist), Dragan Krstic (laboratory technician), and Bojana Nedic (model) for their patience, understanding, and help during the shoot for this book; and Katarina, for love, faith, and support.

Allan Jenkins would like to thank Valeria Dragova for her incredible patience and dedication to the art of posing nude.

Ocean Morisset would like to give a big thanks to his friend Thomas Atkins II for the use of his beautiful apartment.

Gavin O'Neill wishes to thank Amani Faiz (assistant), Elsa Morgan (make-up), and Aliénor Balland (model).

Gabriele Rigon extends grateful thanks to Valentina Piccini for acting as his model and to Nigel Wright for helping to make it such an enjoyable shoot.

Ragne Kristine Sigmond would like to thank the model Kala Kristiansen and the make-up artist and hairdresser Trine Juul Nørskov; also Knud Erik Jakobsen for permission to photograph at the medieval castle, Middelaldergården

Publisher's acknowledgements:

Dorling Kindersley would like to thank Steve Willis, for colour correction in the Defining Styles & Approaches and Exploring Techniques chapters; Adam Brackenbury, for additional retouching in the Postproduction chapter; Liz

Moore and Sarah Hopper for picture research; for the index, Cnris Bernstein; for proof reading, Tracie Davis; Models Sarina Carruthers (jacket) and Adam Monnsen; Stephen McIlmoyle, hair and make-up artist (jacket); and

a huge thanks to Nigel Wright for the reportage photography for the Photographers' Gallery chapter (a true photographer in the making!).

Picture acknowledgements:

The publisher would like to thank the following for their kind permission to reproduce their photographs:

Key: a-above; b-below/bottom; c-centre; l-left; r-right; t-top

7 Art+Commerce: © Horst P. Horst (tr). 10 Réunion des Musées Nationaux Agence Photographique: Photo RMN - © Hervé Lewandowski (r). Telimage: © Man Ray Trust/ADAGP, Paris and DACS, London 2007. (l). 11 Art+Commerce: © Horst P. Horst. 12 Société française de photographie: (image is a retouched reproduction). 13 Réunion des Musées Nationaux Agence Photographique:

Photo RMN - © Droits réservés. 14 Corbis: Bettmann. 15 Musée de l'Elysée: Lehnert & Landrock, Cairo. 16 Réunion des Musées Nationaux Agence Photographique: Photo RMN – © Hervé Lewandowski. 17 Réunion des Musées Nationaux Agence Photographique: Photo CNAC/MNAM Dist./Jean-Claude Ianchet. 18 Telimage: © Man Ray Trust/ADAGP, Paris and DACS, London 2007. 19 (c) Bill Brandt/Bill Brandt Archive Ltd. 20 Leni Riefenstahl Produktion. 21 Christie's Images Ltd.: Harry Callahan Estate. 22 Art+Commerce: © Horst P. Horst. 23 Réunion des Musées Nationaux Agence Photographique: Photo CNAC/MNAM Dist. RMN/Philippe Migeat/© ADAGP, Paris

and DACS, London 2007. 24 Arno Rafael Minkkinen. 25 Réunion des Musées Nationaux Agence Photographique: Photo CNAC/MNAM Dist. RMN - © Philippe Migeat. 26 Ralph Gibson (www.ralphgibson.com). 27 © Lucien Clergue. 28-29 Art+Commerce: © Steven Meisel, courtesy Advertising Archives.

All other images © Dorling Kindersley
For further information see: **www.dkimages.com**